FIVE

CENTURIES

of TAPESTRY

FIVE

CENTURIES

of TAPESTRY

from The Fine Arts Museums

of San Francisco

Revised Edition

ANNA GRAY BENNETT

THE FINE ARTS MUSEUMS OF SAN FRANCISCO

CHRONICLE BOOKS

Copublished by The Fine Arts Museums of San Francisco
and Chronicle Books.

Five Centuries of Tapestry is published with the assistance of
The Andrew W. Mellon Foundation Endowment for Publications.

Produced by the Publications Department of The Fine Arts
Museums of San Francisco: Ann Heath Karlstrom, Director
of Publications, and Karen Kevorkian, Editor.
Edited by Deborah Bruce, San Francisco, and Ann Heath Karlstrom.
Index by Susan DeRenne Coerr.
Design and composition by Wilsted & Taylor Publishing Services.
Printed and bound in Singapore, through Overseas Printing
Corporation, San Francisco.

Library of Congress Cataloging-in-Publication Data

Fine Arts Museums of San Francisco.
 Five centuries of tapestry from the Fine Arts Museums of San
Francisco / Anna Gray Bennett. — Rev. ed.
 p. cm.
 Includes bibliographical references and index.
 ISBN 0-8118-0213-2 : $49.95. — ISBN 0-8118-0206-X (pbk.) : $29.95
 1. Tapestry—California—San Francisco—Catalogs. 2. Fine Arts
Museums of San Francisco—Catalogs. I. Bennett, Anna G.
II. Title.
NK2985.S26F56 1992
746.3'074'79461—dc20 91-46518
 CIP

 ISBN 0-8118-0206-X (paper)
 ISBN 0-8118-0213-2 (cloth)

Distributed in Canada by Raincoast Books
112 East Third Avenue, Vancouver, B.C. V5T 1C8

10 9 8 7 6 5 4 3 2 1

Chronicle Books
275 Fifth Street
San Francisco, California 94103

Printed and bound in Singapore.

Contents

Director's Foreword

The great range of the tapestry collection at The Fine Arts Museums of San Francisco was little known before the publication in 1976 of *Five Centuries of Tapestry from The Fine Arts Museums of San Francisco* and the circulation of the exhibition it catalogued. Unforeseen enthusiasm attended those two events with the result that the catalogue was soon out of print. The interest in tapestry persisted, however, and the Museums were the beneficiary as the collection continued to grow through gift and purchase.

Encouragement to reprint the catalogue came from many directions over the years, but only with the receipt in 1986 of a matching grant from The Andrew W. Mellon Foundation did the Museums begin to have much hope of carrying out such a project. By the time the match was completed three years later, it was clear that simply reprinting the original catalogue would serve neither the Museums nor the waiting readers adequately. The collection had increased substantially as had scholarship in the field. Though Anna Bennett, the author of the original catalogue, had retired from work at the Museums and gone on to other projects, she still was willing and eager to approach the business of updating and expanding the catalogue. She pursued the task with the intelligence,

professionalism, and humor that always informs her work. Within a year of having begun the rewriting, she submitted her manuscript for the revised, expanded catalogue.

We are grateful to Anna Bennett and to all those who participated with her in producing this new, more complete catalogue of the tapestry collection at the Museums. The Andrew W. Mellon Foundation Endowment for Publications was crucial to the development of the book, for without its support this project could never have begun. In addition, it has been our good fortune that Chronicle Books joined in the effort to help this volume find its way to all those readers who have awaited its completion.

Most tapestries are of such dimensions that only a few can be displayed at any given time in a museum. Riches of collections such as this too often remain known only to the curators and scholars who have found their way to the study of these woven objects. This publication brings the beauty of the collection to its public in a way that no exhibition ever can.

Harry S. Parker III
Director of Museums

Preface and Acknowledgments

The preface to a second edition should address the question of why the book should be republished at all. In the case of *Five Centuries of Tapestry*, the decision to publish was a simple matter of supply and demand: the supply had long since been exhausted, but, surprisingly, the demand had not. The larger question, and the more difficult to answer, is why the demand. Since the first edition appeared in 1976, the tapestry field has shown almost frenetic activity. The most prestigious art museums in the country have published collection catalogues of their vast holdings. Exhibitions have been presented and symposiums held all over the world, from Melbourne to Bergen-op-Zoom. Tapestries are studied, exhibited, and woven as they have not been since the 1920s. A more sophisticated public has, apparently, acquired the taste.

The Museums' decision to republish, ultimately dependent on this revival of interest, afforded a rare and welcome chance to correct the errors of the first edition and to widen its scope with new information. The larger book that has resulted includes tapestries acquired since 1976 by purchase, gift, and bequest, and selected furniture pieces with tapestry covering. New photography has encouraged a greater percentage of color images; advances in computer technology eased the task of coordinating the original text with a flood of new data.

Certain things have remained constant in this period of rapid change: a spirit of community among tapestry people and their readiness to help each other. Perhaps this reflects the nature of tapestry itself. While multiple paintings on a single theme are certainly known and were even numerous in the late nineteenth century, tapestries were almost always designed as a series. The breaking up of the original suites explains the presence of related pieces in scattered collections, a situation fostering information exchange. Whatever the reason, the generosity of colleagues and friends has been critical to the revision of this book. I acknowledge first my enormous, basic debt to Edith Appleton Standen and to Nello Forti Grazzini, both super-specialists in their fields, who have been my mentors in this project, making corrections and additions, and

carrying on the role so ably performed by Guy Delmarcel in 1976. Among others who assisted materially in different ways in the production of this book, I thank the following generous friends, experts, and benefactors, listed alphabetically since it is impossible to quantify their contributions: Charles Norton Adams, Mark Adams, Candace Adelson, Rotraud Bauer, Adolph S. Cavallo, Lore A. Certoma, Jeannette M. Clough, Isabelle Denis, Carol T. Dowd, Walter Horn, Gregory D. Jecmen, Elisabeth J. Kalf, Alistair Laing, Hal N. Opperman, Edgar Munhall, Charles Murgia, Robert Sarlos, Nadia Tscherny, William Walker, Ian Wardropper, William Wells, and Alice Zrebiec.

Within the Fine Arts Museums family I thank Harry S. Parker III, Director, whose approval and support initiated the project; Steven A. Nash, Associate Director and Chief Curator; Cathryn M. Cootner, Curator in Charge of Textiles; and Lee Hunt Miller, Assistant Curator of Decorative Arts. I am especially indebted to Melissa Leventon, Associate Curator of Textiles, who provided departmental liaison and worked with Michael Whittecar, Senior Technician in charge of textile installation, to assist Joseph McDonald with the difficult and critical photography. Additional refining by Ann Karlstrom raised the level of accuracy and usefulness of the references. I thank Ann Karlstrom and Karen Kevorkian of the Publications Department and editor Deborah Bruce for guiding the manuscript through the steps of production. I am grateful to Leslie Smith, Senior Conservator of Textiles; her intern, Glenn Petersen; and Jim Wright, Chief Conservator of Paintings, for technical information and advice. Jerry Smith, Librarian, was tireless in the search for the necessary books; intern Susan Kerner and docents Virginia Anderson and Maude Crawfurd made valuable contributions. I owe a special personal debt to Josephine Palmer for a year of expert office help, for her eagle eye that forestalled many errors, and her good humor that enlivened the most routine procedure.

Anna Gray Bennett

Tapestry Redux

The publication of *Five Centuries of Tapestry* in 1976 was celebrated by a historic exhibition of The Fine Arts Museums' newly rediscovered and rejuvenated tapestry collection. The event was made possible by a two-year conservation project orchestrated by Anna Bennett and carried out by a group of volunteers trained for the project. Their commitment reclaimed for future generations a previously undervalued and neglected textile treasure. Looking back after fifteen years, there is a sense of wonder that the collection came so close to extinction and that the efforts to save it had such unexpected and lasting results.

The tapestries were washed and mended to lessen the damage of grime and age. But the irreparable spoiler of tapestry is light. Strict guild regulations show that medieval dyers were well aware of the threat that light posed to dyestuffs and fibers, yet its danger to this collection was ignored until late in the twentieth century, with the result that what had been created with skill and precautions underwent relentless degradation by overexposure to the strong California light.

Color that is absolutely lightfast does not exist in wool. Fading is still a problem that concerns tapestry makers. Therefore, a tapestry designer must use every possible means to insure that the woven image will not fade away. Jean Lurçat, one of the pioneers of modern French tapestry, had four rules of design that relate to this problem:

1. Use a robust coarse weave.
2. Use a simplified palette of color.
3. Build the design on strong value contrasts.
4. Use shading that is unique to weaving.

I would add a fifth point: develop a strong graphic sense of design. By graphic I mean clearly defined, without the illusionist and atmospheric effects of painting. Definite shapes can combine with line and pattern to create a feeling of shallow depth while maintaining the flatness of the wall. It is an altogether unpainterly approach.

In the 1950s Lurçat was still considered controversial in Aubusson because he was making tapestry "cruder" and eliminating the weavers' "art" of imitating paint. Most did not understand his revolutionary idea that a strong value system (relationships of light and dark) in tapestry is more important than color. Tapestry is a bold mural medium; subtlety fades.

The destruction of many contemporary pieces is woven into them. Recently a large watercolor was copied in tapestry by a famous Aubusson atelier. Well-meaning and accomplished, the weavers reproduced the subtle pale pink washes that defined the large flowers of the design. Unfortunately, within ten years of normal exposure to light and urban air, that nuance (and its beauty) will be gone.

It is shocking that in the 1990s, tapestry people have not learned the most basic principle of tapestry design: *value relationships, not color relationships, will decide the survival of an image*. This principle can be demonstrated in some pieces of the Museums' collection where the color is badly faded but the design and its message are still intact. Some other tapestries of the collection have large areas that appear to be flat, neutral color. Close examination of the actual weaving details shows that there were originally distant landscapes or cloudscapes woven in subtle tints of color, but with little value contrast. The colors have faded with time and the land/cloudscapes have disappeared completely.

Historically, the design of tapestry was conceived and sketched by an artist, enlarged by a cartoon designer, and then given to weavers. Sometimes the cartoon had only a general overall design, and the details were added by the weavers. This combination of skills produced marvelous results in the Middle Ages because all those involved were aware of tapestry's demands and limitations. But as the Renaissance advanced, as perspective developed and the illusion of realism was pursued in oil painting, tapestry followed suit. Its two-dimensional mural nature forgotten, tapestry evolved from an enlivened picture plane into an illusionary window in the wall. Influenced by the painters of realism, the creators of tapestry gradually turned it into a copy medium—a very expensive copy medium, since it was necessary to dye thousands of tints and shades of wool colors and use ever-finer warp and weft to achieve subtle imitations of painted nature.

Writing about an exhibition of French tapestries that came to America after World War II, René Huyghe, then Chief Curator of the Louvre, said that "tapestry has always, in its successes as in its failures, been submissive to painting. For all the arts of flat figuration, painting has been the leader, the major art, to which the others have conformed. But if painting can so easily abandon itself to the tricks of realism, or to those of plastic research, tapestry, which is essentially mural and thus decorative by function, can only use the latter." He goes on to write about the masterwork of the exhibition, "that zenith which has never yet been surpassed, the hangings of *L'Apocalypse d'Angers*. . . . Never has tapestry conformed as much to the profound laws of its art, and yet, even at this instance, painting is at the root, since the designer drew his inspiration from miniatures. . . . But he finds there a graphic art, dominated by the arabesques of the line, its power of movement and interlacement, which is already in conformity with its peculiar decorative aims. These plastic resources, basicly [*sic*] present in miniature technique, come into their own, dazzling, attaining their

greatest lyricism in the dimensions and simplification natural to tapestry."[1]

It is the graphic quality, not realism, that energizes tapestry. This graphic quality is apparent in the earliest fragments of Greco-Roman (Coptic) and Peruvian tapestries as well as the Gothic, and it surfaces from time to time in later centuries in spite of a preoccupation with each current style of realism.

We enjoy Gothic tapestries for their directness of vision and lack of guile, for their audacity in placing people and rose vines against broad stripes of arbitrary colors, and unicorns, dogs, hunters, and maidens all in a world of flowers and foliage that seem endlessly repeated, but are not actually repeats. That is their textural richness. It comes not from a surface texture of fiber irregularities but from design, using great numbers of small elements (flowers, foliage, emblems, initials) all carefully delineated.

It was the Gothic period that first produced a sizable body of large-scale tapestries. In small dimensions weaving can become intrusive. It can even become its own subject matter, which is perfectly valid. But in mural-size tapestry, weaving becomes the matrix which holds an image in a way unique to all the mediums of art. For that reason, tapestries should be large and should be designed from thirty feet away.

We learn from all periods of history. For those of us who work in the tapestry medium, the new edition of *Five Centuries of Tapestry* makes available again a family album of the ancestors—a record of our roots. These works contain the experience and labor of thousands of men and women who have presented ideas and images in weaving. Since we are trying to do the same thing, it is a great sourcebook of successful (and some unsuccessful) solutions to designing and weaving problems.

These centuries-old tapestries have meaning and message for contemporary artists and weavers not only because of their survival through time but also because we can study their use of the basics of visual communication: form, organization of space, dark and light, and color. The way these elements are used to communicate an idea can be as important as the idea itself, and it is what gives the emotional impact to the idea—gives the juice to life. Today most of us haven't time to really see and experience the visual. So we intellectualize it and replace the reality with words. To appreciate the visual takes some time and effort. To create it takes even more.

The question often heard in a gallery of tapestries is, How long did it take to weave? What is never asked is, How long did it take to design? The answer now for American tapestry designers might well be, A lifetime. Few who design today can afford to have their designs woven by others, so they must master two fields—design and weaving. But the time it takes to excel in weaving is time lost in growth as an artist/designer. Archie Brennan, tapestry maker and former director of the Dovecot Studios in Edinburgh, complains that American tapestry design has

"a certain 'ho-hum' . . . quality." He suggests that the "lack of depth in imagery choice, development, organization, and drawing" is perhaps because "the hours and weeks needed to weave a tapestry can inhibit time spent on design exploration and, to greater loss, take days away from the broader experience of looking, drawing, stopping, dreaming, trying, failing, discarding ideas, nurturing ideas, and developing them—all apart from and before the 'real' work of weaving a tapestry."[2]

Today's designers may also have the disadvantage of having been protected from the "inhibiting" effect of an academic training. In my art school years, students studied life drawing, portraiture, still life, landscape, composition, color theory, anatomy, perspective, graphic design, even lettering. They worked in charcoal, pencil, ink, tempera, pastel, watercolor, and oil. As their talents matured, some were exposed to ideas about space, plasticity, and expressionism held by such exponents of abstract art as Hans Hofmann. The academic foundation was forever modified by that experience of wild, free color, exuberant execution, and the unexpectedly sensitive discipline of spatial relationships. But the foundation was not forgotten.

There has been a strong upsurge of interest in tapestry making in America during the last fifteen years. A weaving demonstration, planned as part of the *Five Centuries of Tapestry* exhibition in 1976, seems to have played a part in this phenomenon. Graduate students from San Francisco State University, weaving several hours a day in one of the galleries, completed a small tapestry before the exhibition closed. Three of these weavers formed the nucleus of the San Francisco Tapestry Workshop, where hundreds of students learned the technique of Aubusson weaving. This courageous enterprise, though short-lived, has been followed by others like the Center for Tapestry Arts in New York.

The future of tapestry in America may be shaped by these teaching and technique-sharing centers where artist/weavers can perfect their technical skills. This weaving experience must combine with a personal realization that the hardest part of tapestry making is creating a design so appropriate for tapestry that it would not be successful in any other medium. Coming to grips with this challenge may mean accepting a ratio of seven designs scrapped to every one design woven. Then American tapestry may come to full flower. Some great new expressions of the joy of life may yet lie within those magic walls of wool—walls that appear so solid, yet move in a breeze.

Mark Adams
San Francisco, 1991

NOTES

1. René Huyghe, "French Tapestries in Paris," *Magazine of Art* 40, no. 1 (January 1947): 11.
2. Archie Brennan, "Tapestry in America—An Overview from Slightly Outside," *Fiberarts* (January/February 1990): 30–33.

FIVE

CENTURIES

of TAPESTRY

History of the Collection

The tapestries of The Fine Arts Museums of San Francisco represent two traditions of collecting. Many of the tapestries from the California Palace of the Legion of Honor collection were gifts from private individuals who had purchased them for their own homes. A greater proportion of the M. H. de Young Memorial Museum collection was bought especially for the museum, usually from donated funds. These very different traditions came together in November 1972, when the two museums merged to become The Fine Arts Museums of San Francisco. The Legion of Honor provenance brought exciting variety, that of the de Young greater concentration and control.

On 20 November 1895, the first tapestry (cat. no. 46) was recorded in the Memorial Museum's accession book as a gift of the California Midwinter International Exposition. This entry summarizes the museum's beginning. Michael de Young had been impressed by the Columbian Exposition held in Chicago in 1893, and he promoted an exposition in San Francisco the following year. Golden Gate Park, then hardly more than sand dunes, was chosen as the site of this venture. The exposition left a dollar surplus and various exhibits as the nucleus of a new museum, first known as the Memorial Museum, then as the M. H. de Young Memorial Museum (fig. 1).

At this early period, the museum was not exclusively devoted to art. Material of every kind was accepted. In a potpourri of objects and curiosities, tapestries were hung with respect as examples of the "European Art" so earnestly cultivated by the new society. Between the wars, interest in tapestry received an important impetus from the 1922 *Retrospective Loan Exhibition of European Tapestries* held in San Francisco, with a catalogue by Phyllis Ackerman. In the thirties the tapestry collection was strengthened under the directorship of Dr. Walter Heil. Dr. Heil raised funds by personal appeal to acquire the museum's first Gothic tapestry, *Rabbit-Hunting with Ferrets* (cat. no. 3). He also brought to the staff Dr. Elisabeth Moses, whose interest in tapestries had a far-reaching effect.

The forties saw a strengthening of the Flemish collection: four fine Teniers tapestries (cat. nos. 63–66) were purchased. Mr. Mortimer Fleishhacker gave *The Bear Hunt* (cat. no. 41) from the sixteenth century and Mr. Richard Gump added five tapestries from the sixteenth and seventeenth centuries (see cat. nos. 36, 38). Two panels of *The Story of Cyrus the Great* (cat. nos. 42, 43) were gifts of Mr. and Mrs. Daniel C. Jackling.

The four great panels of *The Redemption of Man* series (cat. nos. 11, 12, 14, 15) given in 1954 by the Hearst

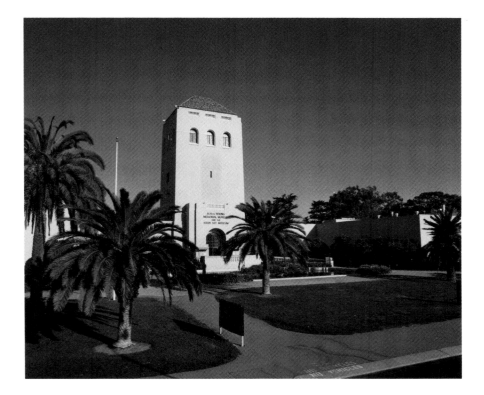

FIGURE I
M. H. de Young Memorial Museum,
Golden Gate Park, San Francisco

I

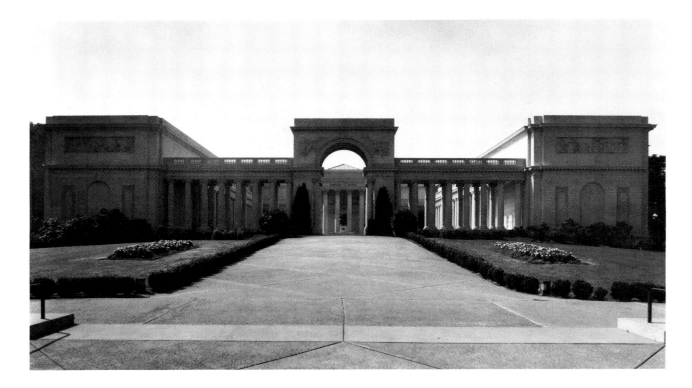

FIGURE 2
California Palace of the Legion of Honor,
Lincoln Park, San Francisco

Foundation, represent the greatest single tapestry gift to the de Young Museum. Only in Palencia, Spain, is there another such concentration of this famous series. In 1959 the Roscoe and Margaret Oakes Foundation made possible the purchase of four Beauvais tapestries with chinoiserie elements (cat. nos. 80–83), giving distinguished coverage to that exotic phase of French eighteenth-century decorative art.

The California Palace of the Legion of Honor (fig. 2) was presented to the people of San Francisco in 1924 by Mr. and Mrs. Adolph B. Spreckels. An important collection of tapestries formed rapidly at this museum in Lincoln Park. The French government made the initial gift of four Gobelins turn-of-the-century tapestries (cat. nos. 94–97). Thereafter the character of the Legion collection was determined largely by the taste of its donors. Most of these, like Archer Huntington, were connected with the Legion's founders by family or friendship. Mr. Huntington's first gift was a magnificent set of four *Portières des dieux (The Elements and the Seasons*, cat. nos. 74–77). Between 1926 and 1931, Mr. Huntington gave eleven tapestries, along with other textiles of importance. Mrs. Spreckels was also responsible for attracting the collection of Mr. and Mrs. H. K. S. Williams (see cat. nos. 10, 55, 68–73). The Williams collection barely escaped the Occupation of Paris. It was said to have left on board the last ship to go through Gibraltar.

During the forties and fifties, various gifts enriched the holdings of all periods. Mmes Kelham and Lewis gave a splendid Beauvais *Abduction of Orithyia* (cat. no. 79), and Catherine D. Wentworth a late set of *The Acts of the Apostles* (cat. nos. 47–52). The Hearst Foundation gave two panels of *The Triumph of the Seven Virtues* (cat. nos. 23, 24), and a third (cat. no. 22) was given by the Provident Securities Company on behalf of the Crocker family.

The history of the combined collection began with the merger of the two museums. The family of Hélène Irwin Fagan provided a splendid gallery suite to exhibit Mrs. Fagan's gift of Gothic tapestries. *Scenes from the Life of Christ* (cat. no. 17) was purchased in 1976 with funds from the Roscoe and Margaret Oakes Trust. *Simon the Magician* (cat. no. 5) came to the Museums the same year from Sidney Ehrman. Generous bequests from Whitney Warren (cat. nos. 58, 67) and Elizabeth Brokaw Adams (cat. nos. 1, 13, 18, 35) have filled important gaps in the collection, as has the purchase of a Renaissance panel designed by Bernard (Barent) van Orley (cat. no. 25) and a panel (cat. no. 98) from Albert Herter's looms which joined the American collections at the M. H. de Young Memorial Museum. The promised gift of a Mark Adams tapestry (cat. no. 100) completes the Museums' historic collection with a product of our own time that expresses a contemporary aesthetic.

Design

What is tapestry? Since the word is used loosely to refer to various kinds of textiles, those works that do not qualify as tapestries in the strict museum sense may be conveniently excluded at the outset. The classic misnomer, always cited, is the Bayeux Tapestry, which is technically not a tapestry at all but a monumental piece of embroidery, worked in colored wools on coarse linen. The distinction between a woven and an embroidered piece holds, whether the underlying textile is fine linen or coarse canvas. The design of a true tapestry is built up in the course of the weaving; the fabric has no existence independent of the design.

The reverse is not quite true, however. The design of a tapestry does have a previous and independent existence in another medium. It is first a drawing or painting, then a full-scale pattern or cartoon, before being translated into a weaving. The word cartoon is borrowed from the Italian *cartone*, a large piece of paper. In Raphael's time it meant a full-scale design for a painting or a work in a different material. The term acquired humorous overtones in the nineteenth century during a competition of designs for frescoes in the Houses of Parliament; Punch parodied the entries with pseudo-solemn *cartoons*.[1]

Not uncommonly in our time, weavers make their own tapestry cartoons or, dispensing with a cartoon, weave the design directly. The interaction of mind and hands at work has sometimes resulted in tapestries of striking originality. In the case of the great figural tapestries of the past, which depicted a scene or told a story, the entire scheme had to be set before the weaving was started. The work of creation was divided between a painter, who made the drawing or model, and the weaver, who executed it. This separation of function was maintained by custom and enforced by law. Any attempt on the part of the weaver to encroach on the prerogative of the painter was put down energetically.[2] Still another artist, the cartoon designer, usually intervened between the painter and the weaver. He enlarged the painter's model to the full size of the projected weaving, making other changes as dictated by his technical understanding to assist in the transition from one medium to another.

No cartoons have survived from the Middle Ages, but we know that in the fourteenth century illuminated manuscripts inspired the models from which cartoons were developed, as in the famous *Apocalypse* of Angers. We believe that the cartoons of this time were summary in nature, with colors merely indicated and values given in grisaille.[3] A full description has survived of the preparations for a fifteenth-century tapestry series commissioned for the Church of the Madeleine at Troyes. An ecclesiastic wrote the story, a painter made a small model on paper, and a seamstress and her assistant assembled bed linen on which the cartoons were painted by the painter and the illuminator.[4] The oldest surviving cartoons are believed to be those from the early sixteenth century, painted in distemper on paper after Raphael's designs, and now in the collection of Queen Elizabeth II (see cat. nos. 47, 48, 51, 52).

Works in other media represent earlier stages in a tapestry's evolution. A preliminary sketch on paper is shown with catalogue no. 27. The next step, the model, from which the full-scale cartoon is developed, is represented by the finished oil sketches illustrated with catalogue nos. 53 and 54. Comparisons with the tapestries show that important design changes were still possible at this level of development. When the cartoon was finished, however, the design was set. Variations were virtually limited to the borders, and to the amount of the cartoon to be woven.

Boucher's oil painting *Vertumnus and Pomona* (fig. 3), in The Fine Arts Museums' collection, is actually a cartoon. The vertical strips into which it was divided for the horizontal looms of Beauvais are plainly visible in a raking light. Six weavings of the cartoon are known. The wide example at The Metropolitan Museum of Art (fig. 4) shows that the cartoon has sustained losses on three sides. In other respects the tapestry is a mirror image of the cartoon from which it was drawn. Its richer effect is achieved by that minute rendering of exquisite detail which is the special province of tapestry. All cited preparatory works were intended for low-warp weaving, which reverses the design. As in these cases, the cartoon designer usually reversed an image in advance, anticipating the action of the loom. Omission of this step resulted in the left-handed hunters of catalogue no. 41, *The Bear Hunt*.

NOTES

1. Graham Reynolds, *The Raphael Cartoons* (London: Victoria and Albert Museum, 1966), 5.
2. Alphonse Wauters, *Les tapisseries bruxelloises* (1878; reprint, Brussels: Editions Culture et Civilization, 1973), 48.
3. Jules Coffinet, *Arachné ou l'art de la tapisserie* (Paris: Bibliothèque des Arts, 1971), 49.
4. Emile Mâle, *L'art religieux de la fin du Moyen Age en France*, 3d ed. (Paris: A. Colin, 1925), Conclusion II.

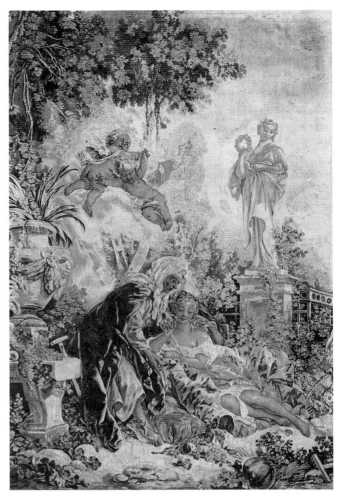

FIGURE 3
Studio of François Boucher, *Vertumnus and Pomona*, oil on canvas,
3.14 × 1.84 m (10 ft. 3¾ in. × 6 ft. ½ in.). The Fine Arts Museums
of San Francisco, Mildred Anna Williams Collection, 1967.11

FIGURE 4
Vertumnus and Pomona, wool and silk, 3.05 × 2.06 m (10 ft. × 6 ft. 9 in.).
The Metropolitan Museum of Art, New York. Bequest of Benjamin
Altman, 1913, 14.40.708

Weaving Technique

BASIC STRUCTURE

Tabby is the name given to the simplest kind of weaving in which one set of yarns, under tension, is interlaced at right angles with another. The mender who uses a darning egg for repair work has, in effect, set up a loom, first establishing a grill of strong vertical threads. These threads are the warps, held equidistant by the stretching action of the darning egg. Working from one side to the other, the mender's needle, carrying the weft, fills in the warp grill, passing over and under alternate warps. When the needle reaches the edge of the repair, it is doubled back, its direction reversed to pass under those threads it had passed over on the previous passage. The woven surface built up in this way has a checkerboard appearance, the warp threads being as prominent as the wefts (fig. 5).

Tapestry is a plain weaving with a special feature: the two sets of interlacing yarns are unequal in character and weight. In tapestry weaving the warp yarns are coarse, undyed, and widely spaced. The wefts are fine and colored. As the web builds, the wefts are packed densely together with a comblike tool until they cover the warps completely. The weft alone appears on the face of the tapestry, the warps being hidden beneath the surface and their

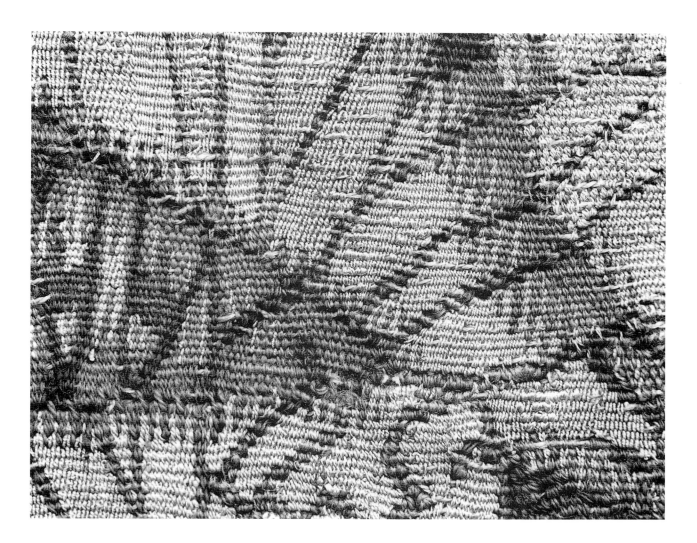

Detail, *Scene at a Royal Court*, cat. no. 9, close-up of the woven surface

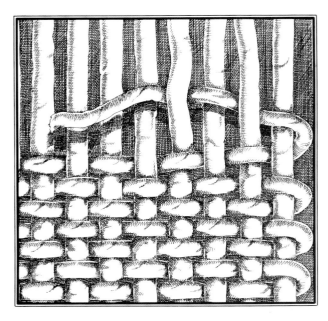

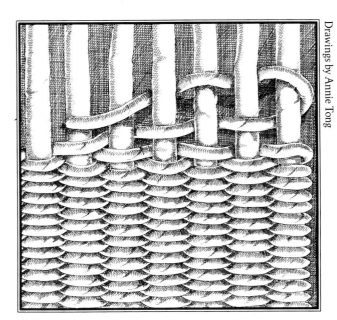

Drawings by Annie Tong

FIGURE 5
Balanced plain weave. Warp and weft threads are equally prominent, producing a checkerboard effect.

FIGURE 6
Weft-faced plain weave. The finer weft threads have been packed together to cover the warp threads completely.

presence sensed from the visible ridges. These ridges can be seen in the lower portion of the illustration showing weft-faced plain weave (fig. 6). On exhibition, the ridges of the tapestry run horizontally, or parallel with the floor, as in the drawing (fig. 7). The finished tapestry has been given a quarter turn so that it hangs by its weft threads. The reasons for this well-established custom are discussed under "Transfer and Orientation of Design."

THE HIGH-WARP LOOM

Analogies have been drawn between weaving and darning, as if weaving were done with a needle. The reweaving of damaged areas is, in fact, done in this way. However, the large dimensions of tapestries and their industrial manufacture demanded the development of very large frames or looms to hold the work, sometimes measuring fourteen to sixteen feet in length. In practice, the weft is not threaded under and over the warp, as it has been described for clarity, but is passed swiftly through a shed formed by dividing the warps into sets of odd and even yarns.

The high-warp loom was used for centuries in France and is still used at the Gobelins manufactory. The warp is stretched vertically between two rollers and held under tension. The weaver works from the back. He must walk around the loom to check his progress from the finished face, or he can peer through the warps, as in the illustration, and see at least a portion reflected in the mirror that hangs before the work (fig. 8).

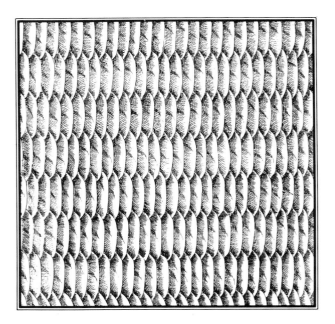

FIGURE 7
Tapestry on exhibition. The tapestry has been turned, bringing the warps into horizontal position.

6

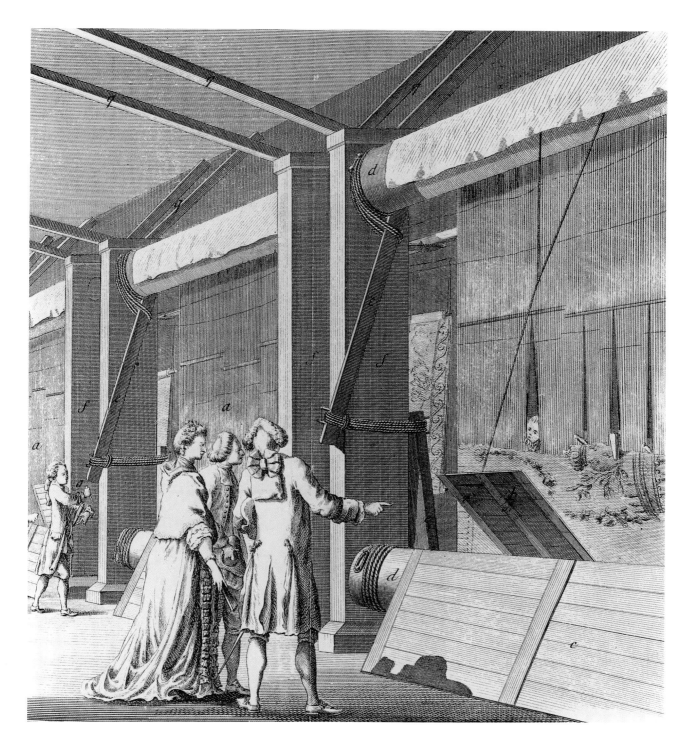

FIGURE 8

High-warp loom (front view). From Denis Diderot, *A Diderot Pictorial Encyclopedia of Trades and Industry*, ed. Charles Coulston Gillispie, 2 vols. (New York: Dover, 1959), pl. 329 (detail, right).

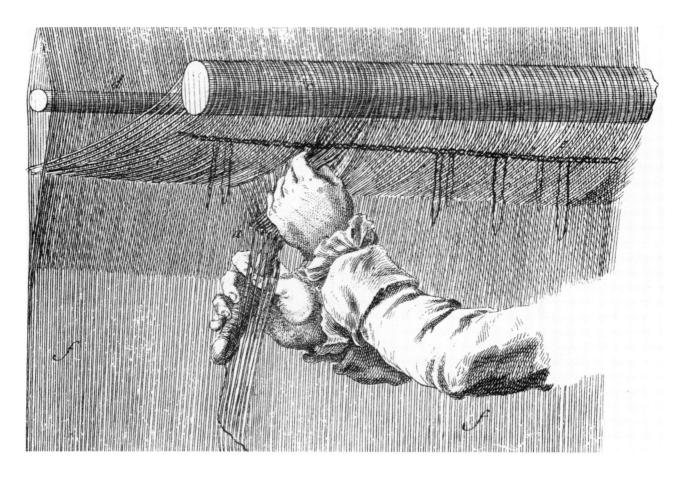

FIGURE 9
Detail of high-warp loom as seen by the weaver, showing *a*. Shed Rod, *b*. Shed One, *c*. Shed Two, *d*. Heddles. Diderot, pl. 333 (detail).

The detailed drawing shows the working area from the weaver's point of view (fig. 9). The division between the odd and the even warps is maintained by a shed rod. The set of warps that ordinarily lies nearer the weaver is stationary. The second set is capable of being drawn toward the weaver by means of small loops, or heddles, attached to each warp of that set. A brief study of the drawing will reveal the position of the two sheds. The first is maintained by the shed rod and can be enlarged when the weaver reaches up through the heddles and grasps the warps on his side of the rod. The second shed is created when the weaver takes a section of the heddles attached to the warps on the far side of the shed rod and pulls them toward himself, as he does in the illustration. When the second passage has been completed, the heddles are released, allowing the attached warps to return to their normal position and reestablishing the first shed. In high-warp weaving, the heddles must be grasped and held by one of the weaver's hands, leaving only one hand free for the weaving.

THE LOW-WARP LOOM

Diderot stated that "no clear and exact working drawings of the looms of the fifteenth, sixteenth, and seventeenth centuries have been handed down to us." However, his illustrations of an eighteenth-century low-warp loom probably give a reasonable idea of the great horizontal looms on which the Flemish tapestry industry was built (fig. 10). This loom was developed from the ordinary shuttle loom and offered the timesaving device of pedal-controlled heddles which freed the weavers' hands for the weaving. The warp was stretched in a horizontal plane between two rollers. Several weavers usually sat in a row before the work. Each weaver, working within an area of less than two feet, could raise and lower the heddles over his section of the weaving by pressing the pedals beneath his feet. Every warp was attached to a heddle, instead of every alternate warp as in the case of the high-warp loom. The warps were not raised individually, but in groups, since the heddles were joined to harnesses. A harness is visible in the

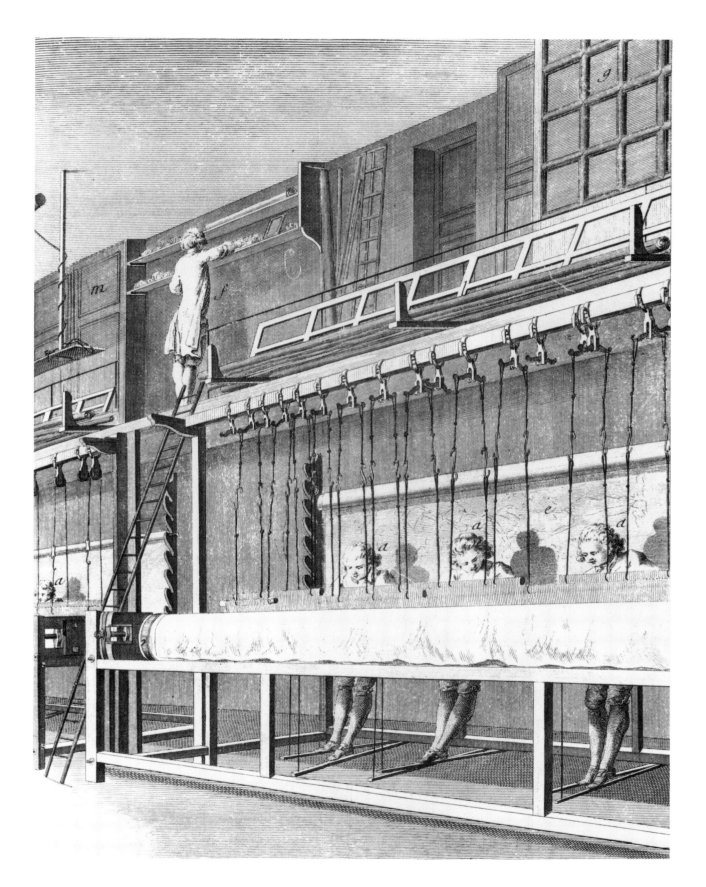

FIGURE 10
Low-warp loom. Diderot, pl. 336 (detail, right).

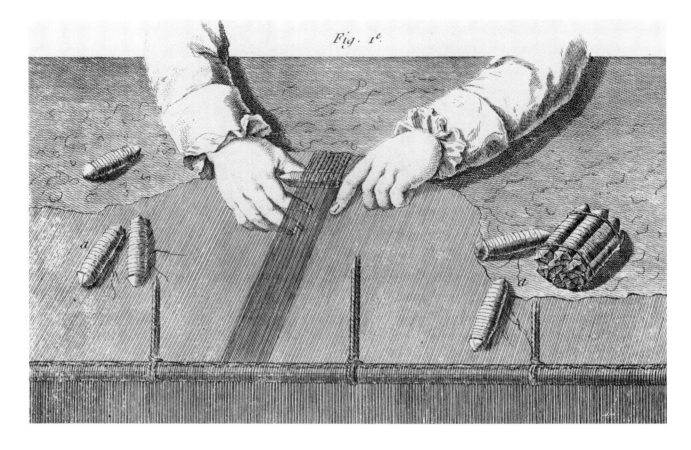

FIGURE II
Weaving on low-warp loom. Diderot, pl. 337 (left).

foreground of the detailed drawing in figure 11. The har-
nesses raised sections of warp in response to the pressure
on the pedals, thus creating the shed for the passage of the
weft-loaded bobbin.

The cartoon, the full-scale design that the weavers fol-
lowed, was cut into vertical strips and laid beneath the
warp. These vertical divisions are faintly visible in Bou-
cher's cartoon (fig. 3) and in those designed by Raphael
and shown with catalogue nos. 47, 48, 51, and 52 (*The Acts
of the Apostles*). Looking down through the warp yarns to
the image below, the weaver could reproduce the most in-
tricate details with great fidelity. Since he worked from the
back of the tapestry, the finished side of his work lay face-
to-face with the cartoon.

The fixed and inverted position of the front face of
the tapestry was the great disadvantage of the low-warp
method. It did not allow the weaver to follow the progress
of his work, nor to see large portions of it at a time. He
could, at best, see a small area by introducing a mirror
between the cartoon and the tapestry. Soufflot, adminis-
trative director of the Gobelins, urged the engineer Vau-
canson to invent an improved low-warp loom that could
be tipped up so that the weaver could follow his work with
almost as much freedom as the high-warp worker.[1] Until
this improvement was made, the weaver had less opportu-
nity to exercise his artistic judgment, and his dependence
on the cartoon was necessarily more complete. On the
other hand, he could and did execute intricate tapestries
based on elaborate cartoons, and at much higher speeds
than were possible in high-warp weaving. The loss of a
measure of the weaver's control of his work was the price
paid for the greater speed required for large-volume
production.

NOTES

1. Jean Mondain-Monval, *Correspondance de Soufflot avec les
Directeurs des Bâtiments concernant la Manufacture des Gobelins
(1756–1780)* (Paris, Libraire Alphonse Lemerre, 1918), 42–46.

Transfer and Orientation of Design

Tracing paper became available in the seventeenth century, easing the work of the high-warp weaver who had to mark his warps with the outlines of the design. The cartoon could be traced onto sections of paper and held against the warps for easy transfer. Before this innovation, the weaver probably squared off both cartoon and warps and copied the design square by square.

No such problem preoccupied the low-warp weaver, whose cartoon lay beneath the warp. However, since he worked from the back, the tapestry he produced was a mirror image of the cartoon. All cartoons prepared for his use had to be reversed beforehand in order for the weaving to correspond to the original concept of the painter. In addition to these complications, the weaver was, in all probability, weaving the design sideways on the loom.

The reasons dictating this custom were both practical and aesthetic. The dimensions of tapestries appropriate for castle or cathedral were often vast. A width of twenty-five feet was not unusual. To weave such a tapestry in the direction of the design would require a twenty-five-foot loom—obviously an impossibility. The cartoon was, therefore, laid sideways beneath the warp, strip by strip. The loom could be as small as the tapestry's vertical dimension. Completed and taken from the loom, the tapestry was given a quarter turn to bring the design into proper axis.

Aesthetic considerations also determined the direction in which the design was woven. Vertical elements, such as trees and standing figures, are a normal feature of most representational imagery. If executed in the direction of the warp, such elements would result in many long, vertical slits, the formation of which will be discussed under "Color: Structural Aspects." These slits would be undesirable in view of structure as well as appearance. Thicker lines are inevitable in the direction of the widely-spaced warp, and oblique lines in either direction will always appear *en escalier*. By realizing the design perpendicular to the warp, the weaver avoided long slits and could make lines only one weft thick where needed. One last reason: horizontal ridges catch the light as the tapestry hangs, unifying the design. Vertical ridges would have the opposite effect.

Color: Structural Aspects

The solid color areas of tapestry are structurally simple: a warp grill filled with a continuous one-color weft as in plain weaving. Large areas of solid color, however, are not typical of tapestry, which achieves its richest effects by a profusion of intricate forms and varied colors spread over the entire visual field. These color changes are structural in nature, and they have a profound effect on the character of the web.

The introduction of a new color means a discontinuing of the previous weft. Where this change occurs, the strong interlacing action of the weft in binding together the warp grill is interrupted. If this interruption recurs between the same warps for several rows, a slit results that may be long enough to weaken the structure of the fabric. A study of figure 12 will show that slits have been formed between *a* and *b*, and between *c* and *d*. Note that each color area is woven separately. The light-colored weft, for example, is not carried across, but is looped around the warp at the point of the color change and its direction is reversed. The dark weft makes its own small selvage by looping around the adjacent warp. Between the two warps a slit occurs. The easiest way to deal with a long slit and the method most frequently used is simply to sew up the slits, often while the tapestry is still on the loom.

Other ways were found to join the color areas during the weaving, eliminating the need for the sewing operation. These methods are known as dovetailing and single or double interlocking.

Dovetailing is a joining which is visible on the front face of the tapestry as well as on the reverse. Wefts of adjacent colors are wrapped, either singly or in pairs, alternately around a common warp. Sometimes larger groups of wefts are alternated for special effects (fig. 13).

Interlocking is a neater solution and results in a stronger textile, but it is time-consuming for the weaver. Wefts of adjoining colors are wrapped, not around a warp, but around each other between the warps. Single interlocking weft threads are illustrated in figure 14.

An even closer joining is achieved by interlocking in pairs. This process is known as double interlocking. The points of interlocking are staggered so that each loop of one color locks into two loops of the other color. Hardly visible on the front face, this technique appears on the reverse side as a projecting ridge (fig. 15).

The weaver or weavers of the *Spanish Bishop Saints* (ca. 1468), totally in command of the medium, varied the method of color joining to achieve different effects. In the few square inches representing a saint's mouth (fig. 16),

FIGURE 12
Formation of slits

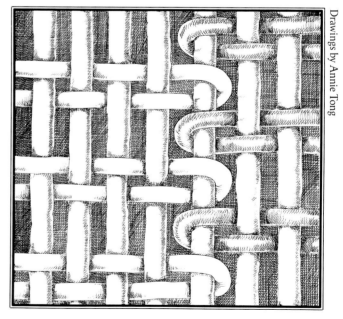

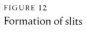

FIGURE 13
Dovetailed wefts

Drawings by Annie Tong

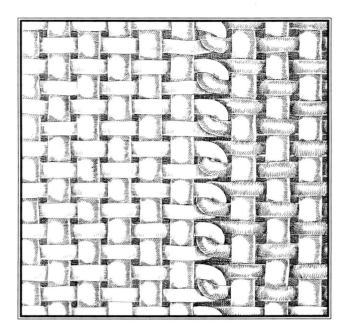

FIGURE 14
Single interlocking

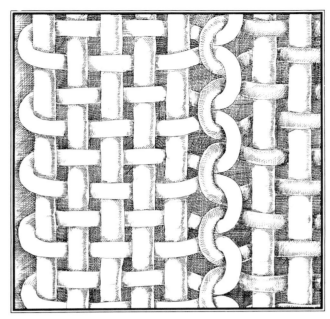

FIGURE 15
Double interlocking

three different joinings were used: a slit between the lips, later sewn together, for a definite division; a double interlocking for a smooth color change within the lip itself; and dovetailing to give a slightly ragged line at the mouth's lower edge.

Small unsewn slits were exploited to suggest the contours of the face by means of the small shadows they produce. These slits, made by interrupting the weft where no color change occurred, also conveyed the texture of hair, foliage, or drapery. Generally these small slits were not large enough to threaten the strength of the fabric and therefore did not need to be sewn.

Weavers also achieved special textural effects by *eccentric weaving*, packing the weft unevenly to create a three-dimensional surface.

COLOR CONTROLS

Dyestuffs and dyeing methods were carefully controlled. Only certain natural dyes were allowed: those that had proved to be resistant to light. Many of these dyes were made from plants grown locally. Pastel, or woad, furnished the blue color later supplied by indigo. Madder gave a warm red color. The yellows usually came from weld, perhaps the oldest of the European dyestuffs and once known as "dyer's mignonette." The dyeing process itself was subject to guild supervision. Guild officials enforced their established standards, a practice that accounts in great measure for the remarkable survival of Gothic color.

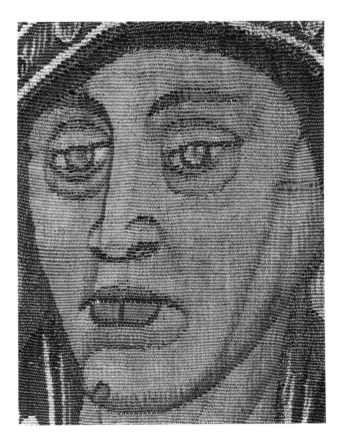

FIGURE 16
Detail, *Spanish Bishop Saints*, cat. no. 2

13

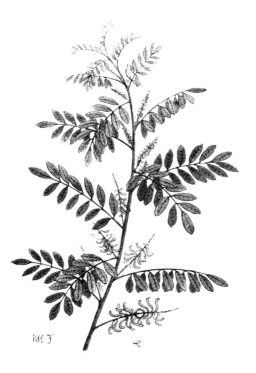

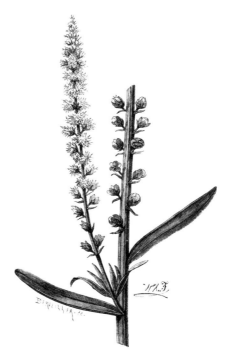

FIGURE 17
Indigo (*Indigofera tinctoria*). From Louis Figuier, *Les merveilles de l'industrie*, 4 vols. (Paris: Furne, Jouvet [1873-77]), 2:620.

FIGURE 18
Weld *(Reseda luteola)*. Figuier, 2:658.

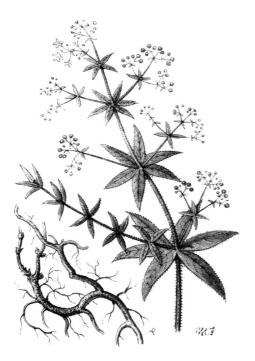

FIGURE 19
Madder (*Rubia tinctorum*). Figuier, 2:640.

FIGURE 20
Archil (*Roccella tinctoria*). Figuier, 2:641.

Woad (*Isatis tinctoria*) grows as a biennial or perennial that reaches two to five feet in height and belongs to the family Cruciferae. Its leaves provide the dyestuff. To produce the dye, a process is used similar to that for indigo vat dyeing. The discovery of the sea route to India and subsequent importation of the cheaper indigo caused woad to fall into disuse.

Indigo (*Indigofera tinctoria*) is a shrub of the legume, or pea, family with oval leaflets and spikes of tiny reddish-yellow flowers (fig. 17). Its use spread from India throughout the ancient world, and then to Europe in the sixteenth century. Production of the dye depends on fermentation of the leaves. The leaves are cut up, immersed in water, and allowed to ferment. The liquid produced is oxidized, and the paste that settles to the bottom of the vessel is processed into cakes. These dye cakes are insoluble in water and must be acted upon chemically to release the indigo into solution so it can be absorbed by the textile material. Various reducing agents have been used to accomplish this, including stale urine, wheat bran, madder, and various chemical compounds. The yarn is dipped in the solution; the color develops when it is exposed to air. Repeated dipping produces darker shades.

Weld (*Reseda luteola*), an annual herb growing to about three feet, is related to the mignonette family (fig. 18). The entire plant with the exception of the roots was chopped and dried to provide the yellow dye pigment. Weld requires a mordant, or special chemical, to prepare the fibers to accept the dye and to increase color fastness.

Weld was used with a blue dye to produce the various greens.

Madder (*Rubia tinctorum*) is a herbaceous perennial climber that gives the best and most enduring red dye of any plant (fig. 19). Used from antiquity, it was cultivated for the thin, fleshy roots that furnished the important dye. The roots were washed, allowed to dry, and finely ground to powder and stored in bags or casks. Madder is a mordant dye; alum was used traditionally as the agent.

An animal source for red dye was found in the dried bodies of kermes (*Coccus ilicis*), an insect found on various evergreen oaks in the Mediterranean area. After the conquest of Mexico, the cochineal insect (*Coccus cacti*) replaced kermes as the principal source of scarlet dye in Europe. Used with mordants, especially with tin, it gave brilliant colors.

Archil, also known as orchil, is a dye that comes from *Roccella tinctoria*, a lichen that grows on rocks along the shores of the Mediterranean (fig. 20). The plants are about two inches high, each consisting of a fungus member and an algae member. The dye potential is contained in the acids found in the inner part of the lichen. It gives colors in the purple range.

Brazilwood (*Caesalpinia*), the heartwood of various species of the Caesalpinia, produces red dyestuffs. Before the discovery of the Americas, the supply came overland from the Indies. The wood was rasped to a coarse powder and soaked in water to release the dye. Brazilwood was also combined with cochineal and madder to produce other colors and shades.

FIGURE 21
Detail, *Rabbit-Hunting with Ferrets*, cat. no. 3, showing *hachures*

COLOR BLENDING

The limitation of colors in the Middle Ages to about two dozen shades (as compared with 14,000 in the nineteenth century) was responsible for the development of a free and remarkable style.

First of all, such a limitation precluded any exact imitation of nature. The choice of colors was frankly arbitrary and artificial. However, as early as the fourteenth century, weavers looked for ways to achieve more realistic effects. Unrelieved colors placed side by side give the appearance of stained glass or of a wool mosaic. Weavers avoided these effects by the use of hatchings, or *hachures*, as they were called. These interpenetrating, comblike processes of adjoining colors produce, at a distance, the effect of a color blend (fig. 21).

The main function of the early experimental hachure was to blend the shades. Only incidentally did hachures assist in suggesting three-dimensional form. The forms of draperies, for example, were communicated primarily by linear means, and only secondarily by hachures. Their use, however, added immeasurably to the vitality of the tapestry and to the vividness of both color and design.

After the success of panel paintings in the fifteenth century, patrons demanded that tapestries resemble

paintings more closely. Hachures in the early sixteenth century had the specific function of conveying three-dimensional form. So effective was their use that the figures evoke sculpture more than painting: spaced systematically, according to an accepted formula, the hachures convincingly produce the illusion of deeply sculpted folds (fig. 22). The approaching Renaissance was to demand pictorial effects and modeling achieved by subtle color gradations. The hachure became obsolete, and with its virtual disappearance, tapestry lost part of its distinctive character. Figure 23, a detail of an eighteenth-century Beauvais tapestry, shows a subtle blending of many shades to reproduce skin tones and facial contours. The hachures of the costume have an essentially decorative function.

FIGURE 22
Detail, *Scenes from the Life of Christ*, cat. no. 17, showing *hachures*

FIGURE 23
Detail, *The Audience of the Emperor*, cat. no. 83, showing color blending

LATE MEDIEVAL
TAPESTRIES

Growth of the Industry

Tapestry weaving was a mature art in the late fourteenth century, its industrial organization sufficiently advanced to undertake commissions of extraordinary size. Tapestries of modest dimensions and medium skill must have been woven in an experimental period, but these have not survived. The bridge is now gone between *The Apocalypse* of Angers and such small-scale European fragments as Cologne's *Cloth of St. Gereon* (eleventh century), the *Baldishol* of Norway (eleventh to thirteenth century), and the Halberstadt pieces (twelfth to thirteenth century). The giant pieces, whose appearance seems so sudden, developed in answer to certain needs in the late Middle Ages.

The wooden fortresses of chivalry's great days had disappeared, replaced by castles that strike us as typically medieval, but which actually date from the end of the period. Massive defensive walls of stone enclosed interior spaces that were dark, cavernous, and drafty. The lords of these gloomy strongholds prized the tapestries that made them more habitable. The flowing fabrics masked rough stone walls, adjusting to their uneven surfaces. Rich color and strong design visually "furnished" the empty halls. Allegories, scenes from plays, and woven stories of every kind mitigated the boredom of enforced confinement and provided distraction between hunts and military skirmishes. Scenes from the Bible and lives of the saints were commissioned for churches. Some ecclesiastical tapestries had a permanent place around the church choir; others hung between the pillars of the nave on feast days.

Tapestries were easily transported and quickly installed. Both features were valuable. As the lord of the castle progressed from one property to the next, exhausting provisions and entertainment seriatim, his tapestries went with him, to be rehung on the nails awaiting at the next stop. The poor condition of the upper portions of many medieval tapestries attests to the frequency with which they were removed and rehung. They accompanied the lord to the field of battle and lined the streets for his triumphal return.

Tapestries were accumulated in numbers far exceeding need. Philip the Good of Burgundy found it necessary to construct a vaulted building expressly for tapestry storage,[1] and Henry VIII of England owned two thousand pieces at one time.[2] The nobility recognized these objects of conspicuous luxury as a splendid means of emphasizing high station. Their essential function, as Edith Standen has observed, was for grandeur. Hoarded, they proclaimed status; transferred, they functioned as currency of large denomination. They made persuasive gifts to heads of state or influential prelates. On at least one occasion, they served as a prince's ransom.[3] Relatively durable, not easily divided, tapestries represented skilled man-years which could be stored as power-producing treasure.

ENGLISH WOOL

An existing cloth industry made possible the meteoric course of tapestry manufacture. It provided a wool supply, a labor pool, even the horizontal loom itself, ready for adaptation. Inherited also from the parent industry were the powerful guilds and a transportation system for supplies and marketing which reached across northern Europe. Tapestry making, a specialization within the woolen cloth industry, was distinguished by quality at every step, beginning with the raw material: superior English wool.[4]

This commodity played a pivotal role in the economic and social history of the late Middle Ages. Flanders had a double stake in preserving its free flow: profit from trading the raw material and an even greater profit from its manufacture into woolen cloth. The luster and length of English wool fiber had been prized since Roman times, but the key advantage seems to have been its accessibility to the Hanseatic trade routes. London lay within easy distance of Bruges, the great reloading port of Europe. For three centuries Flanders clothed Europe—in English wool.

An ominous change occurred in the fourteenth century, when silt began to close the Zwin, Bruges's artery to the sea. Concurrently, Edward III of England, the "Royal Wool Merchant," squeezed the wool flow to Flanders in a move to divert the supply intended for export instead to looms newly set up in England. However, the conditions that brought down the Flemish cloth industry developed from within. Behind the splendid Cloth Halls, the workers lived in unbearable squalor.[5] Their oppression by the merchants sharpened bitter class divisions. Efforts on the workers' part to better their lot made them pawns in larger conflicts, in the power struggles between France and Flanders, and France and England. Guild was pitted against guild, and town against town. Repressive and retaliatory measures as well as religious persecution swelled the exodus to England, where Flemish skills laid the foundation for England's greatness in the textile industry.

THE TAPESTRY WEAVING CENTERS

PARIS. Superior skill and powerful patrons protected the tapestry weavers from most of the hardships that beset the ordinary cloth workers. The first center of their industry

was Paris. Ten were sworn into the Corporation of Tapestry Weavers in 1302 as *tapissiers de la haute lisse* (using high-warp or vertical looms). Inventories record the industry's rapid growth. Princely holdings soon exceeded any practical purpose and were constantly increased by the merchant-weavers. Nicolas Bataille of Paris, the most famous of these entrepreneurs, furnished 250 hangings to the court between 1378 and 1400. He is remembered best for *The Apocalypse* of Angers. Toward the end of the century, contracts frequently called for the "fine thread of Arras." Superior material gave Arras the lead in the competition, and Parisian industry declined. By 1422, only two master weavers were recorded in Paris. Occupation by the English and removal of the court occurred in 1425.

ARRAS. Records of the early production in Arras have perished. The weaving town must have gained workers and commissions from the ruin of Parisian industry. The fame of its looms spread abroad where the name of the town came to stand for the product: a tapestry in England was an *arras*, in Italy an *arazzo*. In 1348 Arras became a Burgundian territory, ushering in an era of magnificent patronage from Philip the Bold to Philip the Good.[6] At mid-century Arras and Tournai to the north were healthy rivals; thereafter Arras declined. Charles the Bold's death at Nancy hastened its ruin, and the end came when Louis XI captured the town in 1477.

TOURNAI. While Arras flourished, looms were busy also in Oudenaarde, Bruges, Brussels, and, above all, Tournai. Although the town belonged to France, it was surrounded by Burgundian territory and shared the commissions of Burgundy's extravagant dukes. Tapestries associated with Tournai convey a dramatic sense of action. Crowded compositions and deliberate chaos pleased the aggressive spirit of the Burgundian court. At the end of the century, plagues and sieges crippled the city. Her weavers did not keep abreast of the times, reusing old cartoons. Eventually, the tapestry trade deserted Tournai and went to Brussels.

BRUSSELS. The lead in tapestry production was assumed by Brussels about 1500, although splendid pieces were woven there before that date, such as the *Verdure with Arms of Burgundy* by Jean de Haze (1466). Throughout the sixteenth century, Brussels dominated the market, domestic and foreign, by superior design, perfected technique and a high degree of organization. Horizontal low-warp looms were used almost exclusively, allowing a faster, more mechanical reproduction of the cartoon. The first guild rules, dating from 1450 to 1451, covered qualifications of master weavers, training of apprentices, working rights of foreign weavers, examination and approval of products, and—of particular interest—responsibility for the cartoon. Weavers could draw trees, bushes, animals, fabrics, boats, grasses, and the like, but all other figures must be the work of the professional painter. A generation later, in 1476, the painters brought suit, claiming they had no part in the design. Their victory assured for tapestry the careful composition, restraint, and dignity of Flemish painting.

NOTES
1. George William Thomson, *A History of Tapestry from the Earliest Times until the Present Day*, rev. ed. (London: Hodden and Stoughton, 1930), 96.
2. H. C. Marillier, *The Tapestries at Hampton Court Palace*, 4th ed., rev. (London: Her Majesty's Stationery Office, 1962), 5.
3. Thomson, *History*, 73.
4. Fritz Röhrig, *The Medieval Town* (Berkeley and Los Angeles: University of California Press, 1969), 83.
5. Röhrig, *Medieval Town*, 84.
6. Madeleine Jarry, *World Tapestry from Its Origins to the Present* (*La tapisserie*, Paris: Librairie Hachette, 1968; English ed. New York: G. P. Putnam's Sons, 1969), 54.

1. The Burial of Saint Peter

from The Life of Saint Peter *Series*

Franco-Flemish (probably Tournai), 1460–1462
H: 2.50 m W: 1.25 m (8 ft. 1 in.×4 ft. 1 in.)*
Promised future gift
(Bequest of Marguerite Brokaw Adams)

"In the year of Grace one thousand four hundred and forty-four, God lessened our suffering in every way. Truce was made in France between the mighty French king called Charles of Valois and Henry King of England. . . ." So began the Old French inscription that once surmounted the final panel of the series *The Life of Saint Peter*, commissioned for the Cathedral of Saint-Pierre, Beauvais, by Guillaume de Hellande (bishop, 1444–1462). The truce in the Hundred Years' War was commemorated not only by the inscription, but also by miniature scrolls inscribed PAIX (Peace) scattered over the field of each scene of the series. But the peace, welcomed so joyously, did not hold; fighting resumed and continued sporadically until 1453.[1]

The original number of tapestries in the series is unknown. An inventory made immediately after the donor's death suggests that the various pieces of the weaving, differing in size, were intended for precise locations in the choir so as to surround it completely: above the stalls, behind the high altar, on the door to the choir near the crucifix.[2] The eleven pieces described by the inventory made in 1790 may represent only a third of the original series.

Each of the eleven pieces bore the arms of Guillaume de Hellande and the bishopric of Beauvais, placed in opposite corners above and below the scenes. During the French Revolution, the series was broken up and dispersed, but the subjects are known from early descriptions:[3]

Panel 1. *Guillaume de Hellande Offering the Tapestries to Saint Peter*. Now lost.
Panel 2. *The Healing of Saint Petronilla; The Resurrection of the Disciple George; The Healing of Aeneas*. Beauvais.
Panel 3. *The Resurrection of Tabitha; The Apparition of the Angel to Cornelius the Centurion*. National Gallery of Art, Washington, D.C.
Panel 4. *The Vision of Impure Beasts; The Baptism of Cornelius the Centurion; The Angel Appearing to Saint Peter in Prison*. Beauvais.
Panel 5. *The Angel Leading Saint Peter out of Prison*. Musée de Cluny, Paris (fig. 24).

*Tapestry unavailable for examination at time of publication.

Panel 6. *Saint Peter Beaten by the Satellites of Theophilus; Saint Peter Fed in Prison by Saint Paul*. Beauvais.
Panel 7. *Saint Peter Consecrating the Bishops Linus and Cletus; Christ Warning Saint Peter of the Plot by Nero and Simon; Saint Peter Appointing Saint Clement His Successor; Saint Peter Resurrecting a Young Man in the Presence of Nero and Simon*. Beauvais.
Panel 8. *Christ Appearing to Saint Peter at the Gate of Rome (Quo vadis?)*. Beauvais. Probably once paired with the lost scene of Simon the Magician trying to fly.
Panel 9. *The Martyrdom of Saint Peter*. Beauvais.
Panel 10. *The Martyrdom of Saint Paul*. Museum of Fine Arts, Boston.
Panel 11a. *The Burial of Saint Peter*. Future gift to The Fine Arts Museums of San Francisco.
Panel 11b. *The Apparition of Saints Peter and Paul to Nero*.[4] Private collection, Paris.

The final tapestry, as shown in the line engraving by Ribault that accompanied Abbé Barraud's article of 1853 (fig. 25), was composed of three parts: an inscription in Gothic French describing the truce and main events in the life of Guillaume de Hellande, *The Burial* on the left, *The Apparition to Nero* on the right.[5]

After the dispersal of the series in about 1790, several panels were hung in the Court of Assizes in Beauvais, whence they were returned to the cathedral in 1844, the worse for wear. Another piece was discovered in the lumber room of the cathedral. The eleventh panel was hung in the office of the church councilman during Lent, but by 1853 it had been cut into three pieces to fit into smaller quarters (or to be sold). Some "cannibalizing" went on at this time. Adelson reports that the arms and a PAIX inscription were taken from *The Burial* and used to fill in the top and bottom of the two pieces now in the National Gallery of Art in Washington (fig. 26).[6] The inscription was acquired by Msgr. Douais and burned with the bishop's palace in the bombing of Beauvais in 1940. *The Apparition of Saints Peter and Paul to Nero*, "lost" for years, resurfaced in a private Parisian collection. A partial provenance of *The Burial of Saint Peter* can be reconstructed and follows this entry.

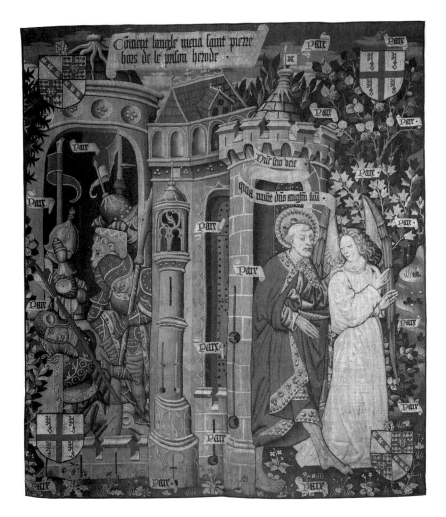

FIGURE 24
The Angel Leading Saint Peter out of Prison, tapestry.
Musée de Cluny, Paris

A two-line inscription (now lost) above the scene stated the subject: *Com[m]ent marcel et epuleus bourgois de rome enseuelirent saint pierre* (How Marcellus and Epuleius, citizens of Rome, buried Saint Peter). The account in *The Golden Legend* is scarcely longer. The burial takes place outside the crenellated walls of Rome, beyond which one glimpses a thoroughly medieval city, with a church, a public building flying a banner, and a domed tower with windows shielded against the sun by canvas awnings.

The body of the martyred saint, square-bearded and tonsured according to tradition, lies on the ground, forming a long diagonal between his two companions. One of the disciples draws the edge of the shroud around Peter's head, which rests on a jeweled halo; the other adjusts the saint's legs, which are wound with strips of cloth like a mummy's wrappings (perhaps an allusion to the telling in *The Golden Legend* that they embalmed the body with aromatic herbs). The faces of the disciples are solemn with grief; one hand is raised in blessing or compassion. The

disciple kneeling in the foreground wears a conical hat and a fur-trimmed tunic of a deep red figured fabric, drawn in at the waist by a gold-studded blue belt. A heavy purse hangs from the belt, and a long knife with a smaller knife in the scabbard. His companion is dressed in a loose violet garment under a blue, short-sleeved robe trimmed at the collar and armholes with a band of quasi-Arabic writing. His hat has a deep turned-back cuff with dots and a high crown ending in a tassel. The PAIX inscription recurs five times.

Certain art historians have attributed the Guillaume de Hellande series to France, others to Flanders. Many have specified Tournai, which is best described as Franco-Flemish. Cavallo summarized the arguments.[7] Henri de Beaumetiel has been proposed as author of the cartoons, based on his painted hangings executed after designs of Robert Campin and Jacques Daret for the chapel of Saint-Pierre at Tournai. After examining all the hypotheses of various art historians, Joubert settles on Jacques Daret as

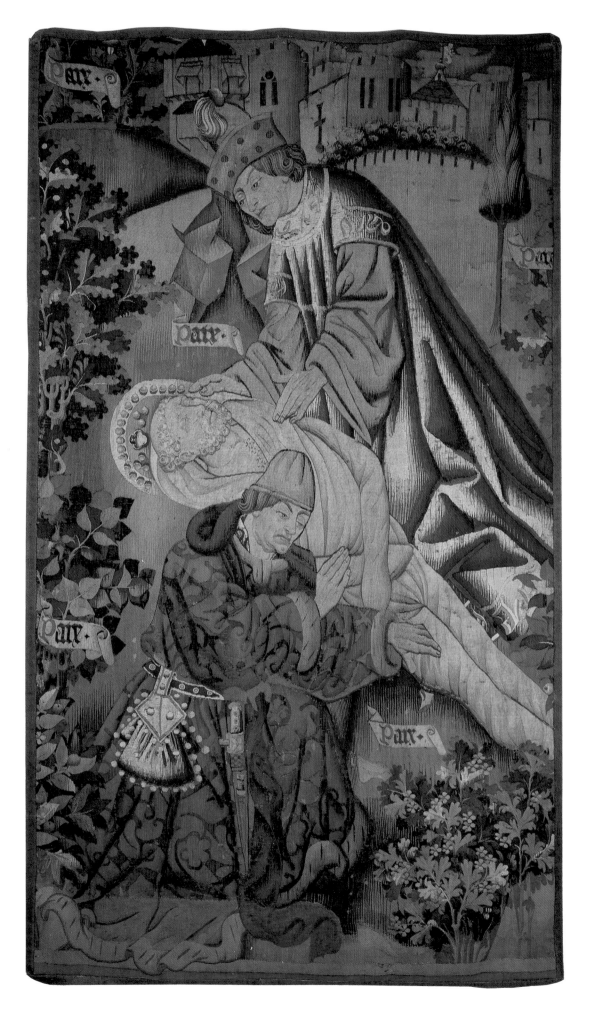

The Burial of Saint Peter

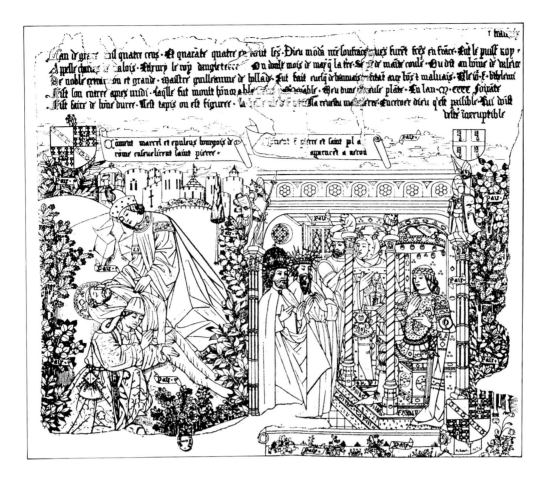

FIGURE 25
Line engraving by Ribault, 1853

the painter whose style is closest to that of the tapestries. Daret lodged with Robert Campin and became his apprentice. The stylistic characteristics linking him with the tapestries are persuasive in his *Presentation at the Temple*, at the Musée du Petit Palais, Paris.[8]

The apparition of Peter and Paul to Nero after their martyrdom, described in *The Golden Legend*, logically follows *The Burial of Saint Peter*, and as the engraving shows, the episode was placed directly to the right of *The Burial* before the two scenes were separated. Catalogue no. 16, a fragment from a slightly later *Life of Saint Peter* series, shows the same iconography, but rendered in a much simpler style. A single panel from yet another *Saint Peter* series (cat. no. 5), also commissioned by an abbot for his church, shows the contest between Simon the Magician and Saints Peter and Paul before Nero. The corresponding scene in the Beauvais series is lost, but it would have been paired with the *Quo vadis* section (Panel 8).

The losses in the lower left corner shown in the engraving were rewoven at a later date, the new material clearly visible because of its uneven fading. The bequest of this

fragment will bring into the public domain another part of the series described by Marthe Crick-Kuntziger as among the foremost productions of the art of tapestry, by virtue of its color, design, and historical importance.[9]

NOTES

1. Adolph S. Cavallo, *Tapestries of Europe and of Colonial Peru in the Museum of Fine Arts, Boston*, 2 vols. (Boston: Museum of Fine Arts, 1967), 1:53. Cavallo summarizes critical commentary that has almost unanimously agreed that the PAIX inscription refers to the 1444 truce, mentioning the coincidence of the bishop's appointment the same year, the recurrence of the word in *The Golden Legend* account of Saints Peter and Paul, and the possibility of its representing the bishop's prayer for peace on behalf of the people. Cavallo cites another tapestry series nearly contemporary with the truce that bears the same inscription, the *Lives of Saints Gervais and Protais* (1443).

2. Fabienne Joubert, *La tapisserie médiévale au musée de Cluny* (Paris: Editions de la Réunion des Musées nationaux, 1987), 17–35, no. 3. Joubert (p. 18) quotes the most ancient reference to the *Life of Saint Peter* series in the inventory of gifts bequeathed by Guillaume de Hellande: "no. 477 . . . pièces de

24

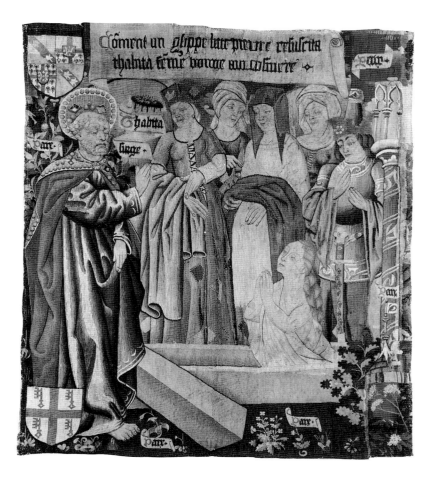

FIGURE 26
The Resurrection of Tabitha, tapestry. National Gallery of Art, Washington, D.C. Bequest of Mrs. Mellon Bruce

moult belle tapisserie lesquelles servent à parer toutes les chaières et le dessus de l'uys du choeur vers le crucifix et au-dessoubs des corps saints derrière le grant autel, semées aux borts de ce mot 'Paix', armoyez chacune pièce aux quatre coings aux armes de l'église et dudit Hellande, esquelles pièces est contenue la vie saint Pierre et est ladite tapisserie moulte riche et moult prétieuse et la donna le dit feu Mgr Guillaume de Hellande . . ." (*Inventaire des reliques et autre aournements de l'église de Beauvais . . . fait ou mois de décembre 1464*, from G. Desjardins, *Histoire de la cathédrale de Beauvais* [Beauvais, 1865], 204–205).

3. Joubert, *La tapisserie*, 19–25. The panels at Beauvais Cathedral were illustrated by Marthe Crick-Kuntziger, "A Fragment of Guillaume de Hellande's Tapestries," *The Burlington Magazine* 45, no. 260 (November 1924): 225–231. The two pieces belonging to Mrs. Mellon Bruce (now at the National Gallery of Art, Washington) are illustrated in George Leland Hunter, "Guillaume de Hellande's Tapestries," *The Burlington Magazine* 46, no. 265 (April 1925): 193–194. G.-J. Demotte published the Cluny panel in *La tapisserie gothique* (Paris and New York: Demotte, 1924), pl. 25.

4. Jacques Bacri, "A New Fragment of Guillaume de Hellande Tapestries," *The Burlington Magazine* 101, no. 680 (November

1959): 402–404. For additional references, see Joubert, *La tapisserie*, 35, bibliography.

5. Abbé Barraud, "Description de deux nouvelles tapisseries exécutées pour la Cathédrale de Beauvais," *Mémoires de la Société académique de l'Oise* (1852–1857), 2:321–328. An illustration after an engraving by Ribault accompanied Abbé Barraud's article and was reproduced by Bacri, "A New Fragment," n. 4.

6. Candace Adelson kindly allowed me to read the relevant portion of her forthcoming catalogue of tapestries in the National Gallery of Art, Washington, describing the two scenes given by Ailsa Mellon Bruce in the context of the whole series. Her review was helpful in the writing of this entry.

7. Cavallo, *Tapestries*, 52.

8. Joubert, *La tapisserie*, 35.

9. Crick-Kuntziger, "A Fragment."

PROVENANCE

Abbé Aux Cousteaux, before 1787 (bequeathed to his servant)
M. Peaucelle of Beauvais, 1854 (acquired from the servant's daughter)
Bacri collection, Paris, 1924
Crocker collection, before 1959
Margaret Brokaw Adams

2. Spanish Bishop Saints

Franco-Flemish (Tournai), before 1468
H: 1.88 m W: 1.68 m (6 ft. 2 in. × 5 ft. 6 in.)
WARP: undyed wool, 6 per cm
WEFT: dyed wool and silk
Bequest of Hélène Irwin Fagan (CPLH), 1975.5.27

The nine churchmen in full ecclesiastical regalia are saints and martyrs who were born in Spain, as is inscribed at the base of the panel: QUI IN HISPANIA NATI SUNT. Ranged in three tiers, all have ornamented haloes and wear copes. The three archbishops carry crosiers; the six bishops and abbots hold pastoral staffs. Their heavy, solemn faces are of the general type associated with the work of Tournai, but there is a definite attempt at differentiation. Scrolls identify each saint by his Latin name.

In the top row, left to right:
ARCHIEP[ISCOPU]S TOLETAN[US], archbishop of
 Toledo (probably an incomplete label)
VALERI[US] EP[ISCOPU]S CESARAGUSTA[NUS],
 Valerius, bishop of Zaragoza
CUES'[?] ABBAS OVI[TEN]SIS, C——, abbot of
 Oviedo

Middle row, left to right:
FULGE[N]CI[US] EP[ISCOPU]S TIGITAN[US],
 Fulgencius, bishop of Astigi
D[OM]INCUS ABBAS (rewoven) SILE[N]SSIS,
 Dominicus, abbot of Silo
FROILLAN[US] EP[ISCOPU]S LEGION[ENSIS],
 Froilan, bishop of León

Bottom row, left to right:
YSIDOR[US] ARCHIEP[ISCOPU]S YSPALE[N]SIS,
 Isidor, archbishop of Seville
JULIAN[US] POMERI[US] ARCHIEP[ISCOPU]S
 TOLETAN[US], Julian Pomer, archbishop of Toledo
STAN——[?] Possibly the rest of his label has been
 inverted and repositioned to the right of the
 bishop, EP[ISCOPU]S[?]

An additional label beneath that of Froilan signals an abbot: S[—]MCUS ABBAS, possibly for Salamancus, an abbot of Salamanca? The abbot is missing in the panel.

This group of saints could only meet in eternity, for their lifetimes span many centuries. The earliest, San Valerius of Zaragoza, was persecuted in the early fourth century. Fulgencius, bishop of Astigi, and his brother, Isidor, archbishop of Seville, were both Doctors of the Church in the early seventh century. One of the most prolific and scholarly writers of the Middle Ages, Isidor

was credited with unifying the faith in Spain. Julian Pomer concentrated the authority of the whole Spanish church in the See of Toledo in the late seventh century. Froilan founded a monastery in the ninth century.

As early as 1926, Phyllis Ackerman pointed out the relationship between the *Spanish Bishop Saints* and a fragment now on loan to the Philadelphia Museum of Art. A study made by J.-P. Asselberghs confirmed this connection.[1] The full-length figure of Saint Thuribus at Philadelphia (fig. 27) has been inserted into a red background of the millefleurs type. His woven label, THURIBI[US] EP[ISCOPU]S ASTORICE[NSI]S, identifies him as Thuribus, bishop of Astorga. His flowing cope suggests the original appearance of the saints in the San Francisco panel.

Asselberghs believed the *Spanish Bishop Saints* of The Fine Arts Museums to be a fragment of a tapestry that belonged to Isabella the Catholic of Spain and appeared on an inventory made in 1504 after her death.[2] The tapestry was described as being without gold, but with much silk, showing the saints of Spain with Our Lady in the center, holding the Child in her arms. The fragmentary panel in San Francisco, with the saints facing three-quarters to the left, may represent the upper right portion of that large tapestry which once measured about 4.27 m × 8.53 m (14 ft. × 28 ft.). The San Francisco group was, in all probability, balanced by another group of Spanish saints facing to the right, with the Virgin and Child in the center. The complete tapestry in its undamaged state bore the arms of the kings of Castile.

Guy Delmarcel[3] called attention to an article by Jan-Karel Steppe that further traces the provenance of Isabella's tapestry.[4] Doña Juana Enríquez, mother of Ferdinand the Catholic, died in 1468. Her inventory lists a tapestry similar in description and dimensions to Isabella's panel at Segovia. Presumably the two are the same, and passed at Doña Juana's death to her son, Ferdinand, and from him to Isabella. After Isabella's death, the tapestry went to the Capilla Real in Granada by bequest. It has not been determined exactly when the transfer was made, but the *Spanish Saints* remained there until 1871. Adolph S. Cavallo states that by 1774 only fragments remained of the tapestries bequeathed by the Spanish monarchs, and all that contained metal threads were burned in 1777 to recover the precious material. Those without metal escaped. Cavallo further

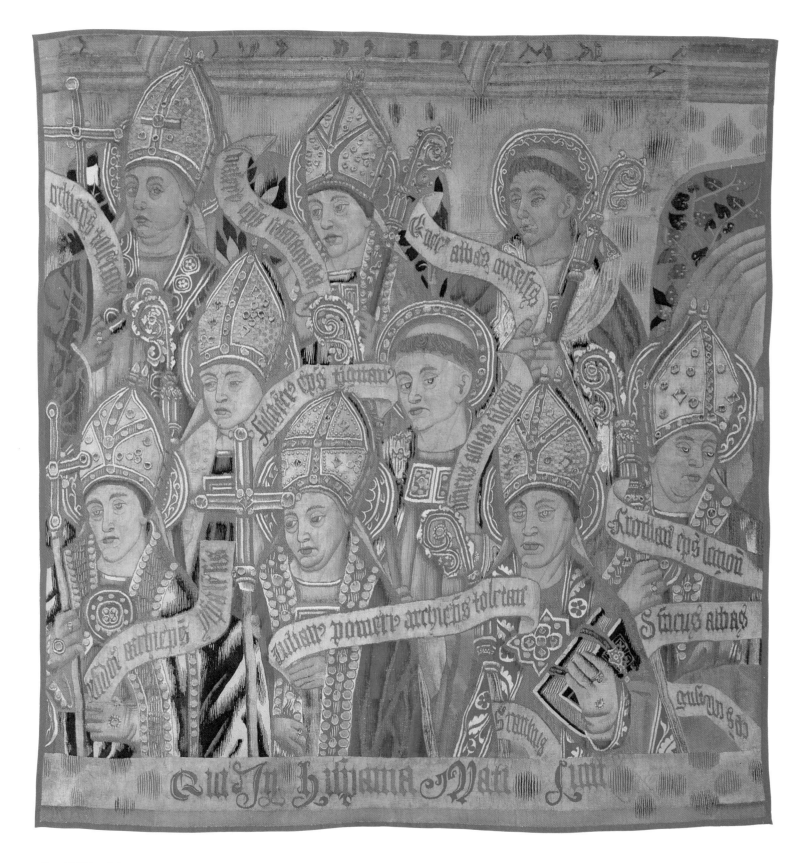

Spanish Bishop Saints

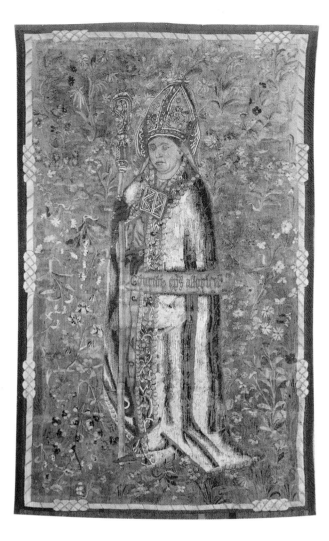

FIGURE 27
Thuribus, Bishop of Astorga, tapestry. Private collection

states that Mariano Fortuny, Sr., purchased a number of tapestry fragments from the Capilla Real in 1871 and sold most of them, including the Museums' piece, in 1875 at the Hôtel Drouot, Paris.[5]

NOTES

1. The St. Thuribus tapestry, lent to the Philadelphia Museum of Art by Mrs. Hope Starr Lloyd and Mr. Floyd T. Starr, has been in storage since 1986. It came from Seidlitz and Van Baarn and was catalogued by Mr. Madeira (Lore A. Certoma, letter to A. G. B., 18 January 1990). Phyllis Ackerman, *Catalogue of a Loan Exhibition of Gothic Tapestries*, exh. cat. (Chicago: The Arts Club of Chicago, 1926), 29, 16 fig.; Jean-Paul Asselberghs, *Les tapisseries flamandes aux Etats-Unis d'Amérique* (Brussels: Artes Belgicae, 1974), 49.

2. Francisco J. Sánchez Cantón, *Libros, tapices y cuadros que coleccionó Isabel la Católica* (Madrid: Consejo Superior de Investigaciones Científicas, 1950), 111.

3. Guy Delmarcel, letter to A. G. B., 11 March 1976.

4. Jan-Karel Steppe, "Vlaamse Kunstwerken in het bezit van doña Enríquez, echtgenote van Jan II van Aragon en moder van Ferdinand de Katholieke," *Scrinium lovaniense: Mélanges historiques E. van Cauwenbergh* (Louvain, 1961), 322–323, 327.

5. Adolph S. Cavallo, letter to A. G. B., 12 August 1985. Cavallo quotes from the Drouot catalogue of 27–30 April 1875, describing no. 140: "les pontifs et abbés espagnols, d'après la légende qui se lit en tête de la tapisserie et les noms qu'ils portent sur leurs vêtements."

PROVENANCE

Doña Juana Enríquez, before 1468
Isabella the Catholic, until 1503
Capilla Real, Granada, until 1871
Hôtel Drouot sale, 27–30 April 1875, no. 140
Hélène Irwin Fagan

3. Rabbit-Hunting with Ferrets

Franco-Flemish (probably Tournai), 1460–1470
H: 3.05 m W: 3.63 m (10 ft. × 11 ft. 11 in.)
WARP: undyed wool, 6 per cm
WEFT: dyed wool and silk
Museum purchase, M. H. de Young Endowment Fund, 39.4.1

Magnificent forests still covered most of northern Europe in medieval times, providing abundant wild game. The privileged class surrounded the hunt with elaborate ritual; the peasants took small animals without ceremony. Both kinds of hunting are represented in tapestries.

In a dense forest of oak, holly, and orange trees, seven men and three women use a ferret to hunt rabbits. The action is vigorous but orderly. Carefully spaced figures, rarely overlapping, demonstrate every part of the hunt, beginning at the lower left. The ferret, wearing a bell, is introduced into the rabbit hole. At the center, the frightened rabbits, flushed from their burrows, rush into the waiting nets and the hands of the hunters. At upper right, a stolid peasant delivers the coup de grace.

Few tapestries have survived showing peasants at work, but inventories prove that they were once as common as hunting and hawking scenes.[1] Medieval Books of Hours represented peasant labor with dignity, relating their tasks to the cycle of nature and the months of the year. (Another rabbit-hunt tapestry, in the Burrell Collection, Glasgow, part of a different series, bears the inscription SEPTE[M]BER.) The dignity of labor, sensed in the strong bodies and vigorous rhythms of their poses, is mixed with another element. The faces are coarse to the point of caricature, and the dress is not merely simple, but untidy. The designer, living in a day of personal ostentation and working for an aristocratic market, took a lofty view of rough peasants at work.

The scheme is two-dimensional, with the figures ranged above each other to suggest depth. Aerial views and elevations are often combined. The artist has turned figures arbitrarily in his search for the most expressive silhouette. Similarly, violets, wild strawberries, and myrtle are clearly recognizable, but their stems and leaves twist into decorative patterns.

Le livre de la chasse by Gaston Phoebus is the basic source of the tapestry imagery. The beautiful miniatures that illustrate it offer a perfect iconographical parallel, although they differ from a formal point of view.

Medium-sized panels of this kind were woven in sets, dividing large halls into more comfortable tapestry "chambers." Two other panels, certainly based on the same series of cartoons, have survived in other collections. The Burrell Collection in Glasgow has another panel from the same set as the Museums' *Rabbit-Hunting*, showing preparations for the hunt (fig. 28). The main event is the subject of the San Francisco tapestry, and a third episode follows the other two in sequence, as depicted in a piece that will one day hang in the Grog-Carven Galleries at the Louvre (fig. 29).[2] In it the hunt is over, and the peasants enjoy a picnic after their labors.

Differences among the three panels could result from their being the work of different weavers. Geneviève Souchal was of this opinion.[3] The *Rabbit-Hunting* in San Francisco seems closer in interpretation to the Glasgow panel than to *A Peasants' Picnic*. Foliage in the *Picnic* is larger, the peasant faces are more heavily caricatured, and colors are brighter, though one cannot be sure whether this represents an original difference or is the result of unequal fading. Considerable reweaving in areas of lost silk weft has given the San Francisco panel some hard highlights that are not apparent in the other two.

Former attributions to Pasquier Grenier must be regarded critically. The scene of *The Woodcutters* supplied to Philip the Good of Burgundy in 1461 by Pasquier Grenier of Tournai offers certain parallels. Many problems, however, analyzed by Francis Salet in 1974,[4] make attribution to Grenier seem untenable. Whether Grenier was a weaver or merely an entrepreneur or a merchant is not clear; nor is it clear that these panels were woven in Tournai. They do share stylistic features that we have come to associate, rightly or wrongly, with Tournai.

NOTES
1. G. Wingfield Digby and Wendy Hefford, *The Devonshire Hunting Tapestries* (London: Victoria and Albert Museum, 1971), 17.
2. *Architectural Digest* (September, 1989): 183 illus.
3. Geneviève Souchal, *Masterpieces of Tapestry from the Fourteenth to the Sixteenth Century*, exh. cat. (Paris: Editions des Musées Nationaux, 1973, and New York: The Metropolitan Museum of Art, 1974), 132–135.
4. Souchal, *Masterpieces* (F. Salet, Introduction), 12–13.

PROVENANCE
William Randolph Hearst

EXHIBITIONS
Tapisseries héraldiques et de la vie quotidienne. Tournai, 1970, no. 19.
Masterpieces of Tapestry from the Fourteenth to the Sixteenth Century.
 The Metropolitan Museum of Art. New York, 1974, no. 53.

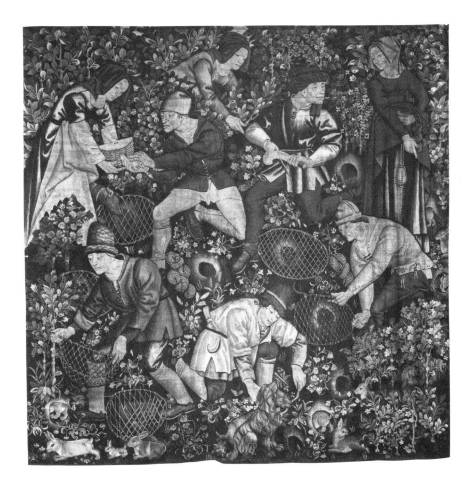

FIGURE 28
The Ferret Hunt, tapestry. The Burrell Collection,
Glasgow Art Gallery and Museum

FIGURE 29
A Peasants' Picnic, tapestry.
Musée du Louvre, Paris,
Gift of M. and Mme
Grog-Carven

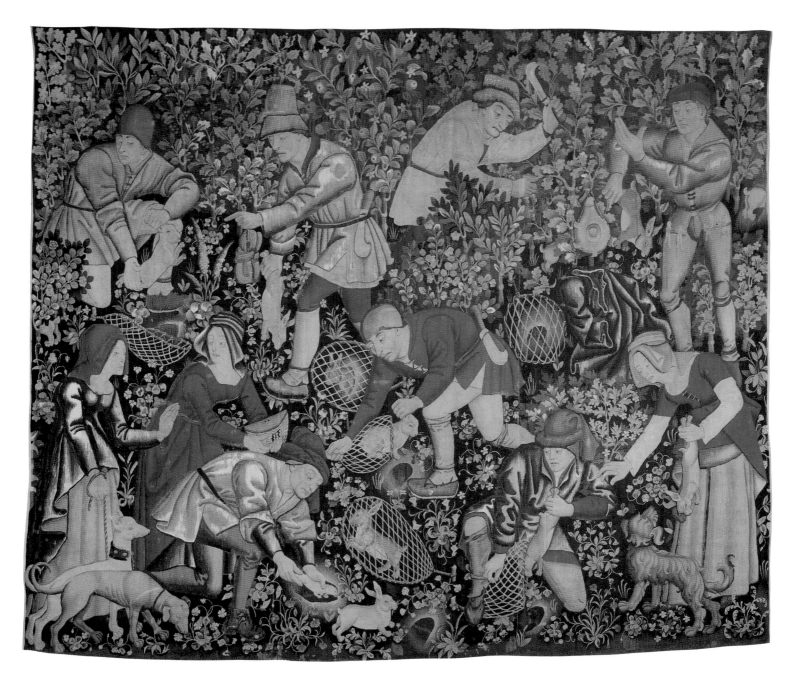

Rabbit-Hunting with Ferrets

4. Abraham and Melchizedek

Franco-Flemish (Tournai), 1460–1470
H: 4.27 m W: 3.76 m (14 ft. × 12 ft. 4 in.)
WARP: undyed wool, 5–6 per cm
WEFT: dyed wool and silk
Gift of the Provident Securities Co. (CPLH), 1969.15

The Book of Genesis tells of the meeting of Abraham and Melchizedek after the battle of Dan (Genesis 14:18–20). The priest-king of Salem brought bread and wine to the patriarch and blessed him. Abraham gave to Melchizedek a tenth part of the plunder.

The tapestry is divided compositionally into two triangles, from upper left to lower right. These triangles correspond to two episodes: the battle still in progress at left, and the meeting of the two men at right.

The smiling knight at top left is at the apex of a pyramid of violent action that descends through a melee of horses and men to its base filled with the bodies of the fallen. The warriors wear moiré and velvet beneath their armor; this is the Battle of Kings.

Spiky outlines of spears, battle axes, and pikes draw attention to the encounter taking place at the right. Outside the gates of the city, as warriors stand quietly at attention, Melchizedek hands Abraham a chalice of wine. The patriarch bends his knee before the priest-king as he takes the wine. He holds the bread in his left hand. Abraham's flowing beard partially conceals the chain mail of his Gothic armor. The label DAVD on his chest is the work of some early reweaver. The priest looks heavenward as he passes the chalice. He is assisted in this ritual act by two others: a man behind him holding a ewer, and the page or acolyte with ewer and chalice at the lower edge. The importance of the priest is conveyed by his robes and the splendid crown over a miter composed, oddly, of three horns instead of the expected two, with a lappet attached to the back. His jewel-trimmed mantle, lined with ermine, falls back to reveal a richly brocaded tunic, woven with much silk. His name, MELCHIS D. appears over his shoulder.

In his Epistle to the Hebrews (Hebrews 7), Saint Paul wrote that Melchizedek prefigured Christ; similarly, the bread and wine foreshadowed the Eucharist. In the same chapter Saint Paul discussed the importance of tithes, recalling Abraham's offering of spoils from the battle.

The banner at upper left carries a large *T* or *Tau*. Across the top, two sections of inscriptions were attached some-time after 1909.[1] These are unrelated to the tapestry and to each other. The left couplet once surmounted a Petrarchan *Triumph of Time over Fame*, of which a complete example may be found at the Kunsthistoriches Museum, Vienna,[2] and a fragment at The Metropolitan Museum of Art, New York.

Left:

LE TEMPS ESMEU APRES NOISES DEBAS
VIELIT ET CASSE SANS CRAINDRE AUCUN PORT
 DARMES

Time sets in motion after tumultuous struggles
He ages and breaks without fear of any resistance

Right:

CAR CHASTE ELLE A . . . VIVRE
PENSANT ANS[I] AU CIEL LE SUYVRE

For she . . . to live chaste
Thinking thus to follow him heavenwards

The high horizon, extreme flattening of forms, and the deliberate chaos of the battle scene are typical of Tournaisian tapestries furnished to the Burgundian court by the weavers of this period.[3]

NOTES

1. Musée des Arts Décoratifs, Paris. *Photo Album II* (Sujets religieux divers, XVe siècle), illus.
2. Pierre Verlet et al., *Great Tapestries: The Web of History from the Twelfth to the Twentieth Century*, ed. Joseph Jobé (Lausanne: Edita, 1965), 75.
3. Jean-Paul Asselberghs, *La tapisserie tournaisienne au XVe siècle* (Tournai, 1967), nos. 11–13.

PROVENANCE

Félix Doisteau Collection
Sale, Hôtel Drouot, 22–25 November 1909, no. 438
Mr. and Mrs. William H. Crocker Collection

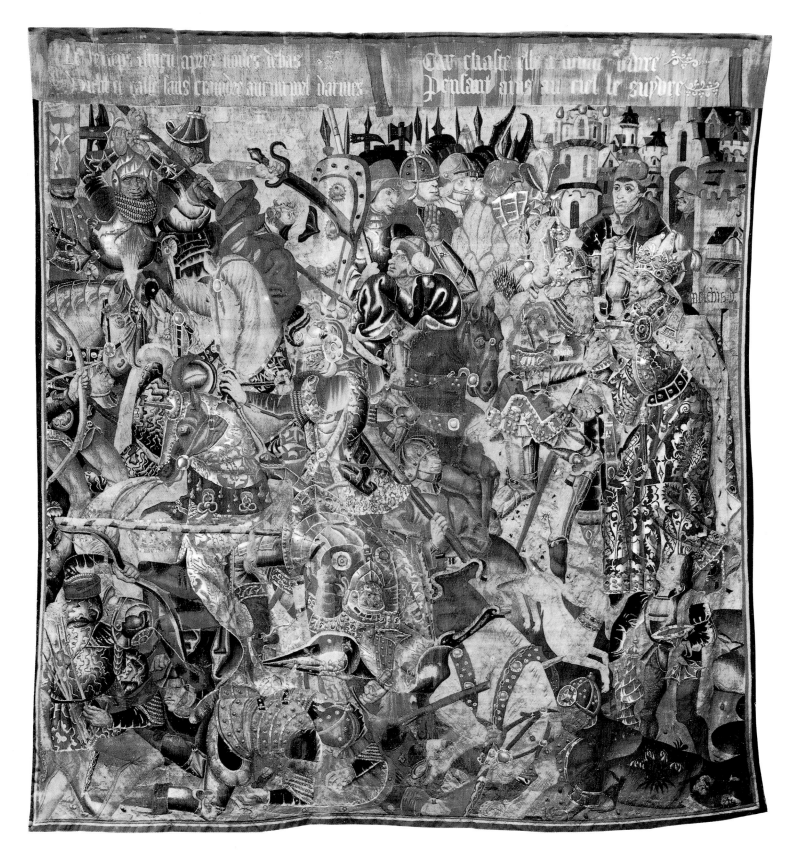

Abraham and Melchizedek

5. Simon the Magician

from The Story of Saint Peter *Series*

Franco-Flemish (possibly Tournai), ca. 1475
H: 2.57 m W: 4.70 m (8 ft. 5 in. × 15 ft. 5 in.)
WARP: undyed wool, 5 per cm
WEFT: dyed wool
Gift of Mr. and Mrs. Sidney M. Ehrman (CPLH), 1959.78

Simon Magus, the sorcerer of Samaria, receives brief mention in the Acts of the Apostles (Acts 8:9–13; 18–19). This biblical Simon, however, is not the one who cast such a potent spell over the Middle Ages. It was, rather, the Simon of apocryphal folklore, a necromancer and manipulator of demons, whose magic tricks endeared him to Nero and fed the medieval appetite for the marvelous. The story of Simon's contest with Peter appears in Jacobus de Voragine's *Golden Legend*, a widely read compilation of religious folklore that drew on earlier authors.[1] Churchgoers saw the subject illustrated in stained glass windows and even found it mentioned in the liturgy.[2]

Saint Peter is accompanied by Saint Paul in art and in legend. Both were believed to have suffered martyrdom in the same hour, and their feasts are celebrated on consecutive days (29 and 30 June). Paul, therefore, witnesses the struggle between Peter and the magician.

The tapestry shows two moments in the story. In the first scene, at left, Simon has taken off from a high tower on the Capitoline hill. An inscription near the top identifies him: SIMO[N] MAUGUS (Simon the Magician). With long green wings attached to his arms, he flies above the walled city of Rome, to the admiration of Nero and his astonished court. The banderole beneath Nero reads: ECCE SIMO[N] ASCE[N]DIT CELUM CUM DIIS IMPERATORIS (Lo, Simon soars in the sky with the gods of the emperor). Nero, carrying a heavy scepter, wears the royal ermine and a closed imperial crown encrusted with pearls. An archer, seen from the back, fingers a large arrow as he watches the airborne magician. Saint Peter, identified by his key, looks at Saint Paul in consternation. The central inscription seems to represent his words: VIDE QUOMODO SIMO[N] ARTE SUA MAGITA NERONIS OCCULOS ET ADSTANCIUM ILLUDIT (See how Simon by his magic art deludes the eyes of Nero and bystanders).

Another inscription summarizes the action in the right half of the tapestry: QUOMODO SIMO[N]MAGUS VOLLANDO CORRUIT (How Simon the Magician fell to earth in mid-flight). Saint Paul kneels in prayer. His prayer, presumably, appears on the banderole: D[OMI]NE OSTEND[E]

EI VANAS ARTES SUAS—NE P[O]P[U]L[U]S QUI CREDITURUS EST DECIPIATUR (Oh Lord, show him that his arts are false, lest the gullible people be deceived). Saint Peter, standing, addresses the powers of darkness. As Jacobus de Voragine tells it, "Then Peter cried out: Angels of Satan, who hold this man up in the air, in the name of my Master Jesus Christ, I command you to hold him up no longer!" Small demons can be seen to desert the falling body of Simon. The magician, whom Guiffrey called "this imprudent aviator," plunges headlong toward the cobblestones.[3]

Antoine de Poisieu, from 1450 to 1453 and from 1473 to 1495 abbot of the ancient Benedictine Church of Saint-Pierre in Vienne, France, commissioned a set of seven tapestries illustrating the life of the patron saint. De Poisieu's arms, on an escutcheon surmounted by an abbot's cross, divide the two scenes of the tapestry. These arms which also fly from one of the watchtowers on the city walls display "gules two chevronels argent a chief parted per fess of the first and second with the motto 'en-du-rez'."[4]

Two tapestries of the set have survived. In addition to *Simon the Magician*, there is a tapestry in the Burrell Collection, Glasgow, that shows the meeting between Peter, newly liberated from the Mamertine prison, and the risen Christ (fig. 30). Peter asks Jesus, DOMINE QUO VADIS (Lord, whither goest Thou?). By the answer, "I go to Rome to be crucified anew," Peter understands that his martyrdom is imminent.

Although a church inventory of 1653 refers to the Burrell piece as the first of the series, that episode follows Simon iconographically, as Delmarcel noted.[5] For it was precisely to punish Saint Peter for the destruction of his magician that Nero sent him to prison.

The tapestries date, in all likelihood, from the second period of the abbot's incumbency. This date, circa 1475, corresponds to the style of contemporary pieces. We know neither designer, weaver, nor place of origin. The treatment of the sky, faces, and fabrics may be more indicative of a period than of a weaving center.[6]

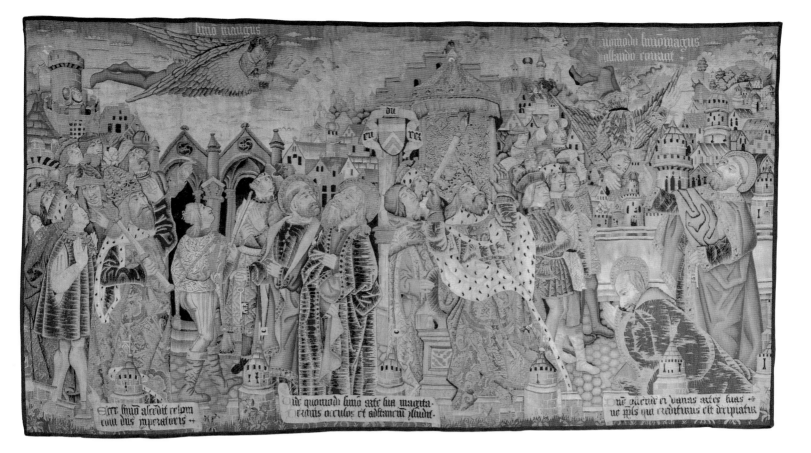

Simon the Magician

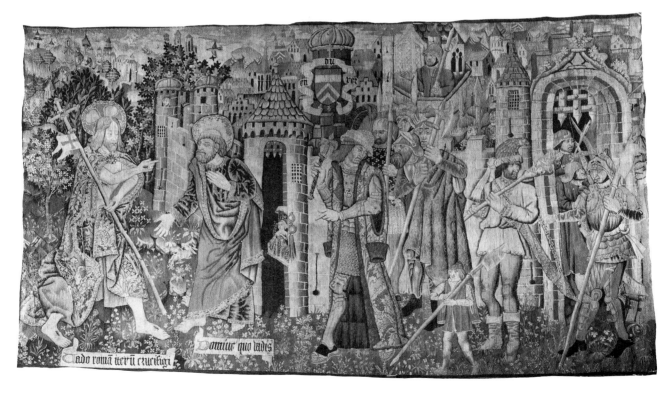

FIGURE 30
Saint Peter's Miraculous Escape from Prison (Quo Vadis), tapestry.
The Burrell Collection, Glasgow Art Gallery and Museum

NOTES

1. Hervé Savon, introduction to Jacques de Voragine, *La légende dorée*, trans. J.-B.M. Roze (Paris: Garnier-Flammarion, 1967).

2. Emile Mâle, *L'art religieux de la fin du Moyen Age en France*, 3d ed. (Paris: A. Colin, 1925), 197–199, 297 n. 5.

3. Gaston Migeon and Jules Guiffrey, *La collection Paul Blanchet* (Paris: Georges Petit, 1913), 64.

4. Description of the same coat of arms on the tapestry in the Burrell Collection: William Wells, "Heraldic Art and the Burrell Collection," *The Connoisseur* 151, no. 608 (1962): 101–105.

5. Guy Delmarcel, letter to A. G. B., 11 March 1976.

6. Julien Coffinet, *Arachné ou l'art de la tapisserie* (Paris: Bibliothèque des Arts, 1971), 62, 192.

BIBLIOGRAPHY

Prudhomme, A. "Le trésor de Saint Pierre de Vienne," *Bulletin de l'Académie delphinale* (23 January 1884), 1885.

Hunter, George Leland. *The Practical Book of Tapestries*. Philadelphia and London: J. B. Lippincott Company, 1925, 66, illus. pl. 21.

Marillier, H. C. "Subject Catalogue of Tapestries." Victoria and Albert Museum, London, ms., n.d.

Seligman, Germain. *Merchants of Art.* New York: Appleton-Century Crofts, 1961, 202.

Wells, William. "The Earliest Flemish Tapestries in the Burrell Collection, Glasgow (1380–1475)." In *L'age d'or de la tapisserie flamande.* International Colloquium (Gent), 23–25 May 1961. Brussels: Paleis der Academien, 1969, 451, 453.

PROVENANCE

Church of Saint-Pierre, Vienne, Isère, France
Paul Blanchet de Rives, Grenoble, 1913
Jacques Seligmann
Sidney M. Ehrman, San Francisco

The Passion of Christ *Series*

In the climate of emotionalism and religious sensibility that pervaded the late Middle Ages, Christ's suffering, death, and resurrection, known as the Passion, inspired extreme forms of devotion and every kind of religious art. None equaled the mystery plays in emotional appeal and public participation. Audiences were very large, drawn from all levels of society, and the productions were lengthy.[1] The addition of miraculous and comic effects undoubtedly pleased the crowd, but the narrative itself remained the principal attraction. The viewers, moving from one *mansion* or platform-stage (fig. 31) to the next as the story unfolded in the village square, could retrace in imagination Christ's steps from the garden of Gethsemane to the hill of Golgotha.

Second only to the mysteries in effectiveness were the tapestry series based on the Passion. These weavings closely paralleled their theatrical counterparts, especially in the choice of episodes, the costumes, and unmistakable bits of stage business. A complete series hanging in a great hall or cathedral must have given the impression of a mystery play permanently in place, enabling castle-dwellers or churchgoers to follow the story from one tapestry to the next, pausing occasionally to find their way through multiple episodes combined in a single panel.

The tapestry designers do not seem to have worked directly from scripts of the plays, some of which have survived.[2] Both playwrights and designers used a common source: the gospels of Matthew, Mark, Luke, and John, expanded by material from Jacobus de Voragine's *Golden Legend* and the *Meditations on the Life of Christ*, the work of an anonymous Franciscan writing for Saint Bonaventure.

An inventory made at the death of Henry VIII of England in 1547 attests to the popularity of the subject.[3] The sixty-nine Passion panels listed seem to have come from seventeen distinct sets, which probably represented a number of different series. It is thus remarkable that nine tapestries, or partial tapestries, woven from the same cartoons of a single series, have survived to our day. This series, to which two of The Fine Arts Museums' tapestries belong, may once have been more extensive.

Additional subjects, unrepresented by the surviving tapestries, can be hypothesized from a set of monumental embroideries worked after the same cartoons. The embroideries depict the following subjects: *The Agony in the Garden and the Kiss of Judas*; *Christ before Annas and Caiaphas*; *Christ before Pilate and Herod*; *Christ and Barabbas and Pilate Washing His Hands*; *The Road to Calvary*; *The Crucifixion and the Harrowing of Hell*; *The Entombment of Christ, Resurrection, and Christ Appearing to the Virgin, the Magdalen, and Saint Peter.*

No tapestry examples are known of the first two: *The Agony in the Garden and the Kiss of Judas* and *Christ before Annas and Caiaphas*. The other designs are represented by at least one example and, in the case of *The Crucifixion*, by no less than four in addition to the embroidery.

The repeated series was woven in Flanders at least four times between 1490 and 1505. Two panels of the group belong to The Fine Arts Museums of San Francisco: *Christ and Barabbas and Pilate Washing His Hands* and *The Crucifixion*. They appear to have come from different sets.

NOTES

1. Sixteen thousand saw the *Crucifixion* scene in Reims in 1490. The Passion of Valenciennes in 1547 lasted twenty-five days.
2. The texts of the plays of Arnoul Gréban (ca. 1450) and Jean Michel (1486) have survived. At least fifteen editions of the latter were printed between 1490 and 1542. Larry Salmon, "The Passion of Christ in Medieval Tapestries," in *Acts of the Tapestry Symposium November 1976* (San Francisco: The Fine Arts Museums of San Francisco, 1979), 80 n. 7.
3. Salmon, "The Passion of Christ," 99 n. 2.

FIGURE 31
Stage Set for the Passion of Valenciennes, 1547.
Miniature by Hubert Cailleau,
accompanying manuscript of the play.
Bibliothèque Nationale, Paris. Rothschild 1.7.3.

6. Christ before Pilate

from The Passion of Christ *Series*

Flemish (probably Tournai), ca. 1500
H: 4.01 m W: 4.34 m (13 ft. 2 in. × 14 ft. 3 in.)
WARP: undyed wool, 5–6 per cm
WEFT: dyed wool and silk
Bequest of Hélène Irwin Fagan (CPLH), 1975.5.25

Two episodes of the Passion story, divided by a low wall, are enacted as if on the stage of the palace *mansion*, with a flowery meadow in the foreground and city rooftops in the distance. The palace is elevated by a few steps and furnished with a throne. At left, Pilate stands outside, addressing the high priest Caiaphas and the other Jews who seek Christ's death. According to custom at Passover time, Pilate offers to release a prisoner. Should it be Barabbas, the thief, who has been led from prison and is held at upper left? Or should it be Jesus, standing with head bowed and hands bound? The crowd calls for the release of Barabbas and the crucifixion of Jesus.

All four gospels tell of the choice made between Christ and Barabbas.[1] In all the accounts, this is followed by the crowning with thorns, and the mockery and scourging of Jesus. Only Saint John tells of a final confrontation between Pilate and the Jews in which Christ is shown after the scourging, a subject generally known as *Ecce homo*, from Pilate's words, "Behold the man." The tapestry has telescoped the two moments, for Christ wears a crown of thorns and the robe of mockery.[2]

To the right of the dividing wall, Pilate sits on his throne of judgment within the palace, his feet resting on a Near Eastern carpet. The fringed canopy over his head bears the inscription PILATUS.ES.CV— —.B[or G]ATUS. Pilate washes his hands in water poured from a ewer into a basin, assisted by a page.

In the biblical account, Pilate's act of disassociation from reponsibility is accompanied by the words "I am innocent of the blood of this just person; see ye to it."[3] The scourging, the crowning with thorns, the ridicule, must come after the symbolic washing of the hands. Since Jesus already wears the crown and the robe in the tapestry, the artist may have followed the script of a mystery play rather than the gospel.

An incident depicted in the background, to the left of the soldier holding Christ, supports this hypothesis. A man lifts his hat and bows to an elegantly dressed woman. Rolled-up bed hangings are visible above his head. The dream of Pilate's wife[4] was a regular feature of the mysteries. Planning to interfere with God's plan for the Redemp-

tion, the Devil whispers in the ear of Pilate's sleeping wife to stop Jesus' conviction. Obediently, the wife sends her maid to Pilate with the message. On the stairs, the maid passes the Devil, "the handsomest gentleman I've ever seen."[5]

The four pieces of *The Passion* series preserved at the Cathedral of Angers are probably the oldest extant weavings of the recurring designs. They were woven before 1505, as they were willed to the Church of Saint-Saturnin at Tours in that year. The first subject, *Christ before Pilate and Herod*, is also represented at the Museum of Fine Arts, Boston, in a wider version that includes the scourging scene. The Angers panel (fig. 32) bears interesting points of comparison with the *Christ before Pilate* at San Francisco. In a similar setting before the palace, Christ stands in the place of Barabbas. The incident, described in Luke 23:1–7, depicts the first time Jesus is led before Pilate. Jean Michel's *Mystère de la Passion* expanded the subject. Finding that Jesus is Galilean, Pilate sends him on to Herod, who appears in the right-hand section.[6] Jesus' refusal to answer his accusers disappoints Herod, who hoped for some miracles. In Michel's mystery, those who ridicule Jesus dress him in the white robe reserved for the insane. He will be returned to Pilate where the narrative continues in The Fine Arts Museums' panel.

No other tapestry is known that corresponds exactly to the one in the Museums' collection, but the subject is duplicated in two large embroidered hangings preserved in the Church of Saint-Barnard, at Romans, Drôme (figs. 33, 34). It has been conjectured that these hangings were the work of a group of women who could not afford to present their church with the more costly weavings. As a substitute, they accomplished the extraordinary feat of reproducing the tapestries in embroidery. The panels, worked in small pieces, were joined, and hands and faces were painted.

Since the related scenes appear only in the Romans embroideries and have no tapestry duplicates, Nello Forti Grazzini has suggested that the San Francisco tapestry might be an isolated addition to the usual set of the *Passion of Christ*, although linked to other subjects of it.[7]

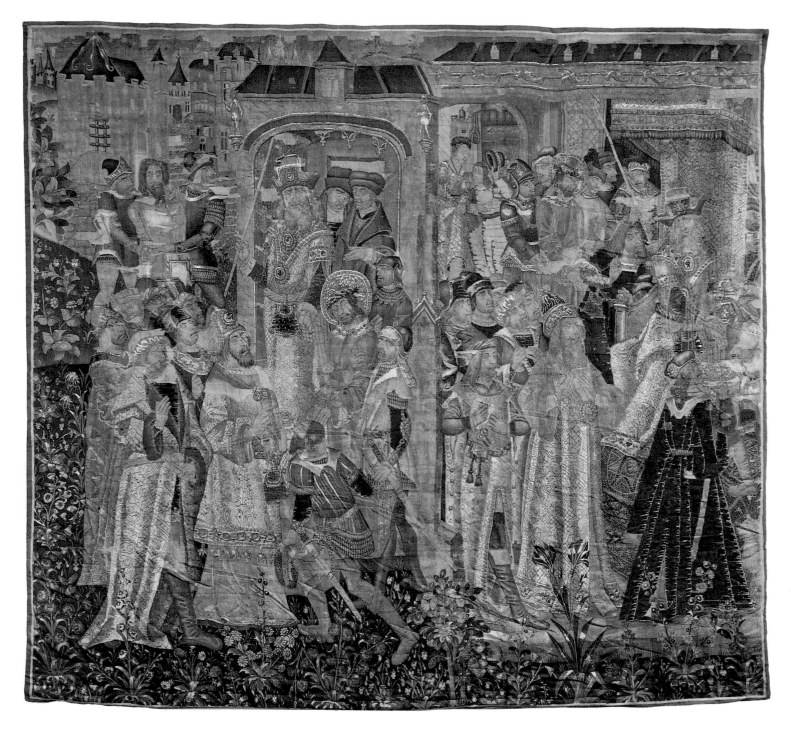

Christ before Pilate

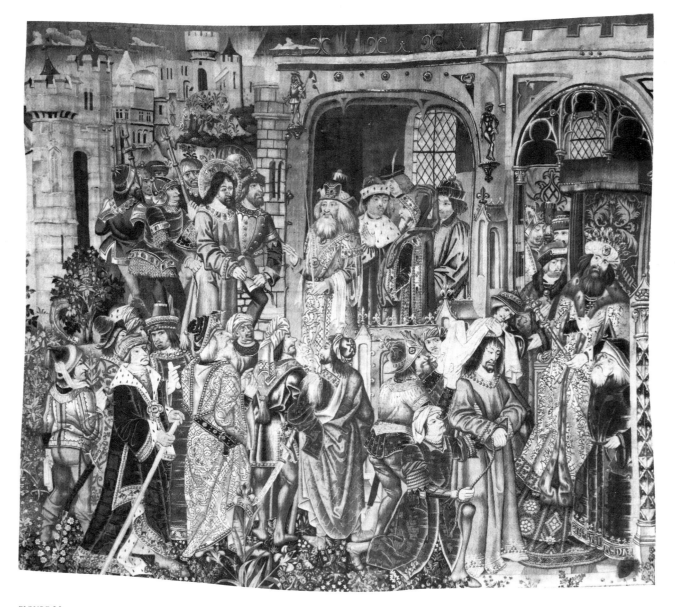

FIGURE 32
Christ before Pilate and Herod, tapestry.
Musée des Tapisseries, Château d'Angers

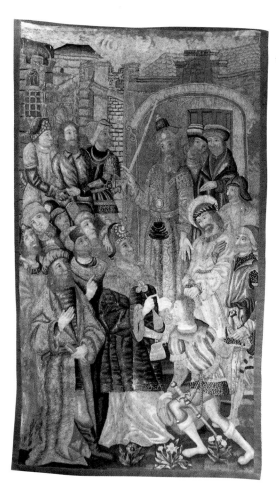

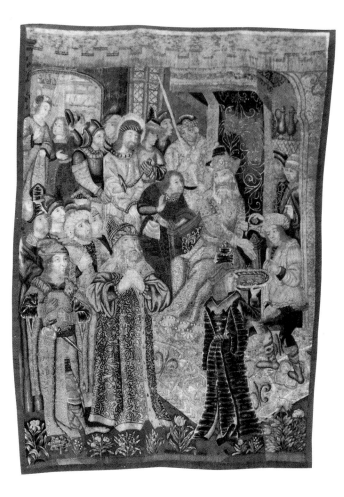

FIGURE 33
Christ and Barabbas (part 1), embroidery.
Church of Saint-Barnard, Romans, Drôme.
Bequest of Charles de Lyonne de Lesseins, 1701

FIGURE 34
Pilate Washing His Hands (part 2), embroidery.
Church of Saint-Barnard, Romans, Drôme.
Bequest of Charles de Lyonne de Lesseins, 1701

For many, the most important aspect of the tapestry is the aesthetic experience it provides. The richness of pattern and the shimmer of distributed lights and color create visual excitement in spite of serious losses in many areas. The skill of the weaver is particularly evident in the textile designs represented and in the transparency of Pilate's sleeves.

NOTES

1. Matthew 27:15–21; Mark 15:6–15; Luke 23:14–24; John 18:39–40.
2. John 19:5–6.
3. Matthew 27:24.
4. Matthew 27:19.
5. James Kirkup, *The True Mistery of the Passion. Adapted from the medieval French mystery cycle of Arnoul and Simon Gréban* (London and New York: Oxford University Press, 1962), 100.
6. Luke 23:8–11.
7. Personal communication, 18 May 1990.

BIBLIOGRAPHY

Farcy, Louis de. *Histoire et description des tapisseries de la Cathédrale d'Angers.* Lille and Angers, n.d., 52–53.
Urseau, C. "La tapisserie de la Passion d'Angers et la tenture brodée de Saint-Barnard de Romans." *Bulletin archéologique du Comité des travaux historiques et scientifiques* (1917): 54–61.
Planchenault, René. *Les tapisseries d'Angers.* Paris: Caisse Nationale des Monuments Historiques, 1955.
Erkelens, A. M. Louise. *Wandtapijten I: Late gotiek en vroege renaissance.* Amsterdam: Rijksmuseum, 1962, 3, 10–13.
Cavallo, Adolph S. *Tapestries of Europe and of Colonial Peru in the Museum of Fine Arts, Boston.* 2 vols. Boston: Museum of Fine Arts, 1967, 1:81–82.
Asselberghs, Jean-Paul. *La tapisserie tournaisienne au XVe siècle.* Tournai, 1967, nos. 23–28 and bibliography.
Salmon, Larry. "The Passion of Christ in Medieval Tapestries." In *Acts of the Tapestry Symposium November 1976.* San Francisco: The Fine Arts Museums of San Francisco, 1979, 79–101. The entire series and surviving sets are discussed with great thoroughness.

7. The Crucifixion

from The Passion of Christ *Series*

Flemish (probably Tournai), 1490–1500
H: 3.55 m W: 3.86 m (11 ft. 8 in. × 12 ft. 8 in.)
WARP: undyed wool, 5–6 per cm
WEFT: dyed wool and silk
Museum purchase, Roscoe and Margaret Oakes Income Fund, in
 tribute to Anna and Ralph Bennett for their many years of
 service to the Museums, 1984.52

The Crucifixion scene was the dramatic climax of the Passion story and essential to every tapestry series based on the theme. Three or four sets were woven on the cartoons of a series designed in the late fifteenth century.[1] Three Crucifixion panels from these sets are known, the most complete and probably the oldest of these at Angers;[2] the Crucifixion is centered in this very wide panel which extends far to the right to include a scene of the *Harrowing of Hell* (fig. 35). A large fragment at the Rijksmuseum, Amsterdam, duplicates slightly more than half the left side of the Angers panel, including the Crucifixion (fig. 36),[3] while a smaller fragment at the Musée des Arts Décoratifs, Paris, reproduces a vertical section on the right depicting witnesses at the foot of the crosses and a small scene above in which Nicodemus and Joseph of Arimathea plead with Pilate for Christ's body (fig. 37).[4] The Fine Arts Museums' *Crucifixion* is comparable to the Rijksmuseum piece in size, and the two tapestries compensate for each other's losses: the San Francisco tapestry lacks the figure of the bad thief, but has retained the deep foreground that is missing at Amsterdam.

Every surviving tapestry of the *Passion* series almost certainly once had a counterpart in the set of monumental embroideries preserved at Saint-Barnard, Romans (fig. 38).[5] A very wide tapestry like that of Angers probably combined the designs for two scenes. The embroidery panel depicting the Harrowing of Hell, corresponding to the right half of the Angers tapestry, was probably executed but has not survived.

At upper left, under the watchful eye of Pilate, who carries a long authoritative wand or scepter, Jesus is led in by a group of richly dressed Jews, identified by turbans, and an armed guard. Jesus' clothing is stripped from him, exposing a body covered with the marks of the flagellation. He is naked except for a loin cloth. Blood drips onto his forehead from beneath a heavy, twisted crown of thorns. Here, as in other representations within this panel, Christ's large halo is embellished with gold tracery

and red and blue areas suggesting cabochon jewels, perhaps a reflection of stage costuming.

In the lower quadrant, Christ is nailed to the cross. One man pierces his right hand. Two others draw ropes taut to secure his feet as a fourth positions a spike to nail them. In the lower corner three men fight over his clothing, beating with bones, tearing hair, bloodying noses. The amount of graphic detail suggests the vigor of the stage productions where realism was admired, sometimes with almost fatal results.[6]

In the center, on horseback, wearing a sword and a purse, Pilate holds up his wand as if to point. An angel gathers up the tiny soul of the good thief. Blind Longinus holds the lance that pierces Christ's side; the blood will miraculously restore his sight. The sponge with vinegar is offered on the end of a spear. (Christ's head has been rewoven in a different position, disturbing the alignment of the body.) The holy women gather at the foot of the cross: Jesus' mother, fainting in the arms of Saint John, the Magdalen with long flowing hair, and two others, possibly Mary, the mother of James the Less, and Salome. Beyond these figures, to the right of the cross, a figure in a cope, perhaps an ecclesiastic, stands with two other men. To conceal the damage to the tapestry in this area and the loss of the figure of the bad thief, two new figures were added to fill the void. Another lacuna, occasioned by the loss of the third cross, was filled rather crudely by clouds and an unexpected medallion with a lamb.

Larry Salmon noted the value of costume changes for dating various weavings from the same cartoon, since the costumes generally kept pace with fashion. Shorter jackets and jerkins and more complex textile patterns seem to be associated with the late fifteenth century. More expressive faces and a more modeled sculptural quality suggest a later date and the influence of the Renaissance. However, a worn-out cartoon may also account for less detail and depth. On the basis of such considerations, The Fine Arts Museums' *Crucifixion* seems to fall between the Angers

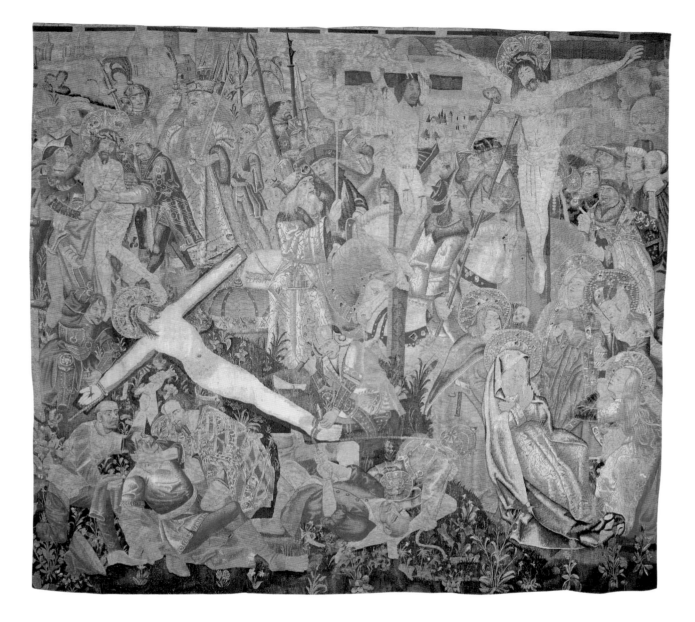

The Crucifixion

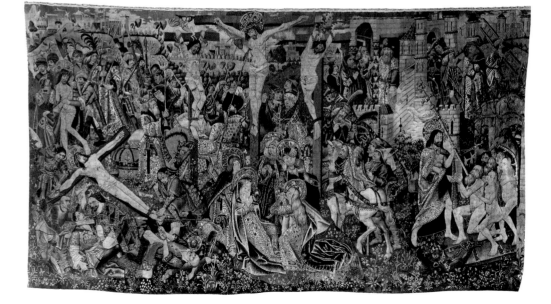

FIGURE 35
*Crucifixion and Harrowing
of Hell*, tapestry.
Musée des Tapisseries,
Château d'Angers

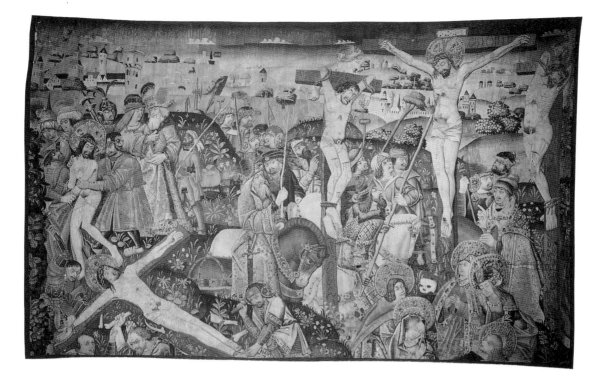

FIGURE 36
Crucifixion, tapestry.
Rijksmuseum,
Amsterdam

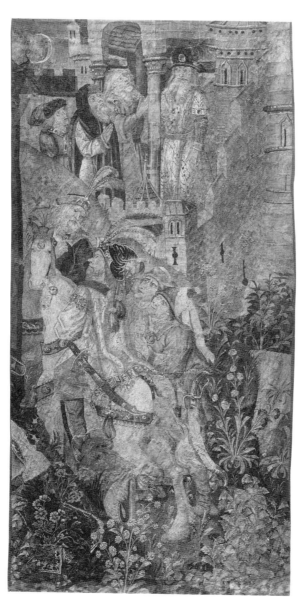

FIGURE 37
Crucifixion, tapestry.
Musée des Arts Décoratifs, Paris.
Gift of M. Jules Maciet

example and the later version at the Rijksmuseum. Its relation to the fragment at the Musée des Arts Décoratifs offers interesting speculation. Certainly, as Salmon pointed out, the Paris piece could not have been part of the Rijksmuseum weaving because of the overlapping of the bad thief's cross. It seems that it could have, and probably did, belong to the same tapestry as the San Francisco panel. The faces are equally expressive, the textile patterns retain a comparable degree of detail, the flowers are similarly treated. Both pieces are 3.60 m high. Reconstructed, they would make a tapestry as large as that of Angers.

The amount of reweaving present is not unexpected in a tapestry of this age. The prostrate figure of Christ being nailed to the cross is largely rewoven, except for the face. This is the only significant area of reweaving, except for the mends and additions at the right edge described above that compensate for loss of the bad thief.

NOTES

1. An earlier *Crucifixion* at La Seo Cathedral, Zaragoza, is entirely Gothic in style. Probably woven at Arras, ca. 1450. Heinrich Göbel, *Wandteppiche. I Teil: Die Niederlande*, 2 vols. (Leipzig: von Klinkhardt & Biermann, 1923), 2: no. 192; Roger-Adolph d'Hulst, *Arazzi fiamminghi* (Bologna, 1961), 33–40; M. Stucky-Schürer, *Die Passionsteppiche von San Marco in Venedig* (Bern, 1972), 85–89; Eduardo Torra de Arana, Antero

Hombría Tortajada, and Tomás Domingo Pérez, *Los tapices de la seo de Zaragoza* (Zaragoza: Caja de Ahorros de la Imaculada, 1985), 68–72. (References furnished by Nello Forti Grazzini.)

2. Musée des Tapisseries, Château d'Angers, Purchase 1854. Jean-Paul Asselberghs, *La tapisserie tournaisienne au XVe siècle* (Tournai, 1967), 33–34, 64–69 illus.

3. Rijksmuseum, Amsterdam, Purchase, R. B. K., 1958–16.

4. Musée des Arts Décoratifs, Paris, Gift of M. Jules Maciet, inv. no. 8350.

5. Church of Saint-Barnard, Romans (Drôme), Bequest of Charles de Lyonne de Lesseins, 1701.

6. Larry Salmon, "The Passion of Christ in Medieval Tapestries," in *Acts of the Tapestry Symposium November 1976* (San Francisco: The Fine Arts Museums of San Francisco, 1979), 79: "Another priest, who was called Messire Jean de Nicey, and was chaplain of Métrange, played Judas, and was nearly dead while hanging, for his heart failed him."

PROVENANCE

Offered for sale by Sotheby's, London, on 3 April 1984 (cat. no. 100), and almost certainly the one cited by Larry Salmon as having been sold at Sotheby Parke Bernet & Co. (London), from a private German collection, on 7 July 1978, no. 159, illus. p. 105. The anonymous purchaser intended the tapestry to be a permanent loan to Leeds Castle, near Maidstone, England (Salmon, "The Passion of Christ," 99 n. 8).

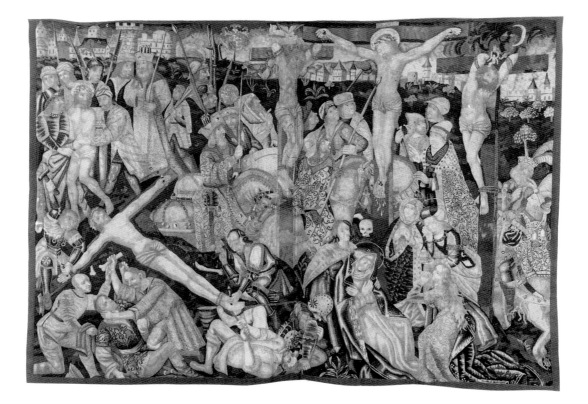

FIGURE 38
Crucifixion, embroidery. Church of Saint-Barnard, Romans, Drôme. Bequest of Charles de Lyonne de Lesseins, 1701

8. Scenes from The Trojan War

A. The Arrival of Paris and Helen

B. Menelaus Assaulting Deiphobus at the Trojan Court

C. The Arming of Hector and Other Scenes

Flemish (probably Brussels), 1500–1510
A: H: 3.00 m W: 1.49 m (9 ft. 10 in. × 4 ft. 10½ in.)
B: H: 2.39 m W: 1.52 m (7 ft. 10 in. × 5 ft.)
C: H: 2.96 m W: 1.77 m (9 ft. 8 in. × 5 ft. 9½ in.)
WARP: undyed wool, 5–6 per cm
WEFT: dyed wool and silk
Bequest of Hélène Irwin Fagan (CPLH), 1975.5.28, 30, 29

The three fragments grouped together here are believed to have come from the same large tapestry. Their framework of jeweled or ornamented columns and pilasters relates them to a number of "tabernacle" tapestries woven in the late fifteenth century. These architectural elements divide scenes that are often arranged in two or more registers. The titles assigned to the group and to the individual panels are based on comparisons with scenes from older series inspired by the same subject.

The Trojan War was a favorite theme in the Middle Ages, with writers, artists, and princes, especially, who imagined themselves to be descendants of the Trojan heroes.[1] A documented tapestry series was woven in Tournai for Henry VIII in 1488. Fragments of other Tournaisian series are in Glasgow, Montreal, and New York (The Cloisters), and four large pieces are in Zamora.[2] More than one series was woven in Brussels, about 1490–1500.[3] Contemporary versions of the story were illustrated, rather than the Homeric epic. The artists' ultimate source was Benoît de Sainte-Maure's *Roman de Troie* or a Latin text, *Historia destructionis Troiae* by Guido of Colonna. Benoît, in turn, had drawn on the late Roman forgers, Dictys of Crete and Dares of Phrygia, who claimed to have lived in Trojan times. The tapestries' portrayal of the Trojan War in completely Gothic terms is in accord with the medieval narratives they illustrate.

The Arrival of Paris and Helen, 1975.5.28

The man and woman arriving by boat at upper right must be Paris and Helen. King Priam sent his handsome son to Greece to bring back his aunt, Hesione. Instead, Paris returns with the wife of Menelaus, king of Sparta. The boat's approach is heralded on the shore by a man who points excitedly, alerting others to the significance of the event. At upper left, the young woman looking seaward could be the prophetess Cassandra, foreseeing the consequences of this abduction.

The figures wind in serpentine procession to the richly dressed courtiers in the foreground. A bespectacled elderly man, absorbed in his reading, is the compositional link between the two groups. Weighted with heavy sleeves, furs, and gold chains, the courtiers react to the news with expressions of alarm. The figures may include the brothers of Paris, Hector and Troilus, whose destinies were also bound up in the fate of Troy.

Menelaus Assaulting Deiphobus at the Trojan Court, 1975.5.30

The title formerly assigned to this fragmentary scene, *Ulysses and Diomedes at the Trojan Court*, has been changed to conform with a similar scene in an isolated Trojan War tapestry at Zaragoza.[4] Following the Zaragoza interpretation, the man with the sword becomes Menelaus, Helen's first husband and leader of the Greeks, attacking Deiphobus, who married her after the death of Paris. This seems a more convincing reading of the scene. The panel has suffered more extensively than the others, having lost a section equivalent to its upper third (1.05 m or 3 ft. 5 in.). At some point in its history, an unrelated inscription was attached to the top of the panel in an apparent attempt to compensate for this loss.

The text of the banderole affixed to the top of the panel represents the last two lines of a quatrain that appears on early weavings of the Petrarchan *Triumph of Death over Chastity*:

puis Atropos et ses deux seurs fatailles
A chastete sans rigele et sans compas

46

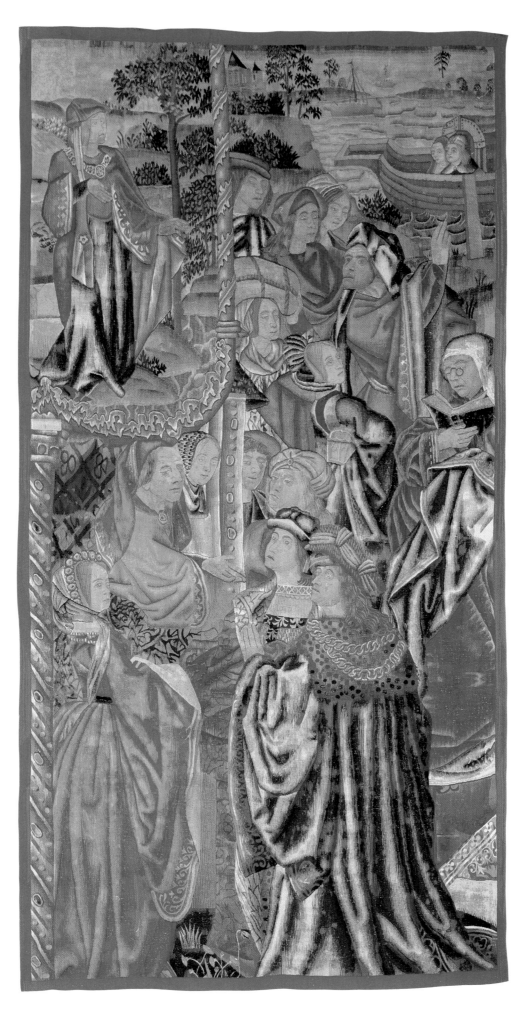

The Arrival of Paris and Helen

Viennent ouvrir le mortel dernier pas
pour demonstrer leurs puissances totalles.

Then Atropos and her two sister Fates
To Chastity without rule or compass
Come to open the last mortal step
To demonstrate their total power.

It is an interesting coincidence that a fragment of *The Triumph of Death over Chastity* belonging to The Fine Arts Museums corresponds exactly to the portion of the weaving to which this verse would be appropriate. The *Triumph* fragment, however, being a late weaving, was not intended to carry an inscription (see cat. no. 20). A patch inserted at lower left shows part of a label . . . RIOSITAS. It appears unrelated.

The Arming of Hector and Other Scenes, 1975.5.29

Hector is being armed for battle in the central foreground. Eldest son of King Priam, he was the bravest of those who fought in defense of Troy. The Homeric passage describing the farewells of Hector and Andromache before one of the early battles of the war has inspired much literature and art. Andromache shows Hector their little son, Astyanax, begging him not to leave the boy fatherless. The medieval version telescopes this scene with another in which Hector's parents try to dissuade him from going into battle. This combined scene is placed immediately before the fatal encounter with Achilles.[5]

In the lower part of the tapestry, a squire kneeling behind Hector buckles on a piece of leg armor. Hector wears chain mail under his brocade shirt. Andromache, at right, has one hand over her heart; with the other she points to Astyanax. Hector turns his face away from his wife to meet the pleas of King Priam, Queen Hecuba, probably Paris and Helen, and one of the sisters. The arming of Hector on the left side of the Zaragoza tapestry is similar to this version. Another episode, called the *Making of the Weapons of Achilles*, corresponds to the small compartmented scene at upper left. The third scene, which is central in the Zaragoza tapestry, takes place in an open loggia. A very large knight, representing Achilles, is offered gold coins and a crown by two women. The hero, in a gesture of furious rejection, throws away the coins. Curiously, the face of one of the women is reflected on his breastplate. Could this be one of the embassies sent to Achilles to persuade him to return to battle?

NOTES

1. Margaret R. Scherer, *The Legends of Troy in Art and Literature* (New York and London: Phaidon Press, 1963), 82.

2. Jean-Paul Asselberghs, *La tapisserie tournaisienne au XVe siècle* (Tournai, 1967), 9–11; Jean-Paul Asselberghs, "Charles VIII's Trojan War Tapestry," *Victoria and Albert Museum Year Book* (London: Victoria and Albert Museum, 1969), 80–84.

3. Eduardo Torra de Arana, Antero Hombría Tortajada, and Tomás Domingo Pérez, *Los tapices de la seo de Zaragoza* (Zaragoza: Caja de Ahorros de la Imaculada, 1985), 178–187, describing *The Wedding of Paris and Helen* and *The Sacrifice of Agamemnon*. I owe this reference to Nello Forti Grazzini.

4. Arana et al., *Los tapices*, 188–195, "The Fury of Achilles" (Series II).

5. Geneviève Souchal, *Masterpieces of Tapestry from the Fourteenth to the Sixteenth Century*, exh. cat. (Paris: Editions des Musées Nationaux, 1973, and New York: The Metropolitan Museum of Art, 1974), 45–57, illus. 53.

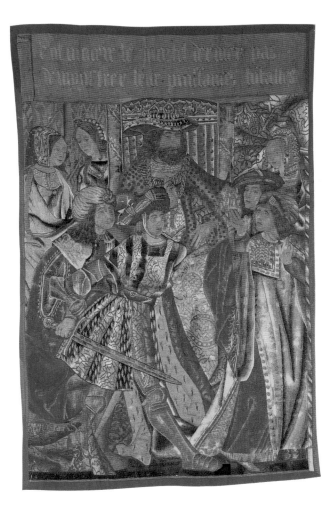 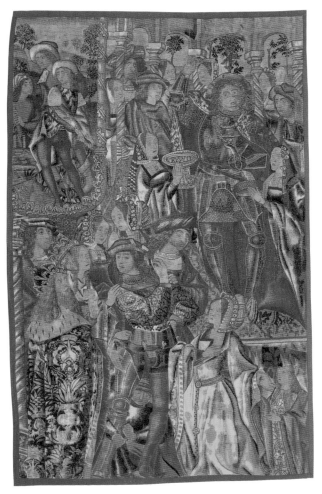

Menelaus Assaulting Deiphobus at the Trojan Court *The Arming of Hector and Other Scenes*

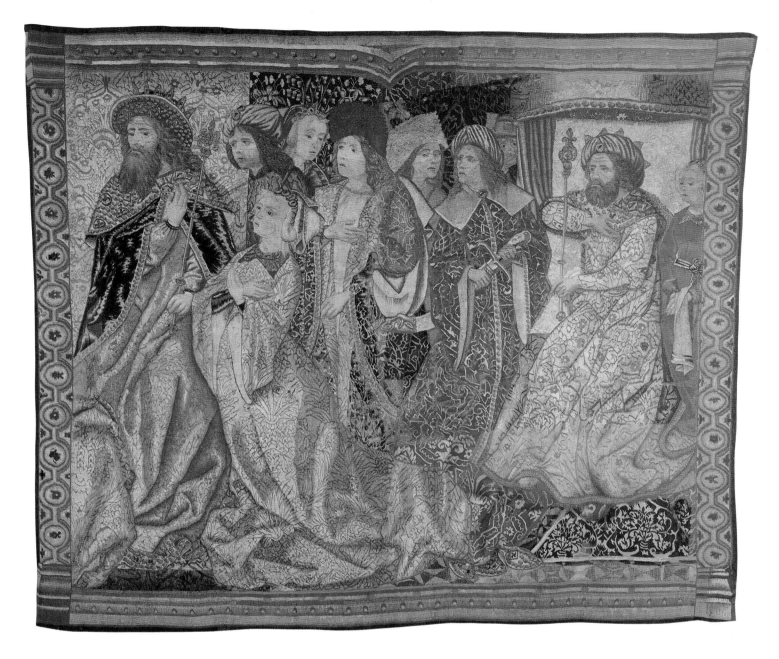

Scene at a Royal Court

10. The Adoration of the Magi *(a fragment)*

Flemish (Brussels), ca. 1500 (design); ca. 1515 (weaving)
H: 2.90 m W: 1.84 m (9 ft. 6 in. × 6 ft. ½ in.)
WARP: undyed wool, 5–6 per cm
WEFT: dyed wool and silk
Mildred Anna Williams Collection (CPLH), 1940.82

This incomplete panel survives from a much larger composition, probably of *The Redemption of Man* type, of which it would correspond to the lower right-hand corner. Two Wise Men, accompanied by a large retinue on foot and on horseback, bring gifts to the young Child. The figure of the Virgin is incomplete. She sits facing slightly right toward the Magi on a cloth-covered platform set back from the flowery foreground. A cloth of honor stretches across the *mansion* behind her. Two angels can be seen on the roof, although they too are cropped; one of them appears to hold a book. Joseph touches his hand to his head in a gesture of wonder and respect at the coming of the Kings. A banner in the background carries the crescent and the star.

The figure sitting at right is a Prophet. His rich mantle is trimmed with moiré, his hat encrusted with pearls. The general appearance of the prophet suggests, as Mâle pointed out long ago, a foreign land, a mysterious antiquity.[1] In his left hand the Prophet holds a tightly rolled scroll. With his right hand he makes an oratorical gesture, as if to say that the prophecy made in that remote time has been fulfilled by the birth of a Savior. The appearance of this Prophet is virtually identical with the one occupying the same corner in *The Combat of the Virtues and the Vices* from the *Redemption of Man* series (Panel 7, cat. no. 14), indicating the reuse of a cartoon.

Another *Adoration* tapestry in the Fogg Art Museum enables us to fill in the losses that The Fine Arts Museums' panel has sustained (see introduction to *The*

Redemption of Man series, Panel 5, fig. 42). It also confirms the inflexible nature of iconography. In both versions, Prophets occupy the corners; the Child inclines toward the Magus; and the cloth-draped *mansion* carries angelic choristers above. In the *Redemption* tapestry, however, an extra scene between the central group and the Prophet shows the Child meeting the young Saint John on a bridge. But Saint Joseph, in the new situation, makes the same gesture of wonder by touching hand to head.

Guy Delmarcel noted that the pattern of the mantle worn by the kneeling Magus closely resembles that of the woman in *Scene at a Royal Court*, dated circa 1500 (cat. no. 9). This observation supports the general impression of archaism that is not entirely dispelled by the presence of a hat in fashion about 1515.[2] Possibly the hat represents an area of later reweaving, or perhaps the entire tapestry from which this fragment comes was a late weaving of an older design, brought up to date by new fashion touches.

NOTES
1. Emile Mâle, *L'art religieux de la fin du Moyen Age en France*. 3d ed. (Paris: A. Colin, 1908), 71.
2. Guy Delmarcel, letter to A. G. B., 11 March 1976.

BIBLIOGRAPHY
d'Hulst, Roger-A. *Flemish Tapestries from the Fifteenth to the Eighteenth Century*. New York: Universe Books, 1967, 121–128, no. 15.

The Adoration of the Magi

The Redemption of Man *Series*

D. T. B. Wood made the pioneering study of an important late Gothic series to which he gave the name *The Seven Deadly Sins*, after an item in Cardinal Wolsey's inventory. His analysis of the complex subject matter, published in 1912,[1] is still valid today, although we now consider the series to comprise ten panels, instead of Wood's eight, and it has acquired the more optimistic title of *The Redemption of Man*.

Majestic in dimensions as in theme, the complete series, placed edge to edge, would require more than seventy-nine meters or 260 running feet of wall space. Only a cathedral or a great palace could have displayed all ten twenty-six-foot panels. Of the estimated six sets woven from the cartoons in the early sixteenth century, about thirty panels or partial panels remain, dispersed among fifteen collections in Europe and the United States. The largest concentrations of the series are at the Cathedral of Palencia, Spain, and at The Fine Arts Museums of San Francisco, each having four panels. There are three at the Kasteel de Haar in the Netherlands.

As Wood showed, the panels are held together by a theme of sweeping grandeur: the salvation of humankind. Within this framework, three story lines cross, recross, and finally converge. The plots are as intricately interwoven as the voice lines of late medieval music.

THE DIVINE CONFLICT. A division of principle exists in the mind of God (Panel 1). His Justice and his Mercy, personified as queenly figures with crowns, contend over the fate of sinful Man (Panel 3). They are reconciled by the promise of a Redeemer (Panel 4). They witness Man's reconciliation with God (Panel 9). On Judgment Day they consign the souls to Heaven or to Hell (Panel 10).

THE HUMAN CONFLICT. Man's moral struggle is externalized as a contest between allegorical Virtues and Vices. A cold war of strategy (Panels 2 and 3) erupts in open challenge (Panel 6), leading to a full-scale battle (Panel 7) in which the Virtues triumph. Despite diversionary tactics and last-minute appeals (Panel 9), the Vices are put down forever on the last day (Panel 10).

THE STORY OF THE REDEEMER. The Redeemer appears in every panel, first as an undifferentiated member of the Trinity (Panels 1 and 2). In Panel 3 he offers himself as Redeemer. He is born in Panel 4, and grows up in Panel 5. Panel 6 shows scenes of his manhood and teaching. He dies on the cross in Panel 7 as the Virtues triumph. He is resurrected in Panel 8 and ascends to Heaven in Panel 9 to complete the Trinity. In Panel 10 he comes in glory to judge.

All but one of the ten designs are represented by examples in the United States of America.[2]

Panel 1. *The Creation and the Fall of Man*, cat. no. 11
The Fine Arts Museums of San Francisco, California
Panel 2. *The Vices Attack Man*, cat. no. 12
The Fine Arts Museums of San Francisco, California
Panel 3. *The Virtues Intercede for Man*, fig. 39
The Metropolitan Museum of Art, New York,
and *The Virtues Intercede for Man* (a fragment), cat. no. 13
The Fine Arts Museums of San Francisco, California
Panel 4. *The Nativity,* fig. 40
The Metropolitan Museum of Art (The Cloisters),
New York
Panel 5. *The Tiburtine Sibyl Showing the Vision of the Madonna and Child to the Emperor Augustus* and *Scenes from the Childhood of Christ*, figs. 41, 42
Fogg Art Museum, Harvard University, Cambridge,
Massachusetts
Panel 6. *Scenes from the Manhood of Christ and from Christian Allegory*, fig. 43
Museum of Fine Arts, Boston, Massachusetts
Panel 7. *The Combat of the Virtues and the Vices*, cat. no. 14
The Fine Arts Museums of San Francisco, California
Panel 8. *The Resurrection*, cat. no. 15
The Fine Arts Museums of San Francisco, California
and *The Resurrection*, The Art Institute of Chicago,
Illinois, fig. 44
Panel 9. *The Ascension*, fig. 45
Kasteel de Haar, Harzuylen, Netherlands
Panel 10. *The Last Judgment*, fig. 46
Worcester Art Museum, Worcester, Massachusetts

The general plan for the artist to follow must have been developed by an ecclesiastic. Besides the authority such an author would command, the tapestries show a familiarity with contemporary literature. Ackerman believed that five mysteries and one morality play were fused in the present script.[3] Cavallo thought the series was based on a mystery play or sermon of the late fifteenth century.[4] Without the exact script, we cannot speak confidently of the source.

The search for the designer and the search for the weaver are related. We have no name for either, but can point to resemblances in documented pieces belonging to other collections. A group of figures in *Redemption* Panel 3 appears also in *The Prodigal Son, Part 1* at the J. B. Speed Art Museum, Louisville. Verdier found a "similarity—almost an identity—of symbolical and decorative patterns."[5] Striking resemblances were noted by Jarry between *The Mass of Saint Gregory*, now part of the Spanish National Patrimony, and prophets, angels, and general compositional features of certain *Redemption* panels.[6] Finally,

Delmarcel compared angel groups in *The Presentation in the Temple* (from the *Life of the Virgin* series at the Palacio Real, Madrid) with those in *Redemption* Panels 5 and 10.[7]

How significant are these resemblances? It is known that both single figures and entire groups were frequently reused in later compositions. *The Mass* and *The Prodigal Son* both retain the old-fashioned architectural "tabernacle" framework which has been discarded in *The Redemption* series. The artist responsible for the latter was not merely an imitator, but an accomplished designer, capable of arranging more than a hundred figures in a composition of power and clarity. The possibility exists that he or his assistants had access to older cartoons and borrowed from them a decade later. *The Mass* has been attributed to the weaver Pieter van Aelst,[8] who sold *The Presentation in the Temple* to Joanna the Mad in 1502.[9] The *Redemption* designer may have been associated with this workshop, or the weaver may have worked with van Aelst or his successors.

VARIOUS SETS

THE NARBONNE SET. *The Creation*, sole survivor of a set of ten presented to the Cathedral of Saint-Just, Narbonne, differs from other *Redemption* pieces in its richness of material. The lavish use of metallic thread suggests that the Narbonne set was the first, or princely, edition.

THE FONSECA SET. Don Juan Rodríguez de Fonseca, bishop of Palencia and Burgos, bequeathed four tapestries to each cathedral before his death in 1524. He may have purchased the Palencia four in Flanders in 1519.[10]

THE BERWICK AND ALBA SET. There is some evidence that the six panels formerly belonging to the dukes of Berwick and Alba were woven later than the Fonseca set. *The Resurrection* from that set, now at The Art Institute of Chicago, has an important figure missing from the right side. The void, either resulting from a damaged cartoon or a deliberate omission, was filled with a large-scale flowering plant.[11]

THE TOLEDO SET. The four *Redemption* tapestries now at The Fine Arts Museums of San Francisco came from the Cathedral of Toledo. The loss noted in the Chicago *Resur-rection* is more evident in the San Francisco *Resurrection* because the void is filled with less skill. The panels from Toledo show consistently less detail than those of the Berwick and Alba set to which the Chicago panel belonged, indicating worn cartoons and a later weaving date.

THE PORTUGUESE SET. Two panels from a set belonging to Manoel of Portugal are at the Worcester Art Museum and the Fogg Art Museum (in two pieces). No guess can be risked as to where they fit into the weaving chronology.

The ten panels of the series are presented in sequence. Those panels belonging to The Fine Arts Museums of San Francisco interface with illustrated examples from other collections to enable the reader, like the original viewers, to follow the flow of the story from Creation to Judgment Day.

NOTES

1. D. T. B. Wood, "Tapestries of the Seven Deadly Sins—I," *The Burlington Magazine* 20, no. 106 (January 1912): 210–222, and "Tapestries of the Seven Deadly Sins—II," *The Burlington Magazine* 20, no. 107 (February 1912): 277–289.

2. Adolph S. Cavallo lists the locations in 1967 of various examples of the designs in *Tapestries of Europe and of Colonial Peru in the Museum of Fine Arts, Boston*, 2 vols. (Boston: Museum of Fine Arts, 1967), 1:94–95.

3. Phyllis Ackerman, "Tapestries: Gift from William Randolph Hearst" (typescript, files, The Fine Arts Museums of San Francisco, January 1954), 4.

4. Cavallo, *Tapestries*, 1:2.

5. Philippe Verdier, "The Tapestry of the Prodigal Son," *The Journal of the Walters Art Gallery* 18 (1955): 9–58.

6. Madeleine Jarry, *World Tapestry from Its Origins to the Present* (*La tapisserie*, Paris: Librairie Hachette, 1968; English ed. New York: G. P. Putnam's Sons, 1969), 105; illus. 106–107.

7. Guy Delmarcel, letter to A. G. B., 11 March 1976.

8. Jan-Karel Steppe, "Inscriptions décoratives contenant des signatures et des mentions de lieu d'origine sur les tapisseries bruxelloises de la fin du XVe et du début du XVIe," in *Tapisseries bruxelloises de la pré-Renaissance*, exh. cat. (Brussels: Musées Royaux d'Art et d'Histoire, 1976), 193–230.

9. Guy Delmarcel, letter to A. G. B., 11 March 1976, citing Elias Tormo Monzo and Francisco J. Sánchez Cantón, *Los tapices de la casa del Rey N.S.*, ed. Pedro Miguel de Artinano (Madrid, 1919), illus. pl. 5a.

10. Cavallo, *Tapestries*, 1:121–122.

11. Christa Mayer [Thurman], *Masterpieces of Western Textiles* (Chicago: The Art Institute of Chicago, 1969), 25, illus. pl. 10.

11. The Creation and the Fall of Man

from The Redemption of Man *Series*

Flemish (Brussels), 1510–1515
H: 4.17 m W: 8.13 m (13 ft. 8 in. × 26 ft. 8 in.)
WARP: undyed wool, 5–6 per cm
WEFT: dyed wool with silk accents
Gift of The William Randolph Hearst Foundation (de Young),
 54.14.1

The *Redemption* series opens with the six days of Creation, as told in the book of Genesis. The Trinity is enthroned in Paradise at upper center. Three Divine Persons sit on a bench in the clouds. They wear magnificent, jewel-trimmed copes and breastplates. Closed imperial crowns, orbs, and scepters symbolize their power. A heavenly chorus sings behind the throne, accompanied by angel musicians playing the harp and the portative organ. On either side of the bench stands a crowned allegorical female figure. In the place of honor, on God's right hand, stands Mercy, holding a lily that is no longer distinguishable. JUSTICIA (Justice), with a sword, is on God's left.

Moving in a semicircular course through Heaven and Earth, the Trinity performs the work of Creation. In the upper left corner, reduced in size to suggest distance, the kingly figures float against the waves and luminous clouds to represent the first two days when God created Light and the Firmament dividing the waters. Below, in the lower left corner, the Three stand on earth. It is the third day: "Let the dry land appear." Moving to the right, to the fourth day, they point upward to the sun, the moon, and the starry sky.

On the fifth day, the birds and fishes take form at the word of God and are blessed with a composite gesture of great beauty. Each hand that blesses is arrested at a different point in making the sign of the cross. "Everything that creepeth upon the face of the earth" was the work of the sixth day: the fox, sheep, rabbit, lion, elephant, and humans. Adam and Eve kneel before the Three Persons of the Trinity, who now appear a little apprehensive.

Above Adam's head, in a magnificent swirl of drapery, the Three Persons move and turn in every direction, as if to survey the works of Creation, or perhaps warning against eating the fruit of the tree of knowledge of good and evil.

The two episodes of Adam and Eve's disobedience and expulsion from the Garden are compressed into the upper right corner. The evil figure of the Devil stands between Adam and Eve. He is disguised with an animal body and a woman's head. The Devil holds up an apple to Eve, while

Eve offers another to Adam. The sequel at the right shows the guilty pair driven from the Garden by a sword-brandishing angel.

The close resemblance between all the male faces raises a point of iconography explained by Emile Mâle.[1] All persons of the Trinity were given the traditional features of Christ on the basis of theological reasoning derived from Saint Augustine. All things came into being at the word of God. Christ was the word made flesh. Therefore, in the Middle Ages Christ was viewed in the double role of Creator and Redeemer, and Adam was created in God's (that is, Christ's) image.

The Prologue of Creation opened the great mystery cycles, the Epilogue of the Last Judgment concluded them, and Christ's story unfolded between these awesome brackets. The *Creation* tapestry, introducing the *Redemption* series, follows a shared formula, confirming the "intimate relationship among the arts."[2]

NOTES
1. Emile Mâle, *L'art religieux de la fin du Moyen Age en France*, 3d ed. (Paris: A. Colin, 1925), 227–228.
2. Robert Sarlos, from essay accompanying model of Historic Medieval Stage, Valenciennes, 1547. *Five Centuries of Tapestry*. Exhibition, California Palace of the Legion of Honor, November 1976: "It was probably not as much a matter of theatre borrowing from the pictorial arts or visual artists copying theatrical performances, as all art forms and artists working from the same cultural bases."

BIBLIOGRAPHY
Wood, D. T. B. "Tapestries of the Seven Deadly Sins—I." *The Burlington Magazine* 20, no. 106 (January 1912): 212–213, 216, 222.
Wood, D. T. B. "Tapestries of the Seven Deadly Sins—II." *The Burlington Magazine* 20, no. 107 (February 1912): 277, 280.
Hunter, George Leland. *Tapestries, Their Origin, History, and Renaissance*. London: John Lane Company, 1912, 279–281.
Ackerman, Phyllis. "Tapestries: Gift from William Randolph Hearst." Typescript, files, The Fine Arts Museums of San Francisco, January 1954.
Comstock, Helen. "Tapestries from the Hearst Collection in

American Museums." In *The Connoisseur Year Book, 1956* (London, 1956), 40, illus. 41.

d'Hulst, Roger-A. *Flemish Tapestries from the Fifteenth to the Eighteenth Century.* New York: Universe Books, 1967, 122–128, 298–299.

Cavallo, Adolph S. *Tapestries of Europe and of Colonial Peru at the Museum of Fine Arts, Boston.* 2 vols. Boston: Museum of Fine Arts, 1967, 1:94.

Jarry, Madeleine. *World Tapestry from Its Origins to the Present* (*La tapisserie*, Paris: Librairie Hachette, 1968). English ed. New York: G. P. Putnam's Sons, 1969, 111–113.

Souchal, Geneviève. *Masterpieces of Tapestry from the Fourteenth to the Sixteenth Century*, exh. cat. Paris: Editions des Musées Nationaux, 1973, and New York: The Metropolitan Museum of Art, 1974, 209–211.

PROVENANCE

Cathedral of Toledo until ca. 1900
Ascher Wertheimer, 1902
Weinberg Collection
William Randolph Hearst Collection

EXHIBITION

Treasure Island, California, 1936

RELATED TAPESTRIES

Cathedral of Saint-Just, Narbonne; Kasteel de Haar, Netherlands.

Of the three weavings of this magnificent design, those in San Francisco and Holland appear nearly identical. The Narbonne version differs, as mentioned before, in its richness of materials.

The Creation and the Fall of Man

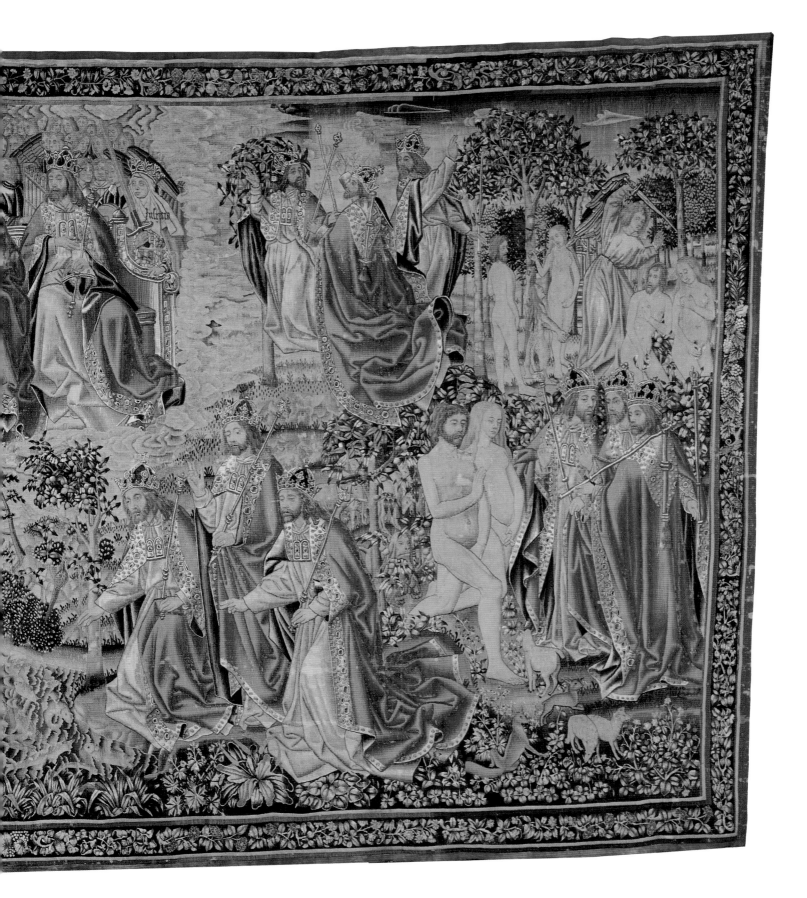

12. The Vices Attack Man

from The Redemption of Man *Series*

Flemish (Brussels), 1510–1515
H: 4.22 m W: 7.92 m (13 ft. 10 in. × 26 ft.)
WARP: undyed wool, 5–6 per cm
WEFT: dyed wool and silk
Gift of The William Randolph Hearst Foundation (de Young),
54.14.2

In the second panel of the *Redemption* series, Man capitulates to Evil in its various seductive forms. His alienation from God, which began with Adam's disobedience in the Garden, is deepened by contact with the Vices. He bears the label of HOMO, meaning Everyman, but he appears a pure exemplar of the Prodigal Son in his ermine sleeves and heavy gold chains. The panel's scheme parallels the plot of a contemporary French morality play called *L'homme pécheur,* or *Sinful Man.*[1]

The Trinity, seated by the Fountain of Life, at upper left, listens to a dispute between two allegorical figures, probably concerning the fate of Man. The object of their argument, HOMO, is driven further from God's presence by Justice with a raised sword. The hooded figure of Guilt, behind him, carries a branch of the fateful apple tree. She is accompanied by a woman dressed in patterned silk, perhaps a damask, whose mincing gait and serpentine silhouette clearly identify her as a Vice.

In the upper register, the turbaned figure of LABOR approaches Man as he and NATURA (Human Nature) sit with CEIDI (the rewoven name is perhaps intended for Acedia, or Sloth), and two other Vices. LABOR presents Man with a shovel, for labor was considered the first step toward redemption.[2] The Vices look distressed and lift hands in protest. Man appears unimpressed.

A new figure threatens Man in the center foreground. Labeled TE[M]TAT for Temptator, he is the Devil, dressed as a rough shepherd in tunic, boots, and hood.[3] His character suggests a boisterous stage presence. He has knocked off Man's hat and now goads him with a spear. Under his belt he carries a shepherd's recorder, probably intended as a symbol of sensuality.[4] MU[N]D[US], the World, waves a bundle of switches; [C]ARO, Flesh, flails away at Man, and Guilt, as usual, attends him. NATURA and another stand by, aghast.

Directly above this scene, an open-air trial is in progress, with the Vices sitting in judgment. Their leader is probably Pride. Avarice sits at her right hand, clutching a purse. Vanity is on her left with a mirror, and Gluttony

holds her empty bowl. The Vice in the same patterned silk holds up for evidence a panel painting of the Expulsion from the Garden. LUXURIA points to this damaging testimony. The case against Man is won by the Vices; the decision is handed down at the right. LUXURIA, in boots and cloak, receives the staff and official badge of the messenger.[5] CULPA pulls impatiently at her cloak. In addition to the inevitable apple branch, CULPA has a carrying case over her left arm, probably containing the verdict.

Below, the Vices arrive in force to make their claim. CULPA has her carrying case and leans on her spear. LUXURIA offers Man a crown. LABOR turns his back and deserts Man, who now rests on his shovel.

The final scene is set in the court of LUXURIA. Over a transparent shift, she wears a silk cloak, pulled up rakishly at the knee. HOMO, elegant in velvet and ermine, genuflects before his new sovereign. He is sponsored by CARO and Gluttony. CULPA attends him, and another Vice pushes away Reason or Contrition. The label, nearly illegible, reads [RA]CIO or [CONTRI]CIO.

In all the Redemption panels except *The Creation,* impressive figures of the Prophets occupy the lower corners, dressed in costumes with a theatrical air. Jeremiah, at left, holds a scroll that reweaving has made illegible in The Fine Arts Museums' version. Other weavings of the design show that his text must originally have read: EJICE ILLOS E FACIE MEA (Cast them out of my sight). The verse, from Jeremiah 15:1, expresses God's displeasure at Man's behavior. The figure in the right corner, probably David, has not unrolled his message, for the promise of the Redemption has not yet been made.[6]

The Prophets embody an important piece of medieval dogma: Saint Augustine's assertion that "the Old Testament is nothing but the New covered with a veil, and the New is nothing but the Old unveiled."[7] The *Biblia pauperum* (printed in 1460) and *Speculum humanae salvationes* (1324) developed this idea. The prophecies inscribed on the Prophets' scrolls are interpreted as references to the scenes enacted before them.

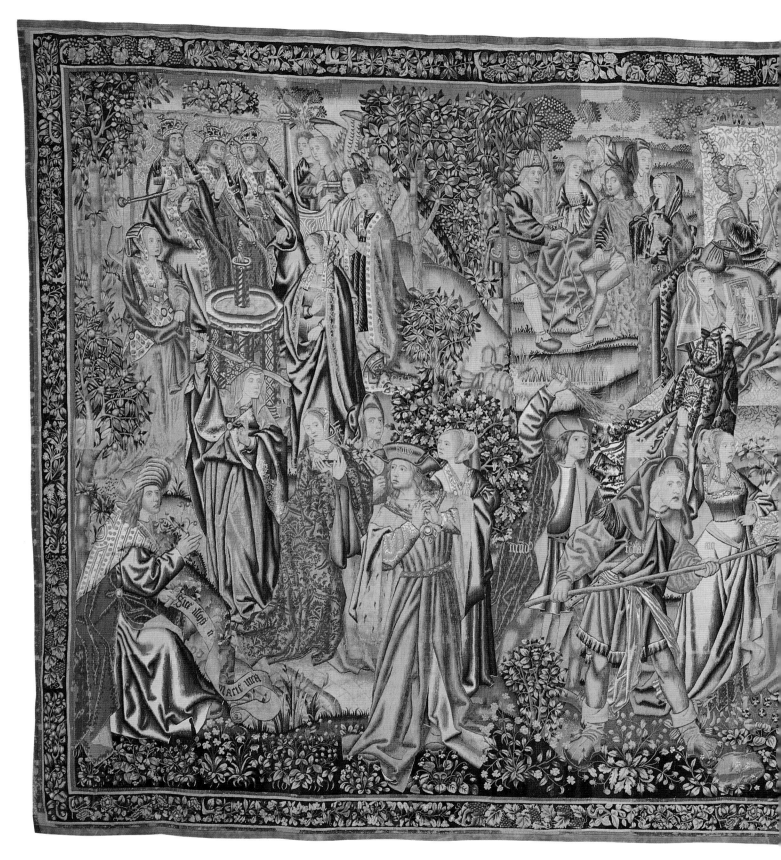

The Vices Attack Man

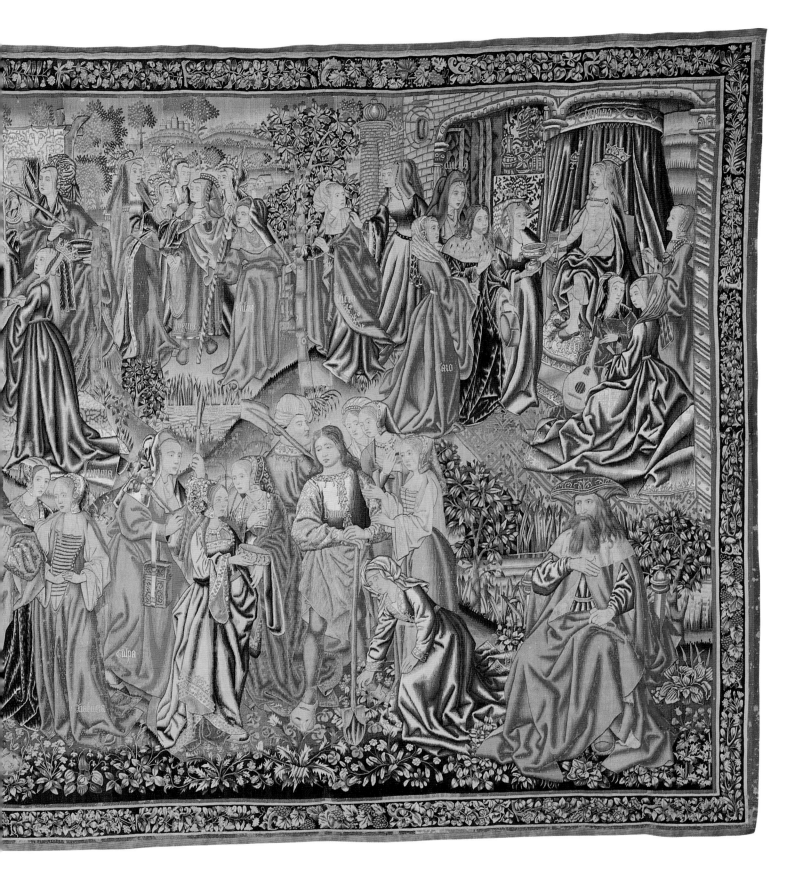

13. The Virtues Intercede for Man

from The Redemption of Man *Series (a fragment)*

Flemish (Brussels), ca. 1515*
Promised future gift (Bequest of Marguerite Brokaw Adams)

The struggle between God's justice and his mercy reaches a critical point in the third panel of the *Redemption of Man* series, represented by a complete weaving at The Metropolitan Museum of Art, New York (fig. 39).[1] The present fragment corresponds to the large tapestry's upper right-hand corner and shows the final episode that prepares the way for three subsequent panels devoted to the Redeemer's story.

The scene has a garden setting with an apple tree at the left. A Divine Person, probably to be interpreted here as Christ, sits on an elevated throne. His authority is symbolized by the scepter and orb. He wears a red cope with wide jeweled borders and a closed imperial crown. Two crowned allegorical figures sit on either side: Charity (CARITAS) in red, holding a scepter, and Humility (HUMILITAS) in blue with a nun's veil, holding a white dove. Misery (MISERIA) stands before the throne, poorly dressed and leaning on a staff. The unlabeled foreground figure is Human Nature (NATURA in the Metropolitan panel). She tears open her robe, exposing a dark undergarment; in the New York version she reveals a wound. MISERICORDIA, or Mercy, kneels at the right, pleading for Man.

Charity points with her left hand to Misery who holds up a charter as reminder of God's promise of Redemption. Presumably in response to this plea, Christ raises his hand as if offering himself to save mankind. In a fifteenth-century mystery play called "Le jugement de Jésus," Christ is summoned by Natura Humana to carry out the contract of Redemption.[2] His acceptance leads to the next three panels dealing with his birth, childhood, manhood, and teaching.

There is evidence of reweaving around the edges of the fragment and in the lower center where an "oriental" rug has been added before the throne. The scene was given a later border, confirming it as a remnant from a larger piece, rather than a panel planned from the start as a partial weaving of the cartoon.

The complete version is dominated by the famous Paradise Lawsuit shown in the upper center of the panel. In this allegorical trial, the case of sinful Man is brought before the throne of God. Mercy and Peace take his part, opposing Justice and Truth. The concept was common

*Tapestry unavailable for examination at time of publication.

ground in the moralizing literature of the Middle Ages and is found in the writings of Bernard of Clairvaux and the pseudo-Bonaventure,[3] and in the Passion play of Arnoul Gréban.[4] Scenes of Man's guilt are depicted to the left of the trial, while scenes on the right offer some hope, as Man is offered arms for the battle against sin, and God is reminded of his promise of Salvation.

Three other partial panels are known that correspond to various parts of the third panel. A horizontal piece in the Victoria and Albert Museum duplicates the lower left corner. An almost square tapestry in the Burrell Collection, Glasgow, duplicates the left half of the tapestry. Seymour de Ricci listed among the partial weavings of the cartoon a fragment from a castle near Evora, Portugal,[5] that duplicates a portion of the lower right side. It is possible that the present fragment came from the same source as one or more of these incomplete panels.[6]

THE REDEMPTION OF MAN, PANELS 4–6

The Story of the Redeemer.

Panel 4. *The Nativity.* The Metropolitan Museum of Art, housed at The Cloisters. A unique example showing events in heaven and on earth leading to the fulfillment of God's promise with the birth of the Savior, including the Marriage of the Virgin, and the Adoration of the Young Child (fig. 40).

Panel 5 (in two sections). *Scenes from the Childhood of Christ.* The Fogg Art Museum, Harvard University, Cambridge. The Tiburtine Sibyl Showing the Vision of the Madonna and Child to the Emperor Augustus (from *The Golden Legend*), the Adoration of the Kings, and Scenes from the Childhood of Christ, including Jesus' meeting with Saint John (figs. 41, 42). An intact weaving is at the Cathedral of Palencia.

Panel 6. *Scenes from the Manhood of Christ and from Christian Allegory.* Museum of Fine Arts, Boston. Scenes on the left show episodes from the life of John the Baptist and the baptism of Christ. Those in the center depict Christ's teachings and ministry: The Woman Taken in Adultery, The Raising of Lazarus. The scenes on the right provide the link with Panel 7 (cat. no. 14). Charity, wearing the pelican symbol on her back, hands the

64

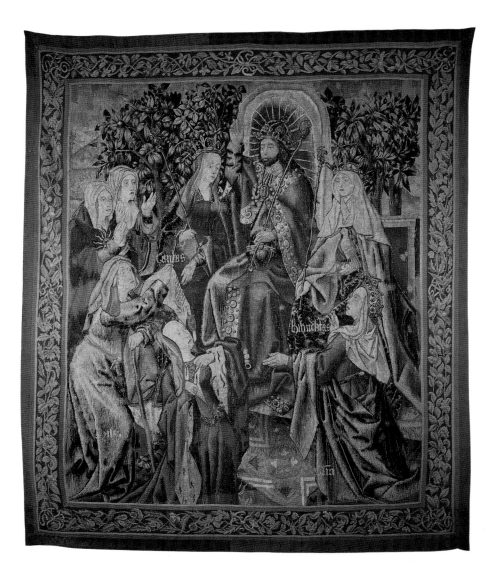

The Virtues Intercede for Man

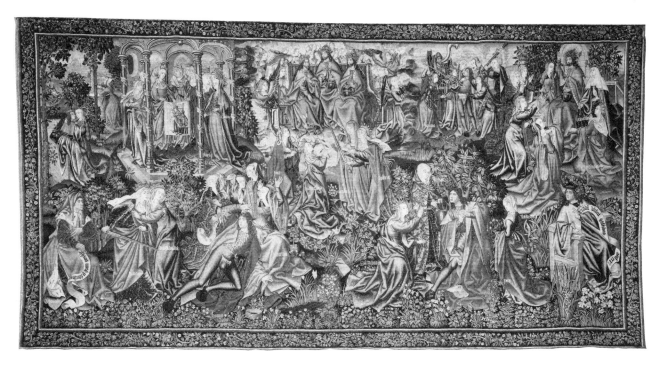

FIGURE 39
The Virtues Intercede for Man, *The Redemption of Man* Series, panel 3,
tapestry. The Metropolitan Museum of Art, New York. Fletcher
Fund, 1938, 38.29

gauntlet of challenge to Envy, seated with her six sister Sins. Above, the seven Virtues arm the Christian Knight, handing him the banner with the five wounds of Christ and a helmet surmounted by a crown of thorns (fig. 43). Thus fortified against Evil, he is ready for *The Combat* that follows.

NOTES

1. The Metropolitan tapestry came from Burgos Cathedral. Another complete weaving is at Hampton Court, from the collection of Cardinal Wolsey and Henry VIII. The Burrell piece came from Knole, via the J. Pierpont Morgan collection.
2. D. T. B. Wood, "Tapestries of the Seven Deadly Sins—II," *The Burlington Magazine* 20, no. 107 (February 1912): 278. Wood refers to the "Jugement de Jésus" in A. Jeanroy and H. Teulie, *Mystères provençales du quinzième siècle* (Toulouse, 1893).

3. Guy Delmarcel, *Tapisseries bruxelloises de la pré-Renaissance*, exh. cat. (Brussels: Musées Royaux d'Art et d'Histoire, 1976), 101.
4. Wood, "Tapestries," 278.
5. Seymour de Ricci, *Twenty Renaissance Tapestries from the J. Pierpont Morgan Collection* (Paris: P. Renouard, 1913); Jules Guiffrey, *Les tapisseries du XIIe à la fin du XVIe siècle*, vol. 6 of *Histoire générale des arts appliqués à l'industrie du Ve à la fin du XVIIIe siècle* (Paris, 1911), 61, fig. 29.
6. Another fragment, possibly from the same source, sold at Parke-Bernet, collection of the late Mrs. Charles B. Alexander, 17–19 April 1941, no. 579. It duplicates the upper central portion of the complete Metropolitan panel (fig. 39) showing the enthroned Trinity.

FIGURE 40
The Nativity and Other New Testament Scenes, The Redemption of Man Series, panel 4, tapestry. The Metropolitan Museum of Art, New York. The Cloisters Collection, Purchase, 1938, 38.28

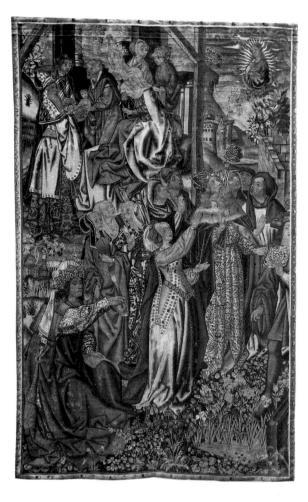

FIGURE 41

The Tiburtine Sibyl Showing the Vision of the Madonna and Child to the Emperor Augustus, Redemption of Man Series, panel 5, tapestry. Fogg Art Museum, Harvard University, Cambridge. Gift of Mrs. Felix M. Warburg in commemoration of the 70th anniversary of Mr. Felix M. Warburg's birth

FIGURE 42

Scenes from the Childhood of Christ, The Redemption of Man Series, panel 5, tapestry. Fogg Art Museum, Harvard University, Cambridge. Gift of Mrs. Jesse I. Straus, in memory of her husband, Jesse I. Straus, Class of 1893

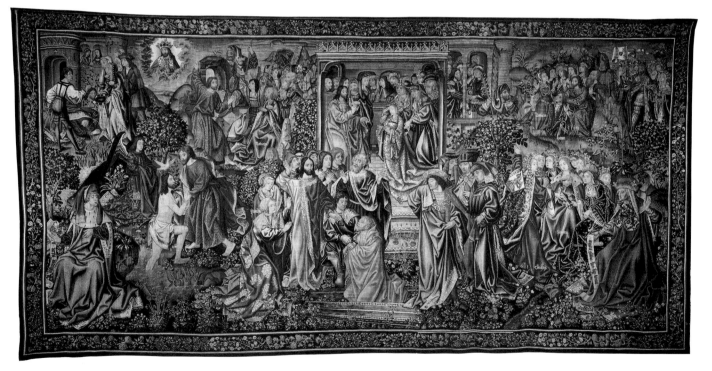

FIGURE 43

Scenes from the Manhood of Christ and from Christian Allegory, The Redemption of Man Series, panel 6, tapestry. Museum of Fine Arts, Boston. Gift of the Hearst Foundation in memory of William Randolph Hearst, 54.1776

14. The Combat of the Virtues and the Vices

from The Redemption of Man *Series*

Flemish (Brussels), 1510–1515
H: 4.17 m W: 7.98 m (13 ft. 8 in. × 26 ft. 2 in.)
WARP: undyed wool, 5–6 per cm
WEFT: dyed wool and silk
Gift of The William Randolph Hearst Foundation (de Young),
54.14.4

The seventh panel in *The Redemption* series, or its "splendid centerpiece," as D. T. B. Wood called it, is actually circular in composition and represents the focal point of the thematic material. In it the forces of good and evil join battle before the cross—symbolism familiar to an age which still read Huon de Mercy's thirteenth-century poem "Tournoîment de l'Anticrist." The basic debt, however, is even older, going back to the late Latin author Prudentius and his *Battle of the Soul*, reworked in the fourteenth century by Guillaume de Deguilleville.[1]

Heralds sound the opening of the tournament, standing on Mount Sinai and on Mount Calvary (the labels are legible in the Burgos example). They are the Old and the New Testament, identified by labels and banners that show, respectively, the Books of the Law and the Chalice of the Eucharist. Their fanfare trumpets are raised in unison, expressing the medieval belief in their harmony. The Old Testament is thinly veiled, suggesting the obscure nature of the prophecies.[2]

In the center of the melee, the Christian Knight, who is perhaps a symbol of the Redeemer, leads the Virtues to victory. He wears Gothic armor beneath the cope of the Trinity. Over his helmet one can barely distinguish the crown of thorns. A white unicorn, long known to be a symbol of Christ, serves as his mount. The Virtues ride behind him, unarmed, showing no fear. Temperance on a lion pours water from a ewer. DEVOCIO DEI (Devotion to God) rides a stag which, according to the Bestiaries, devours harmful serpents. CASTITAS (Chastity) carries a lily and rides on an ass. Sobriety holds a water carafe. The line of defense is completed by PATIE[N]TIA (Patience), HUMILITAS (Humility) with a cross, and DILECTIO (Esteem).

A restless and aggressive spirit animates the enemy. Led by SUPERBIA (Pride) on a white camel, the Vices spring forward, for the most part heavily and incongruously armed. Emblems on their shields and helmets, as well as labels, identify the riders. Although both Virtues and Vices ride animals, the animal symbolism is particularly strong on the side of evil. Animals and animal worship had been linked with sin since Hellenistic times.

Matthias Farinator's *Lumen animae* (1330) strengthened the association with every kind of bestiary lore. He prescribed not only the mounts for the cohorts of Pride, but animal devices as well for crest, shield, and sometimes even for mantle.

The armorial bearings for SUPERBIA are the eagle and the peacock. Close behind her, a fox decorates the crest of Gluttony's helmet. IRA (Anger) follows her, wielding a massive axe. She shows a mad dog on her shield and a hawk on her helmet. ACCIDIA (Sloth) wears no helmet, but a jeweled headdress surmounted by a crown and a monkey. Her shield is emblazoned with an ox. Instead of a weapon, she carries a grassy clod of earth. The explanation of Accidia's strange attributes is biblical, found in Proverbs 20:4 ("The sluggard will not plow by reason of the cold; therefore shall he beg in harvest, and have nothing") and Ecclesiasticus 22:2.[3]

In the right foreground, LUXURIA rides away from the battle, sitting rather daintily on a boar with a chain for bridle. She holds a mirror. AVARICIA (Avarice) rides before her toward the battle. Her helmet is surmounted by a mole, undistinguishable in The Fine Arts Museums' version. The device on her shield is a thin, hungry-looking animal. She rides an oryx and carries a rake.[4] INVIDIA (Envy) rides a winged dragon, originally covered with spots, straight out of the Flemish procession called an *ommegang*. Her shield bears the device of a doglike animal with a long tail; her helmet is a beehive. With a flaming lance she tries to pierce the side of the Christian Knight (Matthew 27:18).[5] At the same moment, he topples SUPERBIA, her sword poised for a blow that is never delivered. The traditional figure for Pride is that of a falling rider.

At this decisive moment of the battle, the supreme sacrifice is being made on the cross. This event, although small in scale and relegated to the background, is, nevertheless, the panel's pivotal point. In the group around the cross one can distinguish Saint John, who supports the sinking Virgin, Saint Mary Magdalen in a moiré gown, and the bearded Longinus.

The victory of that moment is double: the victory of Christ on the cross, and that of the Christian Knight on the moral battlefield. This twofold triumph is celebrated by the ancient hymn, *Pange, lingua, gloriosi praelium certaminis*:

Sing, my tongue, the glorious battle,
Sing the last, the dread affray:
O'er the Cross, the Victor's trophy,
Sound the high triumphal lay,
How, the pains of death enduring,
Earth's Redeemer won the day.

It was composed by Venantius Fortunatus, bishop of Poitiers, and probably first sung about 569. The title is inscribed on banderoles carried by two flying angels.

The scrolls of the Prophets foretell and explain these immense events. Isaiah, at left, says, IPSE VENIT ET SALU-ABIT VOS ISAIS (He comes and he will save you, Isaiah) (Isaiah 35:4). Repairs on the right-hand scroll have made it illegible. Other versions show HIS PLAGATUS SUM ISAIS XIII. It is an answer to the question "What are these wounds in thine hands?" "Those with which I was wounded [in the house of my friends]." The text actually comes from Zechariah 13:6.

NOTES

1. D. T. B. Wood, "Tapestries of the Seven Deadly Sins—I," *The Burlington Magazine* 20, no. 106 (January 1912): 210, and "Tapestries of the Seven Deadly Sins—II," *The Burlington Magazine* 20, no. 107 (February 1912): 278.
2. Emile Mâle, *The Gothic Image: Religious Art in France of the Thirteenth Century*, trans. Dora Nussey from 3d French ed. (1913; reprint, New York: Harper & Row, 1966), 136.
3. Guy Delmarcel, letter to A. G. B., 11 March 1976, cited Siegfried Wenzel, *The Sin of Sloth: Acedia in Medieval Thought and Literature* (Chapel Hill: University of North Carolina Press, 1967), 100.
4. Philippe Verdier, "The Tapestry of the Prodigal Son," *The Journal of the Walters Art Gallery* 18 (1955): 47, n. 20; 50, n. 43.

5. Phyllis Ackerman, "Tapestries: Gift from William Randolph Hearst" (typescript, files, The Fine Arts Museums of San Francisco, January 1954).

BIBLIOGRAPHY

Destrée, Joseph. *Tapisseries et sculptures bruxelloises à l'exposition d'art ancien bruxellois*. Exh. cat. Brussels: Librairie Nationale d'Art et d'Histoire, 1906, 9, illus. pl. 8.
Wood, D. T. B. "Tapestries of the Seven Deadly Sins—I." *The Burlington Magazine* 20, no. 106 (January 1912): 215–216.
Wood, D. T. B. "Tapestries of the Seven Deadly Sins—II." *The Burlington Magazine* 20, no. 107 (February 1912): 278.
Bloomfield, Morton W. *The Seven Deadly Sins: An Introduction to the History of a Religious Concept, with Special Reference to Medieval English Literature* [1952]. Reprint. East Lansing: Michigan State University Press, 1967, 138, 245–249.
Ackerman, Phyllis. "Tapestries: Gift from William Randolph Hearst." Typescript, files, The Fine Arts Museums of San Francisco, January 1954.
Comstock, Helen. "Tapestries from the Hearst Collection in American Museums." *The Connoisseur Year Book, 1956*. London, 1956, 41.
Cavallo, Adolph S. "The Redemption of Man: A Christian Allegory in Tapestry." *Bulletin of the Museum of Fine Arts, Boston* 56, no. 306 (Winter 1958), 164.
Cavallo, Adolph S. *Tapestries of Europe and of Colonial Peru in the Museum of Fine Arts, Boston*. 2 vols. Boston: Museum of Fine Arts, 1967, 1:95.

PROVENANCE

Cathedral of Toledo, 1890
Goldschmidt Frères, 1905
French & Co., 1914
William Randolph Hearst Collection

EXHIBITION

Exposition d'art ancien bruxellois, Brussels, 1906

RELATED TAPESTRIES

Kasteel de Haar, Netherlands; Burgos Cathedral

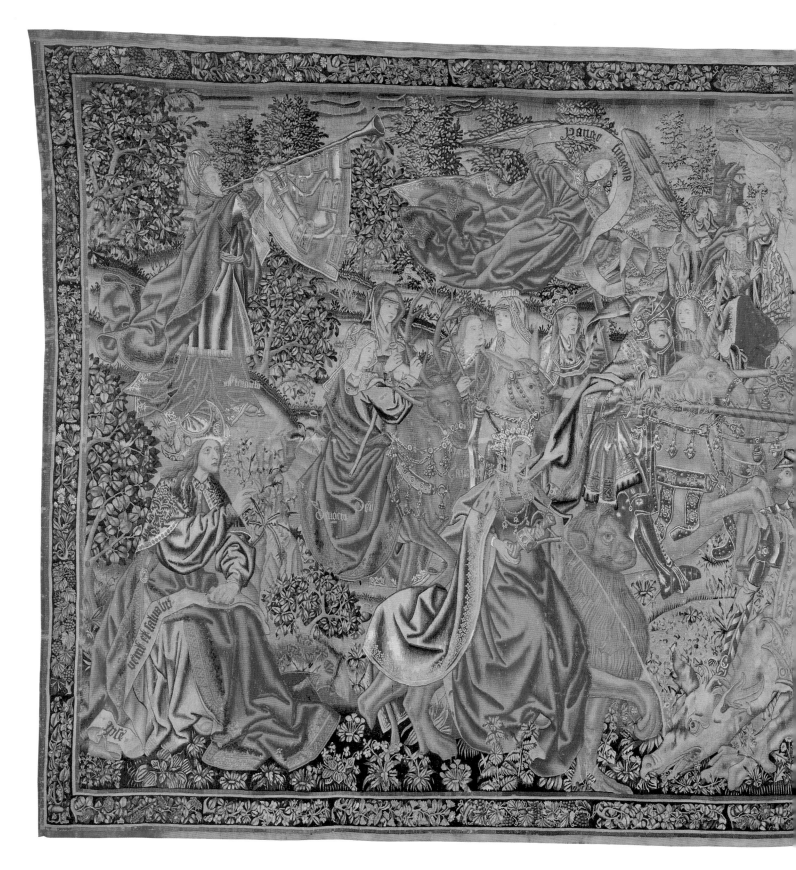

The Combat of the Virtues and the Vices

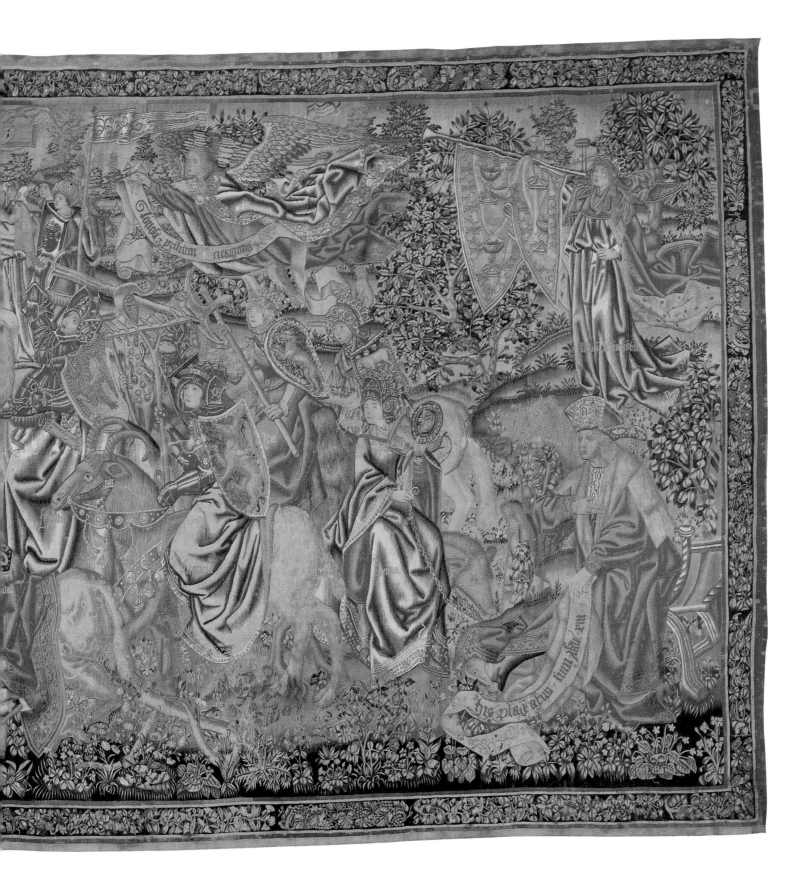

15. The Resurrection

from The Redemption of Man *Series*

Flemish (Brussels), 1510–1515
H: 4.32 m W: 7.87 m (14 ft. 2 in. × 25 ft. 10 in.)
WARP: undyed wool, 5–6 per cm
WEFT: dyed wool and silk
Gift of The William Randolph Hearst Foundation (de Young),
 54.14.3

Scenes of the *Resurrection* and *Ascension* brought the story of Christ's Passion to an end, followed by the epilogue of the *Last Judgment*. The mood of this eighth tapestry of the series is calm after the battle of the preceding panel. Christ, larger than life, stands on the lid of his tomb in the manner of the mysteries, rather than being airborne as paintings often show him.[1] He wears the costume of the Trinity, but his crown is replaced by an aureole of sun rays. Stage directions for Jean Michel's *Passion* instruct that the face of Jesus should be smudged with yellowish gold paint.[2] He holds the banner of the Resurrection in one hand and lifts the other to show the wound in his palm. Seven female figures encircle him—not the seven Virtues, but new abstractions. On the left: Beauty (Pulchritudo), half kneeling; VOLUPTAS (Pleasure), with a harp; Fortitude (Fortitudo), holding a staff, and an unnamed companion. To the right: Reasonableness (Sanitas); Long Duration (Diuturnitas), holding a ring; and winged VELOCITAS (Swiftness).[3] From the sky, the two other persons of the Trinity look down, gesturing as they talk.

To the left of the central group surrounding Christ, the four soldiers who were left to guard the tomb rush away in terror. Older iconography showed them sleeping. Here they respond to the stage effects of thunder, lightning, and earthquake, which had become a feature of the mysteries, altering the iconography. Stage directions for *Mystère d'Arras* gave the instructions "cy est comment les chevaliers tombèrent comme morts quand ils sentirent la terre trembler et qu'ils virent grand lumière et plusieurs autres merveilles." The long, curved sword carried by the soldier has the letters NASI REENI, for Nazarenus or Nazarene. To the right of the soldiers, the three Marys return in wonder from the tomb.

The Harrowing of Hell takes place near the upper left corner of the tapestry. Jesus, now crowned, is accompanied by CARITAS (Charity) and two others, presumably Faith and Hope. Hell's metal doors have been wrenched from their hinges, revealing the cave in the side of the mountain. From Hell's mouth, Jesus rescues HOMO, Natura, Abraham, and others. He uses the staff of his banner to push away the monsters and dragons emerging from below. One of the Vices slides beneath the door. Nearby on a promontory the Tempter puts a long serpentine horn to his lips, blaring his defiance.

To the right, Christ, as a pilgrim on his way to Paradise, stops by the Fountain of Life to receive the homage of an angel. The two tips of the angel's wings can be seen emerging from a cloud. Two figures, who may represent Faith and Humility, accompany Christ. Abraham and a host of others follow, including Dismas, the Good Thief, who carries his Tau cross and hurries to join the procession.

Just to the right of the two other persons of the Trinity in heaven, the risen Christ appears to Mary Magdalen in a garden. Humility, Esteem (Dilectio), and Hope escort him. The Magdalen kneels before him, holding her jar. We are told that she mistook him for a gardener. Indeed, he is shown leaning on a shovel. Gréban's stage directions were "ici vient Jésus par derrière en form d'un jardinier."[4] At this moment Jesus says, "Touch me not: for I am not yet ascended to my Father . . ." (John 20:17). A *Noli me tangere* tapestry at The Art Institute of Chicago shows similar poses and gestures.[5]

Angel musicians play on the roof of the pavilion in which Jesus appears to his mother. A trio sings to the music of harp and viol. Within the *mansion*, Jesus shows his wounds. Faith, Hope, and Charity stand behind Mary. In the group behind Jesus we recognize VELOCITAS, Sanitas, DIUTURNITAS, Pulchritudo, and Fortitudo. A small annex at the right edge contains the scene of the Supper at Emmaus. HUMILITAS and another Virtue are present as Christ sits at the table with two disciples. The moment of recognition is shown when Jesus breaks the bread and the disciples realize he is the risen Christ.

In the left corner of the tapestry, Zecharias says, ECCE REX TUUS VENIT TIBI ZECHAR IX (Behold thy King cometh to thee. Zechariah 9:9). In the opposite corner, Hosea's prophecy reads, VIVICABIT NOS POST DUOS DIES OZEE (After two days He will revive us Hosea. Hosea 6:3).

NOTES

1. Emile Mâle, *L'art religieux de la fin du Moyen Age en France*, 3d ed. (Paris: A. Colin, 1925), 66.
2. Mâle, *L'art religieux*, 68.
3. Identifications, unless in small capitals, have been made from the Chicago version, which is labeled more fully and clearly.
4. Mâle, *L'art religieux*, 77–78.
5. Christa Mayer [Thurman], *Masterpieces of Western Textiles* (Chicago: The Art Institute of Chicago, 1969), 29, illus. pl. 13.

BIBLIOGRAPHY

Wood, D. T. B. "Tapestries of the Seven Deadly Sins—I." *The Burlington Magazine* 20, no. 106 (January 1912): 210, 216, 221, illus. 220, pl. 3.

Ackerman, Phyllis. "Tapestries: Gift of William Randolph Hearst." Typescript, files, The Fine Arts Museums of San Francisco, 1954.

Comstock, Helen. "Tapestries from the Hearst Collection in American Museums." *The Connoisseur Year Book, 1956.* London, 1956, 41.

Cavallo, Adolph S. *Tapestries of Europe and of Colonial Peru in the Museum of Fine Arts, Boston*. 2 vols. Boston: Museum of Fine Arts, 1967, 1:95.

Mayer [Thurman], Christa. *Masterpieces of Western Textiles.* Chicago: The Art Institute of Chicago, 1969, 25, illus. pl. 10.

PROVENANCE

Cathedral of Toledo, 1890
Ascher Wertheimer, 1902
French & Co., 1914
William Randolph Hearst Collection

RELATED TAPESTRIES

The version at The Art Institute of Chicago (fig. 44) is six feet narrower. The omission of vertical strips of the cartoon during the weaving has resulted in peculiarities in the design. The gates of Hell are gone. Christ brandishes his staff in a meaningless gesture. The group beside the Fountain of Life has also disappeared. The weaver, however, faithfully retained the angelic wing tips emerging from a cloud, although the angel has vanished. He has attached the remainder of the angel's robe to the gown of the standing Virtue. An off-center position for Christ and a totally new figure replacing Pulchritudo are other notable changes.

A complete weaving of the design at Burgos, although now in poor condition, shows still other changes from the versions now in America. Inscribed scrolls decorate the floral borders. An extra figure is present before the *mansion* at the right. She fits without crowding into the setting above a splendid pyramid of angulated drapery, raising her hands in wonder.

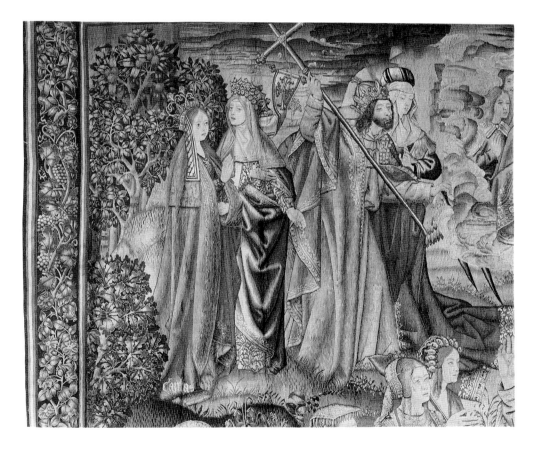

FIGURE 44
The Resurrection (detail), tapestry. Courtesy of
The Art Institute of Chicago, 1946.47

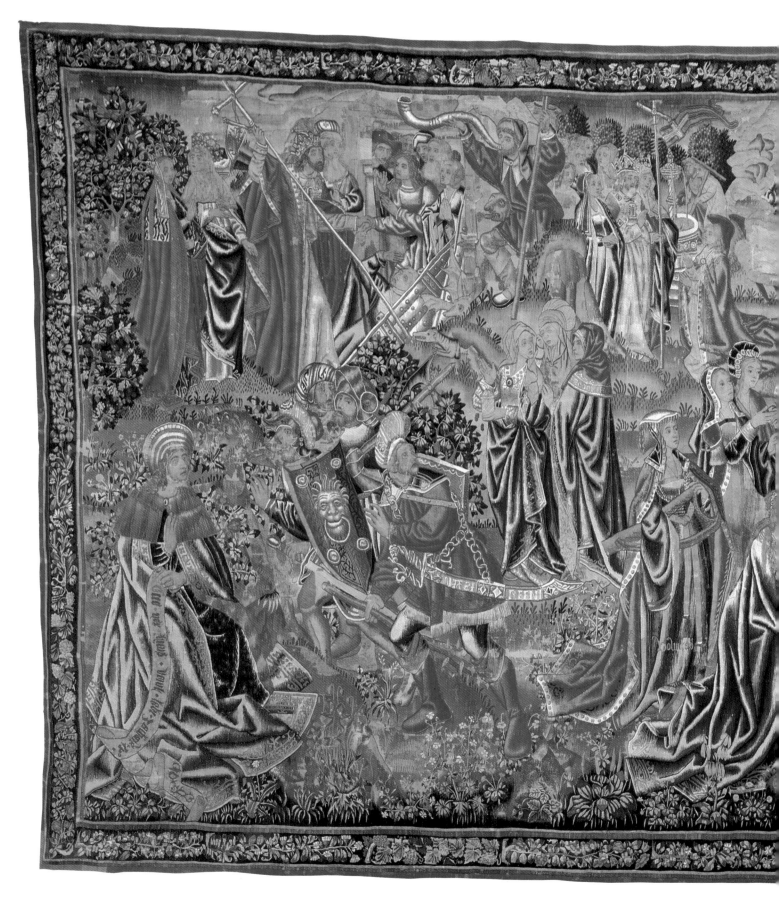

The Resurrection

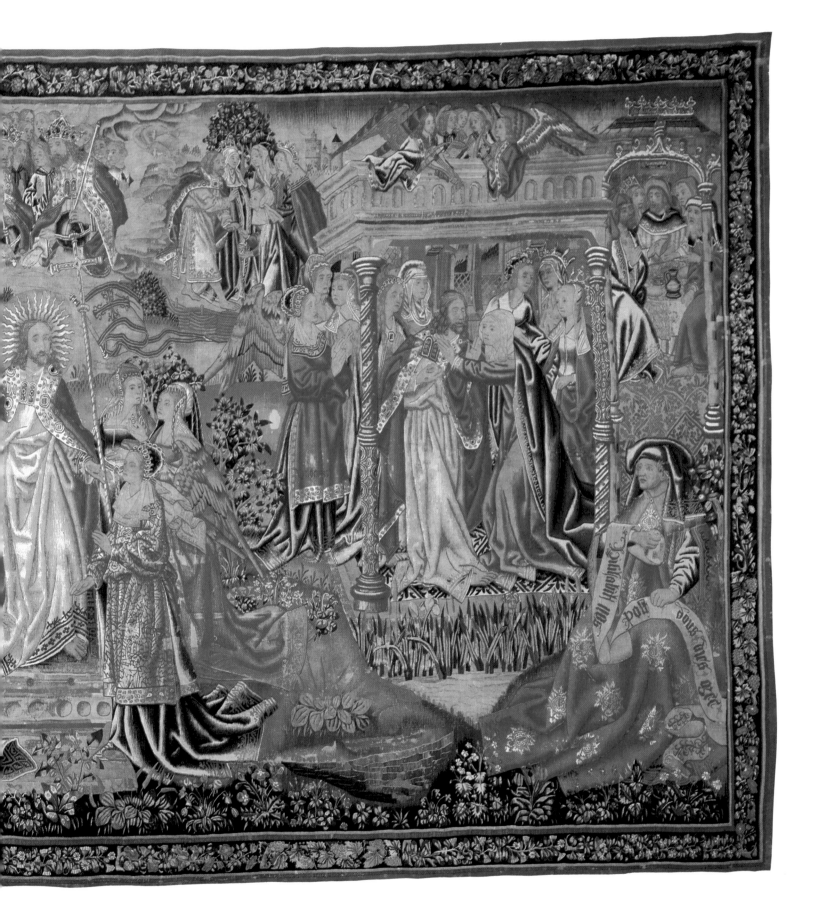

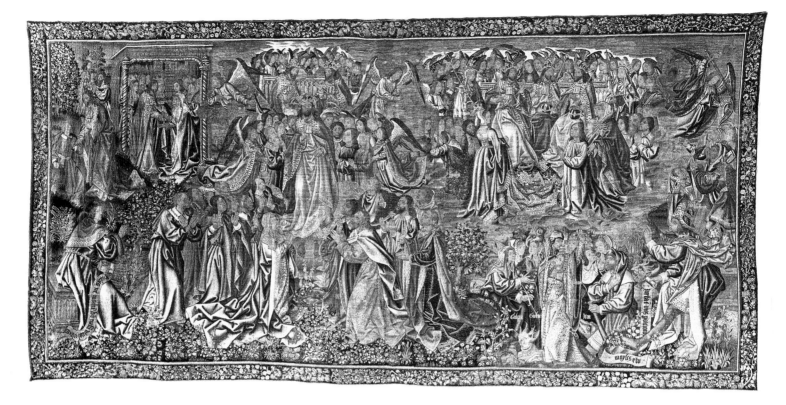

FIGURE 45
The Ascension, The Redemption of Man Series, panel 9, tapestry.
Kasteel de Haar, Haarzuylens, Netherlands

EPILOGUE

The Ascension and *The Last Judgment*

 The Ascension, Panel 9 of the series (fig. 45), is the only panel of the *Redemption* series not represented in the United States. An example may be seen at the Kasteel de Haar, in the Netherlands, and another at Palencia, Spain. In the main scene, Jesus ascends vertically with a crowd of angels, leaving behind the Virgin and the Apostles. His point of departure is marked by two large footprints. He rises to complete the Trinity, while at the other side HOMO is reconciled with God.

 The Last Judgment, Panel 10 of the series (fig. 46), at Worcester, Massachusetts, and in Paris at the Louvre, is dominated by the monumental figure of Christ the Judge, sitting on a V-shaped bench with the Virgin Mary, Saint John, and the Apostles. To the sound of trumpets, the story of mankind comes to an end. The blessed are consigned to heaven and the damned to hell. A host of angels with elongated crosiers thrusts the Vices down at last.

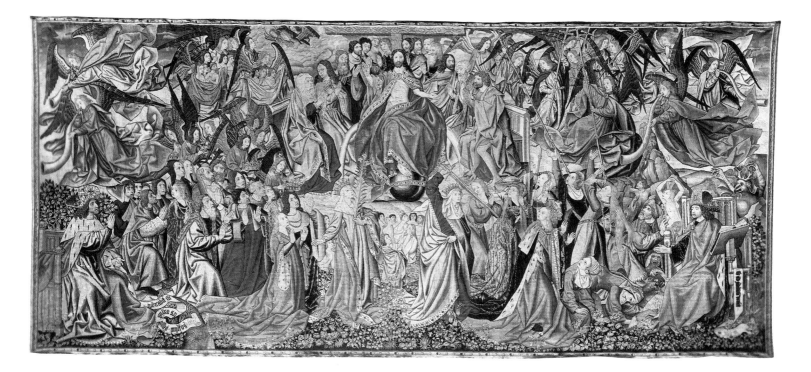

FIGURE 46
The Last Judgment, The Redemption of Man Series, panel 10, tapestry.
Worcester Art Museum, Massachusetts. Museum purchase, 1935.2

16. Saint Paul and Saint Peter Appearing to Nero

Franco-Flemish, 1500–1525
H: 1.83 m W: 1.98 m (6 ft. × 6 ft. 6 in.)
WARP: undyed wool, 5–6 per cm
WEFT: dyed wool
Bequest of Hélène Irwin Fagan (CPLH), 1975.5.23

Jacobus de Voragine's *Golden Legend* recounts the last days of the apostle Paul. Condemned to death, Paul warned Nero that he would appear to the emperor alive after his execution to show the power of Jesus Christ. As he was led to his martyrdom, Paul met the Christian woman, Plautilla, at the Ostia gate, and borrowed her veil to cover his eyes. Miraculous signs marked his execution which, when reported to Nero, caused the tyrant to lock his doors in fear. In spite of these precautions, Paul suddenly stood before him. "Caesar, behold me, the soldier of the eternal and invincible King! And thou, wretched man, shalt die the everlasting death, for having unjustly put to death the servants of this King!" Nero was beside himself with terror.[1]

An architectural frame encloses the small room in which Nero, wearing his imperial crown and sitting on a canopied bed, is confronted by the apparition. Paul and Peter stand before him and raise their hands in greeting; they are monumentally calm and larger than life. Paul carries the two-edged sword that was the instrument of his martyrdom, and Peter carries his key. Two attendants kneel at Nero's bedside. A banderole above Saint Peter's head is inscribed,

C[A]ESAR NOS REGIS [A]ETERNI INVICTI MILITES
SUM'[US] NU[N]C CREDE VEL'[UT] TIBI [A]ETERNU[S]
RESTAT I ITE[M] UT N[O]S

Caesar, we are soldiers of the eternal, invincible king. Now accept it as a fact that just as he withstands you forever, so in like manner do we.

Saint Paul's foot, boldly foreshortened, extends into the border as does that of the attendant. A horizontal band carries symbols resembling card suits, the meaning of which, if any, is not known.

In 1970, Asselberghs pointed out the similarity of The Fine Arts Museums' panel to a fragment of great interest in the Museum of Fine Arts, Boston.[2] The Boston panel has been cut on all four sides. The subject is *Saint Paul Requesting Plautilla's Veil* (fig. 47), taken from the same section of *The Golden Legend*. Figure styles, facial types, script, and weaving apparently are very close. The two panels probably belonged to the same series illustrating the life of Saint Paul or Saints Peter and Paul. They are stylistically unlike

tapestries known to have been produced in the prominent weaving centers.

An earlier tapestry illustrating the same episode is known from an engraving, reproduced as catalogue no. 1, figure 24. The later version, although radically simplified, preserves the traditional iconography.

NOTES

1. Jacques de Voragine, *Le légende dorée*, trans. J.-B. M. Roze (Paris: Garnier-Flammarion, 1967), 430–432.
2. Adolph S. Cavallo, *Tapestries of Europe and of Colonial Peru in the Museum of Fine Arts, Boston*, 2 vols. (Boston: Museum of Fine Arts, 1967), 1:62–63.

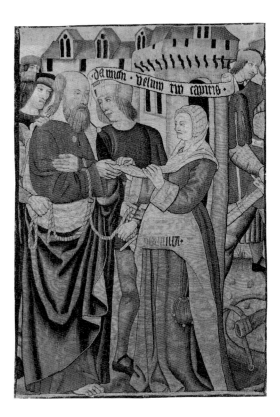

FIGURE 47
Saint Paul Requesting Plautilla's Veil, tapestry. Museum of Fine Arts, Boston. Gift of William de Krafft, 1949, 49.79

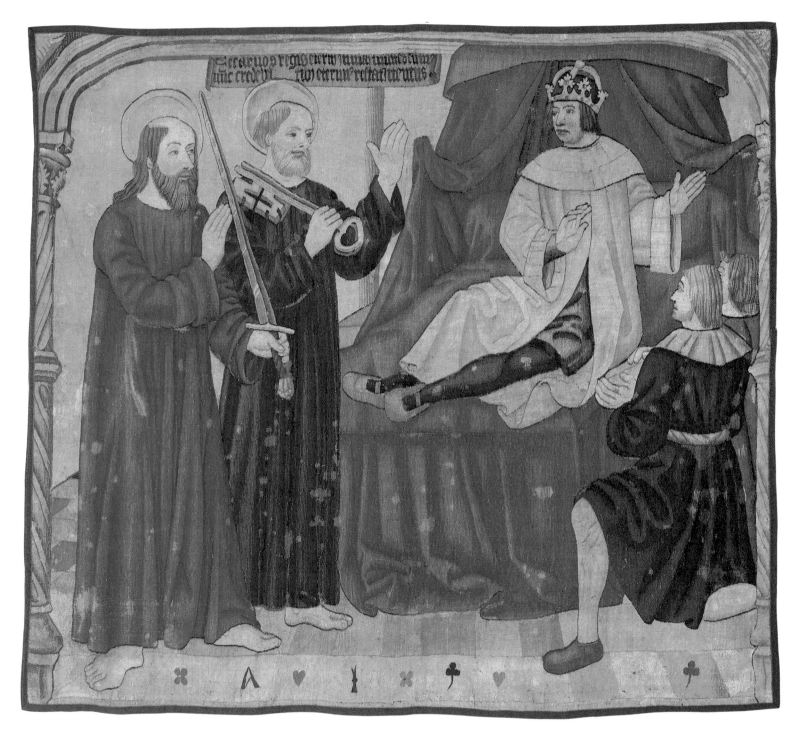

Saint Paul and Saint Peter Appearing to Nero

17. Scenes from the Life of Christ

from The Life of Christ and the Virgin *Series*

Flemish (Brussels), ca. 1510
H: 1.78 m W: 6.10 m (5 ft. 10 in. × 20 ft.)
WARP: undyed wool, 6 per cm
WEFT: dyed wool and silk
Roscoe and Margaret Oakes Collection, museum purchase by
 exchange, gift of various donors, 1976.3

As early as the twelfth century a type of long, narrow tap-
estry had evolved for decorating the choirs of churches.[1]
These specialized hangings filled the space above the stalls
with scenes from Christ's life or the life of the Virgin or
the patron saint. A great number of choir tapestries were
woven in the late Middle Ages and presented by prelates
to their churches where many still hang today. The long,
narrow format was favorable to the presentation of a
sequence of episodes, separated by architectural frames
or dividing columns. One of the most extensive series
of this type was woven in Brussels in 1511 for the Cathe-
dral of Canterbury. Today twenty-six of the panels are
preserved at the ancient Cathedral of Saint-Sauveur at
Aix-en-Provence.[2]

The three *Scenes from the Life of Christ* acquired by The
Fine Arts Museums of San Francisco in 1976 were woven
from the same cartoons as the Canterbury tapestries and
at about the same time.[3] They may once have been part
of an extensive set. As they are today, the three scenes
present a cohesive unity of events associated with the
Easter story.

The Entry into Jerusalem

Jesus, riding on an ass, advances from the left. He raises
his right hand to bless those who greet him at the gates of
Jerusalem. Following Jesus on foot are Peter, young John
holding his hat, and another disciple. The splendid animal
that carries Jesus partially emerges from the confines of
the frame, its forefoot and the cloak on which it steps
extending beyond the narrow floral border.

The entry of Jesus is at once humble and messianic. All
four evangelists record the event (Matthew 21:1–11; Mark
11:1–10; Luke 19:29–40; John 12:12–19). In all details it
fulfilled the prophecy of Zechariah (Zechariah 9:9).

The Church of Saint Andrew at Presteigne, in Radnor-
shire, Wales, possesses another *Entry into Jerusalem*, of
greater height, more complete, and probably older than
the Aix or San Francisco weavings. A jeweled central arch
cuts off corners occupied by David (left) and possibly Elias
(right).[4]

The scene is closely related to a type of fifteenth-
century sculpture of Jesus riding on an ass (the *palmezel*).
These pieces were mounted on small wheels and brought
into the church on Palm Sunday.[5]

The Last Supper

The subject of the central scene of the tapestry triptych is
the last meal that Jesus shared with his disciples. The cor-
responding scene is missing from the set at Aix, although
certainly one once existed. Representations of this event
follow two traditions.[7] The first focuses on its ritual aspect
as the institution of the Eucharist. Matthew, Mark, and
Luke give nearly identical descriptions of this moment
(Matthew 26:26–28; Mark 14:22–24; Luke 22:19–20).
Only John is silent about the incident, but his account
provides the source for the second artistic tradition: the
announcement of betrayal, represented in the present
panel (John 13:24–26).

Jesus has told his disciples that one of them would be-
tray him. Deeply troubled, they look at one another, won-
dering which of them it would be. Jesus has been asked,
"Lord, who is it?" Jesus answers, "He it is, to whom I shall
give a sop [a morsel], when I have dipped it." Jesus gives
the sop to Judas Iscariot. This moment is depicted in the
central scene.

Three of the disciples are recognizable. Peter, at Jesus'
right, is traditionally bald and square-bearded. Judas, con-
forming to a widely accepted tradition, has red hair, and
he clutches in his right hand the purse containing the
thirty pieces of silver. Although in the Bible account John
asks the question, he is shown asleep, leaning against
Jesus. This view resulted from a misunderstanding of
early representations of the event in which the diners
reclined in the old Roman manner.[8]

Delmarcel has pointed out a significant relationship
between *The Last Supper* at San Francisco and an *Ultima
Cena* (dated 1516) at Camaiore. The profile of Judas is
strikingly similar, although the figure is reversed. Further
correspondence exists in the tasseled damask cloths, the
articles on the table, and in the cloth of honor design

which resembles a fifteenth-century Italian velvet or damask. This fabric design appears as a repeating motive in The Fine Arts Museums' panel, where it frames the heads of the disciples with secular haloes.[9]

The Washing of the Feet

In the East the feet of diners were washed by a servant before the meal. Jesus assumed this servant's role as an example of humility.[10] In art, the scene is closely associated with the Last Supper, as the tapestries at Camaiore and San Francisco show. In sixteenth-century representations, Peter raises both hands in protest as Jesus, girt with a towel, kneels before him.

The corresponding panel at Aix is square. The San Francisco panel has been extended by the addition of two men at the right, perhaps to meet specific space requirements. The projection of certain elements from the picture plane, such as the basin and the drapery, does not occur in the Aix example.

A comparison of the corresponding scenes at Aix and at San Francisco indicate that the latter scenes have lost 15 cm in height. The borders have also undergone several restorations. During its Boccara ownership, the narrow border present on the lower edge in 1928 was reconstructed and extended to frame the scenes on all sides.

The arms of an archbishop, denoted by his hat and four tiers of tassels, decorate the tops of the two central columns. These arms were added to the original tapestry and belong to the Bouthillier-Chavigny family which produced several archbishops in the seventeenth and eighteenth centuries.[11] Jarry proposed the name of Victor Bouthillier de Chavigny as owner of the tapestry. He was born in 1590, became a canon in Paris, then bishop of Boulogne, and finally archbishop of Tours (1641), where he died in 1670.[12]

Nello Forti Grazzini has located two tapestries in Reims, at the Palace of Tau, that bear the same Bouthillier de Chavigny arms.[13] They depict *Christ before Caiaphas (or Pilate?)*[14] and *The Flagellation of Christ*. Many shared features suggest that the Reims panels must have been cut from the same long choir sequence as those in San Francisco.

In the large body of commentary written about the Aix series, speculation concerning the designer has centered on the name of Quentin Metsys. He was first proposed by Fauris de Saint-Vincent (1812), an attribution supported by Michiels (1877), Baldass (1933), and Heinz (1963). Destrée more cautiously placed the designer in the general vicinity and under the influence of Metsys (1906), an opinion that Souchal seemed to share (1974). The Aix series was designated a "historic monument" in 1898.

NOTES

1. Madeleine Jarry, *World Tapestry from Its Origins to the Present* (*La tapisserie*, Paris: Librairie Hachette, 1968; English ed. New York: G. P. Putnam's Sons, 1969), 27, illus. 22-23; I. Vandevivere and Jean-Paul Asselberghs, *Tapisseries et laitons de choeur XVe et XVI siècles* (Liège: Imprimerie Soledi, 1971).
2. Marie-Henriette Krotoff, *Les tapisseries de la vie du Christ et de la Vierge d'Aix-en-Provence*, exh. cat. (Aix-en-Provence: Musée des Tapisseries, 1977), 47.
3. Krotoff, *Les tapisseries*, 74.
4. Krotoff, *Les tapisseries*, 74.
5. Louis Réau, *Iconographie de l'art chrétien* (Paris: Presses Universitaires de France, 1955–1959), vol. 2, pt. 2, 399; G. Schiller, *Ikonographie der christlichen Kunst* (Gütersloh, 1968), vol. 2, 29, pl. 48.
6. Guy Delmarcel, letter to A. G. B., 11 March 1976.
7. Réau, *Iconographie*, vol. 2, pt. 2, 410–413.
8. John 13:23, 25; Réau, *Iconographie*, 412.
9. Mercedes Viale and Vittorio Viale, *Arazzi e tappeti antichi*, (Turin: ILTE, 1952), pl. 22.
10. John 13:1–17; Réau, *Iconographie*, 406–409.
11. M. Prévost and Roman d'Amat, *Dictionnaire de biographie française*, 16 vols. (Paris: Letouzey et Ané, 1933–1985).
12. Madeleine Jarry, "Les tapisseries faites sur les mêmes cartons," in *Les tapisseries de la vie du Christ et de la Vierge d'Aix-en-Provence*, exh. cat. (Aix-en-Provence: Musée des Tapisseries, 1977), 69–73, illus. 70, 71.
13. Personal communication, May 1990.
14. See note 2. The corresponding scenes are illustrated on pages 35–36 of the Aix exhibition catalogue, and the problem of distinguishing between Caiaphas and Pilate is discussed on page 21.

BIBLIOGRAPHY

Destrée, Joseph. *Tapisseries et sculptures bruxelloises à l'exposition d'art ancien bruxellois*. Exh. cat. Brussels: Librairie Nationale d'Art et d'Histoire, 1906, pl. 15.

Viale, Mercedes and Vittorio Viale. *Arazzi e tappeti antichi*. Turin: ILTE, 1952, 42–43, pl. 22.

Les trésors des églises de France. Exh. cat. Paris: Musée des Arts Décoratifs, 1965, 33–34. Complete bibliography for the Arts suite.

L'oeil 131 (November 1965): 21; and *L'oeil* 201–202 (September–October 1971), illus. 48.

Boccara, Dario. *Les belles heures de la tapisserie*. Zoug: Les Clefs du Temps, 1971, 48–49.

Souchal, Geneviève. *Masterpieces of Tapestry from the Fourteenth to the Sixteenth Century*. Exh. cat. Paris: Editions des Musées Nationaux, 1973, and New York: The Metropolitan Museum of Art, 1974, 187–191, nos. 83–84.

PROVENANCE

Edouard Allez, 1904
Dario Boccara (sale 30 March 1963, Palais Galliera, no. 127)

EXHIBITION

Gobelins Manufactory, 1928

Scenes from the Life of Christ

18. The Sibyl Agrippa *(a fragment)*

French, ca. 1510*
Promised future gift (Bequest Marguerite Brokaw Adams)

A woman of extreme elegance is posed decoratively against a millefleurs background. Her gown falls in straight pleats of green velvet with golden highlights. Precious stones ornament the deep neckline; a large jewel on a chain is centered on her forehead. Her blond hair is looped in fine braids over an open headdress with an attached rose-colored veil that lifts and twists with a grace reminiscent of Botticelli. Despite her finery, the Sibyl projects an air of melancholy. She holds a bunch of birch branches in her right hand, a long whip with three attached cords in her left, as she gazes sadly toward a banner inscribed SIBILLA . . . DE FLAG. . . . She is the Sibyl Agrippa who foretold the flagellation of Christ.[1] The banderole in its original state would probably have read SIBILLA AGRIPPA VATICINATUR DE FLAGELLATIONE CHRISTI (Sibyl Agrippa foreteller of Christ's flagellation).[2]

According to Mâle, the Sibyls were "la voix du vieux monde," a profound symbol for the Middle Ages that believed Prophets and events in the pre-Christian world prefigured episodes of Christ's story. Whereas the Prophets promised a savior to the Jews, the Sibyls brought the same hope to the pagans.[3] From an original solitary Sibyl, the number grew in representations to twelve. Agrippa and Europa were added in the fifteenth century in the Dominican Filippo Barbieri's *Discordantiae*.[4] Although Barbieri described the Sibyls fully, he made no mention of Agrippa's whip or birch rods. These seem to have been derived from Jean Fouquet's *Book of Hours of Louis de Laval* (1489),[5] which specified Agrippa's age as thirty, as confirmed by French quatrains in the church of Cunaud (Maine et Loire):

> La Sibile Agripa en l'aage
> De trante ans nous a révélé
> Que Ihesus seroit par oultrage
> A une atache flagellé[6]

Other members of this mysterious prophetic group are scattered in this country and abroad. Asselberghs noted the presence of Agrippa and Europa in two early sixteenth-century Tournaisian fragments at the Philadelphia Museum of Art where they appear on a ground of large-scale flowers and leaves.[7] Göbel illustrated a garden tapestry with Sibyls on either side of a fountain that probably symbolizes the Virgin.[8] Boccara showed a similar tapestry, also probably Tournaisian in origin, and cited others in the

Burrell Collection, Glasgow.[9] The Tiburtine Sibyl appears in a panel in the Fogg Art Museum in which she shows a vision of the Madonna and Child to the Emperor Augustus. It is illustrated in *The Redemption of Man* discussion (fig. 41).

As early as 1930, Destrée noted the losses sustained by the tapestry, specifically its rewoven areas at neck, right sleeve, and hem. The present appearance of the tapestry is known only through photographs, but these suggest that further deterioration may have occurred from fading and possibly from restoration. Destrée thought the weaving in its original condition might have shown Agrippa with the Prophet Micah. In spite of losses, *The Sibyl Agrippa* is an elegant example of French tapestry design influenced by the Italian Renaissance.

The generous assistance of Adolph S. Cavallo and of William Wells is acknowledged in identifying the figure as a Sibyl and in providing Destrée's article that described the present piece before its sixty-year seclusion in a private collection. Edith Standen pointed out the location of additional Sibyls.

NOTES

1. Louis Réau, *Iconographie de l'art chrétien* (Paris: Presses Universitaires de France, 1955–1959), vol. 2, pt. 1, 427. See also F. C. Husenbeth, *Emblems of the Saints* (Norwich, 1882), appendix 1 by W. Marsh, "Iconography of the Sibyls," 409, 422–423.
2. Joseph Destrée, "La Sibylle Agrippa: Fragment de tapisserie française, XVe–XVIe siècle," *Annales de la Société royale d'archéologie de Bruxelles* 35 (1930), 131–136.
3. Emile Mâle, *L'art religieux du XIIIe siècle en France: Etude sur l'iconographie du Moyen Age et sur ses sources d'inspiration*, 5th ed. (Paris: A. Colin, 1923), 339.
4. Filippo Barbieri, *Discordantiae: nonullae inter sanctum Hieronymum et sanctum Augustinum* (1481).
5. Bibliothèque Nationale, ms. fr. 920.
6. Xavier Barbier de Montault, "Les Sibylles," chap. 5 in *Traité d'iconographie chrétienne* (Paris: Société de Libraire Ecclésiastique et Religieuse, 1900), 87.
7. Jean-Paul Asselberghs, *Les tapisseries flamandes aux Etats-Unis d'Amérique* (Brussels: Artes Belgicae, 1974), 50.
8. Heinrich Göbel, *Wandteppiche. I Teil: Die Niederlande*, 2 vols. (Leipzig: von Klinkhardt & Biermann, 1923), 1:575–576; 2: pl. 96; Heinrich Göbel, *Wandteppiche. II Teil: Die romanischen Länder*, 2 vols. (Leipzig: von Klinkhardt & Biermann, 1928), 1:288, 2: pl. 321.
9. Dario Boccara, *Les belles heures de la tapisserie* (Zoug: Les Clefs du Temps, 1971), nos. 44–45.

*Tapestry unavailable for examination at time of publication.

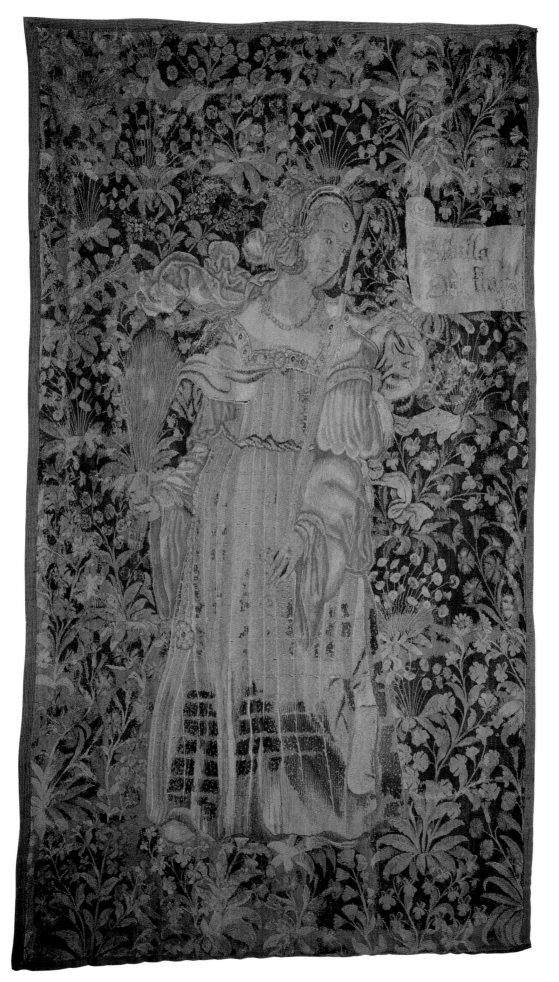

The Sibyl Agrippa

19. Millefleurs Armorial

Flemish (Bruges), 1500–1525
H: 2.69 m W: 2.13 m (8 ft. 10 in. × 7 ft.)
WARP: undyed wool, 4–5 per cm
WEFT: dyed wool
Gift of Mr. and Mrs. Arthur Sachs (CPLH), 1951.32

The decorative impact of this small tapestry is such that its armorial function is all but overlooked. In the center, a stiff wreath encloses arms set on a field of tightly packed, schematic flowers. Birds and beasts, represented with a fine disregard for scale, are evenly spaced around the medallion. The spotted leopards and deer cavort with the dignity of heraldic animals. Birds inhabit the upper section of the field, except for a terrestrial covey of quail. A family of rabbits plays near its burrow.

The arms themselves, long considered fanciful, may in fact be identifiable.[1] They are similar to those of the Frenchman Gabriel Miro (1462–1514), doctor in ordinary to King Louis XII, whose coat-of-arms appears on the *Millefleurs Armorial* in the Burrell Collection, Glasgow.[2]

A stylized tree serves as a central axis. From its branches hang two suits of armor and a large shield or, perhaps, a mirror of irregular shape. The barren landscape is relieved by spiky plants and twin rocks jutting abruptly from the water. If the central feature is indeed a mirror, it may refer to Miro's name, visual puns being common in heraldry.

The flowered field is surmounted by a distant view of a medieval walled town. Vertical combings (*hachures*) blend the band of blue sky into the paler sky area. This is pierced by the conical roofs of towers, marked by arrow-slits, and stiff, stylized trees. Within the protective walls of the town, the church can be distinguished at left, and nearby, a building with a stepped gable, possibly the guild hall. A transitional band of semicircular hills and boldly designed vegetation links the town view with the mass of flowers.

A close examination of the profusion of flowers resolves them into vertical bands, arranged in an established order. These bands recur across the panel like wallpaper patterns. Four are complete "repeats." The economy of such an arrangement is obvious. A small number of cartoon strips, rotated in sequence on the low-warp loom, could produce an effect of rich variety, as it does in this tapestry.

A number of similar pieces have survived, including one at the château at Angers, from the Church of Nôtre-Dame des Ardilliers at Saumur, one in a private collection in Paris,[3] and the Koller piece published by Duverger and Delmarcel.[4] Most of these have been assigned to Bruges and dated between 1500 and 1520. Forti Grazzini links the San Francisco piece with four *Millefleurs with Saint John the Baptist* in Monza[5] and notes others with similar ground: a *Millefleurs with a Leopard* (Rijksmuseum, Amsterdam), a *Millefleurs with Animals* (Perpitch Collection, Paris), and a fragmentary cushion cover at the Victoria and Albert Museum, London.[6]

NOTES

1. Nello Forti Grazzini (personal communication), May 1990.
2. *Treasures from the Burrell Collection*, exh. cat. (London: Hayward Gallery, 1975), 24, no. 90.
3. See Dario Boccara, *Les belles heures de la tapisserie* (Zoug: Les Clefs du Temps, 1971), 37.
4. Erik Duverger and Guy Delmarcel, *Bruges et la tapisserie* (Bruges: Mouscron, 1987), 38–39, fig. 18, and nos. 5–6, 197.
5. Nello Forti Grazzini, *Gli arazzi. Monza. Il Duomo e i suoi tesori* (Milan, 1988), 107–139, especially 113–114.
6. Edith Standen has also signaled three related pieces at the Cincinnati Art Museum: nos. 1972.358, 1973.5, and a loan, 7.1946, with a landscape at the top (letter to A. G. B., 1 March 1990).

BIBLIOGRAPHY

Göbel, Heinrich. *Wandteppiche. I Teil: Die Neiderlande.* 2 vols. Leipzig: von Klinkhardt & Biermann, 1923, 1: 286–287; 2: fig. 254.

Hullebroeck, Adolphe. *Histoire de la tapisserie à Audenarde du XVe au XVIIIe siècle.* Renaix: Presses du maître-imprimeur J. Leherte-Delcour, 1938, 143.

Planchenault, René. *Les tapisseries d'Angers.* Paris: Caisse Nationale des Monuments Historiques, 1955.

Heinz, Dora. *Europäische Wandteppiche I.* Braunschweig: von Klinkhardt & Biermann, 1963, 250.

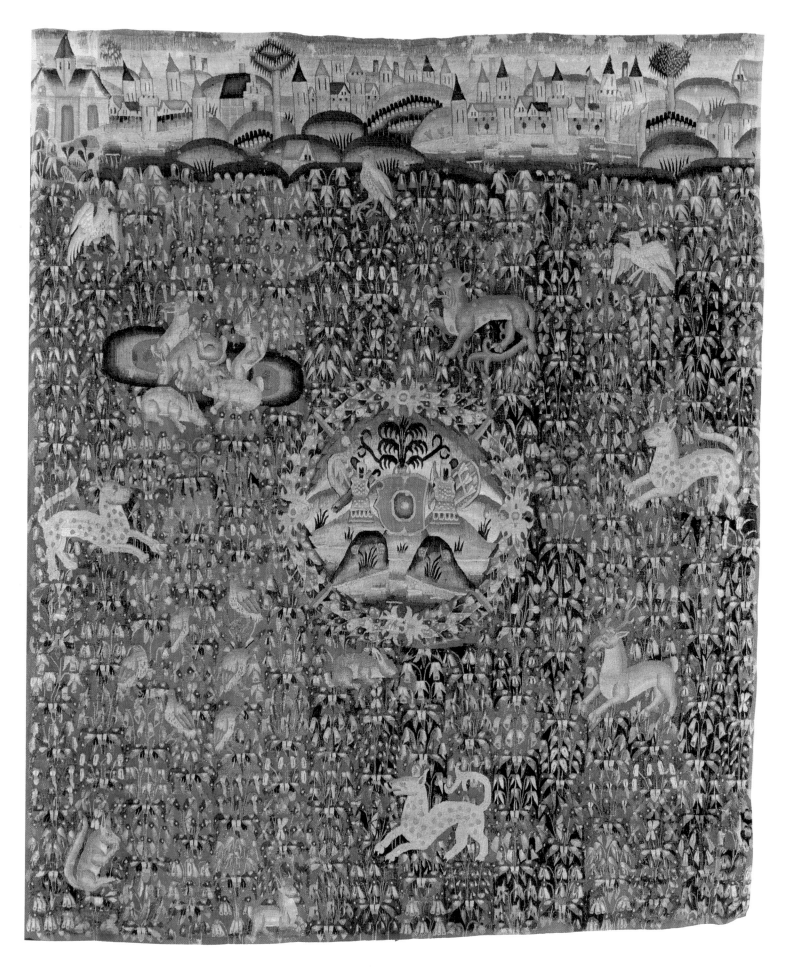

Millefleurs Armorial

SIXTEENTH-CENTURY TAPESTRIES

1519 and After

Raphael's famous *Acts of the Apostles,* delivered by Pieter van Aelst to the Vatican in 1519, established the prestige of Brussels's workshops and a new pictorial style in tapestries. They accelerated certain changes already under way, such as deepening perspective and a central focus of interest that made the late Gothic style instantly outmoded. Tapestries became like windows: one looked through their wider borders at heroic events and splendid spectacles. The most successful designer in the new manner was Bernard (Barent) van Orley, whose exuberant style blended the Italian and Flemish traditions. The same facility earned his successor, Michel Coxcie, the title of "the Flemish Raphael."

Material conditions as well as talented designers contributed to the supremacy of Brussels. The rulers of the Low Countries preferred to make their residence there, attracting the courtiers and distinguished visitors necessary to support a luxury industry. The weavers of Brussels were inundated with orders. The higher prices that their work commanded invited abuses; to protect the local industry,

it was decreed in 1528 that every tapestry of a certain size or value must carry the official mark of Brussels, a red escutcheon between two *B*s. These regulations were extended by an imperial edict in 1541 that required the weaver's mark as well. Weavers of Antwerp and other centers were prosecuted for fraudulent use of the Brabant-Brussels mark.

The Renaissance brought an increasingly secular viewpoint, new themes and learning, and an eclectic spirit that freely combined sacred and profane material. The tapestries designed for the public and private lives of Renaissance patrons fairly reflected their new interests and attitudes, their fresh view of the world and their place in it.

Chronology and subject matter have determined the grouping of the sixteenth-century panels in this catalogue division. Their principal types are Triumphs, Heroes, and Verdures—those amazing botanical extravaganzas which, in the words of the English poet Andrew Marvell (1621–1678), have the effect of "Annihilating all that's made / To a green thought in a green shade" ("The Garden").

20. The Triumph of Death over Chastity *(a fragment)*

Flemish, 1510–1525

H: 3.23 m W: 2.03 m (10 ft. 7 in. × 6 ft. 8 in.)

WARP: undyed wool, 4–5 per cm

WEFT: dyed wool and silk

Gift of Mr. and Mrs. Robert Gill through the Patrons of Art and
 Music, 1975.4.2

The ceremonial aspect of medieval life expressed itself in processions of every kind—those transporting sacred relics, pilgrims bound for a shrine, the march to an execution, or the *joyeuse entrée* of a visiting prince.[1] The humanist Petrarch (1304–1374) fused these spectacles with the Roman triumph of antiquity to form a new and exciting image. His long allegorical poem, *I trionfi* (1352), furnished the inspiration and the machinery for the Triumphs that appear in the art of the next two centuries. All the processional Triumphs share certain essential features: the allegorical figure borne on a triumphal chariot, the symbolic beasts drawn from the Bestiaries, and the exemplars of biblical and classical origin.[2]

The Fine Arts Museums' *Triumph of Death over Chastity* shows a portion of such a procession. Buffaloes in harness occupy the center of the panel.[3] The pale buffalo looks ahead toward the woman who leads; the darker animal looks back at the vehicle being drawn, of which only the front edge is visible. The youth labeled INNOCENCE holds up a half-filled urinal. Overhead a thread dangles from a spindle in the hand of an unseen figure. The path of the procession leads through a flowery meadow where a pale, nunlike form sprawls beside a broken column. Reptiles twist in the grass and in the air. Crows, harbingers of calamity, fly ahead of this strange cortege. A complete weaving of the design at the Kunsthistorisches Museum, Vienna, reveals the full scheme and expands our understanding of the present fragment (fig. 48).

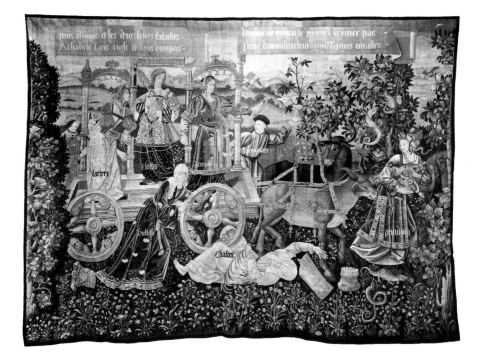

FIGURE 48
The Triumph of Death over Chastity, tapestry.
Kunsthistorisches Museum, Vienna

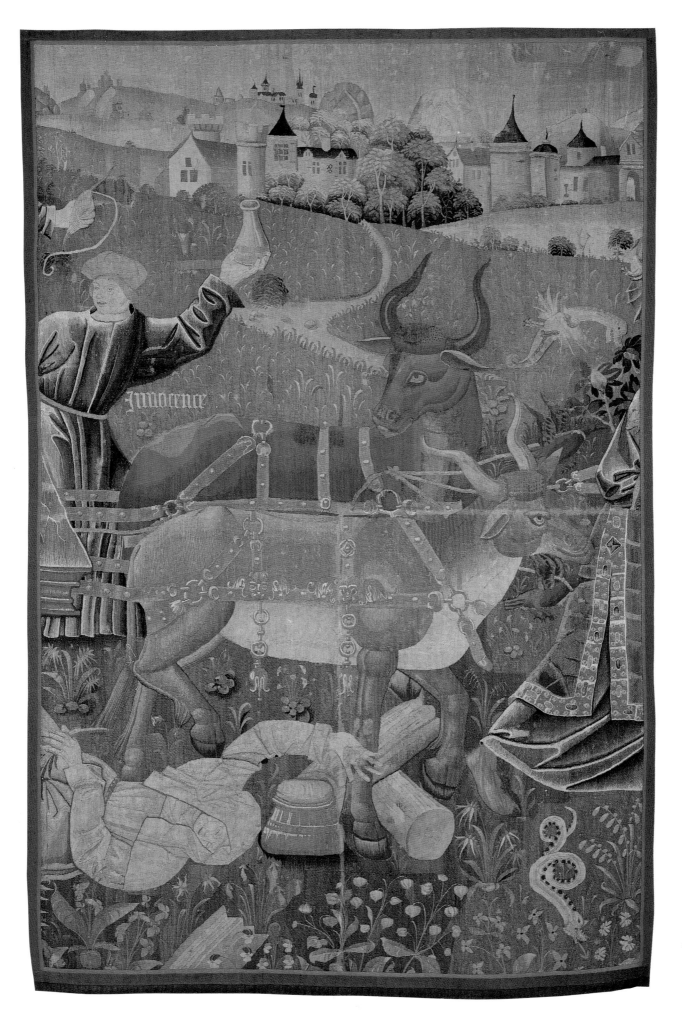

*The Triumph
of Death
over Chastity*

The lead figure of the procession is PANDORA, who strides ahead, scattering reptiles from her fateful box.[4] Part of her jeweled tunic is visible in the San Francisco fragment, as is the harness with which she draws the buffaloes. She is the forerunner of disease and death; the crows hitched to the yoke are her attributes. They cry, "Cras, cras," (Tomorrow, tomorrow). Their message became the promise of Hope after Andrea Alciati's *Emblemata* (1531), but the implication here must be "Tomorrow, Death."[5] The chariot that is cut off at the left edge is seen in the Vienna version to carry the three Fates: CLOTHO, who spins the thread of life; LACHESI[S], who draws it out; and ATROPOS, who breaks it off. The broken thread in the fragment hangs from the spindle of Atropos.

The chariot is about to pass over the body of CHASTETE (Chastity). The full version shows that it is VIE[I]LLESSE (Old Age) who pushes the wheel. Chastity is an idealization of Petrarch's Laura who died in the plague of 1348. The inscription in the Viennese tapestry reads,

PUIS ATROPOS ET SET DEUX SEURS FATAILLES
A CHASTETE SANS RIGELE ET SANS COMPAS
VIENNENT OUVRIR LE MORTEL DERNIER PAS
POUR DEMONSTRER LEURS PUISSANCE TOTALLES

Then Atropos and her two sister Fates
To Chastity without rule and without compass
Come to open the last mortal step
To demonstrate their total power.[6]

The identity of the youth dressed as a doctor is more obscure. Göbel offers a possible solution.[7] A morality play called *Christienté qui était malade* was published in Neuchâtel in 1533. The urine of suffering Christianity was presented to the physician, who symbolized the Savior, and who made his diagnosis and offered the remedy. The word INNOCENCE near the doctor may refer to the cure as well as to the physician. Innocence will strengthen and prepare humanity to meet Death when it comes.

The complete set of six panels at Vienna depicts the successive triumphs of Love, of Chastity over Love, Death over Chastity, Fame over Death, Time over Fame, and finally Eternity over Time.[8]

Several series of *Triumphs* were designed in the course of the sixteenth century and each of these was woven several times. The set at Vienna and the fragment in San Francisco belong to a rather simple version of the series. Elisabeth Scheicher made a thorough study of all early sixteenth-century versions showing triumphal processions and arranged them into three groups on the basis of iconographical and technical evidence.

One series was based on French models[9] that may be connected with the court of Louis XII. A Flemish version of this series is known through examples at the Victoria and Albert Museum and Hampton Court. It has French and Latin verses in the borders, written by Jean II Robertet.[10] Derivative series followed. A complete set of simpler designs and abbreviated French verses is preserved in Vienna. Some years after the Vienna weaving, the cartoons were woven again; the fragments now at The Metropolitan Museum of Art and probably other fragments in the Hyde Collection, Glen Falls, New York, belong to this set. They are coarser in detail and in execution. Scheicher places at still greater distance from the Vienna set the *Triumph of Fame over Death* at the Musées Royaux d'Art et d'Histoire, Brussels (fig. 49). Its execution is even coarser; inscriptions have been abandoned, and an entirely new landscape has been substituted for the background. The fragment at The Fine Arts Museums also lacks inscriptions, and the background scenery conforms in style to that of the Brussels panel, executed in the same dry manner with a similar handling of the flowers, thus the San Francisco *Triumph* appears to belong to the same late weaving as the Brussels piece.

NOTES

1. Johan Huizinga, *The Waning of the Middle Ages: A Study of the Forms of Life, Thought, and Art in France and the Netherlands in the Dawn of the Renaissance* (reprint, Garden City, N.Y.: Doubleday [Anchor Books], 1954), 11.
2. D. D. Carnicelli, ed., *Lord Morley's "Tryumphes of Fraunces Petrarck": The First English Translation of the "Trionfi"* (Cambridge: Harvard University Press, 1971), 38; Morris Bishop, *Petrarch and His World* (Bloomington: Indiana University Press, 1963), 196–199.
3. Elisabeth Scheicher, "Die *Trionfi*, eine Tapisserienfolge des kunsthistorischen Museums in Wien," *Jahrbuch der kunsthistorischen Sammlungen in Wien* 31 (1971): 27 n.61. Brown buffaloes are established iconography in the Triumph of Death in French and Italian art. Scheicher cites Liliane Guerry, *Le thème du "Triomphe de la Mort" dans la peinture italienne* (Paris: G. P. Maisonneuve, 1950), 190.
4. Erwin Panofsky and Dora Panofsky, *Pandora's Box: The Changing Aspects of a Mythical Symbol* (Princeton: Princeton University Press, 1956), 14, cited by Elisabeth Scheicher, "Die *Trionfi*," n. 66.
5. Panofsky and Panofsky, *Pandora's Box*, 27–33.
6. See cat. no. 8 (*Scenes from the Trojan War*).
7. Heinrich Göbel, *Wandteppiche. I Teil: Die Niederlande*, 2 vols. (Leipzig: von Klinkhart & Biermann, 1923), 1:104.
8. Pierre Verlet et al., *Great Tapestries: The Web of History from the Twelfth to the Twentieth Century*, ed. Joseph Jobé (Lausanne: Edita, 1965), 74–75.
9. Scheicher, "Die *Trionfi*," 46.
10. Guy Delmarcel, "Text and Image: Some Notes on the Tituli of Flemish 'Triumphs of Petrarch' Tapestries," *Textile History* 20, no. 2 (1989): 321–329.

PROVENANCE

Mr. and Mrs. Daniel C. Jackling Collection

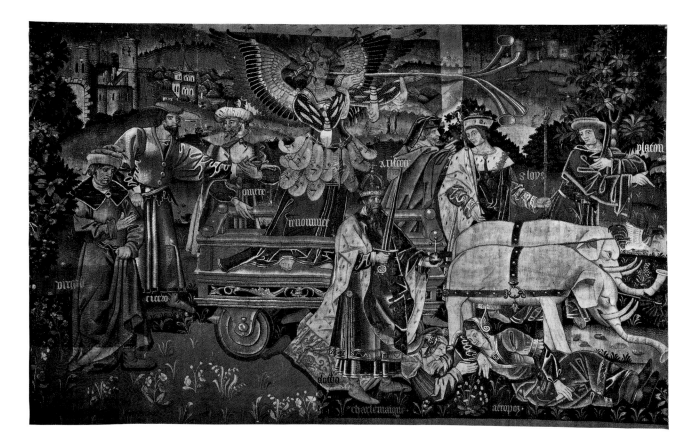

FIGURE 49
The Triumph of Fame over Death, tapestry.
Musées Royaux d'Art et d'Histoire, Brussels

21. Scenes of Court Life

Flemish (Brussels), ca. 1520
H: 3.43 m W: 3.35 m (11 ft. 3 in. × 11 ft.)
WARP: undyed wool, 6–7 per cm
WEFT: dyed wool and silk
Gift of the Provident Securities Co. (de Young), 69.27

The title given to this panel is an admission that its exact subject is not known. The labels commonly found on tapestries of this period would be helpful in this case. Labels were, in fact, essential since all subjects, whether myths, Bible stories, or allegories, were depicted in contemporary costumes and settings. Furthermore, the same figures were reused for unrelated subjects. Fourteen of the twenty-four figures in the present scene, for example, can be traced to other tapestries. This reuse of cartoons throws interesting light on the working methods of the master weavers.

A group of courtiers is framed in a narrow floral border. The seated queen in the center foreground is the panel's key figure. An attendant holds an open casket of jewels before her; a page offers her a covered vessel; two ladies-in-waiting bring up a cloth of honor behind her. Looking intently at the queen, a young man in princely costume draws a chain from the treasure box. Other clusters of figures flirt, examine jewels, sing, or exchange rings. The trio at lower right provides a contrast: the impressive bearded figure, with his back to the queen, gestures in conversation with his young companion, as if explaining or commenting upon the scene.

The static figures, weighed down by their rich costumes, perform a decorative, rather than narrative, function. Their faces are not expressive; no sense of drama is suggested. The fashions are those of the court of Margaret of Austria, regent of the Netherlands from 1507 to 1530, and daughter of Emperor Maximilian I and Mary of Burgundy.[1] The designs of a stylistically cohesive group of tapestries have been attributed to artists working in Brussels in the period of 1510 to 1520, including Jan van Roome and Leonard Knoest. The *Scenes of Court Life* is attributed to the same group because of its obvious borrowings from two celebrated earlier tapestries.

These two are now in Brussels: *The Story of Mestra: Mestra's Petition*, at the Palais Royal, and *Bathsheba at the Fountain*, at the Hôtel de Ville. The graybeard in the right foreground of the San Francisco panel reappears with his companion in the *Mestra* panel in about the same position (fig. 50). In this context, he is the god Neptune.[2] The *Bathsheba* tapestry (fig. 51) furnished several figures. The ring-giving group to right of center, in the upper register, is repeated exactly. The seated queen and her companion are reused with modifications. The figures at upper center of *Scenes of Court Life* are related to a similar group in three other tapestries. The resemblance to the man and three women above the fountain in *Bathsheba* is vague; the resemblance is closer to a group in *Music and Dancing* at the Musées Royaux d'Art et d'Histoire in Brussels, but an older version of that tapestry now at Zaragoza furnishes the closest parallel.[3] The attendant holding the jewel box before the queen owes something to the figure of Bathsheba.

In most cases the borrowed sections have retained their original positions in the new composition. Generally, after the first weaving, the cartoon became the property of the master weaver and was kept in his atelier. He was free to draw from it as many weavings as he liked, or to sell it to another weaver. By recombining sections for new subjects, even further profit could be wrung from the existing designs. The possible connection of Knoest's workshop with the San Francisco tapestry offers an interesting field for speculation.

NOTES
1. Guy Delmarcel, *Tapisseries bruxelloises de la pré-Renaissance*, exh. cat (Brussels: Musées Royaux d'Art et d'Histoire, 1976), 13.
2. Delmarcel, *Tapisseries*, no. 29.
3. Guy Delmarcel, letter to A. G. B., 23 April 1976.

PROVENANCE
Collection Charles Stein, Galerie Georges Petit, Paris, 8–10 June 1899, no. 240, p. 65.

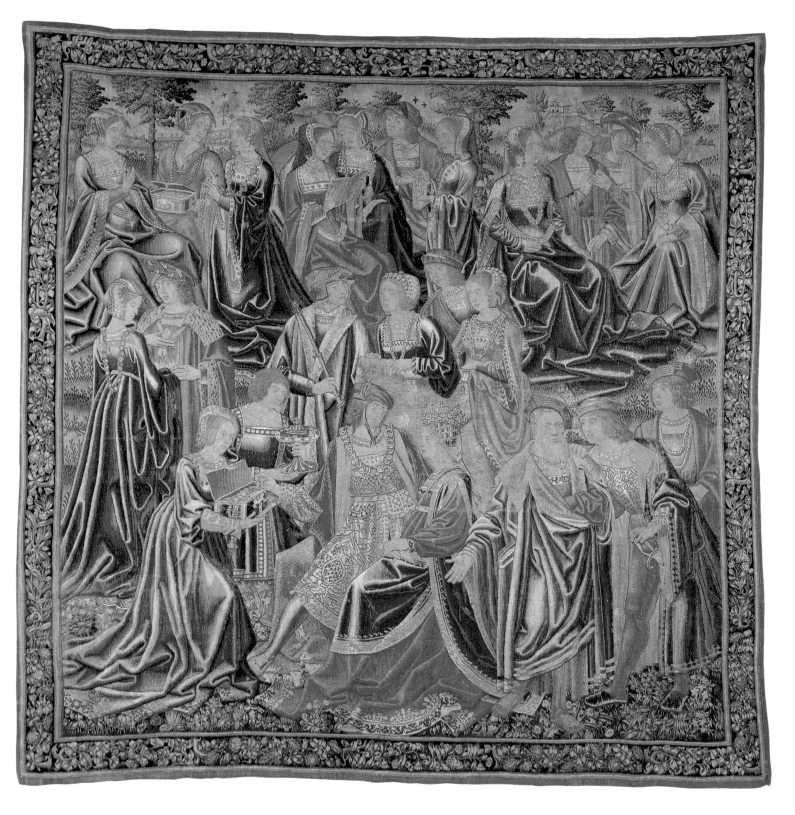

Scenes of Court Life

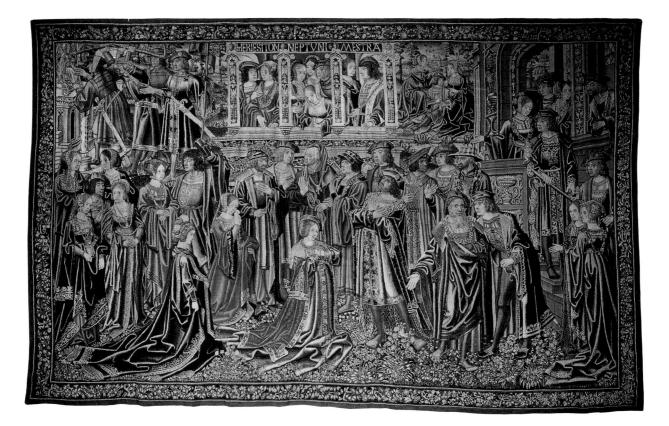

FIGURE 50
The Story of Mestra, tapestry.
Palais Royal, Brussels.
Copyright A.C.L. Brussels

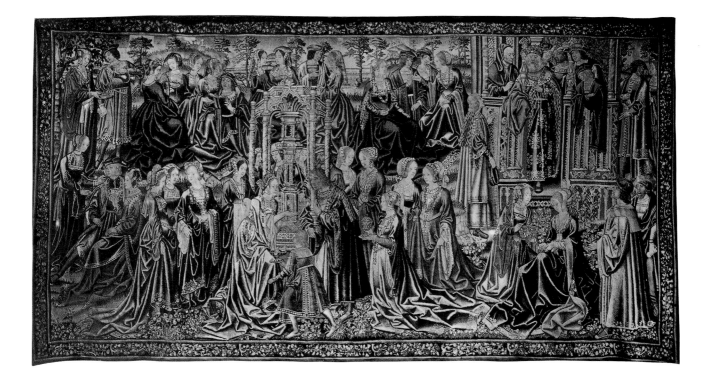

FIGURE 51
Bathsheba at the Fountain, tapestry.
Hôtel de Ville, Brussels.
Copyright A.C.L. Brussels

The Triumph of the Seven Virtues *Series*

The Seven Christian Virtues, so prominent in the literature and art of the Middle Ages, swept into the Renaissance in a sequence of triumphal processions more elaborate than those of the first Petrarchan series. Three of the four cardinal Virtues are celebrated in The Fine Arts Museums' tapestries: *Prudence, Justice,* and *Fortitude. Faith, Charity,* and *Hope,* the theological Virtues, have also survived, in tapestries in other collections (figs. 52, 53, 54). *Temperance* has disappeared, but the subject was certainly designed and woven. Her motto, at least, exists today, attached to a *Prudence* panel at the Biltmore House, Asheville, North Carolina: ILLICITOS ANIMI MODERATIA COMPRIMIT ESTUS TEQUE METRO STRINGIT PLUTE, LYEE, VENUS (Moderation restrains the impulses of the spirit and with her measure curbs you, Pluto, Lyeus [Bacchus], Venus).[1]

Describing the *Seven Virtues* series as a whole, Geneviève Souchal has evoked a majestic vision of the complete ensemble in place. The central panel of *Faith,* remarkable for its frontality, was to be seen *en face.* The other Virtues, three on each side, converge toward Faith—Charity, Justice, and Fortitude from the right; Hope, Prudence, and, undoubtedly, Temperance from the left.[2]

Guy Delmarcel points out the significance of this orientation as a principle of composition developed in Brussels about 1520. Its presence in the *Virtues* series derives from older tapestries: the *Moralities* and the still earlier *Honors* of the Spanish Royal Collection. As Delmarcel states, this convergence toward a central panel, rather than the customary sequence of panels to be read from left to right, is linked with a basic program common to these three sets: they were conceived as a "dynastic morality," a "mirror of the prince," showing the virtues and the rewards that should be the attributes of the leading social class. The sovereigns Charles V and Isabella of Portugal acquired *The Honors* from Pieter van Aelst in 1526 on the occasion of their marriage in Seville, but the set was planned immediately after Charles's election as German emperor in 1519. Delmarcel has analyzed the iconographical program of *The Honors* on which *The Triumph of the Seven Virtues* so largely depends.[3]

The individual panels of the *Seven Virtues* series adhere to the Petrarchan formula: all elements of the Triumph are present—the allegorical figure, beasts, and exemplars. Among the crowd of figures following the chariot we recognize classical and biblical personages famous in their lifetimes for the Virtue whose train they grace. The pyramidal group builds upward in the neo-Platonic tradition from the human exemplars to the absolute Virtue on the chariot. Episodes from their life stories appear on the periphery in the medieval manner. The slightly wider borders, deepening perspective, and the rounder forms of the figures are characteristic of the second quarter of the sixteenth century.

The series was woven several times. Five *Fortitudes* have survived, some fragmentary. Two types of border were used with the designs: a medallion type as in the Moscow *Hope* and in the Edinburgh and Vienna *Prudences,* and the later floral type found at The Fine Arts Museums of San Francisco, and at Asheville, Chenonceaux, and Toledo.[4] The Fine Arts Museums' panels come from different ateliers, although their borders are the same.

NOTES

1. *Biltmore House and Gardens* (Asheville, N.C.: The Biltmore Co., Inc.), 30.
2. An exhaustive study of the entire series was made by the late Geneviève Souchal and published as "*The Triumph of the Seven Virtues*: Reconstruction of a Brussels Series (ca. 1520–1535)," in *Acts of the Tapestry Symposium November 1976* (San Francisco: The Fine Arts Museums of San Francisco, 1979), 103–153.
3. Guy Delmarcel, "De Brusselse wandtapijtreeks 'Los Honores' (1520–1525). Een Vorstenspiegel voor de jonge keizer Karel V" (unpublished doctoral dissertation, Katholieke Universiteit Leuven, 1981), 2 vols.
4. Ella Siple, letter to Mr. Herbert Weissberger, Carnegie Institute, Pittsburgh, Pennsylvania, 18 May 1955.

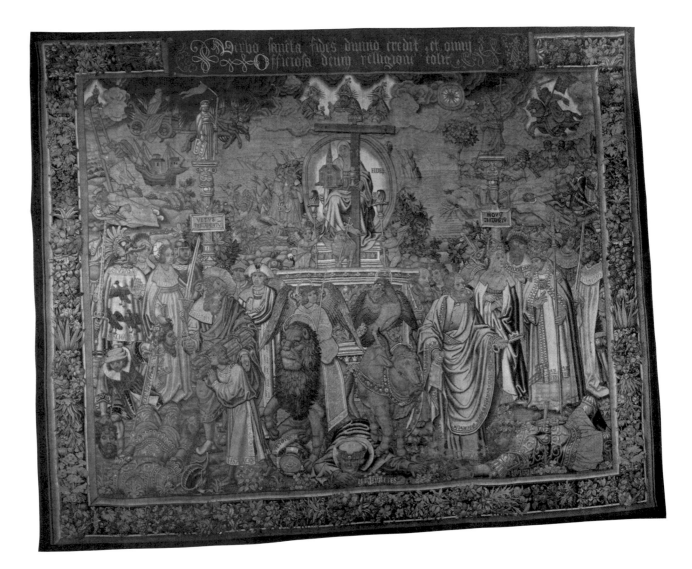

FIGURE 52
The Triumph of Faith, tapestry. Biltmore Estate,
Asheville, North Carolina

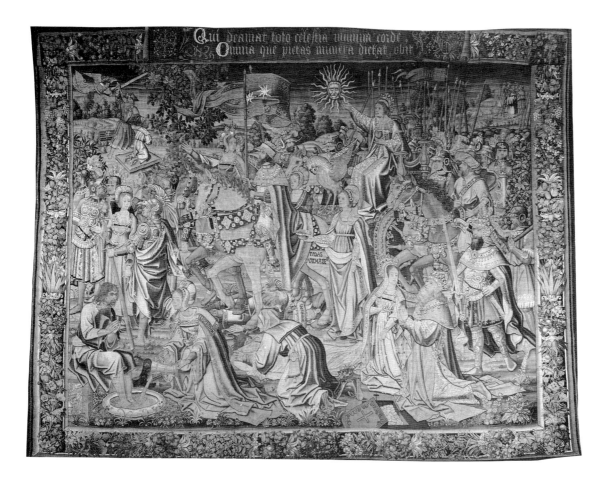

FIGURE 53
The Triumph of Charity, tapestry. Biltmore Estate, Asheville, North Carolina

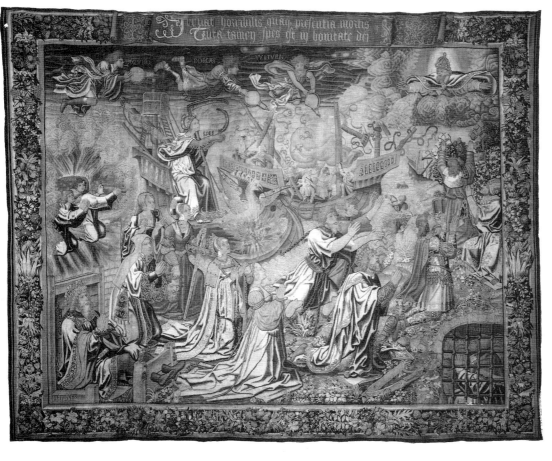

FIGURE 54
The Triumph of Hope, tapestry. The Carnegie Museum of Art, Pittsburgh

22. The Triumph of Prudence

from The Triumph of the Seven Virtues *Series*

Flemish (Brussels), ca. 1535
H: 4.5 m W: 5.59 m (14 ft. 9 in. × 18 ft. 4 in.)
WARP: undyed wool, 6–7 per cm
WEFT: dyed wool and silk
MARKS: *Origin* lower guard, left
 Weaver lower guard, right
Gift of the Provident Securities Co. (de Young), 62.19.3

Prudence, enthroned on her triumphal chariot, faces right. She is crowned with laurel and holds a lance in her right hand, perhaps the lance of Athena, goddess of wisdom. Cranes, symbols of vigilance, stand guard at either side of the throne. With her left hand, Prudence holds at arm's length the double attribute of a mirror ("Know thyself") with a handle formed as a snake biting its tail. The snake is traditionally wise (" . . . be ye, therefore, wise as serpents," Matthew 10:16). CASSANDRA walks at Prudence's right, her name on her book of prophecies. CARNEADE, for Carneades, a sceptic philosopher, strides on the other side of Prudence, his name faintly visible on his hem. Why this philosopher should be wearing armor is unexplained, and the identity of his companion is not known. Carneades carries the flag of Prudence and holds the reins of the dragons that pull her chariot. Their claws seize writhing serpents.

Those who surround Prudence exemplify her three traditional faculties: foresight, intelligence, and memory. At upper left, PROMETHEUS, whose name means "foresight," flies with Pallas Athena past the signs of the Zodiac. Prometheus stole fire from the gods for mortals; the scene of the theft may be shown here, for Prometheus carries a hollow tube. To the right are spears of the army of TITUS. Titus may be an exemplar of Memory, for his destruction of the Temple of Jerusalem showed that God had remembered Christ's prophecy. At the upper right corner, PERSEUS, surely embodying Intelligence, receives a lance and shield from PAL[L]AS Athena. The body of MEDUSA lies at his feet, and behind him, Pegasus, shown as a winged unicorn, bounds away from the springs of Hippocrene. The two corner scenes of Perseus and Prometheus are linked together through Athena, goddess of wisdom, who helped both heroes. They illustrate the role of wisdom in great undertakings.

Below Pegasus are three biblical groups. ASSUERUS, or Ahasuerus, extends his scepter to Esther. Between them are two figures probably intended to represent Haman and Mordecai. To the left, a queen (SABA, for Sheba) listens to a man gesturing in conversation, as she listened to the wisdom of Solomon (I Kings 10:1–9). In the lower right corner, ABIGAEL kneels before King DAVID. Her wisdom was in giving the soft answer that turned away wrath (I Samuel 25:3–42).

GIDEON kneels in the center foreground, holding a flail and a spotted flask. His story is found in Judges 6. He was a liberator, reformer, and judge of Israel. An angel visited him as he threshed wheat. He brought broth, meat, and cakes to the angel, and the sacrifice was miraculously consumed. RACHEL, sitting behind Gideon, was Jacob's favorite wife and the mother of Joseph.

An episode from the story of CADMUS fills the lower left corner. Cadmus, intending to sacrifice to Athena, sent to the well of Ares for water. The dragon guardian of the well killed one messenger after another. The victims lie dead beneath the now wounded dragon. Cadmus is about to land a second blow. Delmarcel believes the Cadmus story is included *because* of the dragon. For Boccaccio[1] and therefore for all literate people into the mid-sixteenth century, the dragon was the symbol of Prudence. The two figures above the Cadmus group were identified by Souchal as IVDITH and Ozeas or Achior, important figures in Judith's story. Still holding the head of Holofernes, Judith lingers beside the well of Ares.

The borders of fruit and flowers in *Prudence* conform to those of the two other *Triumph* panels in The Fine Arts Museums' collection, although the latter belong to a different set. The leaves extend slightly over the edge of the "frame." At top, center, the banderole reads,

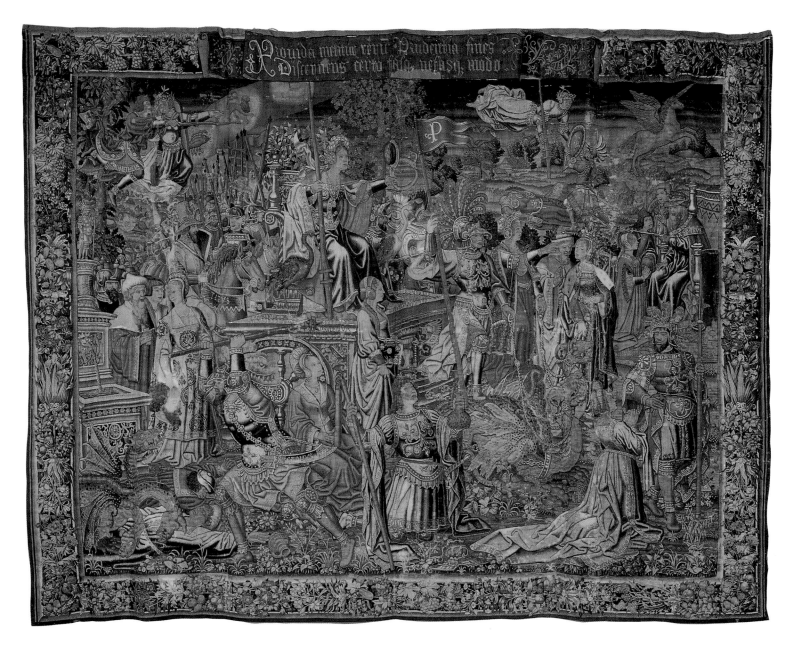

The Triumph of Prudence

23. The Triumph of Fortitude

from The Triumph of the Seven Virtues *Series*

Flemish (Brussels), ca. 1535
H: 4.42 m W: 5.66 m (14 ft. 6 in. × 18 ft. 7 in.)
WARP: undyed wool, 6–7 per cm
WEFT: dyed wool and silk
MARKS: *Origin* lower guard, left
 Weaver lower guard, right
Gift of The William Randolph Hearst Foundation (CPLH), 1957.126

The Virtue of Fortitude or moral strength, apparently conceived as a female allegorical figure like her sister Virtues, wears more masculine armor and a long skirt.[1] Her right arm encircles a column, perhaps representing one that Samson overturned to destroy the Philistines (Judges 16:25). Her left hand strangles a griffon. An enormous eagle rides before Fortitude as her emblematic bird. The chariot is drawn toward the left by lions, symbols of courage and power. Their riders are labeled CINOPE and DENTAT'. Cinope, or Sinope, defended her virginity against the Olympian gods. Dentat[us] is probably intended for L. Sicinius Dentatus, called "The Roman Achilles" by ancient writers. Pliny tells of eighteen spears and twenty-six crowns received as booty,[2] and Valerius mentions L. Sicinius Dentatus.[3] Other tapestries showing this hero are known, in the Milwaukee Art Museum (formerly Milwaukee Art Institute) and elsewhere.[4] PENTHESILEA, Queen of the Amazons, walks nearby.

The Triumph of Fortitude is particularly rich in incident, perhaps because the idea of Fortitude is naturally expressed by dramatic acts. This Virtue's exemplars, however, enact their violent scenes with aloof dignity, showing that they act from principle rather than from passion.

At upper left, Judith's sword, inscribed IVDICH, is lifted high above the head of Holofernes (Judith 13:4–7). A military scene involving ALEXANDER is in the distance in the corner above. The elephant scene comes from I Maccabees 6:28–47.[5] Eleazar, a Jewish warrior fighting King Antiochus V, slipped under the elephant believed to carry the king and stabbed it from beneath, thus sacrificing his life. A label, much restored, identifies the woman on horseback as CLOELIA, the Roman girl given to Porsenna as hostage. Cloelia escaped and swam the Tiber to safety. Porsenna gave her a horse with splendid trappings. Beside the horse swims COCLES, for Horatius Cocles, who held

the bridge against Porsenna. These two exemplars of Fortitude are mentioned sequentially by Valerius Maximus.[6]

Four spectacular figures occupy the foreground: Scaeva, Tomyris, Jael, and, at left, a standing warrior who holds his right hand in the fire. The hem of his tunic reads MVC . . . VOLA, for C. Mucius Scaevola ("left-handed"), a Roman who tried to kill Porsenna. Caught, he burned the hand that had failed him. The kneeling soldier to Scaevola's right is Cassius Scaeva (SCEVA), a centurion in Caesar's army who distinguished himself at the battle of Dyrrachium. His extraordinary image, bristling with spears, was undoubtedly inspired by a thirteenth-century French description, *Li fet des Romains*.[7] The old French description fits him well: *[l]es hantes des darz le covroient autresi come soies coevrent le hericon* (the javelin shafts covered him like [quills on] the porcupine). According to Valeriano (1556), the porcupine is the image of the man who has become hardened amid dangers.[8]

THAMARIS, or Tomyris, Queen of the Massagetae, dips the head of her enemy, Cyrus, into a bucket of blood.[9] The energetic young woman in the right corner is Jael, from the Old Testament, who destroyed a sleeping enemy by driving a tent pin into his temple. Her victim is Sisera, who is identified by the letters SIS on his shoulder armor (Judges 4:17–21).

The man confronting the lion between Tomyris and Jael may be Milo of Crotona, according to Geneviève Souchal. Above the lion, King David refuses water brought from the well of Bethlehem by three mighty men at peril of their lives (II Samuel 23:15–17). Souchal identified PHINEES, or Phineus, as the son of Eleazar, who saved the Israelites from plague by punishing a crime (Numbers 25:6–13). IOSUE, or Joshua, the conqueror of Canaan, brings up his army in the rear. NEEMIAS (Nehemiah), is placed near city walls, for he rebuilt the walls of Jerusalem

(Nehemiah 2:17, 3:32). The border conforms to that of *The Triumph of Justice*, except for the banderole which reads,

OBIICIT ADVERSIS INTERRITA CORDA PERICULIS
VIRTUS EQZ IUUAT MORTE RECEPTA SALUS

Valor exposes fearless hearts to hostile dangers.
It helps equally as a source of safety [or salvation]
when death is suffered.[10]

Other weavings of *Fortitude* are found at the Walker Gallery, Liverpool; the Museo de Santa Cruz, Toledo, Spain; the Château de Chenonceaux; and the Château de Langeais (a fragment). *Fortitude*'s motto appears on the *Charity* panel at Chenonceaux.

NOTES

1. Fortitude's armor presents a marked contrast with the armor worn by Queen Tomyris, in the center foreground.
2. M. Calberg, "Le triomphe des vertus chrétiennes. Suite de huit tapisseries de Bruxelles du XVIe siècle," *Revue belge d'archéologie et d'histoire de l'art* 29 (1960): 21.
3. Bk. 3, chap. 2, no. 24.
4. Edith A. Standen, *European Post-Medieval Tapestries and Related Hangings in The Metropolitan Museum of Art,* 2 vols. (New York: The Metropolitan Museum of Art, 1985), 1:34.
5. Calberg, "Le triomphe," 22.
6. Cocles: Bk. 3, chap. 2, no. 1; Cloelia no. 2.
7. F. Flutre and K. de Vogel, *Li fet des Romains (Les faits des Romains)*, ed. Sneyders (Paris, n.d.), 485.
8. Mercedes Viale Ferrero, "Quelques nouvelles données sur les tapisseries de l'Isola Bella," in *L'art brabançon au milieu du XVIe siècle et les tapisseries du château de Wawel à Cracovie: Actes du colloque international, 14–15 décembre 1972. Bulletin des Musées Royaux d'Art et d'Histoire* 45 (1973; offprint, Brussels, 1974): 119.
9. Herodotus, *The Histories*, Bk. 1, 205.
10. Translated by Charles Murgia, Professor of Classics, University of California, Berkeley.

PROVENANCE

See *The Triumph of Justice*, cat. no. 24.

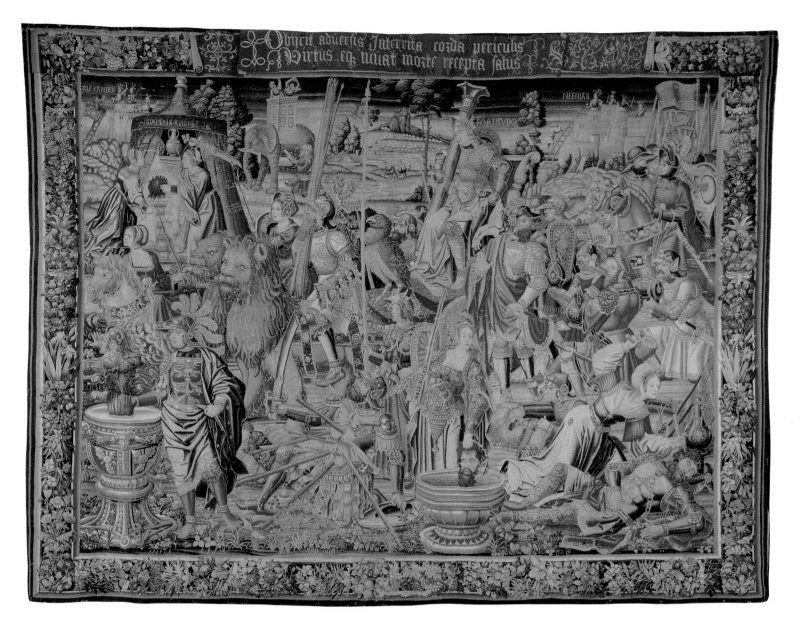

The Triumph of Fortitude

24. The Triumph of Justice

from The Triumph of the Seven Virtues *Series*

Flemish (Brussels), ca. 1535
H: 4.40 m W: 5.51 m (14 ft. 5 in. × 18 ft. 1 in.)
WARP: undyed wool, 6–7 per cm
WEFT: dyed wool and silk
MARKS: *Origin* lower guard, left
 Weaver lower guard, right
Gift of The William Randolph Hearst Foundation (CPLH), 1957.125

Justice wears a rich crown and a red gown with flowing sleeves. She is enthroned on a triumphal chariot drawn toward the left by two unicorns. The Virtue's emblematic bird, the crane, keeps his vigil at her feet. In her left hand she holds the scales and a sword inscribed IVSTICIA. Justice leans forward to receive a second sword from God the Father, who gives his blessing. The unicorns, ancient symbols of Christ, are ridden by Sara and Joseph, who prefigured Christ and the Virgin—Sara because she conceived by God's will and contrary to all expectations; Joseph because his story foretold the events of Christ's life on earth.[1] They ride before Justice to intercede for sinners. Another biblical figure is NOE (Noah), who kneels with his family beside the Ark to give thanks. The form of the Ark is interesting. Its hull is like that of a galleon, and its central portion, or "castle," resembles a centrally planned Italian Renaissance church. Other Old Testament figures include REBECCA, at the left edge of the tapestry; RACHEL and IACOB (Jacob) walk beside the chariot.

The classical allusions are more numerous than the biblical ones. Under the hooves of the unicorns lie SCILLA and MARI', for Sulla and C. Marius. These ruthless men were noted for their injustice, as was CATILINE, whose broken column is barely visible by the white unicorn's rear leg, a detail noted by Geneviève Souchal. CHARUNDE, for Charondas, the lawgiver, falls gracefully on his sword, having broken one of his own laws. SELEUCHUS, or Zeleuchus (right corner), has one eye covered. He introduced the *lex talionis*, the law of "an eye for an eye." His son, convicted of rape, was condemned to lose his eyes for the crime. Seleuchus sacrificed one of his own eyes to save his son from total blindness. Guy Delmarcel has pointed out that the *Facta et Dicta* of Valerius Maximus is the basic source for

these classical allusions.[2] Valerius gives Seleuchus and Charondas adjacent citations in his chapter *De Justitia*.[3] Midway between Seleuchus and the chariot stands CORNELIA. Souchal identified her not as the mother of the Gracchi, but as the great Vestal who was unjustly accused and buried alive.[4]

Three warriors in parade armor walk before the unicorns. Two are labeled SCIPIO AFRICAN' and CATO. Scipio was famous for his success in war and for his restraint in dealing with the spoils of war. Cato, beside him, preferred honor without life to life without honor. They too are cited adjacently in Valerius Maximus.[5] Below these figures the episode of TRAJAN and the widow is enacted. The widow points to her dead son lying before the emperor. The little boy died as a result of the recklessness of Trajan's son; the woman demanded and received justice from the emperor. (The story is found in *The Golden Legend*, but is far older than that compilation; its earliest surviving appearance may be an Anglo-Saxon version of 713 that was preserved at the Abbey of Whitby.)[6] The soldiers who follow the chariot of Justice and carry her banner, inscribed IVSTICIA, are led by FABRICIUS, the incorruptible. His refusal to be bribed so impressed the enemy that the soldiers he was sent to ransom were returned to him gratis.

The opulent border of fruit and flowers holds a banderole which reads,

ASTREA UTILIBUS RECTUM PREPONERE SUADENS
TUIQZ SUUM IUSTA IUS DARE LANCE IUBET

Astrea [goddess of Justice], advising [you] to prefer
 what is right to what is expedient,
Commands each of you to administer her justice
 impartially [with just balance of the scale].

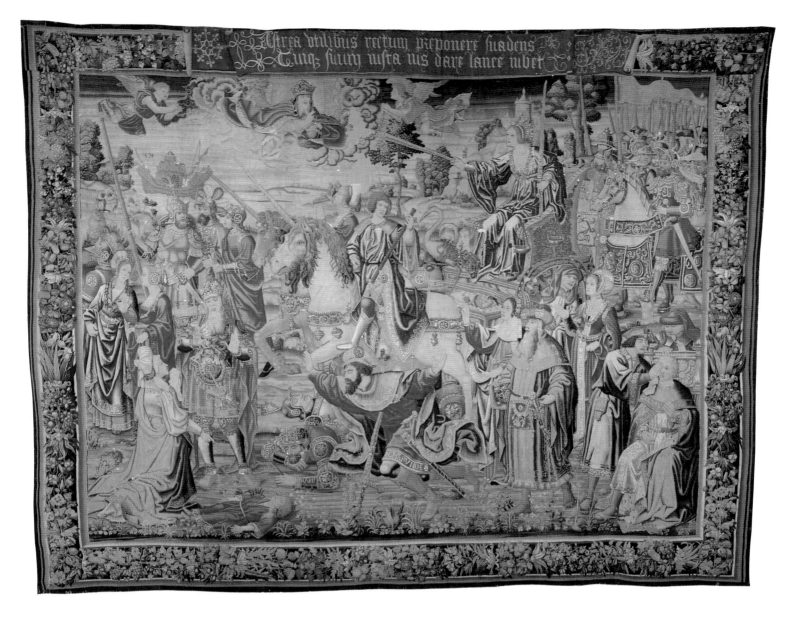

The Triumph of Justice

NOTES

1. M. Calberg, "Le triomphe des vertus chrétiennes. Suite de huit tapisseries de Bruxelles du XVIe siècle," *La revue belge d'archéologie et d'histoire de l'art* 29 (1960):17. Calberg credits Xavier Barbier de Montault.
2. Sulla, Bk. 6, chap. 5, no. 7; Marius, Bk. 6, chap. 9, no. 14.
3. Seleuchus, Bk. 6, chap. 5, ext. 3; Charondas, ext. 4.
4. Geneviève Souchal, "*The Triumph of the Seven Virtues*: Reconstruction of a Brussels Series (ca. 1520–1535)," in *Acts of the Tapestry Symposium November 1976* (San Francisco: The Fine Arts Museums of San Francisco, 1979), 124.
5. Scipio, Bk. 3, chap. 2, no. 13; Cato, Bk. 3, chap. 2, no. 14.
6. Guy Delmarcel, letter to A. G. B., 23 April 1976, cited Anna Maria Cetto, *Der Berner Traian und Herkinbald Teppich* (Bern, 1966), 18.

PROVENANCE

The Triumph of Fortitude and *The Triumph of Justice* were gifts of The William Randolph Hearst Foundation in 1957. Marillier believed they may have been in the collection of the marqués de dos Aguas, Spain. One of the earliest mentions of a similar set of Seven Virtues can be found in the inventory of the tapestries made after the death of Isabella of Portugal, wife of the emperor Charles V in 1539.* No other example of *Justice* is known to have survived.

*Guy Delmarcel, letter to A. G. B., 23 April 1976, cited *Archivo general de Simancas*, Casa y Sitios Reales, leg. 67, fol. 26r.

ILLUSTRATED

Pleister, Wolfgang and Wolfgang Schild. *Recht und Gerechtigkeit im Spiegel der Kunst*. Cologne: DuMont Buchverlag, 1987, 170, fig. 272.

The Story of Jacob *and* The Story of Moses *Series*

Raphael completed the decoration of the Vatican Loggie with Old Testament scenes in 1519. The impact of these paintings, plus the success of Raphael's designs for *The Acts of the Apostles*, must account for the numerous Old Testament stories in tapestry that began to appear about 1535. Bernard (Barent) van Orley established the massive type of the biblical hero that recurs in derivative series for the next hundred years. Van Orley's work is represented in the Museums' collection by *Jacob's Dream* (cat. no. 25), an important fragment from a series illustrating the patriarch's life, first woven by Willem de Kempeneer about 1535. A celebrated ten-panel set hangs in the Musées Royaux d'Art et d'Histoire in Brussels; a later weaving is at the Uffizi, in Florence.

Later series, inspired by van Orley's designs, perpetuated his Old Testament prototype, all bearing a strong family resemblance to each other. Very early in its institutional life, in 1927, the California Palace of the Legion of Honor acquired six important Renaissance tapestries which had belonged to Charles Mather Ffoulke, purchased from Princess Barberini in 1889. The present Prince U. Barberini believes that these six panels came into the Barberini collection in the seventeenth century through Cardinal Francesco Barberini.[1] Published in the Ffoulke catalogue of 1913 as *The History of Moses*,[2] the tapestries were known by this title until 1970, when Jean-Paul Asselberghs pointed out the mixed subject matter. Since the names of Jacob and Moses do not occur together in the old inventories, as Delmarcel observed,[3] and based on the physical evidence presented by the tapestries themselves, the tapestries are accepted as representing two series and designated as *The Story of Jacob* and *The Story of Moses*, each comprising three panels.

Without reference to iconography, the presence of two different series is immediately suspected because of the different ground color of the narrow bands of interlacing ribbons defining the inner and outer limits of the borders: red bands for the *Moses* subjects and gold for the *Jacob*. Also, two different weavers' marks appear on the two groups. Schneebalg-Perelman attributed the mark found on the *Moses* panels to Pieter van Aelst the Younger, active between 1505 and 1548.[4] No name has been suggested for the other weaver, who used the circle-and-cross mark on two of the *Jacob* panels (cat. nos. 26 and 28).

The activity of this unknown weaver was summarized by Asselberghs as sub-contracting and collaborating with other weavers whose marks appear in conjunction with his. The borders he used were not distinctly or exclusively his, but were used also by other weavers.[5] Fifteen pieces are known to bear his enigmatic mark. Besides the two San Francisco pieces, one is at the Musées Royaux d'Art et Histoire, Brussels (*The Story of Hercules*); three are at the Cathedral of Cuenca (*The Story of Saul*); three are at the Civiche Raccolte d'Arte Applicata, Milan (*The Story of Elijah and Eliseus* panels); one is at the Church of the Calavatravas, Madrid (*The Story of Augustus*); three are at the National Museum of Bavaria (*The Story of Saul*); and one was formerly in the Saint-Seine collection (*Fishing Boats*). The dates assigned to these tapestries fall in the decade 1550–1560.

Although two different weavers were responsible for the execution of the *Moses* and the *Jacob* panels, it seems certain that they were designed by the same artist. He was probably a follower of Bernard van Orley, possibly in the entourage of Michel Coxcie and his occasional imitator.[6] Forti Grazzini cites a set of *Solomon* at the Cathedral of Novara as being very likely drawn from cartoons by the same painter.[7] The designer of the grotesque borders was influenced by the engravings of Cornelis Floris.[8]

NOTES

1. Marcel Roethlisberger, "Deux tentures bruxelloises du milieu du XVIe siècle," *Oud Holland* 86, pt. 2–3 (1971): 88 n. 1.
2. Charles M. Ffoulke, *The Ffoulke Collection of Tapestries* (New York, 1913), 112.
3. Guy Delmarcel, letter to A. G. B., 23 April 1976.
4. Sophie Schneebalg-Perelman, "Un grand tapissier bruxellois: Pierre d'Enghien, dit Pierre van Aelst," in *L'âge d'or de la tapisserie flamande*, International Colloquium (Gent), 23–25 May 1961 (Brussels: Paleis der Academien, 1969), 417.
5. Jean-Paul Asselberghs, *Les tapisseries flamandes aux Etats-Unis d'Amérique* (Brussels: Artes Belgicae, 1974), 8.
6. Roethlisberger, "Deux tentures," 89.
7. Nello Forti Grazzini, letter to A. G. B., 5 June 1990.
8. Magdalena Piwocka, "Les tapisseries à grotesques," in *Les tapisseries flamandes au château de Wawel à Cracovie: Trésors du roi Sigismond II Auguste Jagellon*, ed. Jerzy Szablowski (Antwerp: Fonds Mercator, S.A., 1972), 312–330.

25. Jacob's Dream

from The Story of Jacob Series (a fragment)

Flemish (Brussels), ca. 1540
Designed by Bernard (Barent) van Orley (ca. 1492–1541/42)
Woven by Willem de Kempeneer (fl. 1521–1548)
H: 3.40 m W: 2.49 m (11 ft. 2 in. × 8 ft. 2 in.)
WARP: undyed wool, 7.5 per cm
WEFT: dyed wool and silk
Museum purchase, Elizabeth Ebert and Arthur W. Barney Fund
 (de Young), 77.14

The subject of the second panel of *The Story of Jacob* series at the Musées Royaux d'Art et d'Histoire in Brussels is *Jacob's Departure and Dream*. The episode takes place in a marble-floored Renaissance palace (fig. 55). A frightened Jacob, who has stolen his brother's birthright (see cat. no. 27) heeds his mother's warning that Esau plans to kill him after Isaac's death (Genesis 27:41). Esau's anger is shown in a secondary scene on the gallery over Rebekah's head. The moment of parting is the subject of the left two-thirds of the tapestry. Blind Isaac, sitting on the edge of his bed, holds up a cross and blesses his son as Rebekah urges a speedy departure. Jacob has his staff and water bottle already in hand; his flying mantle suggests the haste with which he leaves his father's house. His journey will serve the double purpose of escaping Esau's rage and of searching for a wife among his mother's people.

An ornate marble column, hung with garlands, divides the *Dream* episode in Brussels from the *Departure*. The left edge of the San Francisco fragment begins just right of the column, the marble base of which is visible in the left foreground. The loss of an architectural frame in no way detracts from the *Dream's* composition.

Chapter 28 of Genesis tells of Jacob's journey and of his extraordinary dream. In the tapestry he sleeps on a pile of stones, his staff and water bottle beside him. Above his head, angels ascend and descend a ladder reaching up to heaven. God the Father at the top promises protection and prosperity. Awakening the next morning, Jacob pours oil on the stone where he had rested, designating it as a holy place. This episode is shown in the middle ground, at the left edge. A group of shepherds tend their sheep below the cloud hiding God the Father. Jacob inquires after Laban, his uncle, and the shepherds point out Rachel, who is tending sheep in the left distance. Walls and towers, perhaps the town of Bethel, are outlined faintly in the background.

A comparison of the San Francisco *Dream* with the right third of the second Brussels panel shows a slight shifting of the cartoon: there is less sky at the top, more water at the bottom. A *Story of Jacob* series at the Uffizi in Florence was also described as slightly diminished in height, its second panel lacking the dream episode.[1] Because of this correspondence in the amount of cartoon woven, one is tempted to wonder whether the San Francisco fragment might once have been part of the tapestry belonging to the Italian state collection.[2] This hypothesis, however, is contradicted by a recent catalogue of the Uffizi collection that makes no mention of any sign of a cut on the right side of the *Departure's* border.[3] The Italian tapestry, therefore, would seem to be a complete tapestry, although woven from only the left two-thirds of the cartoon. The San Francisco fragment must have been cut from the corresponding *Departure and Dream* panel (no. 2) of another set of the series.

The Italian set bears the mark of Willem de Kempeneer. His mark, a *W* with a *4*, is confused in the early (and recent) literature with that of Willem de Pannemaker, a *W* with a *P*. According to Delmarcel, who pointed out this distinction, all *Jacob* sets were woven by Willem de Kempeneer.[4]

NOTES
1. Marthe Crick-Kuntziger, *La tenture de l'histoire de Jacob d'après Bernard van Orley* (Antwerp: Imprimeries Générales Lloyd Anversois, 1954), 30: "The episode of the ladder that appears in a dream [is missing]. . . . The cartoon has been a little diminished in height."
2. Anna G. Bennett, "Four Tapestries with Identity Problems," *Apollo* 111, no. 216 (February 1980): 111–112, illus. p. 110, fig. 4.
3. *Gli Uffizi. Catalogo generale* (Florence: Centro Di, 1979), 1051. I owe this reference to Nello Forti Grazzini.
4. Guy Delmarcel, letter to A. G. B., 12 February 1980.

PROVENANCE
Frederick A. Juillard
Juillard McDonald

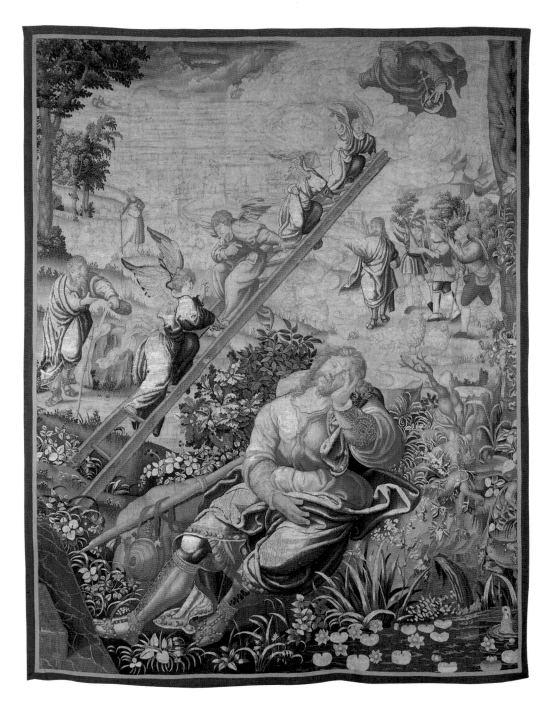

Jacob's Dream

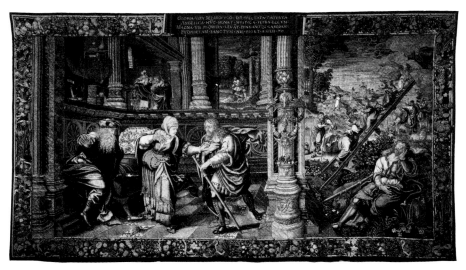

FIGURE 55
Jacob's Departure and Dream, tapestry.
Musées Royaux d'Art et d'Histoire, Brussels

26. Jacob and Rebekah

from The Story of Jacob *Series*

Flemish (Brussels), ca. 1550
H: 4.22 m W: 3.99 m (13 ft. 10 in. × 13 ft. 1 in.)
WARP: undyed wool, 7 per cm
WEFT: dyed wool and silk
MARKS: *Origin* lower guard, left
 Weaver lower guard, right
Museum purchase (CPLH), 1928.8

The twenty-seventh chapter of Genesis tells how the patriarch Isaac, grown old and blind, felt himself near the end of his life and wished to confer on Esau the spiritual and material blessings that were the birthright of the eldest son. His wife, Rebekah, knew of his intention and devised a way to divert the blessing to her favorite son, Jacob. Her scheme was one of substitution, depending for its success on critical timing and sensory deception. While Esau hunted for venison as Isaac requested, Rebekah sent Jacob for two young goats which she planned to prepare as savory meat. Jacob, disguised as his brother, was to present the dish to Isaac and thus preempt the blessing before Esau returned.

The well, which draws the eye to the upper left corner, recalls an incident in the life of Rebekah (Genesis 24). Abraham sent his trusted servant, Eleazar, to find a wife for his son, Isaac. After a long journey to the land of Abraham's kindred, Eleazar stopped beside a well with his camels. There he prayed that the woman who should give him and his camels water to drink would be the one intended to be Isaac's wife. Eleazar's prayer was answered; Rebekah gave him and his camels water and took him home to her father's house. The presence of the well in this scene helps to identify her.

Rebekah bends toward her son like a conspirator, her finger raised as if directing him: "Go now to the flock, and fetch me from thence two good kids of the goats" (Genesis 27:9). Her instructions have already been carried out:

Jacob holds the kids in his arms ("and he went and fetched, and brought them to his mother" [Genesis 27:14]). The iconographic ambiguity results from the telescoping of two moments of the story.

The volume of the figures is emphasized by drapery looped around the forms. For all their weight and plasticity, the bodies move stiffly, and the faces are inexpressive. Exotic costume touches, such as the lion-headed sandals, attempt to suggest a different time and place.

The borders are nearly the same for all panels of the *Moses* and *Jacob* series. The top border is half the size of the other three. Mythological beings, perhaps Minerva and Neptune in the Jacob and Rebekah panel,[1] sit on miniature chariots in the lower corners. From the headdresses of each, an ascending structure of fanciful ironwork, or *ferronnerie*, supports pairs of fantastic birds, fruits, flowers, and standing figures imprisoned in circlets of iron. A putto plays his hurdy-gurdy near the center of the lower border.

Very similar borders surround three series at Wawel Castle, Kraków: *The Story of the First Parents*, *Noah*, and *The Tower of Babel*.

NOTE

1. Magdalena Piwocka, "Les tapisseries à grotesques," in *Les tapisseries flamandes au château de Wawel à Cracovie: Trésors du roi Sigismond II Auguste Jagellon*, ed. Jerzy Szablowski (Antwerp: Fonds Mercator, S.A., 1972).

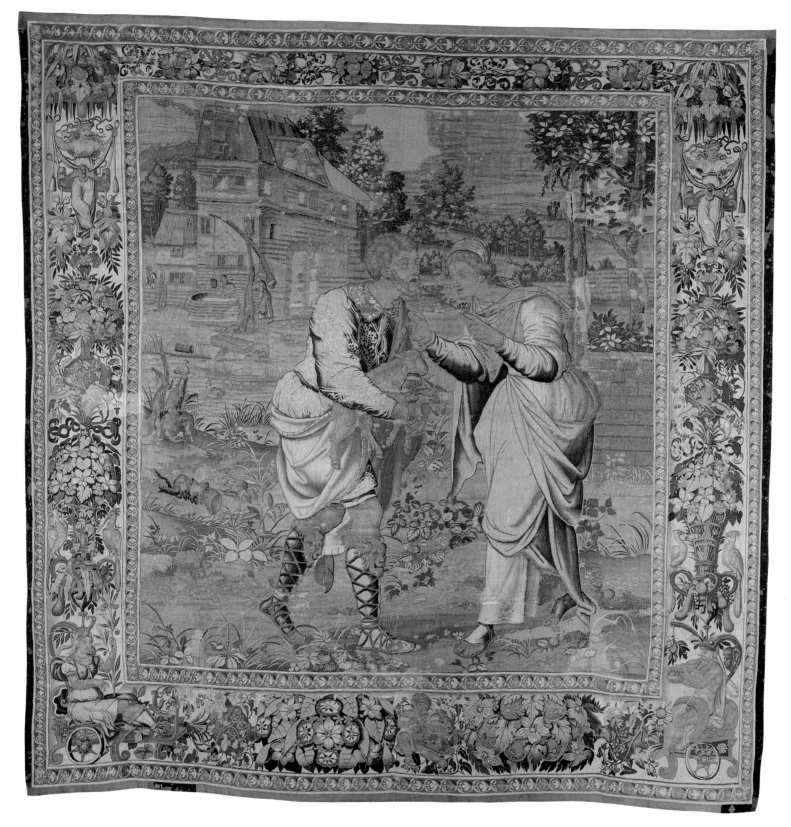

Jacob and Rebekah

27. Jacob Receiving the Blessing Intended for Esau

from The Story of Jacob *Series*

Flemish (Brussels), ca. 1550
H: 4.29 m W: 5.18 m (14 ft. 1 in. × 17 ft.)
WARP: undyed wool, 6–7 per cm
WEFT: dyed wool and silk
MARK: *Origin* lower guard, left
Museum purchase (CPLH), 1930.25

The blessing of Jacob takes place in a Renaissance palace with inlaid marble floors, marble columns, and walls ornamented with gilt grotesques. Jacob appears three times in the panel, showing the progressive action of the story. Reversing the old medieval tradition, the story flows from right to left, beginning in the well-appointed Flemish kitchen at the top right corner. Rebekah hands her son the dish of savory meat. Slightly to the left, Jacob descends the stairs, holding the platter with a thick cloth over his hand. Still further left, he kneels as Isaac pronounces the blessing. Rebekah, apprehensive, hovers nearby to see her scheme realized. Through the archway, Esau is seen returning home with his hunting dogs and spear, a small deer over his shoulder.

The figure of the patriarch projects power, rather than weakness. He is splendidly bearded, his head is wrapped in a turban and his heavy body clothed in a robe of brocade. He blesses with his right hand; his left rests "upon the smooth" of his son's neck. The gesture defines the critical moment of the deception, for Esau is a hairy man. To pass off her younger son as his brother, Rebekah has covered his neck with the skins of goats, clearly visible under the old man's hand.

Bernard van Orley's magnificent *Story of Jacob* is the treasure of the Musées Royaux d'Art et d'Histoire in Brussels.[1] Woven by Willem de Kempeneer about 1535, it clearly inspired the style, composition, and iconography of at least four later series of the sixteenth and seventeenth centuries. The three *Jacob* panels at The Fine Arts Museums represent the earliest of these derivative series: later sets followed by Martin Reynbouts, Jan Raes, and Jacques

van Zeunen.[2] The influence of van Orley is particularly strong in the present panel, *Jacob Receiving the Blessing*, which corresponds to the right two-thirds of Panel 1 of the Brussels series (fig. 56). Dr. Marcel Roethlisberger discovered an artist's preparatory drawing in Milan which fits somewhere into this sequence (fig. 57). A three-way comparison of the sketch with the present panel and with another now at the Generale Bankmaatschappij in Antwerp (fig. 58) raises interesting questions. Because the direction of the design was reversed, Roethlisberger believed the sketch to be "either a final model by the artist before the elaboration of the large cartoon, or an old copy of the lost original model."[3] Rather than a preparatory drawing for the present mid-sixteenth-century tapestry, it seems to have been a model for a later tapestry woven by Jan Raes, now in Antwerp. The kitchen and stairway scenes and the scene with Esau point to the San Francisco panel, but the form of the grotesque tracery and the fringed tablecloth are details incorporated into the later weaving by Jan Raes. The artist who made the sketch may have worked from the San Francisco panel or from the model from which it was developed.

NOTES

1. Marthe Crick-Kuntziger, *La tenture de l'histoire de Jacob d'après Bernard van Orley* (Antwerp: Imprimeries Générales Lloyd Anversois, 1954), 29–32.
2. Jean-Paul Asselberghs, *Chefs d'oeuvre de la tapisserie flamande: Onzième exposition du château de Culan*, exh. cat., 12 June–12 September 1971, 29, no. 23.
3. Marcel Roethlisberger, "Deux tentures bruxelloises du milieu du XVIe siècle," *Oud Holland* 86, pt. 2–3 (1971): 89, 95.

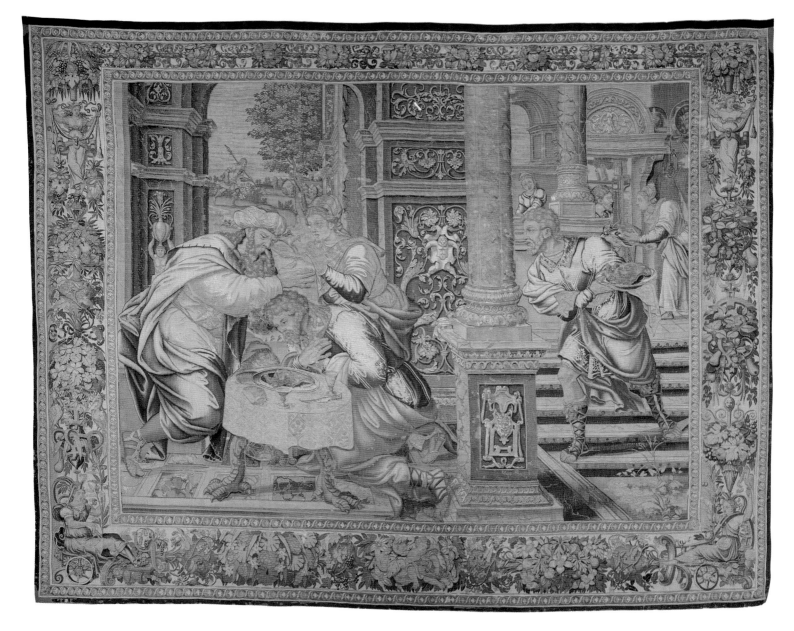

Jacob Receiving the Blessing Intended for Esau

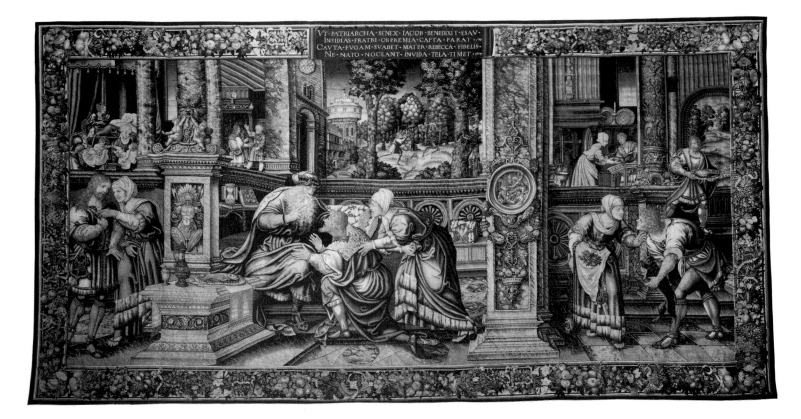

Jacob Receiving the Blessing Intended for Esau, tapestry.
Musées Royaux d'Art et d'Histoire, Brussels

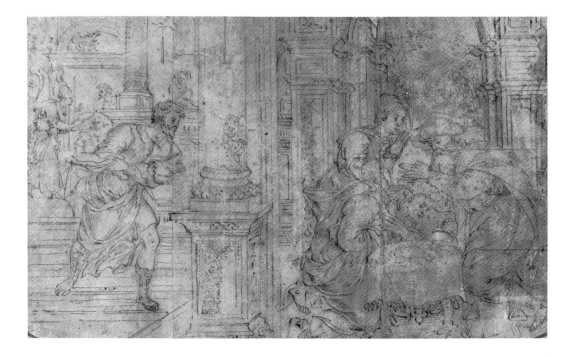

Anonymous, Flemish, *Jacob Receiving the Blessing Intended for Esau*,
ca. 1580–1600, pen and ink on paper. The Fine Arts Museums of
San Francisco, Achenbach Foundation for Graphic Arts, Gift of
Ralph and Anna Bennett, 1989.2.45

FIGURE 58
Isaac Blessing Jacob, tapestry. Generale Bankmaatschappij, Antwerp

28. The Reconciliation of Jacob and Laban

from The Story of Jacob *Series*

Flemish (Brussels), ca. 1550
H: 4.22 m W: 5.18 m (13 ft. 10 in. × 17 ft.)
WARP: undyed wool, 6–7 per cm
WEFT: dyed wool and silk
MARKS: *Origin* lower guard, left
 Weaver lower guard, right
Museum purchase (CPLH), 1930.24

When Christians interpreted the Old Testament in terms of their own theology, the reconciliation of Jacob and Laban was held to prefigure the reconciliation of Christ and the Gentiles. The subject of this panel, chronologically third in the *Jacob* suite at The Fine Arts Museums of San Francisco, corresponds to the subject of the sixth tapestry of the *Jacob* series of the Musées Royaux d'Art et d'Histoire of Brussels (fig. 59), although the composition is quite different. Both tapestries contain the iconographic essentials for illustrating the thirty-first chapter of Genesis: search and concealment, the covenant, the farewell.

Fearing Laban's jealousy, Jacob departed abruptly from his father-in-law, taking with him his wives and his rich flocks. Without Jacob's knowledge, Rachel had stolen from her father's households his idols and had concealed them among her belongings. Laban and his brothers pursued the fugitives and overtook them at Mount Galaad.

The search for the stolen idols occupies a large space in the van Orley tapestry, the trunk appearing three times. In the San Francisco version, the trunk appears only once, inconspicuously, in the opening of the tent in the upper right corner. The women seated before the tents recall the fact that Rachel hid the idols by sitting on them.

The San Francisco panel focuses on the covenant, rather than on the search. The heap of stones raised as a witness of reconciliation (Genesis 31:46–48) is shown twice. Two men seem to quarrel in the middle distance ("and Jacob was wroth and chode with Laban" [Genesis 31:36]). At upper left they eat from the top of the heap of stones (Genesis 31:46). In the foreground, the words that presumably pass between them are familiar to anyone

raised in the Judeo-Christian tradition: "The Lord watch between me and thee, when we are absent one from another" (Genesis 31:49).

"And early in the morning Laban rose up and kissed his sons and daughters and blessed them; and Laban departed and returned to his place" (Genesis 31:55). Van Orley pushed the leave-taking into the distance, while it preempts the lower right third of the San Francisco composition. Considerable independence was shown by the later artist in this bold shift of emphasis.

His artistic invention, however, seems to have lagged behind. Van Orley's variety is replaced by monotony; witness the duplicating pose of the women making their farewell, and the head of the young male in the leave-taking scene repeated again in the altercation scene in the middle distance. Laban's profile from the central foreground episode is repeated exactly in the farewell scene and in the following entry (cat. no. 29). It reappears in a tapestry, *The Story of Ezekiel*, in the Bob Jones University collection, Greenville, South Carolina.[1] These repetitions suggest limited ability or limited imagination on the part of the designer.

The lower border shows three new variations: a lute-playing corner figure on a chariot at left, another at right with an olive branch, and, in the center, a reclining nude with a cornucopia.

NOTE
1. Jean-Paul Asselberghs, *Les tapisseries flamandes aux Etats-Unis d'Amérique* (Brussels: Artes Belgicae, 1974), fig. 24.

The Reconciliation of Jacob and Laban

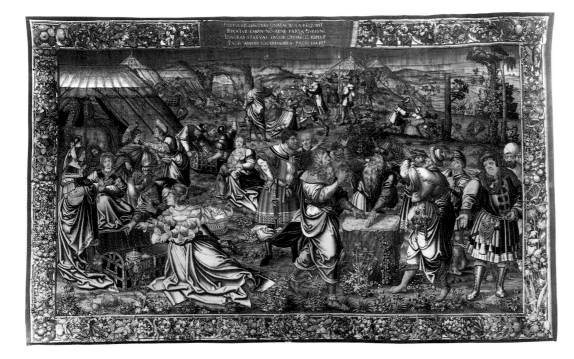

FIGURE 59
Laban, Who Has Rejoined the Fugitives, Concludes a Solemn Alliance with Jacob, tapestry. Musées Royaux d'Art et d'Histoire, Brussels

29. Gathering Manna

from The Story of Moses *Series*

Flemish (Brussels), ca. 1550
H: 4.22 m W: 5.18 m (13 ft. 10 in. × 17 ft.)
WARP: undyed wool, 6–7 per cm
WEFT: dyed wool and silk
MARK: *Weaver* right guard, bottom
Museum purchase (CPLH), 1929.5

The powerful, troubled figure of Moses, the God-inspired leader, stirred the imagination of Renaissance artists. His story is a sequence of divine interventions. The miracle of the manna that saved the Israelites from starvation in the wilderness became a symbol of God's providence.

The passage of the Red Sea lay behind the Israelites, but a pitiless desert stretched before them and they murmured against Moses and Aaron because they had no food. God fulfilled his promise to "rain bread from heaven" (Exodus 16:4). In the morning manna covered the ground, white like coriander seed with the taste of wafers made with honey. God gave careful instructions for its harvesting. An omer (about three and a half quarts) was to be gathered for each person daily, and a double amount to be taken on the sixth day, for no manna would fall on the Sabbath (Exodus 16:22–26).

The large figure of Aaron on the left (see Laban in the preceding entry) points toward the Israelites who have gathered manna in containers of every kind. One can see tents dotting the hills, some grazing cattle, and a camel. Moses, at right, identified by his rod, holds up two fingers of his right hand, a reminder to gather the double amount on the sixth day. A man and woman in the center foreground fill an ornate vessel with the miraculous food.

Roethlisberger astutely observed the resemblance of these two figures to two others in *Rebekah and Eleazar* by van Orley (fig. 60) at the Kunsthistorisches Museum, Vienna.[1] This artistic borrowing is confirmed by the *rinceau* ornamentation of the vessel which has been appropriated from the well decoration of the Vienna panel.

Narrow interlacing ribbon bands on either side of the floral border have a red ground here as on all three *Moses* panels. Variations occur in the border elements. The left-hand corner figure is familiar. The group on the right resembles the traditional representation of Charity: a mother nursing a small child. The central position is occupied by a satyr father, nymph mother, and satyr child.

Dr. Schneebalg-Perelman attributed the weaver's mark found in the right guard to Pieter van Aelst the Younger. She reasons that the older van Aelst, who wove *The Acts of the Apostles* for Pope Leo X, would have been a centenarian in 1550.[2]

NOTES

1. Marcel Roethlisberger, "Deux tentures bruxelloises du milieu du XVIe siècle," *Oud Holland* 86, pt. 2–3 (1971): 107.
2. Sophie Schneebalg-Perelman, "La tapisserie flamande et le grand témoignage du Wawel," in *Les tapisseries flamandes au château de Wawel à Cracovie: Trésors du roi Sigismond II Auguste Jagellon*, ed. Jerzy Szablowski (Antwerp: Fonds Mercator S. A., 1972), 416.

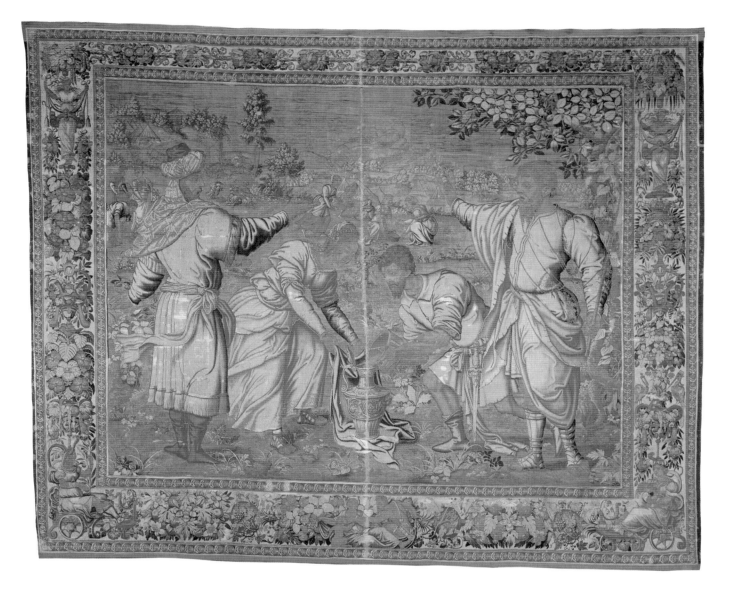

Gathering Manna

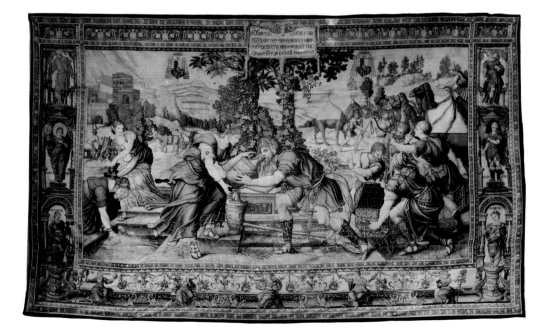

FIGURE 60
Rebekah and Eleazar, tapestry.
Kunsthistorisches Museum, Vienna

30. Joshua Defeating Amalek at the Battle of Rephidim

from The Story of Moses *Series*

Flemish (Brussels), ca. 1550
H: 4.22 m W: 6.30 m (13 ft. 10 in. × 20 ft. 8 in.)
WARP: undyed wool, 6–7 per cm
WEFT: dyed wool and silk
MARKS: *Origin* lower guard, left
 Weaver right guard, bottom
Museum purchase (CPLH), 1930.2

A battle rages across the largest of the *Moses* panels. The Israelites, encamped at Rephidim, have been attacked by Amalek. Joshua leads the resistance while Moses, on a nearby hilltop, secures the Lord's victory through prayer. "And it came to pass, when Moses held up his hand, that Israel prevailed: and when he let down his hand, Amalek prevailed" (Exodus 17:11). Aaron and Hur, on either side of Moses, can be seen supporting the hands of Moses as the tide of battle turns and the Israelite flag moves forward.

The indiscriminate carnage of the old Gothic melee, modified by classical models, has evolved into contests between paired adversaries. Joshua holds Amalek at his mercy, and this posture of victory is repeated elsewhere. The Israelites are generally shown in three-quarter view looking down, and the Amalekites in three-quarter view looking up.

On the evidence of this limited inventiveness, we are perhaps justified in looking elsewhere for the inspiration of the foreground figures of Joshua and Amalek. The five pieces of *The Story of Moses*, noted in 1553 as belonging to Sigismund Augustus of Poland, seem to have included the subject of the Amalekite war.[1] Whether or not these *Moses* panels were part of the large group commissioned from Coxcie is not known.[2] If they do represent a lost series by Coxcie, they might have contributed to the present panel.

Whatever its source, the Joshua figure has relatives and descendants. It closely resembles Hercules in *Hercules and Cacus* at the Musées Royaux d'Art et d'Histoire in Brussels, which Crick-Kuntziger thought might have been designed by Coxcie.[3] Two figures with the poses of Joshua and Amalek, with variations, occupy the foreground of a late sixteenth-century tapestry in a French private collection probably depicting *The Siege of Troy*.[4] Forti Grazzini points out a tapestry from a *David* (?) set at the Château d'Ussé, France, in which there is a figure that duplicates that of the man at right in the *Amalek* panel, who is falling from his already fallen horse.[5]

NOTES

1. Marcel Roethlisberger, "Deux tentures bruxelloises du milieu du XVIe siècle," *Oud Holland* 86, pt. 2–3 (1971): 90 n. 13.
2. Anna Misiag-Bochenska, "Tapisseries historiées: Scènes de la Genèse," in *Les tapisseries flamandes au château de Wawel à Cracovie: Trésors du roi Sigismond II Auguste Jagellon*, ed. Jerzy Szablowski (Antwerp: Fonds Mercator, S.A., 1972), 82.
3. Marthe Crick-Kuntziger, *Catalogue des tapisseries (XIVe au XVIIIe siècle)* (Brussels: Musées Royaux d'Art et d'Histoire, 1956), 49, no. 36, pl. 45.
4. Dario Boccara, *Les belles heures de la tapisserie* (Zoug: Les Clefs du Temps, 1971), 85.
5. Nello Forti Grazzini, personal communication, June 1990.

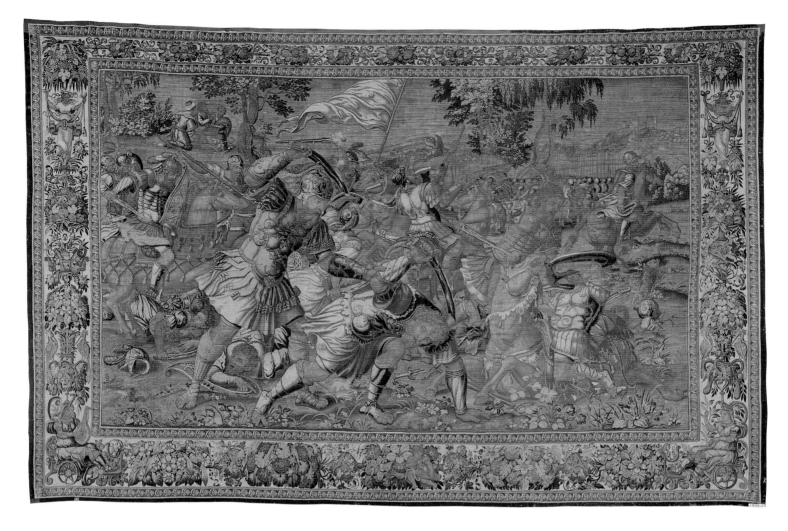

Joshua Defeating Amalek at the Battle of Rephidim

31. Moses Receiving the Tablets

from The Story of Moses *Series*

Flemish (Brussels), ca. 1550
H: 4.24 m W: 4.29 m (13 ft. 11 in. × 14 ft. 1 in.)
WARP: undyed wool, 6–7 per cm
WEFT: dyed wool and silk
MARKS: *Origin* lower guard, left
 Weaver right guard, bottom
Museum purchase (CPLH), 1930.1

Moses kneels with arms upraised to receive from God the Tablets of the Law. Two small angels hold the stone tablets so that the commandments can be "written with the finger of God" (Exodus 31:18). The inscription reads,

VNV / CRE / DE / DEVM / + NEC / IV / RES / VANE
HABE / AS / IN / HONO / RE / PAREM / ES [for
PARENTES]
Believe in one God. Do not swear in vain. Honor thy parents.

A second scene, enacted in the middle distance, is framed by the ivy-bearing tree at the right. Descending from the mountain with the tablets, Moses discovers the Israelites dancing around the Golden Calf as Aaron stands passively by. Moses' anger is expressed in the torsion of his body as he lifts the sacred tablets to dash them to the ground.

A long diagonal composition dramatizes the contact between God and Moses. Van Orley used the same device to show God commanding Abraham in *The Departure of Abraham for Egypt* (fig. 61) at the Kunsthistorisches Museum, Vienna.[1] From the surviving examples, van Orley's Abraham seems the basic model for the patriarch communicating with God. The Moses of The Fine Arts Museums' panel is an inflated version of Abraham, paired with a God borrowed from the *Adam and Eve* panel at Florence's Accademia, attributed to Vermeyen.[2]

NOTES
1. Marcel Roethlisberger, "Deux tentures bruxelloises du milieu du XVIe siècle," *Oud Holland* 86, pt. 2–3 (1971): 107.
2. Roethlisberger, "Deux tentures," 107–108.

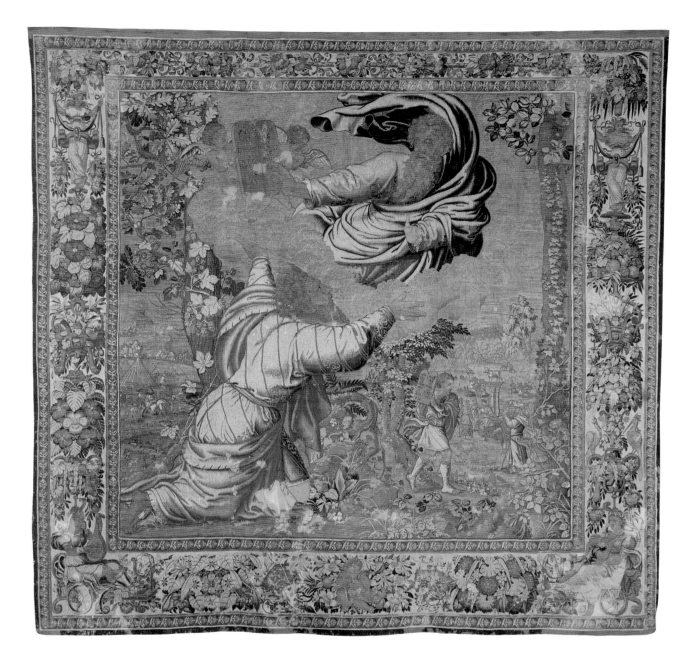

Moses Receiving the Tablets

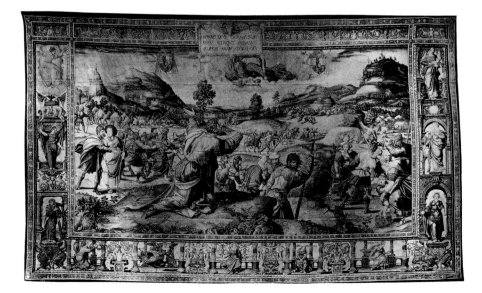

FIGURE 61
The Departure of Abraham for Egypt, tapestry.
Kunsthistorisches Museum, Vienna

32. Verdure with Peasant Dance

Flemish (Brussels), 1550–1575
H: 3.10 m W: 2.79 m (10 ft. 2 in. × 9 ft. 2 in.)
WARP: undyed wool, 5–6 per cm
WEFT: dyed wool and silk
MARKS: *Origin* lower guard, left
Gift of Mrs. Louis Sloss (CPLH), 1953.30

A tapestry is called a *verdure* when its main subject is the greenwork of nature: landscapes, forests, leaves, and fruit. Animals, hunters, and mythological beings are the usual additions to the verdure; a genre scene is somewhat unexpected. The present panel is divided visually into two triangles. The left is filled with the rich disorder of a dense thicket of greenery. Foxgloves bend above two large-scale rabbits in the foreground. Vines, heavy with grape clusters, encircle the trunk of an oak. The right upper portion of the tapestry shows villagers dancing in a clearing bordered by steep-roofed houses, with the village church visible at the right edge. The couples perform different figures of a dance to music supplied by an instrument that seems to be a kind of bagpipe.

The border is closely related to those that surround the *Story of Jacob* and the *Story of Moses* panels (cat. nos. 26–28, 29–31). Two narrow bands of pale blue ribbons intertwine on a red ground. Between them, fruit, flowers, and mythological figures are connected by a red grillwork. The top border, as in the *Moses* and the *Jacob* panels, is narrower than the other three. Female figures on miniature triumphal chariots anchor the corners, and a female figure with a curved horn (Fame?) marks the midpoint of the lower border. The grill ascends vertically from the chariots, holding masses of fruit and flowers, and imprisoning slim standing figures high on each side. These hold up ribbons with pendant fruit garlands.

The Antwerp artist Cornelis Floris was the first to playfully imprison nymphs and satyrs in metal cages (see cat. no. 38). The designer of the present borders, identified as designer of the *Jacob* and *Moses* borders, was probably also an Antwerp artist working in the spirit of Floris, if not under his direct influence. He was, perhaps, in the entourage of the artist who designed the grotesque borders for the magnificent suite at Wawel Castle, Kraków, Poland.[1]

NOTE

1. Magdalena Piwocka, "Les tapisseries à grotesques," in *Les tapisseries flamandes au château de Wawel à Cracovie: Trésors du roi Sigismond II Auguste Jagellon*, ed. Jerzy Szablowski (Antwerp: Fonds Mercator, S.A., 1972), 312–330.

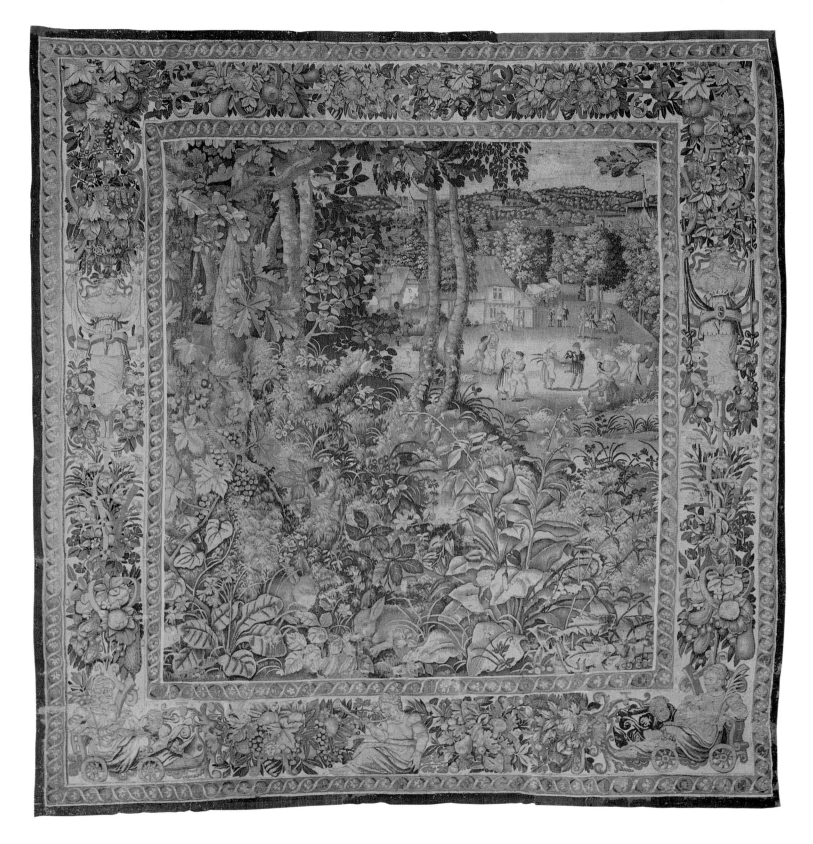

Verdure with Peasant Dance

33. The Ostriches

Flemish (probably Brussels), ca. 1570

H: 3.43 m W: 2.51 m (11 ft. 3 in. × 8 ft. 3 in.)

WARP: undyed wool, 5–7 per cm

WEFT: dyed wool and silk

California Midwinter International Exposition, 1895 (de Young),
3748

Two ostriches of monumental size are arranged like a habitat group in a natural history museum. The nearer one stares fixedly at her eggs, which lie uncovered amid the rich vegetation. The other, surprisingly simian, ignores the eggs and reaches up to taste the grapes hanging overhead. Tree trunks on either side frame a clearing in the mid-distance where ostriches strut in the sunlight. Delicate, Raphael-inspired grotesque elements form a border between two bands of interlacing ribbons. Time has taken a heavy toll in faded color, and areas of reweaving blur the design in several places. The fascination of the panel remains, however, heightened by its unusual iconography and its relationship with the great tapestry suites from which it derives.

The geographical discoveries of the sixteenth century stimulated interest in the natural sciences. Numerous zoological treatises appeared at mid-century, most of them profusely illustrated by woodcuts.[1] Familiar animals were drawn from observation, the more exotic ones from descriptions or from fantasy. These animals provided the theme for a remarkable group of animal verdures, which enjoyed a great vogue in the 1560s. The animals, at rest or in combat, are depicted in a luxuriant forest in which man has no place. Two magnificent series of this type survive at Wawel Castle, Kraków, and at the Palazzo Borromeo, Isola Bella, near Milan. Roethlisberger made the basic study of the Borromeo tapestries, analyzing their relationship to the animal verdures of Wawel.[2] *The Ostriches* of The Fine Arts Museums and a related piece at the Musée Lorrain, Nancy, belong to a later, more modest series on the theme. Their kinship with their distinguished relatives, however, is unmistakable.

These landscapes with animals date from the third quarter of the sixteenth century, when the new interest in zoology fused with the legacy of the Bestiaries, incorporating both their fabulous and biblical elements. Although they appear purely descriptive to us, in their own time they carried a heavily didactic message. The principal source was the Bible, as is clearly shown in *The Ostriches*, which corresponds to the left side of a tapestry in the Borromeo collection. The latter carries the inscription from Job 39:14–15: DESERIT IN TERRA OVA SUA UT IN PULVERE FOVEANTUR NEC COGITAT PEDIBUS EA DISSIPARI ET A

BESTYS CONCULCARI POSSE. ETC. JOB XXXIX. PROVIDENTIA DEI OMNIA GUBERNANTUR. ([The ostrich] abandons her eggs on the ground, leaving them to warm in the dust. She forgets that a foot could tread on them, a wild beast could crush them, etc. . . . God's Providence governs the world.)[3] The interpretation of this text presents difficulties. The ostrich, represented in the book of Job as a stupid animal, seems a strange example to follow. Mercedes Viale Ferrero's penetrating study clarifies the matter. Saint Jerome explained that the ostrich lacked only worldly wisdom. Counter-Reformation writers developed the point that simple souls could come to know God more easily, trusting in his providence. The ostrich, a simple animal, is shown eating the grapes which are a symbol of the Church, of Christ's sacrifice, and of life eternal (John 15:5). The attention of the other ostrich is directed back toward the eggs. Viale Ferrero refers to the belief that after ostriches lay eggs, they stare at them to hatch them by means of rays coming from their eyes.[4]

The old name for the Wawel tapestries was *pugnae ferrarum*—battles of the wild beasts. The Nancy panel (fig. 62) fits this description. A lynx devours a fox or a wolf in the foreground; at the water's edge a partridge family watches as a bird of prey flies off with one of the chicks. Viale Ferrero interprets this scene as corrupted Nature. The original goodness of Nature has been corrupted by sin.[5]

The grotesque border that encloses both panels has delicacy and charm. It recalls the type designed by Raphael and woven by Pieter van Aelst for the Vatican *Acts of the Apostles* (1519). But here the grotesque elements are arranged to interact humorously with one another. Fanciful creatures play with the large masks and heads; animals sprout from *rinceaux* flowers.

Willem Tons the Elder, believed to have worked with Bernard van Orley, was long regarded by Polish scholars as author of the verdure cartoons. Roethlisberger endorsed this attribution in writing of the Borromeo pieces. Later, Dr. Bernasikowa of Kraków suggested the cartoons had come from the Antwerp workshop established by Pieter Coecke van Aelst to produce cartoons for Brussels weavers. The artist was probably in the entourage of his son, Pieter Coecke van Aelst the Younger.[6] The designer of

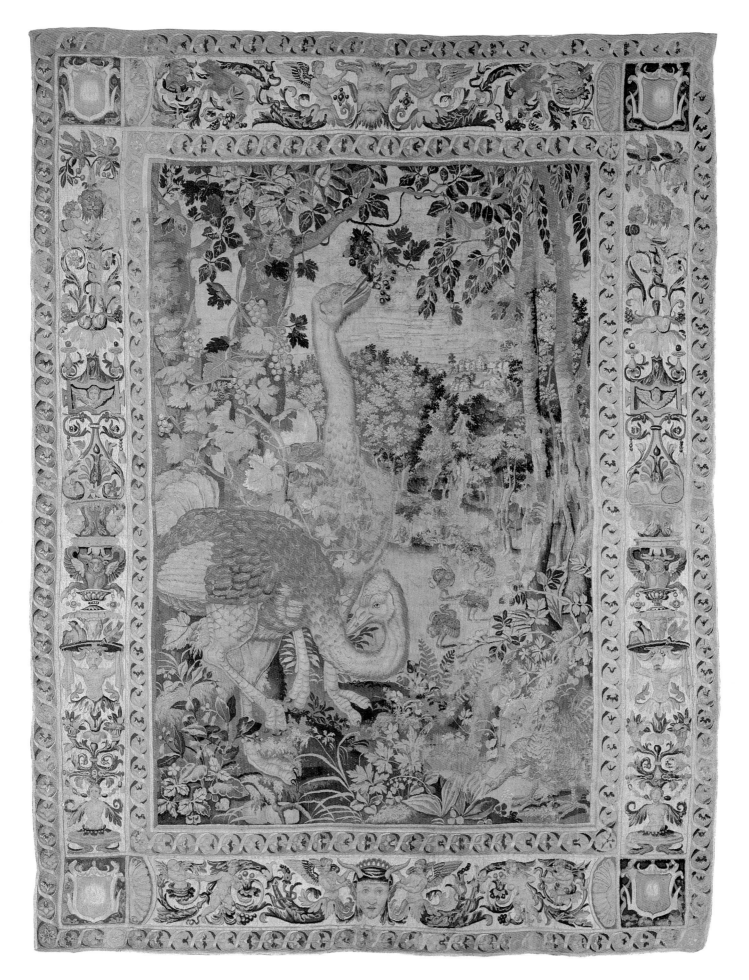

The Ostriches

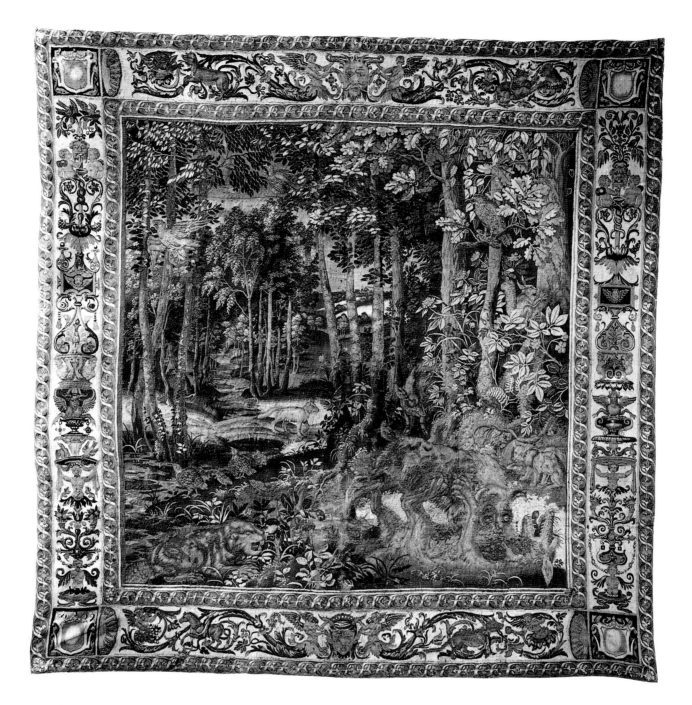

FIGURE 62
Verdure, tapestry. Musée Lorrain, Nancy

34. Large-leaved Verdure

Flemish (possibly Grammont), 1550–1560
H: 2.79 m W: 3.96 m (9 ft. 2 in. × 13 ft.)
WARP: undyed wool, 4 per cm
WEFT: dyed wool
Gift of Charles de Limur and his sister, Mary Ethel Weinmann,
 74.28

An immense plant with curling, dentated leaves fairly bursts from its frame of fruit and flowers. Its surrealist forms of greenish blue are charged with animal energy. Here and there, the leaves' crisp outlines are interrupted by delicate floral sprays, exotic birds, snails, and dragonflies. Urns and vases with grotesque masks decorate the golden-tan frame. From these containers, bunches of flowers, fruit, and leaves extend laterally into the picture plane and hang from above and below in heavy swags.

Splendidly decorative pieces such as this are often called *feuilles de choux*. The leaves resemble those of the thistle more than the cabbage, but they are rooted in fantasy. The success of this type in the mid-sixteenth century is proven by the great numbers that have survived. Oudenaarde and Grammont (Geerardsbergen) competed in this genre, and their products are virtually indistinguishable.[1] Asselberghs[2] observed that those of Oudenaarde tend to show a paler color scheme, often including yellow; but the dark-background type is also traceable to that center.[3]

NOTES

1. Jean-Paul Asselberghs, *Les tapisseries flamandes aux Etats-Unis d'Amérique* (Brussels: Artes Belgicae, 1974), 27.
2. Jean-Paul Asselberghs, remarks made at The Art Institute of Chicago, recorded by Christa Mayer Thurman, ca. 1970.
3. The type is illustrated by Heinrich Göbel in *Wandteppiche. I Teil: Die Niederlande*, 2 vols. (Leipzig: von Klinkhardt & Biermann, 1923), 2: no. 441 ("St. Truijen?") and no. 470 ("Geerardsbergen [Grammont]"); Dario Boccara, *Les belles heures de la tapisserie* (Zoug: Les Clefs du Temps, 1971), 108 ("Enghien"); Edith A. Standen, *European Post-Medieval Tapestries and Related Hangings in The Metropolitan Museum of Art*, 2 vols. (New York: The Metropolitan Museum of Art, 1985), 1:177–179, no. 24 (two fragments with Grammont mark, other similar pieces listed).

Large-leaved Verdure

Verdure with Landscape and Animals

36. Córdoba Armorial

Spanish, ca. 1625
H: 2.51 m W: 2.39 m (8 ft. 3 in. × 7 ft. 10 in.)
WARP: undyed wool, 4–5 per cm
WEFT: dyed wool
Gift of Richard B. Gump (de Young), 44.28.1

The central shield is that of the first marqués de Huétor de Santillán, Don Diego Fernández de Córdoba, who married Doña María de la Cueva Bazán y Benavides, a daughter of the seventh conde de Santisteban del Puerto. Her family arms form the right part of the shield, Don Diego's the left half.[1]

The shield, set against a field of dark blue, has a fanciful outline of metal scrolls and extrusions. Small flags with curling strings and tassels surround it on three sides. These flags may represent the territories of the family dominions. The corners are filled with a graceful linear design suggesting decorative ironwork.

Above the shield is a band with the motto SINE IPSO FACTVM EST NIHIL (Without him nothing is accomplished). This kind of pious statement is not infrequently found on armorials. A similar motto is known in English heraldry: *Sine deo nihil*. Both mottoes may derive from the words of Jesus in John 15:5: "Without me ye can do nothing" (*Sine me nihil potestis facere*).

The panel has a wide border which supports a late-sixteenth- or early seventeenth-century date. It is filled with a rather crude strapwork design emphasized at the midpoints. Four small family crests occupy the corners. Beginning at upper left and reading clockwise, they are Córdoba, Santillán, Carrillo, and Mendoza de la Vega. The Mendoza de la Vega crest at lower left represents the union of the Mendoza and the de la Vega families. The inscription of *Ave Maria*, which rightly belongs with it, is shown in the tapestry as AVEM ARIA.

Neither the author of the design nor the place of origin is known. It has been established that certain ateliers, like that of Pedro Gutiérrez of Salamanca, specialized in armorial pieces. This weaver moved to Madrid before 1600.[2]

NOTES
1. Dálmiro de la Válgoma, letter to Dr. Paulina Junquera de Vega, Madrid, 17 February 1973.
2. Heinrich Göbel, *Wandteppiche. II Teil: Die romanischen Länder*, 2 vols. (Leipzig: von Klinkhardt & Biermann, 1928), 1:466.

BIBLIOGRAPHY
Thomson, F. P. *Tapestry: Mirror of History*. New York: Crown Publishers, 1980, 106.

Córdoba Armorial

37. Guardiola Armorial

Spanish, before 1645
H: 2.46 m W: 2.24 m (8 ft. 1 in. × 7 ft. 4 in.)
WARP: undyed wool, 4 per cm
WEFT: dyed wool
Museum collection (CPLH), Z1973.1

The tapestry displays the arms of the ancient Guardiola family whose residence was within the walls of the city of Barcelona, near the monastery of San Pedro de la Puellas. It may have been woven for Garau de Guardiola y Ferrero, Perpetual Bailiff General of Barcelona and of the Principality of Catalonia.[1] He was made Gentleman of the Order of Calatrava on 31 March 1645 (Archivo Histórico Nacional de Madrid). Since the Order of Calatrava does not appear on the arms, the tapestry was probably woven before the date of his ennoblement.

Puns are not unusual in heraldry. The Guardiola who chose the device of the eye for his coat of arms exploited the similarity of his name to the word *guardia*, or "guardsman." The guardsman's characteristic watchfulness is expressed by the symbols of the eyes, shield, helmet crest, and corner motive, and is stated explicitly in the motto: IN PACE ET BELLO PERSPICACES (Sharp-sighted in peace and in war). Two baleful eyes stare from the central shield on either side of a dentate band.[2] The helmet has a peacock for crest, recalling the mythical guardian, Argus, who had a thousand eyes. In each corner stands a small crane, like a sentinel, holding a stone in its claw. Should the crane fall asleep on guard, the stone would fall, recalling it to duty. The crane is therefore a symbol not only of watchfulness, but of prudence (see cat. nos. 22 and 24, *The Triumph of Prudence* and *The Triumph of Justice*). These ideas about the crane are ancient and are found in Pliny, Horapollo, Erasmus, and P. Valeriano.[3] A study of the subject was made in 1957 by H. M. von Erffa.[4]

The conservative quality of Spanish art can be appreciated by comparing this armorial with the preceding one, woven earlier. Certain features remain constant: the general color scheme of orange, gold, tan, and blue; the strapwork border with midpoint emphasis. Ironwork scrolls surround both shields, and corresponding forms fill the corner spaces of both main panels. The changes are equally instructive. The strapwork shows new three-dimensionality, and the motto threaded through its scrolling forms furthers this new illusion of space.

Although Göbel states that tapestry weavers were known in Barcelona in the fifteenth and sixteenth centuries,[5] the designer and weaver of this tapestry are unknown.

NOTES
1. Alberto Carraffa and Arturo García, *Enciclopedia heráldica y genealógica* (Madrid, 1931), vol. 2, s.v. "adarga catalana," 147–148.
2. Carraffa and García, *Enciclopedia*, 2:153.
3. John Shearman, *Raphael's Cartoons in the Collection of Her Majesty the Queen and the Tapestries for the Sistine Chapel* (London: Phaidon, 1972), 54, n. 53. I owe this reference to Nello Forti Grazzini.
4. H. M. von Erffa, "Grus vigilans," *Philobiblon* 1 (1957): 286–308. I owe this reference to Guy Delmarcel.
5. Heinrich Göbel, *Wandteppiche. II Teil: Die romanischen Länder*, 2 vols. (Leipzig, von Klinkhardt & Biermann, 1928), 1:459–462.

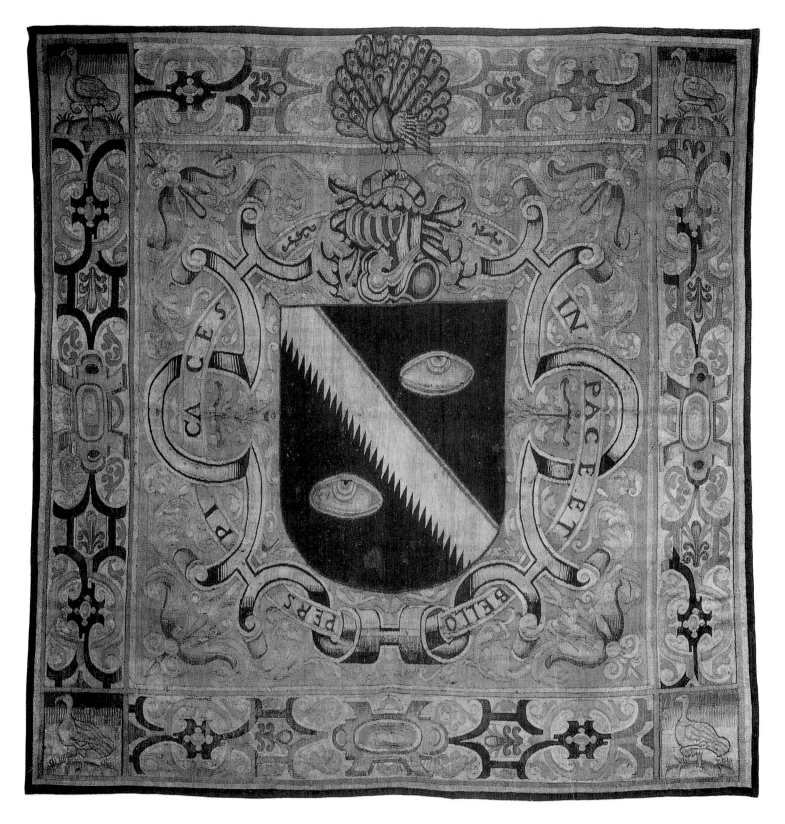

Guardiola Armorial

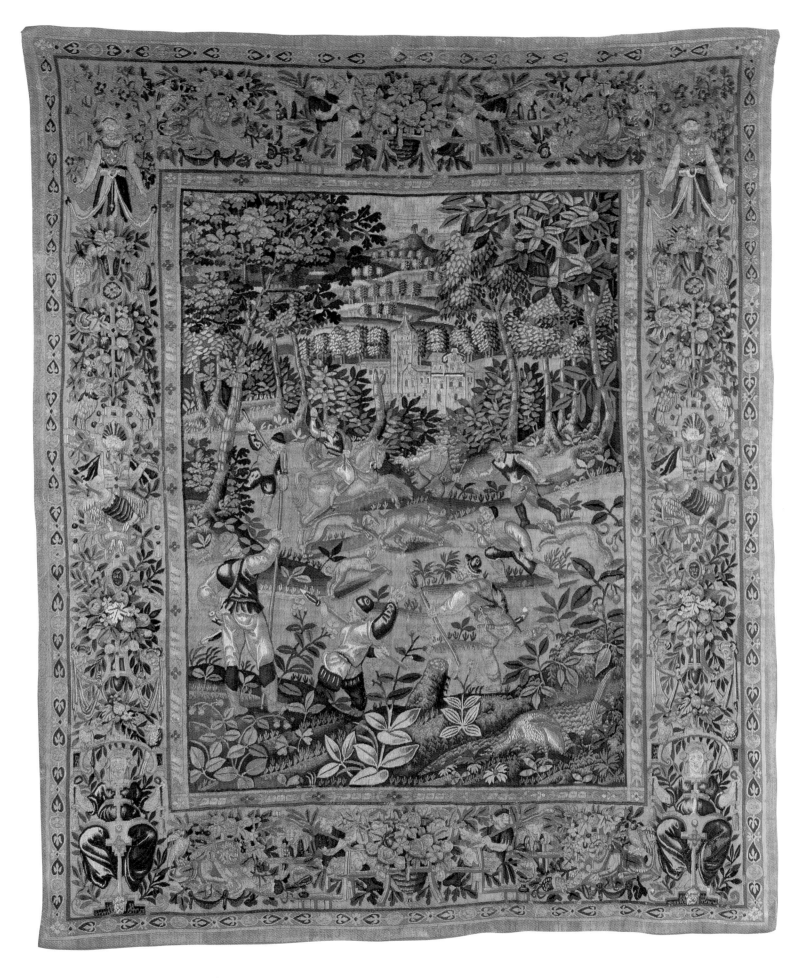

Bear Hunting

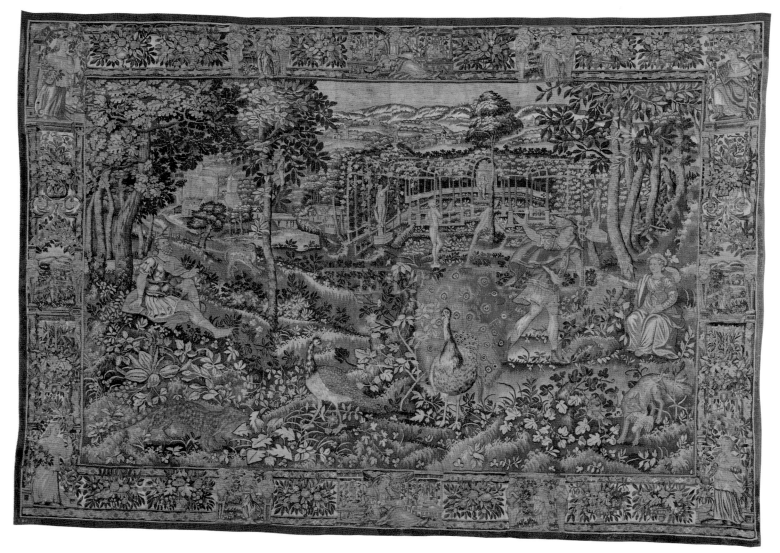

Io Rescued from Argus by Mercury

40. Garden Scene

Flemish (Brussels), ca. 1585
H: 3.40 m W: 3.96 m (11 ft. 2 in. × 13 ft.)
WARP: undyed wool, 7 per cm
WEFT: dyed wool and silk
MARK: *Weaver* right guard, bottom
Bequest of Hélène Irwin Fagan (CPLH), 1975.5.24

Mythological beings in tapestries often symbolize the elements or the seasons (see cat. nos. 74–77). One of the figures in this garden landscape may represent Ceres, goddess of harvest and summer. Her presence might be corroborated by the scene at right, in which hay is cut, raked, and piled onto a wagon.

The figures are all but submerged in the descriptive detail that surrounds them. The eye moves from the rich botanical cover of the foreground to explore multileveled terraces, up steps, over bridges, into airy pavilions, and through the ivied pergolas of a Renaissance villa. Turkeys from the New World are among the many small animals inhabiting this garden. Introduced into Spain in the early 1500s, they were widely dispersed over Europe by the century's end.

Segmented borders came into vogue in the last quarter of the sixteenth century, combining many kinds of thematic material, often without strict symmetry. Emblematic animals, grotesques, small scenes in cartouches, and allegorical figures—none of them having any obvious connection with the main picture panel—were the common components.

The allegorical figures are of particular interest because they can be traced to borders designed for *The Acts of the Apostles* woven for Philip II.[1] Erik Duverger's study of related border figures on tapestries at Munich and Plassenburg ob Kulmbach[2] helps with the identification of the allegorical beings surrounding the *Garden Scene*, as does that by Edith Standen of two tapestries in The Metropolitan Museum of Art, New York.[3]

The two figures on either side of the central cartouche of the lower border are Peace (left) with an olive branch, holding the paw of a tame lion; and Obedience (right) with a book on her knee, holding a bundle of switches. Obedience shows respect for the written law and willingness to accept punishment. The corresponding places in the upper border are occupied by Victory (left), sitting on a base decorated with a trophy of arms, holding a mace with metal spikes and a falcon. Duverger identifies the

figure on the opposite side as Prudence. She has wings on her head, holds a sphere and a lance. She has also been called Fortune and Providence. The allegorical figures of Knowledge and Philosophy, as described by Cesare Ripa,[4] conform more or less with this image, having winged heads and holding a globe or ball. At the top of the vertical border, left, Grammar has written a few letters on a tablet.[5] Certainly it is Architecture who sits across from Grammar, holding a carpenter's square and equipped with plumb lines. Music occupies the lower left corner. The figure opposite Music may be Prudence or Foresight, who studies her mirror, and may have a second face which looks behind.

Other elements are enclosed by herms and columns, joined here and there by vestiges of *ferronnerie*. The animal scenes may also have symbolic meaning, as, for example, the fox with the birds in the left border.[6]

A somewhat similar border appears on a *Story of Alexander* in the Kunsthistorisches Museum, Vienna.[7] The borders on the series in Vienna do not seem to fit their main scenes well, leading one to surmise that they may have been appropriated from another set. One, at least, retains its weaver's mark, an *H* surmounted by a *V*, with an *I* between the arms of the *V*. Edith Standen, following Duverger, identifies this mark as probably that of Joost van Herzeele, who worked in Brussels and in Antwerp in the late sixteenth century. The mark on *Garden Scene* is new, but was presumably copied from the original mark when the guards were replaced.

NOTES

1. Edith A. Standen, "Some Sixteenth-Century Flemish Tapestries Related to Raphael's Workshop," *Metropolitan Museum Journal* 4 (1971): 119.
2. Erik Duverger, "Tapisseries de Jan van Tieghem representant l'histoire des premiers parents, du Bayerisches National Museum de Munich," in *L'art brabançon au milieu du XVIe siècle et les tapisseries du château de Wawel à Cracovie: Actes du colloque international, 14–15 décembre 1972. Bulletin des Musées Royaux d'Art et d'Histoire* 45 (1973; offprint, Brussels, 1974): 23–29.

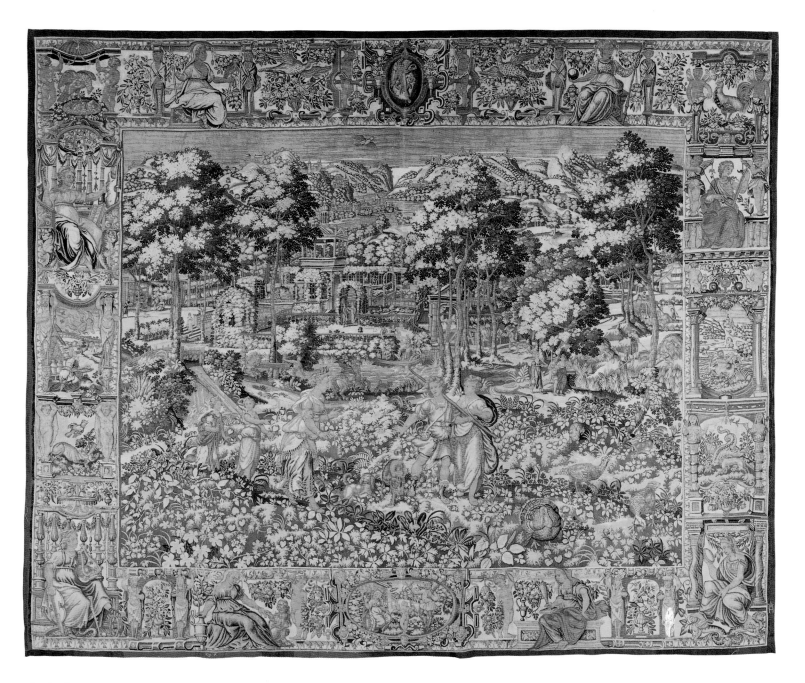

Garden Scene

41. The Bear Hunt

Flemish (Brussels), 1575–1580
H: 3.60 m W: 2.95 m (11 ft. 10 in. × 9 ft. 10 in.)
WARP: undyed wool, 6 per cm
WEFT: dyed wool and silk
MARK: *Weaver* lower right guard
Gift of Mr. and Mrs. Mortimer Fleishhacker (de Young), 44.27

Hunting was a preoccupation and a passion among the pleasure-loving nobility of Renaissance Europe. Their hunts were carried out with great style and with elaborate ritual involving large retinues of servants. Every stage of the hunt has been recorded in words or in images, from the early preparations to the final moment. The importance of hunting is attested by the frequency with which it appears in the tapestries destined for these same noble patrons.

The eye descends from the majestic snowcapped mountains at the top of the panel through slopes dotted with round trees and buildings to a château at the foot of the hill. Towers, gables, and an arcade overlook a formal garden with a pond at left and a herm-guarded pergola at right. This vista is framed by the thick and minutely described foliage of trees rooted in the clearing, where the final moments of the hunt take place. The action is separated from the picture plane by a *repoussoir* of large-scale plants rendered with a botanist's accuracy.

Two peasant huntsmen with spears rush at the bear, which is sitting upon a third hunter equipped with a shield. Set upon by the dogs, the bear has pinned one of the tormentors to its side and holds up a free paw in supplication or in defiance. A second bear approaches from the left. Another huntsman with a spear hurries toward the bear. He is accompanied by a hatless, richly dressed hunter, obviously the master, who loads his gun from a powder horn, preparing for the kill. Dr. Helmut Nickel identified the small triangular powder horn hanging from the man's waist as the container for fine powder used in the priming.[1] The hunter pours from a larger powder horn that holds coarse powder for the charge itself. The fact that all the action is left-handed is a result of low-warp weaving.

The grotesque elements in the compartmented border, recalling those introduced by Raphael fifty years before, are combined freely with flower-filled vases and small scenes. Depicted in the cartouches are (left) strolling couples and riders in a landscape similar to that of the central panel; (right) the killing of pigs; (top) another couple strolling before a castle and formal garden; (bottom)

Orpheus playing his lyre before Pluto, Persephone, and Cerberus. The allegorical figures in the corners are (clockwise from upper left) Peace, Justice, Prudence, and Abundance.

Minerva, the figure of Peace, wears a short military tunic, but her peaceful aspects are emphasized. Her shield is underfoot and her helmet is tossed aside. She holds a spear in her right hand, a book in her left. A lion's skin is draped over her shoulder and covers her head. Justice balances Good against Evil; the cross outweighs the jewels in her pair of scales. Prudence studies her image intently in the mirror ("Know thyself"), as she holds the serpent of eternity, which bites its own tail. Opposite is the graceful figure of Abundance, her cornucopia filled with flowers.

The designer is unknown. The weaver's mark on the San Francisco panel has been rewoven in its upper half. It might have once conformed to the mark found by Jacqueline Versyp on related panels.[2] Six hunting tapestries at the Museo di Palazzo Venezia, Rome, have been related by Versyp to panels at Laarne, Belgium, and other pieces including the present panel at The Fine Arts Museums. The Roman group all bear the arms of the Vidoni family. A glance at one of these, *The Hunt of the Buffalo* (fig. 63), shows the closeness of the relationship.[3] This piece has evidently been woven partly on the same cartoon, with the large mythological figures superimposed. A buffalo is substituted for the bear, and changes occur in the border.[4]

The attack on the bear reappears in a tapestry sold at the Parke-Bernet auction of 19 September 1952, no. 273, and in a panel with the mark of Corneille Tseraets sold in Munich in 1973.[5] The present panel was sold by Galerie Georges Petit, 4 December 1925, no. 105.

NOTES
1. Personal communication.
2. Jacqueline Versyp, "Zestiende-Eeuwse Jachttapijten met het Wapen van de Vidoni en Aanverwante Stukken," *Artes Textiles* 7 (1971): 23–46.
3. Mercedes Viale and Vittorio Viale, *Arazzi e tappeti antichi* (Turin: ILTE, 1952), no. 46, pl. 47.
4. Versyp, "Zestiende-Eeuwse Jachttapijten," 23–46.
5. Viale and Viale, *Arazzi*, no. 46.

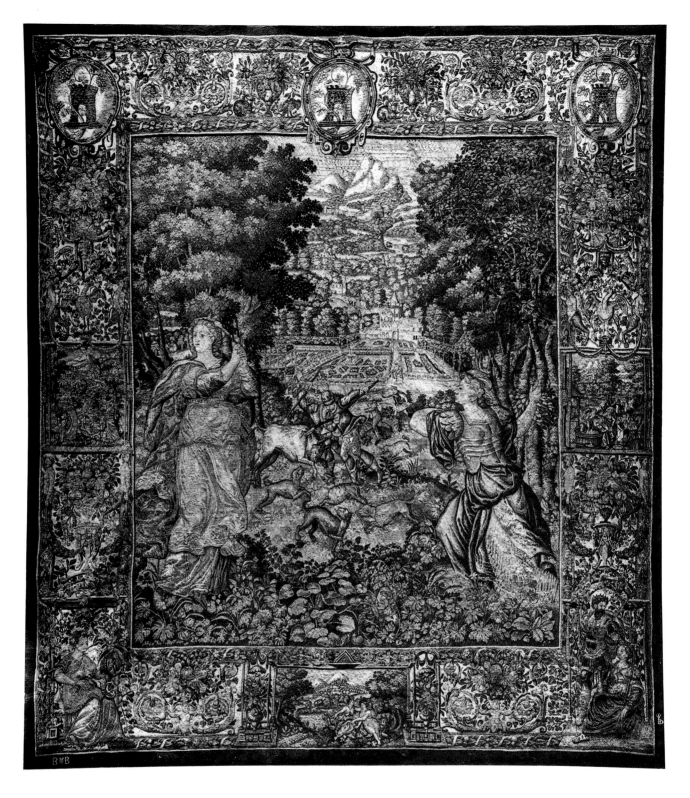

FIGURE 63
The Hunt of the Buffalo, tapestry. Palazzo Venezia, Rome

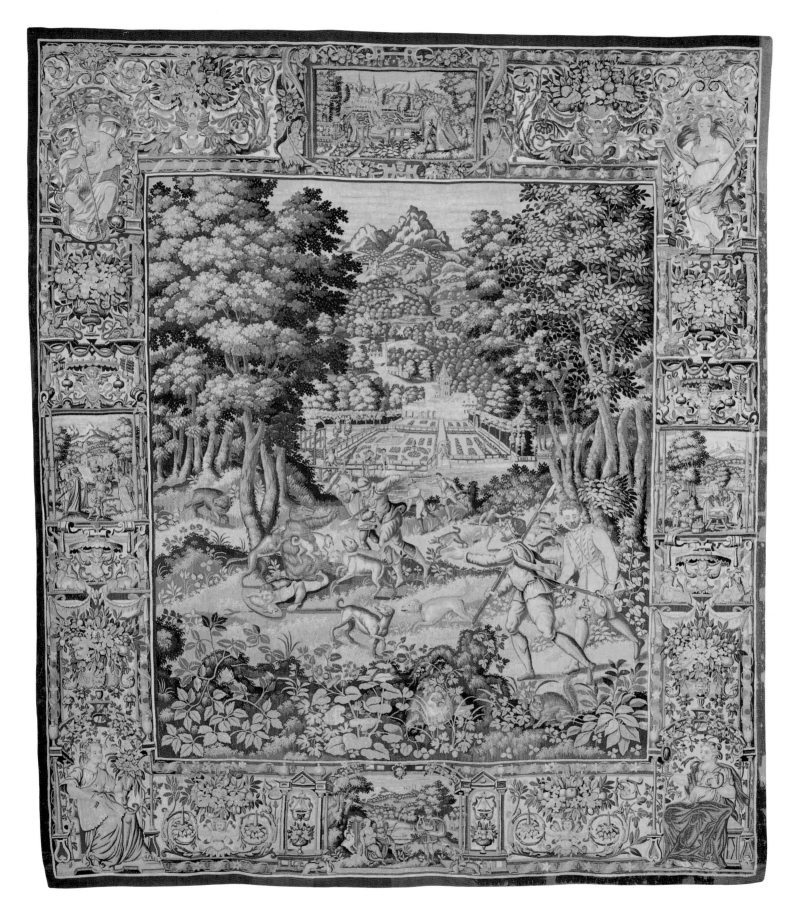

The Bear Hunt

The Story of Cyrus the Great *Series*

The mythical history of Cyrus the Great inspired two important tapestry series in the sixteenth century. The quasi-historical tale of royal ambition and treachery, although remote in time and place, had contemporary parallels and interest for Renaissance viewers, and it allowed the tapestry designers to show rich costumes and settings and to depict dramatic action.

The facts of the historical Cyrus, stripped of legend, are minimal. He was born in 558 B.C., son of Cambyses I. He founded the Persian Empire, was attacked by a coalition of Babylon, Egypt, Lydia, and Sparta, and fell in an expedition against the East about 530–528 B.C. In *The Histories* of Herodotus, Cyrus was the grandson of Astyages, king of the Medes. His military successes were achieved by guile, and death came as he was fighting a barbaric Scythian queen.[1]

The first *Cyrus* series, designed about 1535, is represented by five panels at the Isabella Stewart Gardner Museum, Boston.[2] They deal with Cyrus's youth and early successes. The series must once have been more extensive, for the last panel arrests the story at an indecisive point. The mark of Brussels, Jan der Moyen,[3] and an unidentified weaver appear on some of the panels.

Another *Cyrus* series was designed in the second half of the sixteenth century. Michel Coxcie has been proposed as designer of the first editions of this second series, but his authorship is unproven.[4] The Patrimonio Nacional of Spain owns two sets, one of which is enriched with golden threads. It was sent from Madrid to Toledo for the funeral of Francis II of France in 1560. The signatures of Jan van Tieghem and Nicolas Leyniers appear on pieces of the first set, Series 39. The pieces of the second set, Series 40, are from revised cartoons. Both sets include two episodes common to the San Francisco collection, *Cyrus Captures Astyages* and *The Victory of Queen Tomyris*.[5]

The designs were woven several times, with various borders. Those of the Spanish collection have a dominant motive of animals, other sets combine Virtues and floral forms. The tapestries at The Fine Arts Museums, woven about 1600, have the same borders as a pair at the City Art Museum of St. Louis, Missouri.[6] Fruit and flowers, stiffly arranged in an ornate vase, are held in a frame embellished with amorini, grotesques, and vines. Small scenes in strapwork frames interrupt the borders at mid-point. Virtues in herm-guarded pergolas occupy the corners. The two in St. Louis show a mark interpreted as an interlacing *W* and *S*, possibly the mark of Willem Segers.[7]

Other editions of *Cyrus* are known, among which are four pieces by Jan van Tieghem once owned by the countess of Clanwilliam (sold Christie's, London, 8 November 1979). Another set of four belongs to the marquess of Bath at Longleat House, Warminster. Two cut pieces in Milan, Fondazione Bagatti-Valsecchi, will be catalogued by Nello Forti Grazzini, to whom I owe the information about these related pieces.

NOTES

1. Herodotus, *The Histories* (reprint, Baltimore: Penguin Books, 1968), vol. 1, 107–216.
2. Adolph S. Cavallo, *Textiles: Isabella Stewart Gardner Museum* (Boston: Trustees of the Isabella Stewart Gardner Museum, 1986), 48–55.
3. Guy Delmarcel, "Jules Romain: L'histoire de Scipion. Tapisseries et dessins," *Bulletin Monumental* 136 (1978): 369.
4. Nello Forti Grazzini, personal communication, June 1990.
5. Paulina Junquera de Vega and Concha Herrero Carretero, *Catálogo de tapices del patrimonio nacional*, vol. 1, sixteenth century (Madrid: Editorial Patrimonio Nacional, 1986), 179–284 (nine pieces); 290–296 (six pieces).
6. Jean-Paul Asselberghs, *Les tapisseries flamandes aux Etats-Unis d'Amérique* (Brussels: Artes Belgicae, 1974), 32.
7. *Bulletin of the City Art Museum of St. Louis* 5 (1920): 4–7, illus.

EXHIBITION

Retrospective Loan Exhibition of European Tapestries, San Francisco Museum of Art, 1922, nos. 26 and 27. Catalogue by Phyllis Ackerman.

42. Cyrus Captures Astyages

from The Story of Cyrus the Great *Series*

Flemish (Brussels), ca. 1600
H: 3.56 m W: 4.57 m (11 ft. 8 in. × 15 ft.)
WARP: undyed wool, 6–7 per cm
WEFT: dyed wool and silk
Gift of Mr. and Mrs. Daniel C. Jackling (de Young), 52.24

Young Cyrus, wearing the victor's laurel, offers to restore to his grandfather, Astyages, the crown he has just won from him in battle. Astyages, hand on heart, appears moved by the magnanimity of this grandson whose death he planned. Soldier guards close the composition at right as do bound captives at left. Underfoot is a carpet of leafy plants; the "thousand flowers" of Gothic times has become a "thousand leaves."

The middle ground shows varied activity. The peaceful rusticity of the extreme left—woodchopping and picnicking—becomes progressively more disturbed, leading through military skirmishes to invasions of an armed camp at right. Further back the scattered houses of a village are surmounted by castle-crowned foothills and fantastic mountain peaks.

An unusual feature of this piece is the attempt to show the exotic costumes of an alien culture, in contrast to the earlier *Cyrus* scenes in the Gardner series, in which the designer put Medes, Persians, and Scythians in the European court costumes of the day. Herm-guarded pergolas occupied by Virtues fill the corners, and smaller-scale Virtues are repeated in the upper and lower borders.

The Virtues in the borders can be identified by their attributes. Justice with scales sits at lower left. She is balanced by a Virtue, perhaps Hope, holding a flowering branch. Those in the corresponding positions at the top may be identified as Peace and, perhaps, Valor. Prudence with her mirror is at the right side of the top and bottom borders, with an unspecific counterpart at left.

A tapestry with nearly identical borders was sold by Semenzato-Nuova Geri, Milan, 17 April 1986, lot 230. It has the same weaver's mark as the Vidoni Hunts in Rome, illustrated with catalogue no. 41, figure 63.[1] Some connection must exist between the weaver of the *Cyrus* panels in St. Louis and San Francisco, since a nearly identical border was used.

NOTE
1. Nello Forti Grazzini, personal communication, June 1990.

EXHIBITION
Retrospective Loan Exhibition of European Tapestries, San Francisco Museum of Art, 1922, no. 26. Catalogue by Phyllis Ackerman.

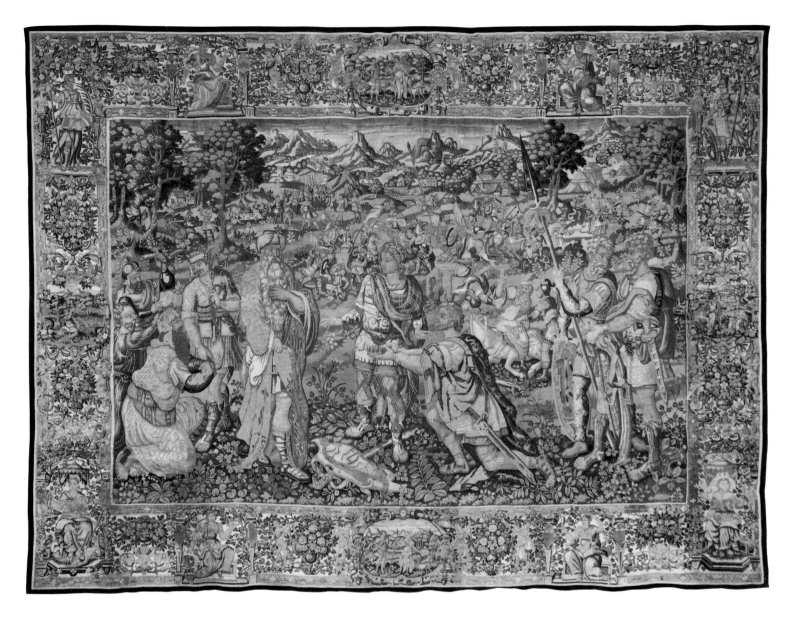

Cyrus Captures Astyages

43. The Victory of Queen Tomyris

from The Story of Cyrus the Great *Series*

Flemish (Brussels), ca. 1600
H: 3.51 m W: 4.95 m (11 ft. 6 in. × 16 ft. 3 in.)
WARP: undyed wool, 6–7 per cm
WEFT: dyed wool and silk
Gift of Mr. and Mrs. Daniel C. Jackling (de Young), 49.15

Many accounts were given of the death of Cyrus. Herodotus chose the version for *The Histories* that he judged most likely to be true. It has no basis in historical fact. According to the legend, Tomyris, queen of the Massagetae, believed Cyrus responsible for the death of her son, who had committed suicide in captivity. Tomyris first defeated Cyrus in battle, then subjected his body to indignity. She ordered his severed head to be plunged into a container of blood, saying, "Now . . . you have your fill of blood." It is interesting that the container, described by Herodotus as a skin, has become an ornate metal vessel in the tapestry, decorated with the scene of Judith holding the head of Holofernes.

The earliest known representation of Tomyris with the head of Cyrus is found in the fourteenth-century *Speculum humanae salvationis*, where she is bracketed with Judith (triumphing over Holofernes) and Jael (over Sisera). The three prefigure the Virgin Mary who triumphed over Satan through the death of her son.[1] Illustrations of the *Speculum* are usually set in a battleground, and the tapestry has retained this setting. In contrast, the large painting at the Museum of Fine Arts, Boston, by Peter Paul Rubens or his assistants (1622–1625), shows an interior scene with a queen in trailing silks and ermine.

The tapestry has the same mountain scenery and leafy foreground as its companion piece, although large sections of the plants have been rewoven, as has the area surrounding the head of Cyrus and the head itself. Other versions show a head quite handsome in death, with dark hair and beard. The vigorous and barbaric character of the Massagetae is communicated by pictorial detail. They are represented as a nation of archers. The central warrior carries a curious case with projecting bow and arrows. Tomyris, who hands her bow to an attendant, has a quiver of arrows on her left hip. Another Amazon with a bow stands in the mid-distance. In the background, Massagetae warriors occupy the high ground, from which vantage point they hurl rocks and spears on the enemy caught in the narrow canyon. Two strange war machines in the form of huge bows are being drawn and aimed at the invaders.

Costume design and fabric attempt to further express the Scythian character. The archer carrying out the queen's order wears a tunic of the kind of exotic brocaded pattern typical of fourteenth-century weaving at Lucca. Behind him, the graybeard lifting his hand in horror is dressed in a textile with calligraphic strips suggesting Persian or Arabic writing. Headdresses and weaponry are all strange and anticlassical, intended as an indication of the wild and unpredictable nature of Tomyris's people.

In addition to the present example, several other versions are known. *The Queen and Cyrus* in the later set of the Spanish Royal Collection has the compartmented Virtues border.[2] In 1983 The Fine Arts Museums received a second *Victory of Queen Tomyris* from Mr. and Mrs. Joseph W. Cochran III (see Appendix B).

The two *Cyrus* tapestries from the Jackling collection are said to have hung in the Strozzi Palace and to have passed through the J. P. Morgan collection, although this cannot be verified.

NOTES

1. Michelle Facos, "Rubens's 'The Head of Cyrus Brought to Queen Tomyris': An Alternative Interpretation," *Rutgers Art Review* 8 (1987): 39–41.
2. Paulina Junquera de Vega and Concha Herrero Carretero, *Catálogo de tapices del patrimonio nacional*, vol. 1, sixteenth century (Madrid: Editorial Patrimonio Nacional, 1986), 296.

EXHIBITION

Retrospective Loan Exhibition of European Tapestries, San Francisco Museum of Art, 1922, no. 27. Catalogue by Phyllis Ackerman.

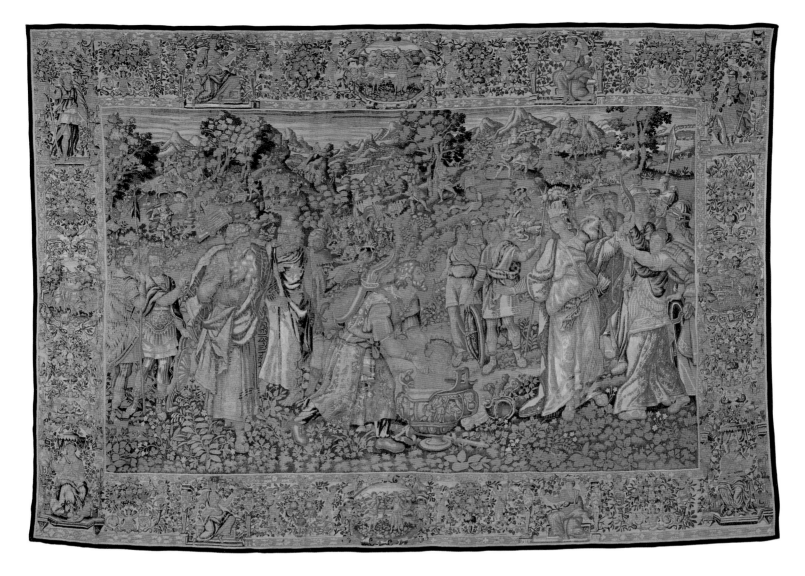

The Victory of Queen Tomyris

44. Grotesques on Red Ground

Tapestry fragment used on a fire screen

Probably Flemish, third quarter sixteenth century
H: 88 cm W: 67 cm (34½ in. × 26¼ in.)
WARP: undyed wool, 6 per cm
WEFT: dyed wool and silk
FRAME: France, ca. 1700. Wood, carved and gilded
Gift of Archer M. Huntington (CPLH), 1931.146

The footed wooden frame is richly gilded and carved with leafy *rinceaux* on a diapered ground. It has a heavy valence at its base and is surmounted by a large shell.[1]

The frame holds a tapestry with a rose-red ground that may once have been part of a much larger piece. Figures and objects typical of the grotesque style are supported by spindly scaffolding on which are performed such ritual functions as making offerings and holding garlands. The design, as it now appears, is asymmetrical. The central female herm, with a deep blue base, protected by an unsupported pale blue canopy, is the object of worship of a youth holding a bowl of fruit and a bearded man holding two hoops (?). She is flanked by smoking lamps and tall, lighted candles. A boy at left carries on his head an amphora with flowers. Opposite, a griffon turns his head to look back toward the herm. The lower tier is dominated by two well-muscled mermaids with double tails. They hold a thick, bound garland of laurel leaves and flank a bearded head—not a mask, for it has a directed gaze.

The grotesque style of the late Renaissance derives ultimately from the discovery of the Golden House of Nero in the late fifteenth century. Adapted first by Pinturicchio and Signorelli, the grotesque theme was used by Raphael and his followers in the Loggie of the Vatican. The architectural framing and system of divisions are features of Roman mural painting. Masks, amphorae and festoons in Flemish tapestries imitate the manner of Italian artists such as Giovanni da Udine. Grotesque designs were a favored filling for tapestry borders and, more important, they were also employed as separate compositions. An impressive example of the latter (Brussels, ca. 1553) at Wawel Castle, Kraków, surrounds the monogram SA of Sigismund Augustus II.[2]

Louis XIV's interest in acquiring sixteenth-century Brussels tapestries and in having new French tapestries designed to imitate them creates difficulties in distinguishing some French grotesque tapestries from their Flemish inspiration.[3] The traditional repertory of herms, mermaids, griffons, candelabra, and garlands is present in the late French versions as well as in The Fine Arts Museums' example, but with some differences in style. The mermaids of The Fine Arts Museums' panel are muscular in the Renaissance manner. Flowers are scarcer, fruit more abundant. Faces are less prettified. The strapwork of the mid-sixteenth century is missing, but the fragile divisions and tasseled canopies appear in Flemish tapestry borders of about 1580.[4]

This fragment of a sixteenth-century Flemish tapestry was mounted, probably by a nineteenth- or twentieth-century dealer, as the central element of a fire screen of the Louis XIV period.

NOTES

1. A duplicate frame was sold at Sotheby's, Monaco, 7 December 1984, no. 994.
2. Magdalena Piwocka, "Les tapisseries à grotesques," in *Les tapisseries flamandes au château de Wawel à Crocavie: Trésors du roi Sigismond II Auguste Jagellon*, ed. Jerzy Szablowski (Antwerp: Fonds Mercator, S.A., 1972), 289–330.
3. See "Triumph of Bacchus," illustrated with cat. no. 78.
4. For a late Aubusson example, see Dominique Chevalier, Pierre Chevalier, and Pascal-François Bertrand, *Les tapisseries d'Aubusson et de Felletin 1457–1791* (Paris: S. Thierry and Bibliothèque des Arts, 1988), 88.

Grotesques on Red Ground

SEVENTEENTH- AND EIGHTEENTH-CENTURY TAPESTRIES IN THE NETHERLANDS

Tapestries in the Netherlands

Religious wars and civil strife in the late sixteenth century forced sporadic emigrations of tapestry weavers from the southern Netherlands. Some settled in France, others in Holland, England, Germany, and Italy. Flemish names fill seventeenth-century rosters of workers at the Gobelins, at Beauvais, and at the Mortlake manufactory in England.

Depleted as it was by this centrifugal dispersal of talent, the Flemish tapestry industry maintained its standards of craftsmanship. A core of important weaving families remained in the old locations, operating in the traditional way. Several of their names appear on tapestries of the seventeenth and eighteenth centuries in The Fine Arts Museums' collection: Raes, van Leefdael, van den Hecke, van der Borcht.

The important tapestries of this period were designed in Antwerp. Peter Paul Rubens and Jacob Jordaens are the great names of that city, although tapestry design represents a small fraction of Rubens's work. Several series were executed in his grandiose, pictorial style. With them, tapestries moved closer to the concept of woven pictures. The case is somewhat different with Jordaens. Tapestry design represented a larger part of his total oeuvre, and his training as a painter of wall hangings in distemper sensitized him to the problems of textile design. After Rubens and Jordaens, a generation of second-rate artists and a deteriorating economy undermined tapestry production.

Before it collapsed, the industry enjoyed a temporary reprieve in the success of the Teniers tapestries. Landscapes with peasant villagers at work and play supplied the popular taste for the "real" and the familiar. Derivative scenes in the spirit of Teniers appeared far into the eighteenth century.

In spite of the government's attempts to protect and encourage the failing industry, it succumbed at last to the economic situation and to a changing way of life. Alphonse Wauters, writing the basic study of Brussels tapestries in 1878, noted that the high level of Brussels weaving was maintained until the last atelier closed in 1794: "The industry finally disappeared, not like a star which gradually pales, but like the sun which sets in all its brilliance, in all its splendor."[1]

NOTE

1. Alphonse Wauters, *Les tapisseries bruxelloises* (1878; reprint, Brussels: Editions Culture et Civilization, 1973), 1–2.

45. Judith Dining in the Camp of Holofernes

Flemish (probably Oudenaarde), 1560–1570
H: 3.43 m W: 3.18 m (11 ft. 3 in. × 10 ft. 5 in.)
WARP: undyed wool, 5–6 per cm
WEFT: dyed wool and silk
Museum purchase (de Young), 49748

During its half century in the M. H. de Young Memorial Museum collection, this tapestry was known as *Roman Wedding*, a general title that did not identify the clearly specific moment of a particular story.

A table is set under an elaborate canopy, apparently in an armed camp, for tents and soldiers are visible in the distance. Two military men sit with a young woman at a table. Prominent in the foreground is a large wine cooler from which a serving boy has removed a carafe to fill a wine glass. The unhelmeted warrior, with his arm around the woman, turns to her as if in question. She, unsmiling, gestures toward her attendant who holds a pitcher.

Wendy Hefford recognized the subject as part of the story of Judith and suggested the present title. Her identification is supported by an early sixteenth-century representation of the event in a large tapestry showing several scenes of the story.[1] The moment depicted is found in Judith 12:1–2:

> Then he [Holofernes] commanded them to bring her in where his silver dishes were, and gave orders that they should set some of his own food before her, and that she should drink his wine. But Judith said, "I cannot eat them, for it might give offense, but I will be supplied with the things I have brought with me."

The Book of Judith tells how King Nebuchadnezzar of Assyria sent his general, Holofernes, to wage war against the Israelites. Holofernes beseiged them in the town of Bethulia and cut off their water supply. The Israelites began to waver in their resistance. Judith, a beautiful young widow, resolved single-handedly to deliver her people from Holofernes. Taking a supply of food, she left the town with her maid and walked into the camp of the enemy. Holofernes was captivated by her beauty and deceived by her words. He invited her to a banquet with the intention of seducing her, but was defeated in his purpose. Overcome by wine, he was easily dispatched by Judith, who cut off his head, put it in the bag in which she carried her provisions, and returned with it to Bethulia. In the words of Judith's song of triumph,

> Her sandal ravished his eye,
> And her beauty captivated his soul.
> The scimitar passed through his neck.[2]

Judith's courage, piety, and determined action made her a standard exemplar of Fortitude and Prudence (see cat. nos. 22 and 23).

The panel is attributed to Oudenaarde on the basis of specific resemblances to four published pieces, two from a *History of St. George*, that have the marks of Oudenaarde and an unidentified weaver.[3] They were sold at Christie's, 1 December 1966, no. 161. The points of correspondence are the rich borders with large fruits and, especially, the strong cast shadows; the use of dark outlines and similarities of costume can also be cited.

NOTES

1. Heinrich Göbel, *Wandteppiche. I Teil: Die Niederlande*, 2 vols. (Leipzig: von Klinkhardt & Biermann, 1923), 2: no. 231, illus.
2. Edith Standen called my attention to this quote from Judith 16:9.
3. Adolphe Hullebroeck, *Histoire de la tapisserie à Audenarde du XVe au XVIIIe siècle* (Renaix: Presses du maître-imprimeur J. Leherte-Delcour, 1938), 176–178 nn. 165–168, illus. XCVIIIa–b, XCIX a–b; Nello Forti Grazzini, *Arazzi del cinquecento a Como*, exh. cat. (Como: Società Archeologica Comense, 1986), 95–99 n. 14. Dr. Forti Grazzini links with the so-called St. George pieces two tapestries from a *Story of Perseus* (one at Palazzo Arcivescovile, Como; another sold by Sotheby Parke Bernet, Florence, 18–20 November 1981, no. 491) because of similar borders with architecture, decorations, and plants. Forti Grazzini attributes them to Oudenaarde.

Judith Dining in the Camp of Holofernes

46. Romulus Bringing the Head of Amulius to Numitor

from The Story of Romulus and Remus *Series*

Flemish (Brussels), ca. 1535 (design)–1625 (weaving)

Woven under direction of Jacob Geubels II and Jan Raes I (early
 seventeenth century)

H: 2.69 m W: 4.51 m (8 ft. 10 in. × 14 ft. 9½ in.)

WARP: undyed wool, 7 per cm

WEFT: dyed wool and silk

MARKS: *Origin* lower guard, left
 Weavers right guard, top; right guard, bottom

California Midwinter International Exposition (de Young), 3755

Flemish tapestries were among the earliest acquisitions of the newly formed institution that was to become the M. H. de Young Memorial Museum. One of these was known as *After the Battle*. The panel is recognized today as part of *The Story of Romulus and Remus* series that was woven several times in Brussels from the mid-sixteenth to the early seventeenth century. Four different border types were used with the series of designs. Elisabeth Mahl made the basic study of the Series VIII and XXI in the collection of the Kunsthistorisches Museum, Vienna.[1]

The episode depicted in the present tapestry seems to be without classical precedent and must, therefore, be based on a late medieval or early humanistic work that has not yet been recognized as the source. Certainly it follows an established iconographic tradition. Bernard (Barent) van Orley's drawing of 1524 in Munich shows the same subject with a different composition.[2]

A young soldier, identified by the inscription in the Vienna Series VIII/4 as Romulus, rushes toward the center where a king sits beneath a canopy. Romulus holds before him a severed head from which the king recoils in horror. Numerous onlookers enlarge the main group and are integrated into the landscape in small clusters. The scene describes one episode in a dynastic struggle for power in early Rome. The action is summed up by the inscription: ROMULO ABCISSUM NUMITORI IMMANIS AMULI ENSE CAPUT PUGILI REGNAQUE REDDIT AVO (Romulus gives back to Numitor the head of great Amulius, severed with a sword in battle, and restores power to his grandfather).[3] Amulius, brother of Numitor, had usurped the royal power. His death restored command to the rightful ruler.

The earliest weaving of the episode known to have survived is a fragmentary panel, with the mark of Willem de

Pannemaker, probably from the 1540s. It was shown by Jacques Seligmann in Paris in 1934.[4] Its corresponding scene has an architectural setting, with borders of flat, venous tracery.

Another early weaving, circa 1560, bears the mark of Frans Geubels and belongs to Series VIII in Vienna. The same figure group has been given a landscape setting and a compartmented border of Virtues with an inscription and floral elements. A taller version, also by Frans Geubels, is part of Series XXI in Vienna. Its date is also about 1560 or a bit later. It is an expensive edition, with silk and gold threads. The zoological borders used with it were also used by Nicolas Leyniers for the *Cyrus* series of the Spanish Royal Collection. The piece is now at The Toledo Museum of Art, Ohio (fig. 64).

The Fine Arts Museums' version was woven in the early seventeenth century, for it bears the marks of Jan Raes I and Jacob Geubels II, known to have been active at this time. The design retains the canopy of the Vienna Series XXI, but additional figures have been added to the composition and the delicacy of detail has been lost. A comparison of the rather mechanically treated foreground and the rich variety of plant forms in the Toledo panel, or a comparison of the facial expressions in the two versions, gives the impression that The Fine Arts Museums' tapestry is a late weaving of a much earlier cartoon, probably using a cartoon in poor condition.

A near duplicate of the San Francisco panel was no. 101 in the J. Horace Harding Sale, Parke-Bernet Galleries, Inc., 1 March 1941. The panel is a little narrower on both sides, and has a Virtues border like the Series VIII border, but without the inscription. Nello Forti Grazzini points

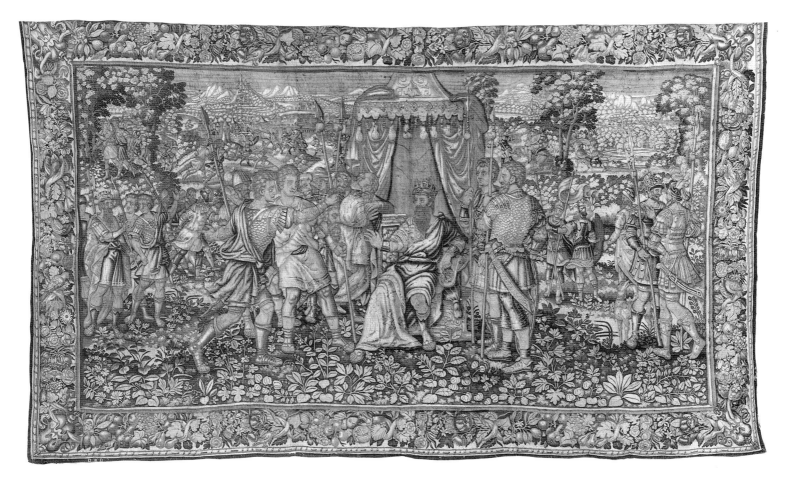

Romulus Bringing the Head of Amulius to Numitor

FIGURE 64
Romulus Bringing the Head of Amulius to Numitor, tapestry.
The Toledo Museum of Art, Gift of Florence Scott Libbey, 1954

The Acts of the Apostles *Series*

The art-historical importance of Raphael's famous designs is more familiar, perhaps, than their original purpose and subsequent history. The tapestries were commissioned by Pope Leo X for the lower walls of the Sistine Chapel. Michelangelo's ceiling, completed in 1512, had destroyed the "original decorative equilibrium."[1] The tapestries may have been intended to restore that aesthetic balance. The subject was traditional in the Vatican. Several medieval series of *The Acts of the Apostles* had hung there, the earliest dating to Carolingian times.[2] The designs of Raphael, painted in distemper on paper, were woven in Brussels under the direction of Pieter van Aelst between 20 December 1516, when the final payment was made to Raphael, and 26 December 1519, when seven of the ten were hung in the papal chapel. "The whole chapel was struck dumb at the sight," wrote the papal majordomo, Paris de Grassis, in his journal.

A reconstruction by scholars of the original placement of the series in the chapel adds to our understanding of the iconography.[3] Two sequences hung on either side of the altar. The honor of the right-hand position went to Saint Peter as the first head of the church and papal prototype. Episodes from his life illustrated the historical basis of papal authority and the exercise of its administrative power. On the opposite wall a corresponding sequence showed the acts of Saint Paul as missionary to the Gentiles. In the first panel Paul witnessed the stoning of Saint Stephen. Subsequent episodes illustrated Paul's conversion and ministry. The other subjects of the series, not represented in The Fine Arts Museums' collection, are

The Miraculous Draught of Fishes (Story of Saint Peter)
The Healing of the Lame Man (Story of Saint Peter)
The Blinding of Elymas (Story of Saint Paul)[4]
Saint Paul in Prison (Story of Saint Paul)

Elaborate borders were designed for this first weaving with such disparate themes as the history of the Medici, the Elements, Fates, Seasons, Hours, Liberal Arts, and Seven Virtues. Each border was intended to be appropriate to the subject of the main panel. The careful correspondence between border and main subject went awry in van Aelst's workshop, where the cartoons were mismatched. The mix-up obscured the purposeful relationship between picture panel and border, making the borders seem decorative rather than iconographically meaningful. Edith Standen notes the possible implications of this precedent for later tapestries.[5]

Raphael's models—either the original cartoons or contemporary copies—remained in Brussels as the property of van Aelst's workshop.[6] From them, van Aelst drew sets in rapid succession for Francis I, Henry VIII, and Philip II. The tapestries thus disseminated the style of the Italian High Renaissance over the capitals of Europe. In 1623 Sir Francis Crane purchased the remaining seven cartoons for the Mortlake factory. More than a dozen sets came from the Mortlake works. In the eighteenth century the long strips into which the cartoons had been cut for the low-warp loom were pasted together. Now the property of Queen Elizabeth II, the cartoons are on loan to the Victoria and Albert Museum for exhibition.

At least fifty-five sets or partial sets have been traced to Raphael's cartoons.[7] These sets were drawn directly from Raphael's cartoons, from copies of them, or from new cartoons based on engravings; or they were based on drawings of the tapestries already woven. Each copyist added something of himself and subtracted something of the master.

The Fine Arts Museums of San Francisco have an early seventeenth-century set of six *Acts of the Apostles*, not included in the Kumsch study of derivative series. The earlier provenance of the set is not known. Four of the six designs have a remote but recognizable connection with the Raphael cartoons. The fifth and sixth correspond in subject to lost cartoons of Raphael's and are based on entirely new designs.

None of the panels carries the Brussels mark, although five have exceptionally clear weaver's monograms. They were attributed to Brussels by Jean-Paul Asselberghs (20 April 1970) and assigned a date in the first quarter of the seventeenth century. The good color and tight weave are characteristic of the work of Brussels.

The designer is unknown. His adaptations of Raphael's designs were not particularly skillful. In every case, the figures are larger in scale and clumsily rendered. The setting is shallower, the composition crowded laterally. The two panels designed without a prototype demonstrate these tendencies to an extreme degree.

The "zoological" borders, representing the Four Elements, compensate for the deficiencies of the picture panels. The concept of these borders can be traced to *The Story of Noah*, woven by Willem Pannemaker for Philip II of Spain between 1563 and 1566.[8] The version used here, with heavy garlands of fruit and flowers suspended from the top frame, was used by Frans van den Hecke in the first half of the seventeenth century for *The Story of Ulysses* in Madrid.[9] A bird appears in each section of garland, representing the element of Air. The lateral borders are Earth, filled with animals both natural and fantastic. Water occupies the bottom border. River gods are shown at either corner and a marine scene in four variations fills the central position. The fourth element, Fire, is not allotted a prominent place but is suggested by a conflagration

in the landscape of the upper right lateral border. The pilaster strips planned for the original Vatican set included the Elements to contrast the blind forces of the universe with the workings of divine omnipotence as revealed in the main panels.[10] The present borders could be interpreted in the same way.

The weaver is unknown. His identical mark and border appear on *Jeux champêtres* at the Château de Blois.[11] The mark and outer border appear on the *Couronnement d'Alexandre* in the castle at Frýdlant, Czechoslovakia.[12] Blažkova notes another *Alexander* set with the same borders and marks at the Pinacoteca of Fabriano, Italy.[13] Delmarcel points out that a mark for place of origin is never found with this particular monogram.

NOTES

1. John White and John Shearman, "Raphael's Tapestries and Their Cartoons," *Art Bulletin* 40 (1958): 194.

2. John Shearman, *Raphael's Cartoons in the Collection of Her Majesty the Queen and the Tapestries for the Sistine Chapel* (London: Phaidon, 1972), 1–20.

3. White and Shearman, "Raphael's Tapestries," 193–221. Creighton Gilbert does not agree with Shearman's arrangement of Raphael's *Acts* in the Sistine Chapel. See "Are the Ten Tapestries a Complete Series or a Fragment?" in *Studi su Raffaello: Atti del Congresso internazionale di studi, Urbino-Firenze, 6–14 aprile 1984* (Urbino: Quattro Venti, 1987), 533–550.

4. A *Blinding of Elymas* with zoological borders was in a sale at Christie's, New York, 17 March 1990, no. 227.

5. Edith A. Standen, "Some Sixteenth-Century Grotesque Tapestries," in *L'art brabançon au milieu du XVIe siècle et les tapisseries du château de Wawel à Cracovie: Actes du colloque international, 14–15 décembre 1972, Bulletin des Musées Royaux d'Art et d'Histoire* 45 (1973; offprint, Brussels, 1974): 229.

6. Shearman, *Raphael's Cartoons*, 139, 144–145.

7. E. Kumsch, *Die Apostel-Geschichte: Eine Folge von Wandteppichen nach Entwurfen von Raffael Santi* (Dresden, 1914).

8. White and Shearman, "Raphael's Tapestries," 211. Willem de Pannemaker's *Elements* borders were without garlands. See Paulina Junquera de Vega, "Les series de tapisseries de 'Grotesques' et 'L'histoire de Noé' de la couronne d'Espagne," *Bulletin des Musées Royaux d'Art et d'Histoire*, 6th ser., 45 (1973): 163–165. Standen lists other sets using borders of this kind in *European Post-Medieval Tapestries and Related Hangings in The Metropolitan Museum of Art*, 2 vols. (New York: The Metropolitan Museum of Art, 1985), 1:158.

9. Patrimonio nacional, Ser. 42. See Paulina Junquera de Vega and Carmen Díaz Gallegos, *Catálogo de tapices del patrimonio nacional*, vol. 2, seventeenth century (Madrid: Editorial Patrimonio Nacional, 1986), 1–5.

10. White and Shearman, "Raphael's Tapestries," 211.

11. *Jeux et divertissements. Tapisseries du XVIe au XVIIe siècle*, exh. cat. (Arras: Musée des Beaux-Arts, 1988), 60–62, no. 17.

12. Jarmila Blažkova, "Les marques et signatures trouvées sur les tapisseries flamandes du XVIe siècle en Tchécoslovaquie," in *L'âge d'or de la tapisserie flamande*, International Colloquium, (Gent), 23–25 May 1961 (Brussels: Paleis der Academien, 1969), 58, 59.

13. Jacqueline Versyp, "Vlaamse wantapijten uit de XVIIe eeuw te Fabriano en te Urbino," in *La tapisserie flamande au XVIIe et XVIIIe siècles*, International Colloquium, 8–10 October 1959 (Brussels: Paleis der Academien, 1959), 212–213, 221.

47. Christ's Charge to Saint Peter

from The Acts of the Apostles *Series*

Flemish (Brussels), 1600–1625
H: 3.81 m W: 3.24 m (12 ft. 6 in. × 10 ft. 7½ in.)
WARP: undyed wool, 6 per cm
WEFT: dyed wool and silk
MARKS: *Weaver* right guard, bottom
Gift of Catherine D. Wentworth (CPLH), 1950.36

The risen Lord appeared to his disciples for the third time as they fished by the sea of Tiberias. Jesus asked the question of Peter three times, "Simon, son of Jonas, lovest thou me?" To Peter's reply, "Yea, Lord, thou knowest that I love thee," Jesus rejoined, "Feed my lambs," and, "Feed my sheep." The account is given in John 21:14–17.

The scene's importance in the iconographical program of the papal chapel is evident. It provides the historical basis for the authority of the pope. As the heir of Saint Peter, he is directly charged by Christ with the care of his spiritual flock.

The scene is sometimes called *The Giving of the Keys* because of the prominence of the keys in Saint Peter's hands.[1] The title is probably inappropriate, for the Jesus of the cartoon merely points to Peter with one hand while he designates with the other the sheep that graze nearby (fig. 65). The lateral squeezing of the composition has obscured the clarity of the statement. The sheep in the tapestry intervene between Jesus and Saint Peter. The disciples, of whom only nine others instead of eleven are visible, have been telescoped in similar fashion.

Much greater interest is given to plant forms than appeared in Raphael's cartoon. The mountainous scenery has effectively raised the horizon. Flemish taste is particularly well represented by the remarkable borders. In the center of the lower border, a triton and a mermaid with a mirror rest on the surface of a feathery sea, surrounded by marine beasts. The borders of two other tapestries of the set show the same scene.

NOTE

1. Matthew 16:18–19 records Jesus' words to Saint Peter, "That thou are Peter, and upon this rock I will build my church; and the gates of hell shall not prevail against it. And I will give unto thee the keys of the kingdom of heaven."

FIGURE 65
Raphael, *Christ's Charge to Saint Peter*, cartoon. By courtesy of the Victoria and Albert Museum

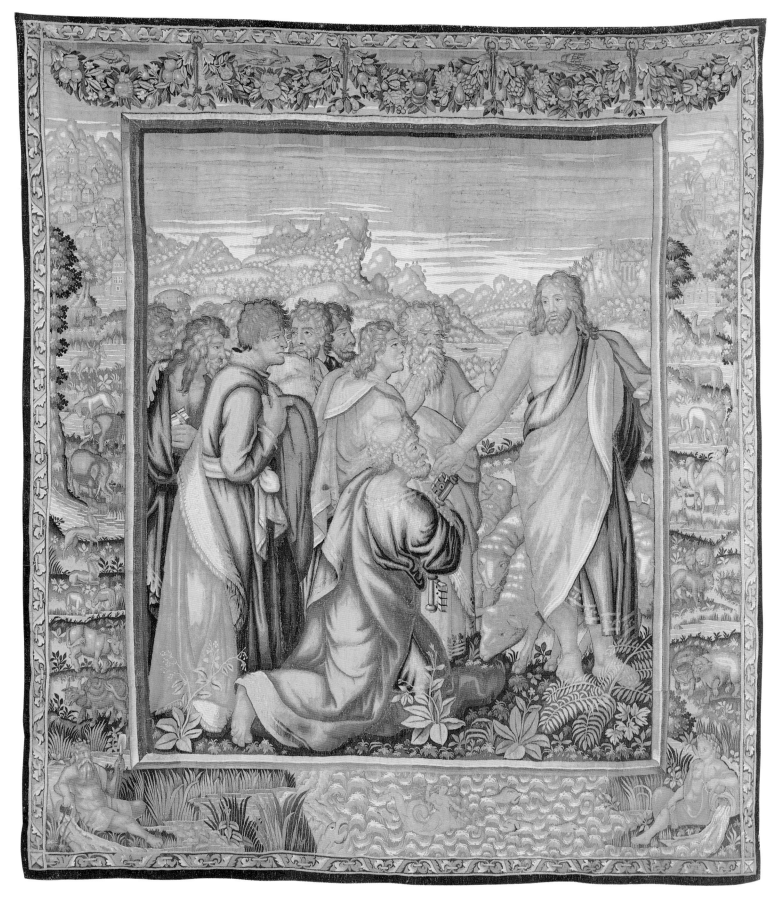

Christ's Charge to Saint Peter

48. The Death of Ananias

from The Acts of the Apostles *Series*

Flemish (Brussels), 1600–1625
H: 3.40 m W: 5.26 m (11 ft. 2 in. × 17 ft. 3 in.)
WARP: undyed wool, 6–7 per cm
WEFT: dyed wool and silk
MARKS: *Weaver* right guard, bottom
Gift of Catherine D. Wentworth (CPLH), 1950.40

The apostles administered the funds of the newly orga-
nized church. Those who owned property sold it and laid
the proceeds at the feet of the apostles to be dispensed ac-
cording to need. In the cartoon and the tapestry, the apos-
tles stand solidly together on a raised central platform.
They are distinguished by their togas and bare feet as well
as by their superior position. The gathering-in of funds
takes place in the left background of the tapestry (where it
is shown more clearly than in the right background of the
cartoon, fig. 66). On the opposite side, Saint John and an-
other apostle dispense alms and blessings.

The punishment of Ananias occurs in the foreground.
His is the first sin of the early church. Ananias had con-
spired with his wife, Sapphira, to withhold part of the pro-
ceeds of a sale. Saint Peter accused him of lying, not to
men, but to God. At the words of Saint Peter, Ananias has

fallen to the ground and is dying, "and great fear came on
all them that heard these things" (Acts 5:1–5).

The connection between this scene and *The Stoning of
Saint Stephen* was brought out by the study of John White
and John Shearman.[1] The episode of Ananias demon-
strated the need for the appointment of deacons to admin-
ister the church funds. Saint Stephen was the church's
first deacon as well as its first martyr.

In the center of the lower border Neptune brandishes
his trident as he steps into a shell-chariot drawn by sea
horses. Three large fish swim before the chariot and two
behind.

NOTE
1. John White and John Shearman, "Raphael's Tapestries and
 Their Cartoons," *Art Bulletin* 40 (1958): 203.

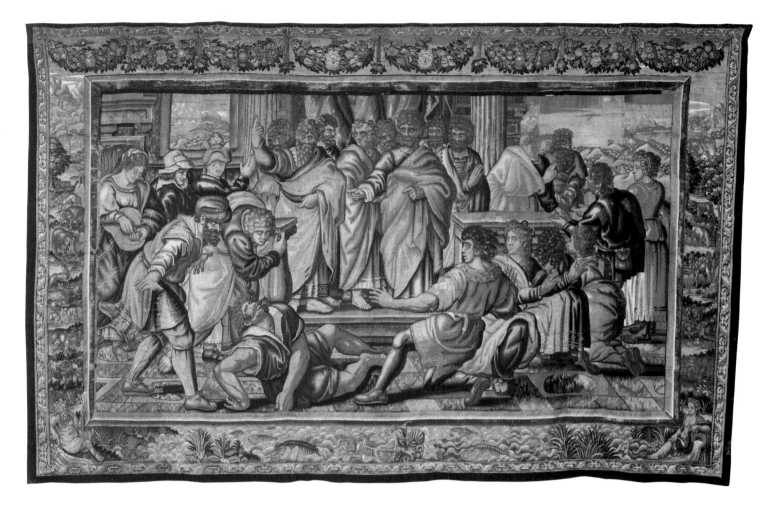

The Death of Ananias

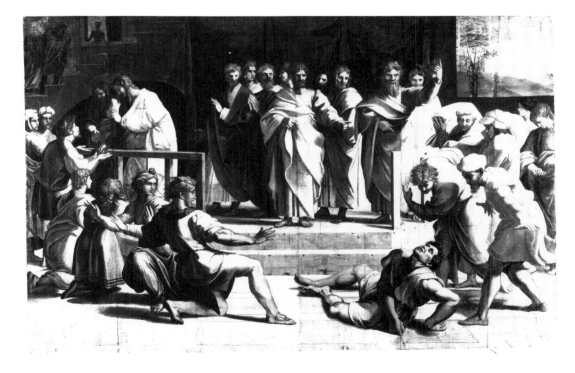

FIGURE 66
Raphael, *The Death of Ananias*, cartoon.
By courtesy of the Victoria and Albert Museum

49. The Stoning of Saint Stephen

from The Acts of the Apostles *Series*

Flemish (Brussels), 1600–1625
H: 3.66 m W: 2.49 m (12 ft. × 8 ft. 2 in.)
WARP: undyed wool, 6–7 per cm
WEFT: dyed wool and silk
MARKS: *Weaver* right guard, bottom
Gift of Catherine D. Wentworth (CPLH), 1950.38

Raphael's cartoon for *The Stoning of Saint Stephen* had disappeared before 1623, when the seven remaining cartoons were acquired for the Mortlake works. Its appearance is known from the Vatican tapestry. The figure of Saint Paul, or Saul as he was then called, is prominent in the Vatican example, occupying the lower right corner. A heap of garments lies before him ("and the witnesses laid down their clothes at a young man's feet, whose name was Saul" [Acts 7:58]). The presence of Saul, or Paul, at the stoning of Saint Stephen justified the inclusion of this scene in the iconographic program of the Sistine Chapel that was devoted to scenes of the lives of Saints Peter and Paul.

The design of the present panel is unrelated to the Raphael design, except perhaps for the general pose of the martyr. It depicts the brief account of Stephen's death given in Acts 7:54–60. He was taken outside the city and stoned. The crenellated walls and the portcullis of the city gate are seen in the background. The turban of the executioner, the columns beside the portal, and the domed building place the event in a distant time and place. The boy sitting near some garments in the middle distance seems too young to be Saul, though the absence of the future saint from the design would interrupt the iconographic program.

Stephen wears a square-sleeved garment open at the sides (a dalmatic, the vestment of a deacon). As he sinks to his knees, he cries out, "Lord, lay not this sin to their charge." A beam of supernatural light touches the head of the first Christian martyr.

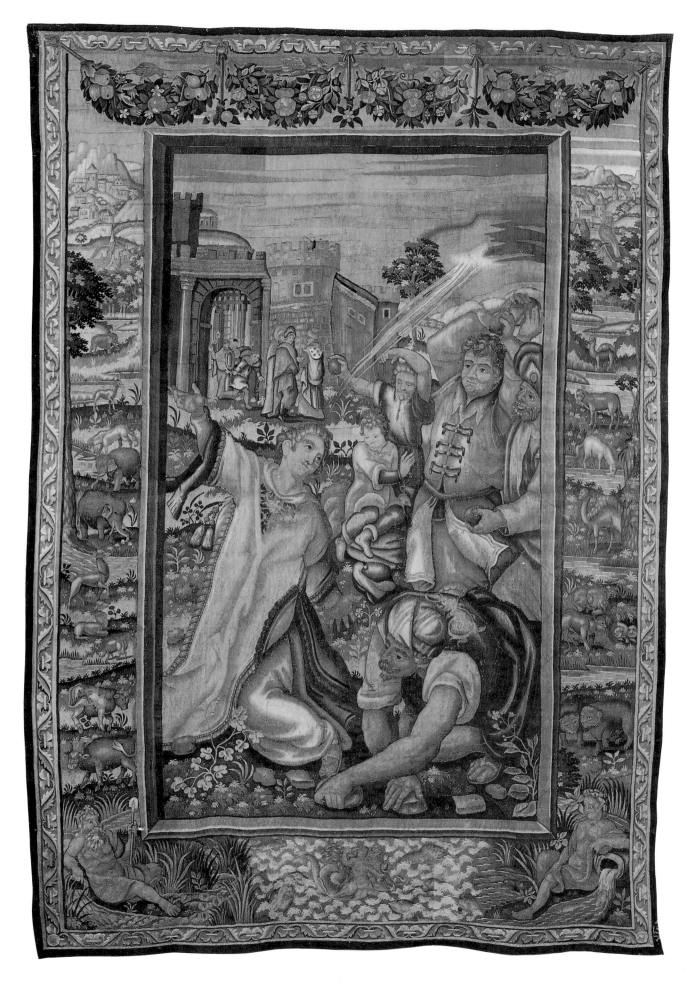

The Stoning of Saint Stephen

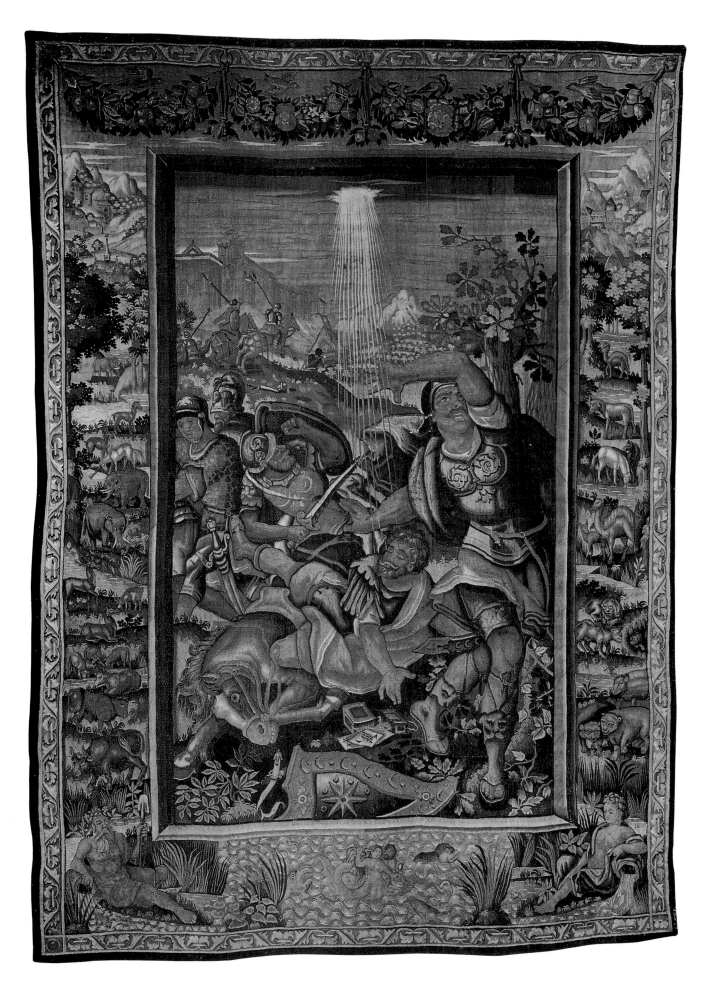

The Conversion of Saint Paul

51. The Sacrifice at Lystra

from The Acts of the Apostles *Series*

Flemish (Brussels), 1600–1625
H: 3.78 m W: 3.86 m (12 ft. 5 in. × 12 ft. 8 in.)
WARP: undyed wool, 6–7 per cm
WEFT: dyed wool and silk
Gift of Catherine D. Wentworth (CPLH), 1950.39

After being expelled from Antioch and nearly stoned at Iconium, Paul and Barnabas fled to Lystra in Lycaonia, where they continued to preach the gospel. Among their listeners was a man crippled from birth. At Saint Paul's command, he walked, cured through faith. Those who witnessed the healing thought it the work of their gods, and called Barnabas, *Jupiter*, and Paul, *Mercury*. The priest of Jupiter brought oxen and garlands in preparation for a sacrifice. Barnabas and Paul tore their garments in grief. The sacrifice was narrowly averted when Paul and Barnabas persuaded the Lystrians that they were fellow-mortals (Acts 14:8–18).

The tapestry is nearly square. Its abbreviated format has eliminated five onlookers at the right edge, but includes the essential figure of the cripple and his discarded crutches. Architectural changes and crowding of the forms have resulted in further compression. Plants replace the stone pavement of the Italian cartoon (fig. 67), and detailed clothing covers the cartoon's seminudity. Even the distant statue of Mercury is decently clad and the sacrificial bull is draped with a patterned cloth and garlanded with fruit. Flemish concern with pattern is evident in the wool of the sheep and the garments of the kneeling worshippers. Other additions are not so easily explained, such as the fictive letters on the headdress of the priest and the fountain in the background with its own version of the Manneken Pis.

Unlike the other panels in The Fine Arts Museums' series, the tapestry does not reverse the design, as would be expected in a low-warp weaving. Since the low-warp loom was normal in Brussels, the tapestry must have been woven on a cartoon that was already reversed, perhaps one based on an engraving of Raphael's design, or based on an existing tapestry. The result restores right-handedness to the wielder of the axe. The peculiar and confusing problem of right-handedness in the Raphael designs has been treated by A. P. Oppe.[1] The central scene in the lower border is unique in the series: a young woman in a dolphin boat playing the viol to an audience of marine creatures.

H. C. Marillier recorded in the Del Drago collection, Rome, "a crude version: (reversed) of *The Sacrifice at Lystra* in an *Elements* border."[2]

NOTES
1. A. P. Oppe, "The Right and Left in Raphael's Cartoons," *Journal of the Warburg and Courtauld Institutes* 7 (1944): 82–94.
2. H. C. Marillier, "Subject Catalogue of Tapestries" (Victoria and Albert Museum, London, ms., n.d.).

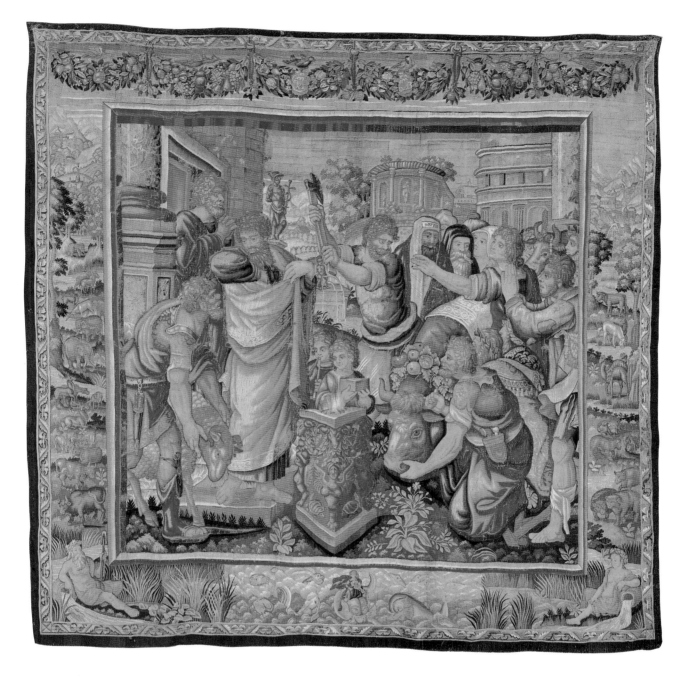

The Sacrifice at Lystra

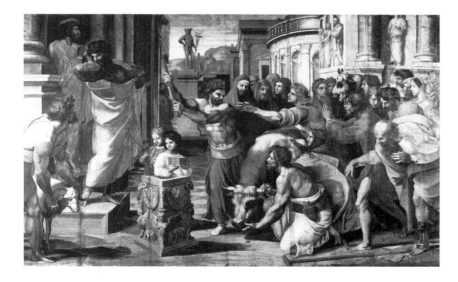

FIGURE 67
Raphael, *The Sacrifice at Lystra*, cartoon.
By courtesy of the Victoria and Albert Museum

52. Saint Paul Preaching at Athens

from The Acts of the Apostles *Series*

Flemish (Brussels), 1600–1625
H: 3.86 m W: 3.24 m (12 ft. 8 in. × 10 ft. 7½ in.)
WARP: undyed wool, 6–7 per cm
WEFT: dyed wool and silk
MARKS: *Weaver* right guard, bottom
Gift of Catherine D. Wentworth (CPLH), 1950.37

In Raphael's day the Sistine Chapel was divided into two halves by a screen or *cancellata*. The first half contained the chancel with the altar and the papal throne. The other, on a slightly lower level, was reserved for the laity. *Saint Paul Preaching at Athens* was intended to hang in the lay section, just beyond the *cancellata*. Its placement enhanced the choice of subject and determined its internal perspective.

According to the account in Acts 17:22–34, Saint Paul addressed the philosophers of Athens from the hill of Mars. In the tapestry he stands above his audience, some of whom are cut off by the lower border. On the wall of the papal chapel, Saint Paul would have towered over the actual secular audience that was the counterpart of the ancient one in the tapestry. Both the real and the pictured audience would be composed of those who mocked, those who postponed judgment, and those who believed. The two believers in the foreground are Dionysius the Areopagite and the woman Damaris.

The tapestry follows Raphael's design more closely than some of the other panels of this series (fig. 68). It has narrowed the original design by eliminating the space behind Saint Paul. Buildings have been omitted to allow a vista of the seaport and distant landscape. The heart of the subject matter, the confrontation of faith and skepticism, is intact. The faces of the listeners show an expressiveness not found at Lystra.

The central scene of the lower border is a duel between two heavily armed mermen. They fight in the midst of the sea, surrounded by sea monsters.

The discussion of the placement of the tapestry is summarized from the White-Shearman study.[1] It was treated in greater detail by Shearman in a later study.[2]

NOTES
1. John White and John Shearman, "Raphael's Tapestries and Their Cartoons," *Art Bulletin* 40 (1958): 208.
2. John Shearman, *Raphael's Cartoons in the Collection of Her Majesty the Queen and the Tapestries for the Sistine Chapel* (London: Phaidon, 1972), 25, fig. 2, and 42–43.

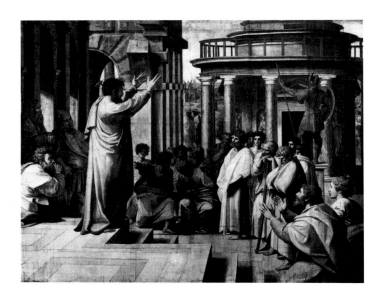

FIGURE 68
Raphael, *Saint Paul Preaching at Athens*, cartoon.
By courtesy of the Victoria and Albert Museum

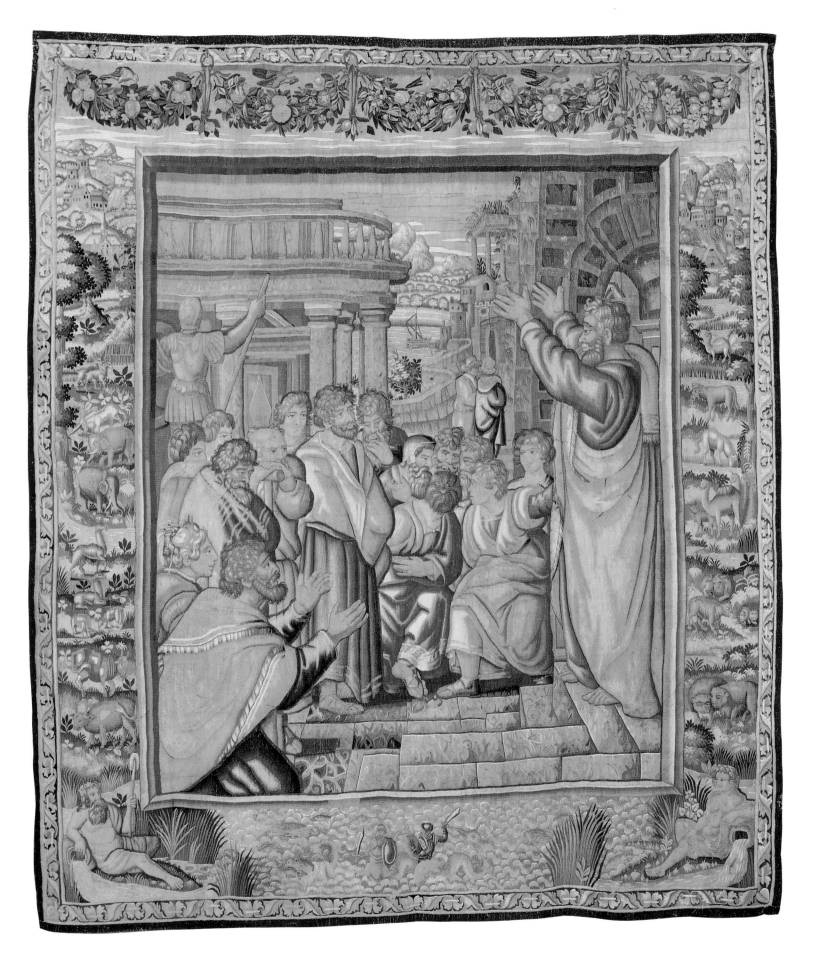

Saint Paul Preaching at Athens

The Story of Achilles *Series*

A new Achilles has appeared in almost every age, re-shaped by current literary sources and prevailing fashion. Medieval romances inspired an Achilles in Gothic armor; the seventeenth-century tapestry series was designed for and by men with access to classical authors. The episodes of the story are grounded in the classics, in general, but the spirit that animates them is purely baroque.

Both Peter Paul Rubens and Jacob Jordaens are associated with this series. Eleven subjects are known through surviving examples—eight designed by Rubens between 1630 and 1632, and three "extra" subjects added by Jordaens.[1] Seven of the Rubens sketches for tapestries are now at the Museum Boymans-van Beuningen, Rotterdam. An eighth is at The Detroit Institute of Arts.

The Rubens subjects are

Thetis Dipping the Infant Achilles into the River Styx
Chiron Educating the Young Achilles
Achilles Found among the Daughters of Lycomedes
Vulcan Giving Thetis Arms for Achilles
The Wrath of Achilles
Briseis Being Returned to Achilles
Achilles Wounding Hector
The Death of Achilles[2]

It is generally believed that after Rubens completed his eight designs, Jordaens added three subjects, perhaps around 1635, the date that marks the beginning of collaboration between the artists. Jordaens finished several works that had been put off because of Rubens's failing health.[3] The new subjects designed by Jordaens are

The Wedding of Peleus and Thetis
Thetis and Achilles before the Oracle
Pan Instructing Young Achilles in Music

A modello for *Thetis and Achilles before the Oracle* is at the Allen Memorial Art Museum, Oberlin College.[4] A. S. Cavallo suggested that Jordaens may have designed an entire series of which we know only three subjects.

The series was woven, in part or in its entirety, over a period of forty years by at least seven Brussels weavers: Daniel Eggermans, Jan and Frans Raes, Jan and Willem van Leefdael, Geraert van der Strecken, and Frans van den Hecke.[5] The Rubens cartoons were also woven at Mortlake.[6] The circumstances of the original commission are not known. Duverger believes that the designs (both sketches and cartoons) Rubens made for his father-in-law, Daniel Fourment, remained the property of the Fourment-van Hecke Society until they were sold in 1653 to the partners van Leefdael and van der Strecken.[7]

This important series is represented at The Fine Arts Museums by two panels, *Thetis and Achilles before the Oracle*, after Jacob Jordaens, and *Achilles Found among the Daughters of Lycomedes*, after Peter Paul Rubens. The panels are signed by different weavers and belonged to different sets, woven at different times. It is interesting to assess in each case the extent to which the style of the painter survives translation into another medium.

NOTES

1. Julius S. Held, *The Oil Sketches of Peter Paul Rubens*, 2 vols. (Princeton: Princeton University Press, 1980), 1:167–184, figs. 123–132. Rubens made the sketches for his father-in-law, Daniel Fourment, who was probably sponsored by some important benefactor, possibly Charles I of England. The sketches are first mentioned in 1643, in an inventory made after Fourment's death ("Acht schetsen op panneel geschildert, d'historie van Achilles": Held, 1:169, referring to J. Denucé, *De Antwerpsche "Konstkamers," Inventarissen van Kunstverzamelingen te Antwerpen in de 16e en 17e eeuwen* [Antwerp: "De Sikkel," 1932], 115).

2. Adolph S. Cavallo, *Tapestries of Europe and of Colonial Peru in the Museum of Fine Arts, Boston*, 2 vols. (Boston: Museum of Fine Arts, 1967), 1:127–129. Cavallo lists the subjects and the locality of all surviving examples known at the time of publication. His titles have been used.

3. H. Gerson and E. H. Ter Kuile, *Art and Architecture in Belgium 1600–1800*, trans. Olive Renier (Baltimore: Penguin Books, 1960), 132.

4. Wolfgang Stechow, "A Modello by Jacob Jordaens," *Allen Memorial Art Museum Bulletin* 23 (Fall 1965): 7.

5. Erik Duverger, "Tapijten naar Rubens en Jordaens in het bezit van het Antwerps handelsvennootschap Fourment-Van Hecke," *Artes Textiles* 7 (1971): 154.

6. Leo van Puyvelde, *Les esquisses de Rubens* (Basel: Holbein, 1948), 85.

7. Duverger, "Tapijten," 121.

BIBLIOGRAPHY

Jaffe, Michael. *Jacob Jordaens, 1593–1678*. Exh. cat. Ottawa: National Gallery of Canada, 1968–1969, no. 270.

Begemann, Egbert Haverkamp. *The Achilles Series. Corpus Rubenianum, Ludwig Burchard*. Brussels: Arcade Press, 1975. Part 10, esp. 104–107, 148.

53. Thetis and Achilles before the Oracle

from The Story of Achilles *Series*

Flemish (Brussels), 1642–1653
Designed by Jacob Jordaens (1593–1678)
Woven under the direction of Jan Raes (mid-seventeenth century)
H: 3.35 m W: 4.62 m (11 ft. × 15 ft. 2 in.)
WARP: undyed wool, 7–8 per cm
WEFT: dyed wool and silk
MARKS: *Origin* lower guard, right
 Weaver lower guard, right
Gift of Mrs. Helen Marye Thomas in memory of Mr. and Mrs.
 George T. Marye, Jr. (de Young), 68.23

Prophecies play an important part in the Greek story of Achilles. The first was made before his birth; others came at critical moments during his lifetime. The visit to the oracle shown in this tapestry, however, is without classical precedent. It appears to have originated in the sixteenth century with the Italian scholar Natale Conti.[1] In Conti's work, Kalchas, the oracle, makes the double prediction that Troy cannot be taken without Achilles, and that he will die if he joins that conflict. As a result of the prophecy, Achilles is hidden in Skyros. That episode is the subject of the tapestry after Rubens represented in The Fine Arts Museums' collection as catalogue no. 54.

The meeting takes place in a marble hall seen through a proscenium frame. Thetis enters from the right with her young son. Each carries an object: Thetis's jar may hold ambrosia to make the boy invulnerable; Achilles carries a round, bright object that suggests the Apple of Discord, remote cause of the Trojan War.[2] A fire blazes on the altar; a sacrificial lamb and vessels lie on the floor. Kalchas, the seer, moves his hand above the flames as he pronounces the fateful sentence. Acolytes on either side hold candles. A niche frames the laurel-crowned head of the priest, whose magnificent blue robe dominates the blond tonality of the panel.

Wolfgang Stechow explored the relationship of the oil sketch by Jordaens (fig. 69), now at the Allen Memorial Art Museum, Oberlin, to the group of tapestries that are derived from it.[3] He showed that the central portion of the painting was extended on all sides *after* serving as model

for the tapestries which, therefore, preserve an earlier stage of the painting. This extension necessitated some repainting of the central portion of the model. The niche behind the priest, for example, had to be painted out before the gallery of spectators could be added. Today the original shell shape of the niche, which is prominent in the tapestry, has reasserted itself through the overpainting of the sketch, and is faintly visible to the naked eye over the priest's head. The original position of the sacrificial lamb is also visible at the base of the altar.

Three weavings of the cartoon are known to have survived, each by a different weaver and each with distinctly different borders:

Jan Raes. It is documented that a set of twelve *Achilles* panels, woven by Jan Raes, was delivered in 1642 by an Antwerp dealer.[4] The Raes panel at San Francisco is three feet shorter than the van der Strecken panel at the Museum of Fine Arts, Boston, and has no metal threads. The lateral borders, part of an architectural frame, are used in extended form in a *Battle of Alexander*, after Jordaens, at the Palazzo Marino, Milan.[5]

G. van der Strecken. The partners, Jan van Leefdael and Geraert van der Strecken, bought the sketches and cartoons for twelve designs of the *Achilles* series from the Fourment-van Hecke partnership in 1653.[6] Van Leefdael and van der Strecken continued to draw series from these cartoons as late as 1662.[7] The Boston weaving, signed by van der Strecken, is rich with metal threads and has the more elaborate border design used for other Achilles

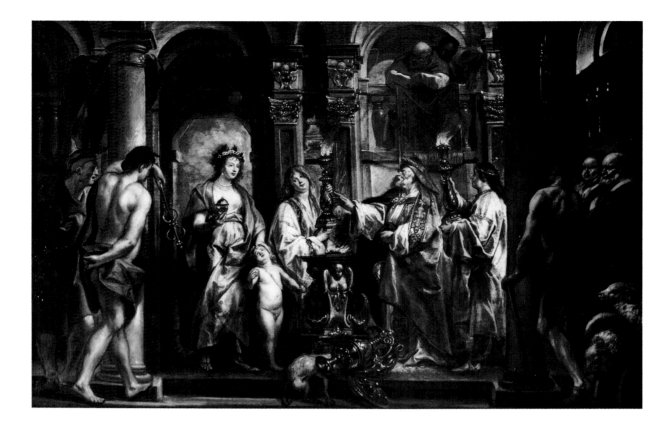

FIGURE 69
Jacob Jordaens, *An Oracle*, oil sketch on panel.
Allen Memorial Art Museum, Oberlin College

subjects, probably designed by Rubens. The herm-caryatids at the sides are individualized as Minerva and Hercules. An inscription in the cartouche reads: ACHILLES PVER / A MATRE ADDVCTVR / AD ORACVLVM (The boy Achilles is led to the oracle by his mother).[8]

Frans van den Hecke. A late weaving at the Palazzo Reale in Turin (ca. 1665) is signed F.V.H. It includes about the same amount of the cartoon used in the San Francisco version, but has very elaborate borders similar to those used for the Achilles subjects at the Musées Royaux d'Art et d'Histoire, Brussels, believed to date from the same period.[9] H. C. Marillier noted another weaving of the Thetis design, showing the right half only, by van den Hecke.[10]

NOTES

1. Wolfgang Stechow, "A Modello by Jacob Jordaens," *Allen Memorial Art Museum Bulletin* 23 (Fall 1965): 65 n. 10.
2. Stechow, "A Modello," 15.
3. Stechow, "A Modello," 5–16.
4. Erik Duverger, "Tapijten naar Rubens en Jordaens in het bezit van het Antwerps handelsvennootschap Fourment-Van Hecke," *Artes Textiles* 7 (1971): 119–121, 148–162.
5. Roger-A. d'Hulst, *Flemish Tapestries from the Fifteenth to the Eighteenth Century* (New York: Universe Books, 1967), 249,

fig. 15. Nello Forti Grazzini notes that d'Hulst published a design by Jordaens that shows the basic elements of these borders in his *Jacob Jordaens*, trans. P. S. Falla (London: Sotheby Publications, 1982), 147. Raes used nearly identical borders in the *History of Samson*, Cremona. Gillam van Cortenberg used them for a later set of *History of Noah*. See Nello Forti Grazzini, *Museo d'Arti Applicata. Arazzi* (Milan: Electa, 1984), 28–32, nos. 10–12.
6. Duverger, "Tapijten," 121.
7. Heinrich Göbel, *Wandteppiche. I Teil: Die Niederlande*, 2 vols. (Leipzig: von Klinkhardt & Biermann, 1923), 1:387.
8. Adolph S. Cavallo, *Tapestries of Europe and of Colonial Peru in the Museum of Fine Arts, Boston*, 2 vols. (Boston: Museum of Fine Arts, 1967), 1:129. Cavallo gives the entire literature on the series.
9. Mercedes Viale Ferrero, "Tapisseries rubeniennes et jordaenesques à Turin," *Artes Textiles* 3 (1956): 67–74.
10. H. C. Marillier, "Subject Catalogue of Tapestries" (Victoria and Albert Museum, London, ms., n.d.), T37S–1946, 92.

PROVENANCE

Mrs. George T. Marye, Jr., wife of the American Ambassador to Russia under Czar Nicholas II, acquired the tapestry in Russia shortly before the Revolution from a lady-in-waiting to the czarina (Phyllis J. Walsh, letter to A. G. B., 28 January 1976).

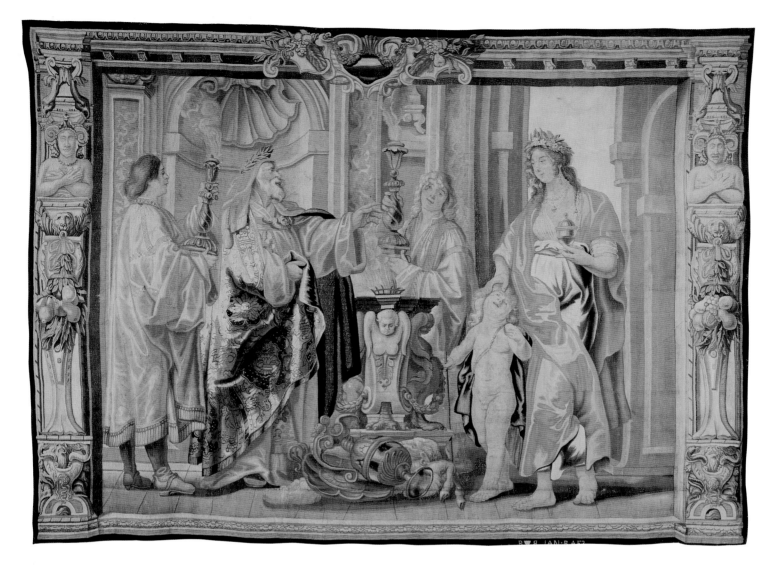

Thetis and Achilles before the Oracle

54. Achilles Found among the Daughters of Lycomedes

from The Story of Achilles *Series*

Flemish (Brussels), 1653–1664
Designed by Peter Paul Rubens (1577–1640)
Woven under the direction of Jan van Leefdael (fl. 1647–1677)
H: 3.84 m W: 5.26 m (12 ft. 7 in. × 17 ft. 3 in.)
WARP: undyed wool, 7–9 per cm
WEFT: dyed wool and silk
MARKS: *Origin* lower guard, left
 Weaver lower guard, right
Gift of Catherine D. Wentworth (CPLH), 1950.35

Ovid, among others, told the story of Achilles at Skyros. To save her son Achilles from the pitiless fate foretold by Kalchas if he should join the Trojan conflict, Thetis dressed him as a girl and hid him at Skyros among the daughters of King Lycomedes. Knowing that the Greeks could not win without Achilles, Ulysses followed him there and unmasked his identity.

Six excited young women surround a basket brimming with jeweled trinkets and shawls. The most regal is surely Deidamia, with whom Achilles has fallen in love. The girls' examination of the basket has been interrupted by Achilles, who, finding a helmet among the trinkets, puts it on. Deidamia and her sisters give him a startled look of recognition. The action is not lost on the crafty "peddler," Ulysses, who whispers to his companion and gestures for silence.[1] The inscription on the cartouche reads: VESTE.PVELLARI / LATITANS. DETECTVS / ACHILLES (Achilles is discovered hiding in women's clothing).

The weaving corresponds closely to an oil sketch by Rubens (fig. 70) at the Museum Boymans-van Beuningen, Rotterdam.[2] The sketch measures 46 cm × 61 cm.[3] Certain compositional changes were inevitable in the drastic change of scale. Patterns had to be added to fill in the vast plain areas, and the figures acquired an oppressively massive quality, with a loss of fine details. The caryatid forms, which were part of the Rubens design and serve to frame the picture panel, do not appear in the van Leefdael weaving at The Fine Arts Museums. Instead, the weaver used an opulent border of heavy swags of fruit and flowers above and below, with lateral borders of an ascending

arrangement of birds, fruit, flowers, and amorini, who also appear at either side of the central cartouche.

The *Achilles* series was the subject of an exhaustive study by Egbert Haverkamp Begemann, who listed the classical and Renaissance authors whose descriptions of the episode contributed to Rubens's artistic vision.[4] Begemann accounts for eleven weavings of the subject.[5] Duverger has shown that the Eggermans version at Vila Vicosa, Portugal, must have been the *editio princeps*.[6] Four weavings are unquestionably by van Leefdael, including one formerly in the collection of Sir Henry B. Samuelson, a variant composition in which Achilles seizes a piece of armor instead of the helmet. This panel may derive from an earlier painting mentioned in the letter from Rubens to Carleton on 28 April 1618, and noted by Crick-Kuntziger.[7] A fifth, signed by van Leefdael and Geraert van der Strecken, with whom he often worked, belonged to the marquis de los Alamos at Jerez de la Frontera.[8]

An anonymous weaving belonging to the Taviel family hung for many years in the town hall of Lille. Its "belles bordures de fruit et de fleurs en festons"[9] suggest the border used by van Leefdael for the version at The Fine Arts Museums. According to Forti Grazzini[10] the same border appears with other sets executed by van Leefdael and van der Strecken: a *History of Constantine* (private collection), a *History of Caesar* (Madrid and Sarasota), a *History of Scipio* (Quirinale, Rome) and a *History of Antony and Cleopatra* (The Metropolitan Museum of Art, New York).[11] The caryatid type of border can be seen at the cathedral of

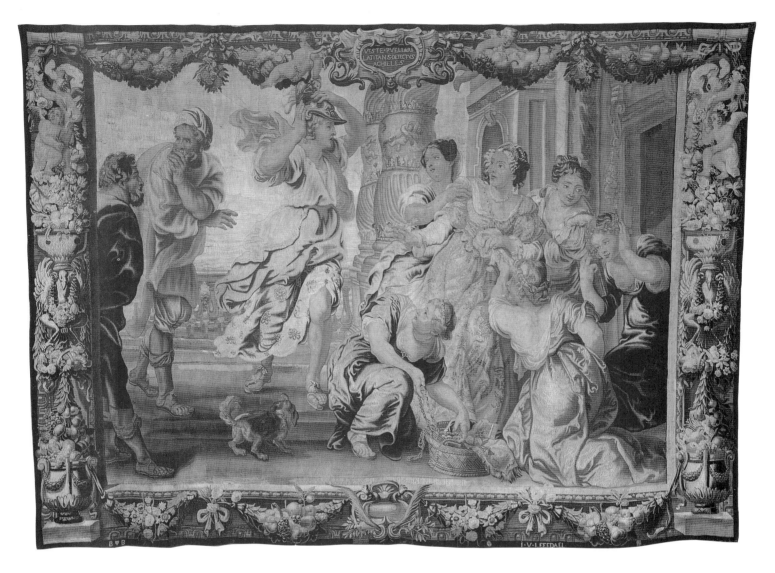

Achilles Found among the Daughters of Lycomedes

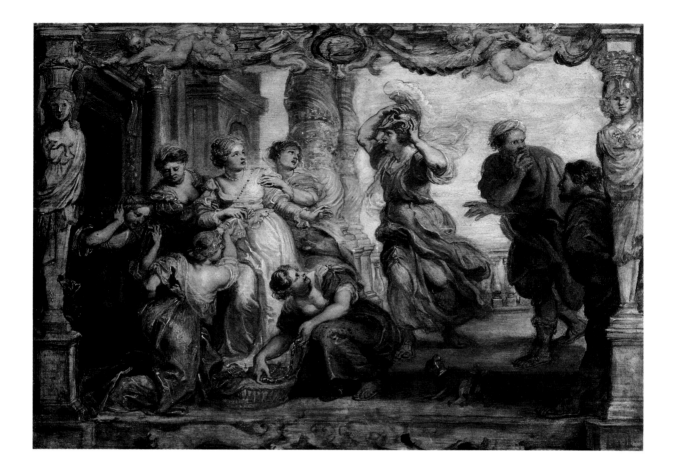

FIGURE 70
Peter Paul Rubens, *Achilles Recognized among the Daughters of Lycomedes*, oil on canvas. Museum Boymans-van Beuningen, Rotterdam. On loan: Dienst voor's Rijks Verspreide Kunstvoorwerpen, The Hague

Santiago de Compostela in a version by Jan Raes.[12] Another caryatid version is at the Vatican Museums, Rome.[13]

NOTES

1. Ulysses is giving a sign to a trumpeter offstage to delay the sounding of his horn although Achilles has been found. The literal source is Statius, *Achilleis*, I, 671–674, mentioned by Julius S. Held, *The Oil Sketches of Peter Paul Rubens*, 2 vols. (Princeton: Princeton University Press, 1980), 1:175, no. 122.

2. Forti Grazzini refers to Held, *The Oil Sketches of Peter Paul Rubens*, 1:175–177, no. 122; 2: pl. 125. He also notes the existence of a "modello," oil on panel, 107 cm × 142 cm, at the Prado, Madrid. The modello, from the "studio" of Rubens, represented a halfway step between the sketch and the [lost] cartoon.

3. Marthe Crick-Kuntziger, "'La tenture d'Achille' d'après Rubens et les tapissiers Jean et François Raes," *Bulletin des Musées Royaux d'Art et d'Histoire*, 3rd ser., 6 (1934): 2–12, 70–71, note complémentaire.

4. Egbert Haverkamp Begemann, *The Achilles Series. Corpus Rubenianum, Ludwig Burchard* (Brussels: Arcade Press, 1975), pt. 10, 104–107.

5. Begemann, *The Achilles Series*, 48.

6. Erik Duverger, "Tapijten naar Rubens en Jordaens in het bezit van het Antwerps handelsvennootschap Fourment-Van Hecke," *Artes Textiles* 7 (1971): 119–121, 148–162, esp. 155.

7. Crick-Kuntziger, "La tenture d'Achille," 70–71.

8. See note 3.

9. Jules Houdoy, *Les tapisseries de haute lisse* (Lille and Paris, 1871), 77–78.

10. Nello Forti Grazzini, *Arazzi a Milano. Le serie fiamminghe del Museo della Basilica di Sant'Ambrogio* (Milan, 1988), 43–44.

11. Edith A. Standen, *European Post-Medieval Tapestries and Related Hangings in The Metropolitan Museum of Art*, 2 vols. (New York: The Metropolitan Museum of Art, 1985), 1:206–217, nos. 32a–e.

12. Marqués de Lozoya, *Santiago de Compostela: La catedral* (Barcelona, n.d.), illus. p. 94.

13. Nello Forti Grazzini, personal communication, June 1990.

BIBLIOGRAPHY

Cavallo, Adolph S. *Tapestries of Europe and of Colonial Peru in the Museum of Fine Arts, Boston*. 2 vols. Boston: Museum of Fine Arts, 1967, 1:127.

55. Rhodopis and King Psammeticus

from The Seven Wonders of the World *Series*

Flemish (possibly Brussels), 1625–1650
H: 3.02 m W: 3.43 m (9 ft. 11 in. × 11 ft. 3 in.)
WARP: undyed wool, 7–8 per cm
WEFT: dyed wool and silk
Mildred Anna Williams Collection (CPLH), 1940.81

The story of Rhodopis, as Strabo told it, recalls that of Cinderella in that a lost slipper led to a royal marriage.[1] While Rhodopis was bathing in the city of Naucratis, an eagle flew off with one of her sandals and carried it to Memphis. There the bird dropped the sandal in the lap of King Psammeticus who was holding court out of doors. Struck by the strange event, as well as by the beauty of the sandal, Psammeticus instigated a search for the owner. When Rhodopis was found, she was brought to Memphis and became the wife of the king.

Rhodopis advances from the left. She wears a pale pink tunic costume with scallops, embroidery, and jewels. Two attendants carry her ermine train. Her dark hair, worn in braids, is surmounted by cascading feathers. She carries before her a golden cup.

Three men in the middle distance dig with hoes and shovels; a fourth carries a burden. Their labor can, perhaps, be interpreted as the building of the third pyramid, "The Tomb of the Courtesan," as Strabo called it. King Psammeticus sits on a throne elevated by two marble steps. He wears a crown, ornamental armor, and a blue mantle. A large eagle flies toward him, carrying the slipper. The king's gesture of surprise is repeated by his courtiers.

Several incomplete sets of *Wonders* have survived from the late sixteenth and seventeenth centuries. The cartoon designers of these sets borrowed the Wonders themselves from engravings. G. Brett has shown the relation of the earlier tapestries to the designs of Maarten van Heemskerck (via the Philip Galle engravings) and the relation of the later ones to the designs of Maarten de Vos (engraved by the de Passe family). De Vos copied much from the earlier designer.

Rhodopis, the courtesan, is mentioned briefly by Herodotus[2] and at greater length by Strabo in that part of his *Geography* describing Egypt.[3] Strabo states that the smallest of the pyramids was built by her lovers; this legendary connection with the pyramids explains her appearance in *The Seven Wonders of the World* series.

Those who wrote about the Seven Wonders did not completely agree which man-made monuments should be included in the list. Antonio Tempesta of Rome, in his *Septem orbis admiranda* of 1608, cited the Colossus of Rhodes, the Statue of Zeus, the Temple of Diana, the Walls of Babylon, the Mausoleum of Halicarnassus, the Pharos of Alexandria, and the Pyramids of Egypt.[4]

The Pyramids subject is now known in several variations. It appears alone, as in this panel, or combined with the Statue of Zeus, as in a very wide tapestry that was at the Galerie Georges Petit, Paris, on 26 November 1928, Collection of O.R.[5] In that version, activities associated with the Olympic games take place before the statue of Zeus Olympius, while the story of Rhodopis and Psammeticus unfolds before the Pyramids. The San Francisco tapestry corresponds to the left half of the wide combined version, and the right half is duplicated by a tapestry sold at Sotheby's, 7 July 1978.[6] The two panels have identical borders and are, presumably, from the same set woven in the mid-seventeenth century. A nearly exact duplicate of the San Francisco *Rhodopis*, with later borders, was in a Hôtel Drouot sale on 1 March 1917.[7] It differed only in two figures added to Rhodopis's entourage at the left edge. Surprisingly, the courtesan herself was missing from two earlier sets of late sixteenth-century date.[8]

Rhodopis has been convincingly shown by Edith Standen to be based on a figure belonging to another *Wonders* subject: the Mausoleum of Halicarnassus, engraved by Philip Galle after Maarten van Heemskerck. The grieving widow, Artemisia, holds a cup from which she has drunk her husband's ashes dissolved in wine. The Fine Arts Museums' tapestry reproduces Artemisia's strange costume with only minor modifications: a feather headdress replaces the crown. The golden cup has been retained, although its meaning is lost in the hands of the courtesan.[9]

When Asselberghs saw the San Francisco panel in 1970, he assigned it tentatively to Brussels with an approximate date of 1625–1650. The borders are tightly packed with *rinceaux* ending in serpents' heads. The serpents hold ribbons that pass through lions' mouths at the corners. The Labors of Hercules mark the center, top and bottom; devils with pendulous breasts, horns, and goat legs appear at the lateral mid-points.[10]

NOTES

1. Strabo, *The Geography of Strabo*, trans. Horace L. Jones (London: Heineman, 1917; reprint, New York: G. P. Putnam, 1932), vol. 8, bk. 17.

2. Herodotus, *The Histories* (reprint, Baltimore: Penguin Books, 1966), vol. 2, 154–155.

3. Strabo, *The Geography*, vol. 8, bk. 17, 93–95.

4. Gerard Brett, "The Seven Wonders of the World in the Renaissance," *Art Quarterly* 12 (1949): 345.

5. Guy Delmarcel, letter to A. G. B., 6 June 1975.

6. Edith A. Standen, letter to A. G. B., 3 January 1989. Sale no. 163.

7. *Catalogue des tapisseries anciennes des XVI, XVII & XVIII siècles . . . appartenant a M. X.*, illus. no. 2.

8. *The Connoisseur* 194, no. 782 (April 1977): 301, illustrated a late sixteenth-century example sold at Christie's, London, 17 February 1977, no. 110, with Brussels town-mark and monogram as the "Building of the Tower of Babel." Delmarcel found a similar example, wider and later.

9. Edith A. Standen, "Some Tapestries at Princeton," *Record of The Art Museum, Princeton University* 47, no. 2 (1988): 3–8.

10. A wide version of *The Temple of Diana at Ephesus* at the Cincinnati Art Museum and a narrower version sold at Christie's, London, 10 March 1988, no. 191, have the same border as The Fine Arts Museums' *Rhodopis* and another *Rhodopis* sold at the Palais d'Orsay, 12 December 1978, no. 114. There must, then, have been two *Wonders* series woven with the same border. I owe this information to Edith Standen. Two early seventeenth-century tapestries illustrating *The Story of Philip of Macedon*, formerly belonging to Elise Stern Haas of San Francisco, had wide borders depicting the Seven Wonders of the World.

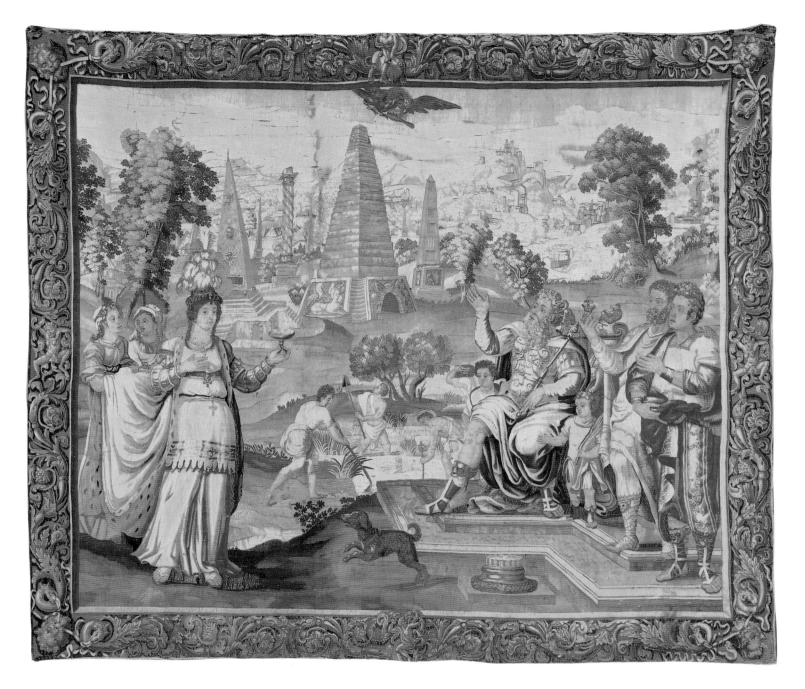

Rhodopis and King Psammeticus

56. The Revenge of Medea

Flemish (probably Brussels), ca. 1750
H: 3.05 m W: 2.95 m (10 ft. × 9 ft. 8 in.)
WARP: undyed wool, 6 per cm
WEFT: dyed wool and silk
Gift of Marian M. Miller (de Young), 1989.44

The story of the enchantress, Medea, and her faithless lover, Jason, is notable for its cruelty, treachery, and passion. Medea practiced her magic arts to win the Golden Fleece for Jason. For him, also, she betrayed her father and murdered her brother. She fled as an exile with the Argonauts, finally settling with Jason in Corinth, where she bore him two sons. Jason's meanness and ambition asserted themselves after a time, and he rejected Medea for the young daughter of the king of Corinth. Medea sent her sons to the bride with the gift of a poisoned robe. Putting it on, the girl was consumed by flames, as was her father when he tried to save her. Medea then killed her children to complete her fearful revenge.

The tapestry shows the moment in the story when Jason and the Corinthians rush from the burning palace to find Medea and kill her. Jason's red cloak swirls behind him. His shield is on his arm, his sword drawn. But he is too late. Medea has stepped from the palace roof into her dragon car, gift of her grandfather, Helius. She makes her escape, having repaid her faithless lover by leaving him wifeless and childless. The story of Medea is found in Ovid's *Metamorphoses* (Book VII) and his *Heroides* (Book XII). Euripides, Seneca, and others gave the Medea story dramatic form.

A famous tapestry series on the subject was woven in the early sixteenth century and is now preserved at the Hermitage. Another was designed by Jean-François de Troy in the eighteenth century. The seventeenth-century series is not so clear. Nello Forti Grazzini notes a seventeenth-century *Jason and Medea* with the BB mark sold at Sotheby's, Florence, 10–11 May 1984, no. 1166. He points to the similarity of Jason's posture with that of Achilles in an eighteenth-century set woven by the van der Borchts circa 1744.[1] A *Departure or Arrival of Jason and Medea*, featuring the same dragon chariot, was in the sale of 5 March 1932, at Lewis & Co., New York.

The tapestry has lively color in shades of blue, green, beige, and red. The very strange border of heavy garlands tied at the corners with red and white ribbons appears to be a replacement carelessly applied, the shading being suddenly reversed in the lower right-hand corner.

NOTE

1. *Combat between Achilles and Paris*, from an *Achilles* set at Musée Jacquemart-André, Paris. See *Les fastes de la tapisserie du XVe au XVIIIe siècle*, exh. cat. (Paris: Musée Jacquemart-André, 1984), 103.

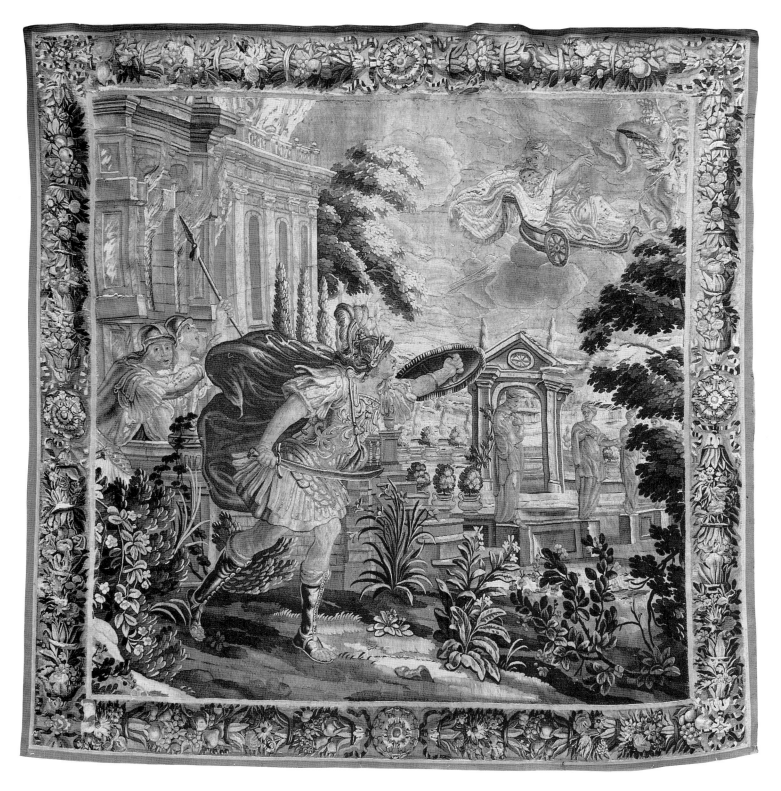

The Revenge of Medea

57. Spring *from* The Four Seasons *Series*

Flemish (Brussels), 1700–1720
Designed by Lodewijk van Schoor (1666–1726)
Attributed to the workshop of Jan-Frans van den Hecke
 (fl. 1662–1691)
H: 3.35 m W: 2.87 m (11 ft. × 9 ft. 5 in.)
WARP: undyed wool, 8 per cm
WEFT: dyed wool and silk
Gift of Archer M. Huntington (CPLH), 1927.183

Two winged female figures personifying April and May sit
on the steps of a garden pavilion. April drapes a garland
over Taurus, the Bull; the sun enters the sign of Taurus on
the twentieth of April. May puts her arm around the
Twins; the twenty-first of May marks the beginning of the
sign of Gemini.[1] A third figure descends the stairs in a
swirl of flying drapery. She wears pearls in her hair and a
diaphanous gown clasped with jewels. She has two sets of
transparent wings. Blossoms fill her left hand; the sash in
her right hand holds roses, jonquils, and narcissus. She
probably represents Flora, or the spirit of Spring, bringing
flowers into the garden. All wear their hair dressed high in
front, following the *fontange* style of the late seventeenth
century.

The tapestry represents the right two-thirds of a design
by Lodewijk van Schoor, the most successful Flemish car-
toon designer of the late seventeenth century. The com-
plete weaving of the cartoon shows an extra figure at the
left, missing in the San Francisco version.[2] The personifi-
cation of March, she completes the trilogy of Spring. Like
her sisters, she has wings, but is dressed in armor since
March, in the ancient world, was dedicated to Mars. She
stands beside Aries, the Ram, whose sign begins about 21
March. The background of the complete weaving shows a
scene of spring gardening. Gardeners move small trees
and set out plants. A dolphin fountain and topiary hedge
fill the background of the narrower version.

The Musées Royaux d'Art et d'Histoire, Brussels, have
another panel of *The Four Seasons* series. It is *Winter* (fig.
71), represented by Aquarius in the posture of a river god;
Pisces, a winged woman holding two fish in a scarf; and a
winged January with two faces, one bearded, the other
young and smooth. A fourth figure, who warms herself at
a brazier, may represent the spirit of Winter, correspond-
ing to the spirit of Spring in the San Francisco tapestry.[3]
Nello Forti Grazzini explains the background as a Carni-
val scene, typical of Flanders in February. Rich floral bor-
ders bearing part of the signature of Jan-Frans van den
Hecke surround the Brussels tapestry. Marillier cites
a panel from the collection of the earl of Iveagh, signed
I.F.V.H., the initials of the same artist.[4]

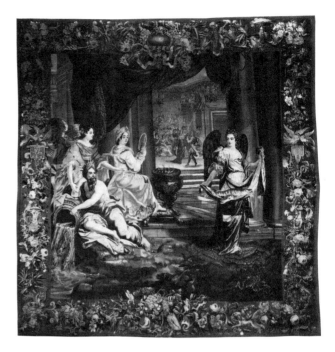

FIGURE 71
Winter, tapestry. Musées Royaux d'Art et d'Histoire, Brussels.
Copyright A.C.L. Brussels

A *Summer* tapestry with different borders was sold at
Christie's, London, 10 December 1981, no. 10. It showed
June, July, and August—Cancer, Leo, and Virgo—with
the spirit of Summer holding a torch.[5]

The borders of the San Francisco panel are not origi-
nal. Whether the original borders resembled those of the
Brussels panel, or, like the *Summer* tapestry, represented
another weaving, is a matter of conjecture.

NOTES
1. Cesare Ripa is the probable iconographical source of these
 winged personifications of the months. In his *Iconologia*, first
 published in 1593, he makes their wings an allegory of their
 continuous course, quoting Petrarch: "Volan gl'anni, i mesi,
 i giorni, e l'hore" (Years, months, days, and hours fly). I am
 indebted to Nello Forti Grazzini for this reference.
2. Dario Boccara, *Les belles heures de la tapisserie* (Zoug: Les Clefs
 du Temps, 1971), 152.
3. Marthe Crick-Kuntziger, *Catalogue des tapisseries (XIVe au
 XVIIIe siècle)* (Brussels: Musées Royaux d'Art et d'Histoire,
 1956), 75, no. 80.
4. H. C. Marillier, "Subject Catalogue of Tapestries" (Victoria
 and Albert Museum, London, ms., n.d.), Months and
 Seasons.
5. Nello Forti Grazzini states that an earlier series showing
 zodiacal signs, designed by Jan van den Hecke, was
 woven more than once in Brussels about 1650.

PROVENANCE
The Fine Arts Museums' tapestry is believed to have come from
 a set of *The Four Seasons* at the Palais de Sagan, Paris.

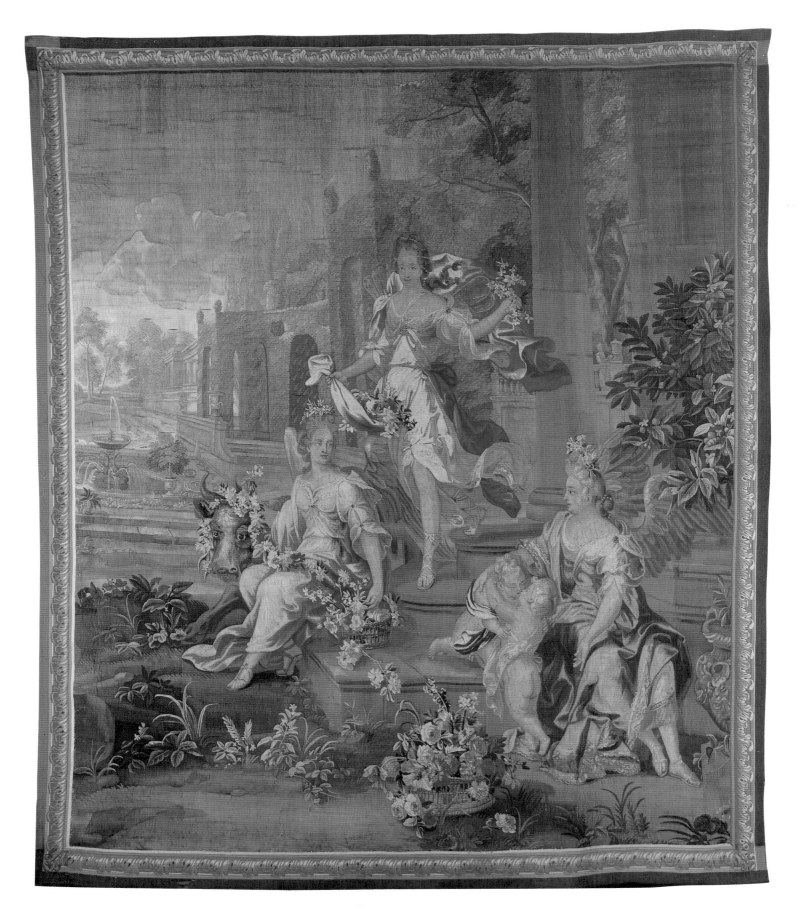

Spring

58. Portiere with Arms of the Visconti Family

Flemish (Brussels), ca. 1690
Designed by David Teniers the Younger (1610–1690)
Woven by Hieronymus Le Clerc (fl. 1676–1719)
H: 3.94 m W: 3.05 m (12 ft. 11 in. × 10 in.)
WARP: undyed wool, 7.5 per cm
WEFT: dyed wool and silk, with metallic threads
MARKS: *Origin* lower guard, right of center
 Weaver lower guard, right
Bequest of Whitney Warren, Jr., in memory of Mrs. Adolph
 Spreckels, (CPLH), 1988.10.23

Supported by two winged figures of Fame holding fanfare trumpets, the arms of the Visconti family of Milan, surmounted by a crown, dominate a distant view of Lake Maggiore. The arms are displayed beneath a curvilinear portico draped with garlands held by amorini, above, and caryatids at each side. Young children at the base of the columns cling to large flower vases. A trophy of armor and weapons of war in the center foreground decorates a framed battle scene, an allusion to military prowess echoed by the blue cameo medallion of Victory on the portico above.

The armorial portiere is believed to have been commissioned by Pirro Visconti Borromeo Arese of Milan (1666–1704), whose daughter Marguerita married his brother, Giulio Visconti. The latter was decorated with the Order of the Golden Fleece in 1721, which accounts for the collar of that order applied to the tapestry at a later date.

Similar armorial portieres were in sales at Sotheby's, Monaco, 9 December 1984; 22 June 1986; and 22 June 1987. An exact duplicate was no. 636 in the Sotheby's, Monaco, sale of 21 February 1988, no. 636, with a full description and bibliography.[1]

NOTE

1. Isabelle Denis, letter to A. G. B., April 1990. I am indebted to Ms. Denis for identifying the arms and providing information about related pieces. Nello Forti Grazzini, *Arazzi a Milano. Le serie fiamminghe del Museo della Basilica di Sant'Ambrogio* (Milan, 1988), 72, 92 n. 30: mention of the Sotheby piece.

BIBLIOGRAPHY

Litta, Pompeo. *Famiglie celebri italiane.* 69 vols. Milan, 1819. Vol. 65, table 12, Visconti di Milano.

Destrée, Joseph. *Tapisseries et sculptures bruxelloises à l'exposition d'art ancien bruxellois.* Exh. cat. Brussels: Librairie Nationale d'Art et d'Histoire, 1906, 50, no. 30, pl. 33.

Göbel, Heinrich. *Wandteppiche. I Teil: Die Niederlande,* 2 vols. Leipzig: von Klinkhardt & Biermann, 1923, 1: 374.

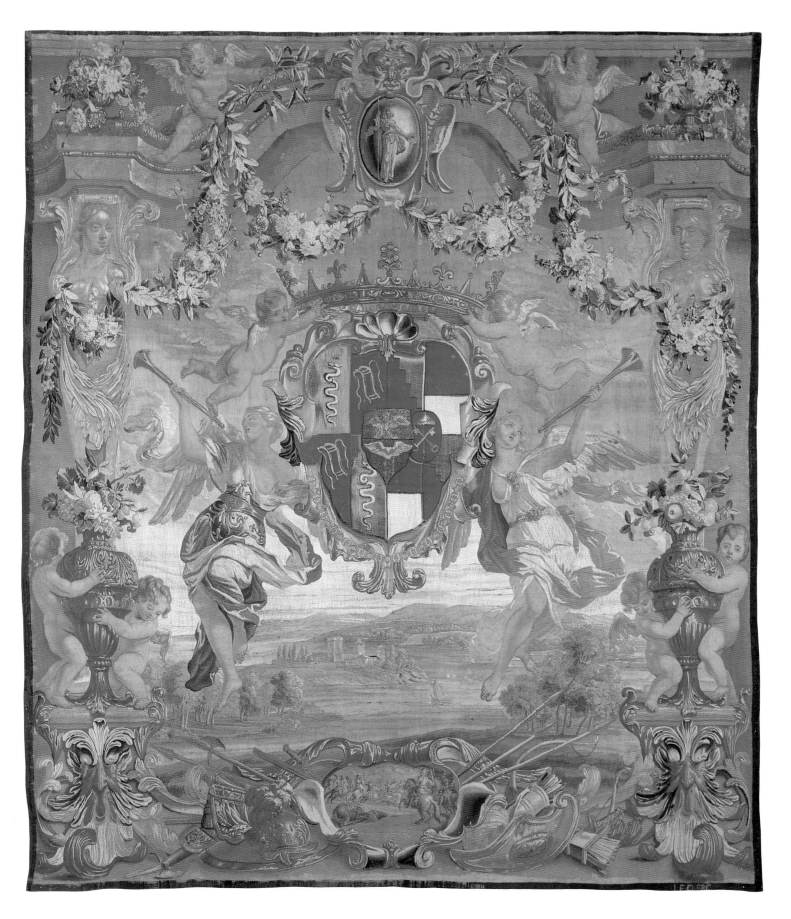

Portiere with Arms of the Visconti Family

59. Mother and Child

Franco-Flemish (Brussels), before 1688, or Lille, 1688–1698
Woven by Jan de Melter (d. 1698)
H: 55 cm W: 40 cm (21½ in. × 15½ in.)
WARP: undyed silk (?), 13 per cm
WEFT: dyed wool and silk, with traces of metallic threads
MARKS: *Weaver* upper right
Gift of Archer M. Huntington (CPLH), 1931.150

I.D.MELTER

In 1679 the weaver Jan de Melter became a dean of the tapestry weavers of Brussels. He prospered there, keeping six looms busy with important commissions from France. These French connections apparently persuaded him to emigrate in 1688 to Lille, which had become a French town in 1667. His atelier there had nine looms in operation, and he drew a pension from France until his death in 1698. Among the works of Melter cited by Houdoy is a *Virgin with the Infant Jesus* after Rubens.[1] The Rubens model has not been found.

The weaving is extraordinarily fine, with much silk. Colors are light; the mother wears a peach-colored gown and a blue cloak. Vestiges of metallic thread are barely visible around the infant's head, and are much darkened by time. Obvious reweaving above the mother's head shows where a halo was removed for some reason. Certain dyes had a destructive effect on the wool, accounting, perhaps, for the repair.

A striking similarity exists between this entry and that which follows (cat. no. 60). For all their correspondence in subject and composition, they project profoundly different moods. The sad and meditative air expressed in this face is far removed from the smiling Madonna who follows.

NOTE

1. Alphonse Wauters, *Les tapisseries bruxelloises* (1878; reprint, Brussels: Editions Culture et Civilization, 1973), 346–347.

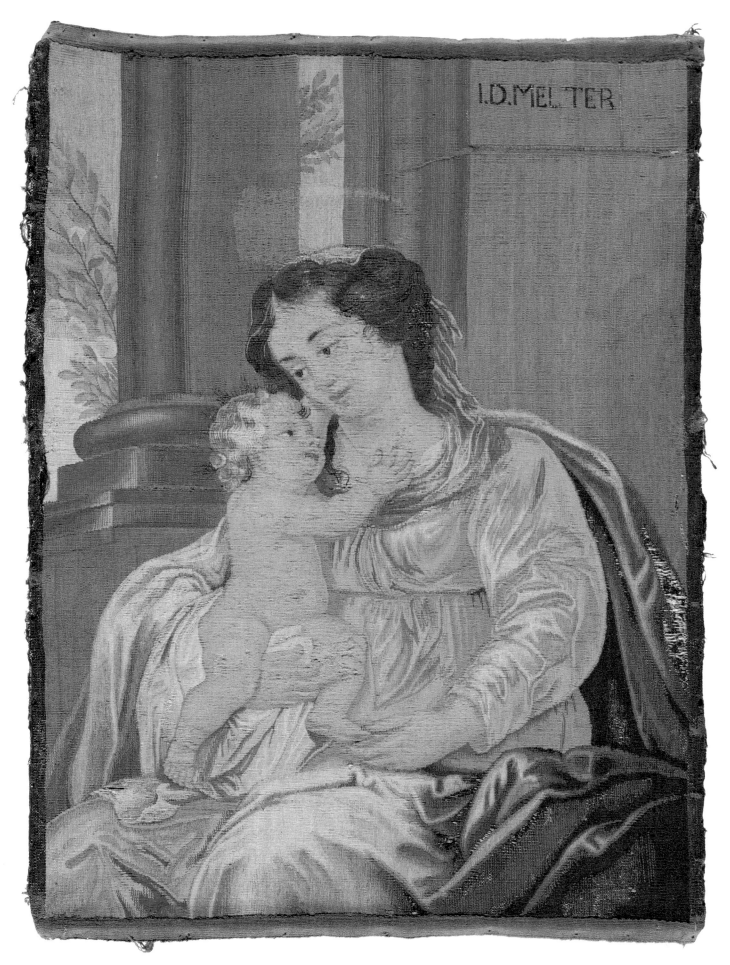

Mother and Child

60. Madonna and Child

Flemish (possibly Brussels), 1680–1700
H: 54 cm W: 39 cm (21 in. × 15 in.)
WARP: undyed wool, 9 per cm
WEFT: dyed silk, with metallic threads
Gift of Archer M. Huntington (CPLH), 1927.180

No doubt the same painting or engraving inspired the *Madonna and Child* of this entry and the *Mother and Child* of the preceding one. Since the sizes agree, it is possible that they were woven from the same cartoon. Although identical in format, the two tapestries give distinctly different expressive effects.

The Madonna holds her child in the circle of her right arm. Her left hand touches his toe, completing the circular rhythm of the composition. The infant looks up at his mother, smiling and reaching for her, and she returns his smile with an expression of maternal tenderness.

Silver thread enriches the Madonna's red gown and her halo. Some of the thread was part of the original weaving; some, of coarser material, has been added at a later date.

A near duplicate of the present entry was in the Parke-Bernet sale no. 289 of 21–23 May 1941, no. 42. An American Art Association-Anderson Galleries sale of 12–14 June 1933, no. 598, described a panel of the Virgin virtually identical in size (18½ in. × 14 in.) and enriched with silver.

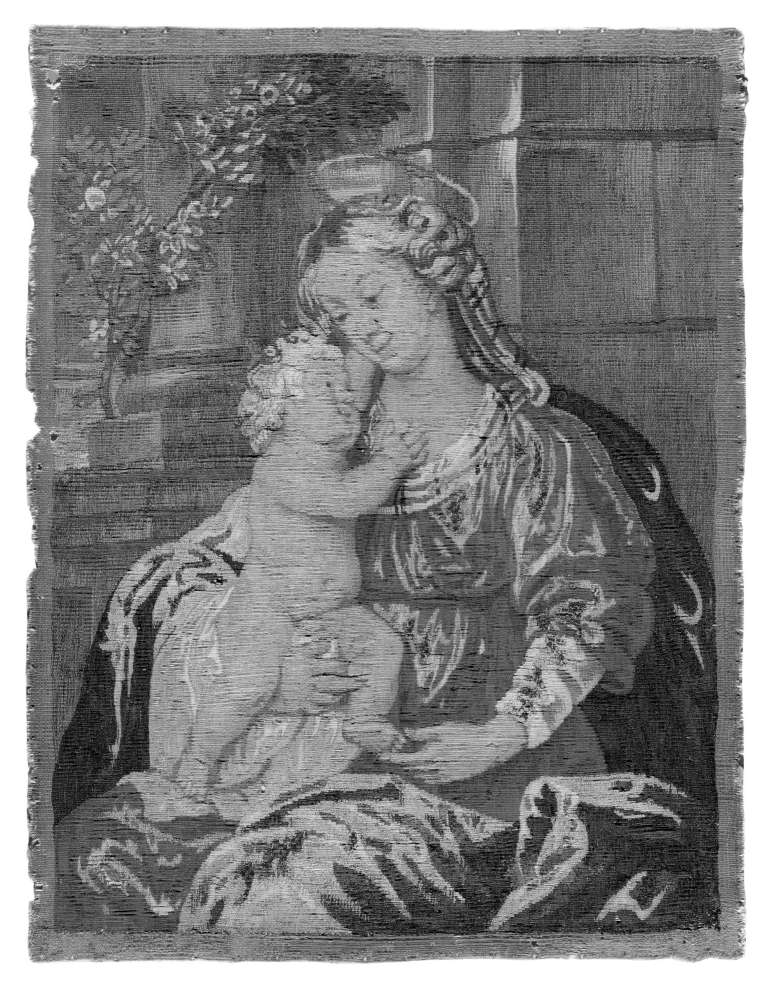

Madonna and Child

61. Confirmation

from The Seven Sacraments *Series*

French or Flemish, 1700–1750
After a painting by Nicolas Poussin (1594–1665)
H: 3.40 m W: 3.25 m (11 ft. 2 in. × 10 ft. 8 in.)
WARP: undyed wool, 7–8 per cm
WEFT: dyed wool and silk
Gift of Sarah M. Spooner (de Young), 25067

Nicolas Poussin painted the subject of *The Seven Sacraments* twice between 1638 and 1648. The first set of seven, painted for his Roman patron, Cassiano dal Pozzo, was completed before the artist was summoned to Paris by Louis XIII and Richelieu "for the glory of France." A thousand artistic chores marred his sojourn in his native land, among them the insistent demand that he make cartoons for royal tapestries after the dal Pozzo *Sacraments*. The assignment was distasteful, and the cartoons did not materialize, although large watercolor studies for the cartoons seem to have been made.[1]

After his return to Rome in 1642, Poussin devoted much of his time to commissions from French friends and patrons, including Paul Fréart de Chantelou, secretary to the superintendent of the Royal Buildings. In 1646 he was at work on an entirely new set of *Sacraments* for Chantelou, which he finished in 1648. These seven paintings, on which the artist concentrated the force of his talent, were, according to Friedlaender, "in content and style Poussin's most remarkable and characteristic works."[2]

His treatment of the subject was new. Lifting the sacraments from a contemporary liturgical setting, Poussin gave these critical moments in human life the authority and dignity of historical events. The sacrament of Confirmation is imagined as it must have occurred in the early Christian church (fig. 72).

The rite is administered in a sepulchral setting, dimly lit by candles and hanging oil lamps. Three heavy sarcophagi loom in the background, one with an effigy figure or a body awaiting burial. The dark verticals of columns and pilasters in grays and tans convey an air of silence and secrecy. Those who await confirmation advance from the right across the foreground in a friezelike procession to kneel before the patriarch at the altar. They represent all ages and conditions and resemble each other only in the simplicity of their manner, in their sincerity and dedication. The patriarch, wearing an early form of priestly vestment, is assisted by a kneeling acolyte holding the holy oil.

The tapestry adheres very closely to the painting, even reproducing the designs of the embroidery and pattern of the marble floor. A major difference is the omission of three figures at the right edge and the lateral compression of the existing figures in that area, especially the mother and child.

The scene is enclosed in a simulated gold frame of the type used by Pieter van den Hecke (see cat. no. 62). Thomson listed the Poussin *Sacraments* as one of the subjects woven in the Parisian ateliers in the first half of the seventeenth century.[3] Fenaille was sure that Poussin's designs were not woven at that time.[4] Weigert conjectured that a tapestry version of the *Sacraments* may have been made, perhaps later, but did not hazard a guess as to where, when, or by whom.[5] Whether all seven of the sacraments were represented, or whether the series was woven more than once, is not known. Undeniably, in spite of the obvious historic interest and value of the panel, *Confirmation* exemplifies what tapestry should not attempt: extensive areas of unbroken color, dull shades, a concentration of forms in one section with corresponding voids elsewhere. The dramatic chiaroscuro of the painting does not succeed in the weaving.

NOTES

1. Maurice Fenaille, *Etat général des tapisseries de la manufacture des Gobelins depuis son origine jusqu'à nos jours 1600–1900*, 1601–1662 (Paris: Librairie Hachette, 1923), 284–285.
2. Walter Friedlaender, *Nicolas Poussin: A New Approach* (New York: Harry N. Abrams [1964]), 56–65, esp. 65.
3. William George Thomson, *A History of Tapestry from the Earliest Times until the Present Day*, rev. ed. (Wakefield, England: EP Publishing Limited, 1973), 426.
4. Fenaille, *Etat général*, 286.
5. Roger-Armand Weigert, *French Tapestry*, trans. Donald and Monique King (London: Faber and Faber, 1956), 104: "It is not impossible that these compositions were reproduced in tapestry, perhaps at a later date."

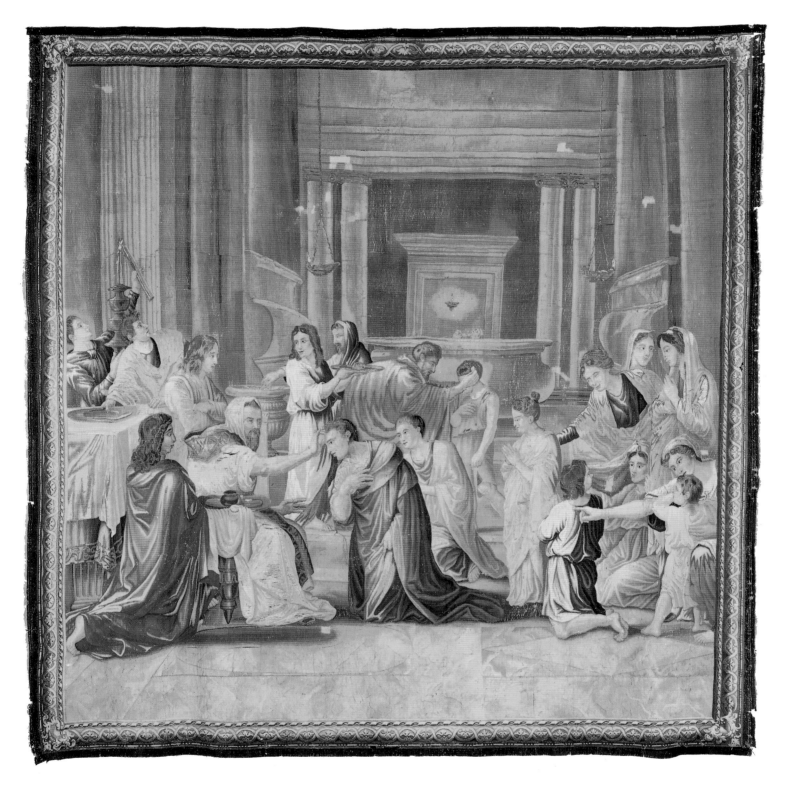

Confirmation

FIGURE 72
Nicolas Poussin, *Sacrament of Confirmation*, oil on canvas.
The Duke of Sutherland Collection. On loan to the
National Gallery of Scotland, Edinburgh

The Teniers Tapestries

French success with pastoral and genre subjects during the seventeenth century led Flemish weavers to promote their own brand of rusticity.[1] They found subjects ready-made in the work of David Teniers II, painter to Archduke Leopold-Wilhelm, governor of the Netherlands, and in the work of the painter's son, David III, who imitated his father. Before the word *boor* (from *boer*) had acquired its present connotation, the life scenes of these *boers*, or country people, clothed in clumsy garments the color of the earth, amused and delighted the upper-middle-class clientele. These peasants stand midway in time between the peasants of Pieter Brueghel and the *Potato Eaters* of van Gogh. They escape the realism of both. Our American tradition offers a parallel in the mid-nineteenth-century work of William Sydney Mount, whose rustics dance in the barn and rest in the shade.

The phenomenal success of Teniers's subjects kept them on Flemish looms for a century. The first center to produce the type in quantity was Brussels, but imitative series followed at Oudenaarde, Lille, Aubusson, and elsewhere. Public demand forced almost every atelier to produce Teniers tapestries. The same cartoons were woven by several different weavers. Those artists who are best known for their adaptations of Teniers designs are Jan van Orley and Augustin Coppens, Ignaz d'Hondt, and J. van Helmont. Certain families of weavers are also associated with the genre: the van der Borcht, van den Hecke, and Leyniers families, and H. Le Clerc and Josse de Vos.

The last weaver of Teniers subjects was also the last to maintain a tapestry atelier in the Netherlands. Jacques van der Borcht, Jr., like his father and uncles, enjoyed the protection of Prince Charles of Lorraine, governor-general of the Netherlands. Prince Charles assisted him in his attempts to continue in a dying industry, but they could not reverse the "changes in tastes, fortunes, and customs."[2] The Brabançon revolution and the French invasion were the final blows that ruined the industry. With the death of Jacques van der Borcht, circa 1794, the last tapestry atelier in the Netherlands closed. The Teniers tapestries are the final expression of a prodigious industrial development.

NOTES

1. H. C. Marillier, *Handbook to the Teniers Tapestries* (London: Oxford University Press, 1932), xv–xvi.
2. Alphonse Wauters, *Les tapisseries bruxelloises* (1878; reprint, Brussels: Editions Culture et Civilization, 1973), 378–379, 419.

62. May Dance

Flemish (Brussels), 1700–1720
Figures attributed to Jan van Orley (1665–1735); landscape to
 Augustin Coppens (fl. ca. 1695)
In the style of David Teniers III (1638–1685)
Woven under the direction of Pieter van den Hecke (fl. 1703–1752)
H: 3.35 m W: 4.06 m (11 ft. × 13 ft. 4 in.)
WARP: undyed wool, 7–8 per cm
WEFT: dyed wool and silk
MARKS: *Origin* lower guard, right of center
 Weaver lower guard, right
Gift of George D. Smith (CPLH), 1957.172

Seven peasant men and women celebrate the first day of
May, dancing energetically to the music of flute and drum
in a clearing before a manor house. At the center of their
dance is a tree encircled by a wreath from which ribbons
flutter. Three other figures in the background dance to the
bagpipe. At left a man tugs at a woman's apron, trying to
draw her toward the dance. These rustic festivities are
watched by two observers in the manor house at right and
by the boy seated astride a large rock in the left fore-
ground. Holding a "bridle" of branches, he pauses in his
game of make-believe to listen to the music and to watch
the dancing. The eye moves from this foreground activity
to the distance where a shepherd drives his flock and to
the cluster of buildings on the horizon. The scene is bor-
dered by an imitation gold frame. The lower guard, out-
side the frame, bears the mark of Brussels and the name
P. van den Hecke.

Another version, attributed to Peter van der Borcht,
is at the Musées Royaux d'Art et d'Histoire, Brussels
(fig. 73). In that weaving, the boy sits on a horse while it
drinks from a pool. Minor variations occur: the shepherd
and his flock are missing, as are some of the other small
background figures.

Asselberghs attributed those cartoons to Jan van Orley
and Augustin Coppens.[1] The attribution has been ex-
tended to The Fine Arts Museums' piece, since it was
surely woven from the same cartoon by a different
weaver.[2] Marillier described the van den Hecke border
as "an inner scroll with a picture frame border outside
formed of a crossed-ribbon scroll and ornaments in the
loops. The corners are finished off with decorative
scallops."[3]

NOTES
1. Marthe Crick-Kuntziger, *Catalogue des tapisseries (XIVe au
 XVIIIe siècle)* (Brussels: Musées Royaux d'Art et d'Histoire,
 1956), no.102; Jean-Paul Asselberghs, *Chefs-d'oeuvre de la tapis-
 serie flamande: Onzième exposition du château de Culan*, exh. cat.
 12 June–12 September 1971, 54.
2. Alphonse Wauters, *Les tapisseries bruxelloises* (1878; reprint,
 Brussels: Editions Culture et Civilization, 1973), 356.
 Dario Boccara, *Les belles heures de la tapisserie* (Zoug: Les Clefs
 du Temps, 1971), 1.
3. H. C. Marillier, *Handbook to the Teniers Tapestries* (London:
 Oxford University Press, 1932), 39.

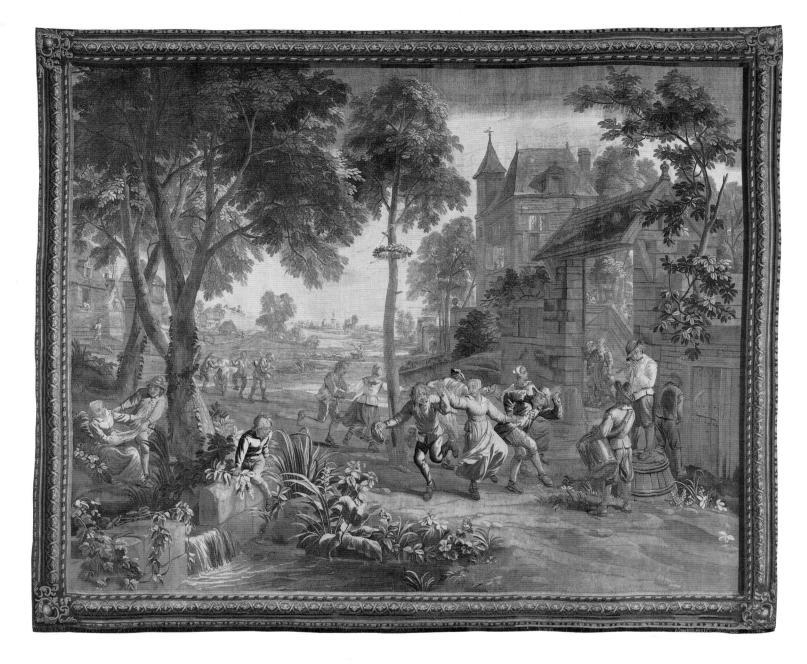

May Dance

63. The Poultry Market

Flemish (Brussels), 1765–1794
Design attributed to Jan van Orley (1665–1735) and Augustin
 Coppens (fl. ca. 1695)
Woven under the direction of Jacques van der Borcht, Jr.
 (fl. 1765–1794)
H: 2.72 m W: 2.41 m (8 ft. 11 in. × 7 ft. 11 in.)
WARP: undyed wool, 6–7 per cm
WEFT: dyed wool and silk
MARKS: *Origin* lower right
 Weaver lower right
Gift of the M. H. de Young Endowment Fund, 44.26.1

This relatively rare subject is usually associated with the weaver Pieter van den Hecke.[1] Two young women sell poultry at an improvised counter before a stone building. One holds up a dead fowl for prospective buyers to inspect. Another girl retreats into the building, carrying a loaded tray on her head. The structure has a chicken coop before it on the left, and a heavy ledge above with a dovecote and three pigeons. A youth sits in the left foreground, holding a live hen and guarding three dead fowl from an interested bulldog. In the right foreground a seated woman holds a bowl for a child who drinks. Secondary figures at various points in the fore-, mid-, and background become increasingly misty and indistinct. The colors are mellow; the texture of the weaving is very fine.

Woven without borders, the tapestry was intended to be set into paneling in the eighteenth-century manner. It has been so exhibited with three other panels by the same weaver: *The Vegetable Market*, *The Vintage*, and *Milking* (cat. nos. 64, 65, and 66).

Both Jacques van der Borcht, who flourished circa 1700, and his grandson, Jacques, Jr., used the signature *I.V.D. Borcht*. The elder Jacques frequently followed his name with the Latin form, *A Castro*. Jacques, Jr., favored the form *IAC: VD: BORCHT*, as on The Fine Arts Museums' panels. He carried on the family industry after the death of his uncles, Peter (died circa 1763) and Frans (died circa 1765), until his own death or retirement in 1794. Panels by Jacques, Jr., are rare because his workshop operation was limited and much of the work left at his death was destroyed by fire.

NOTE
1. H. C. Marillier, *Handbook to the Teniers Tapestries* (London: Oxford University Press, 1932), 44, pl. 31, near duplicate.

PROVENANCE
Duveen Brothers
Mrs. Henry E. Huntington
French & Co.

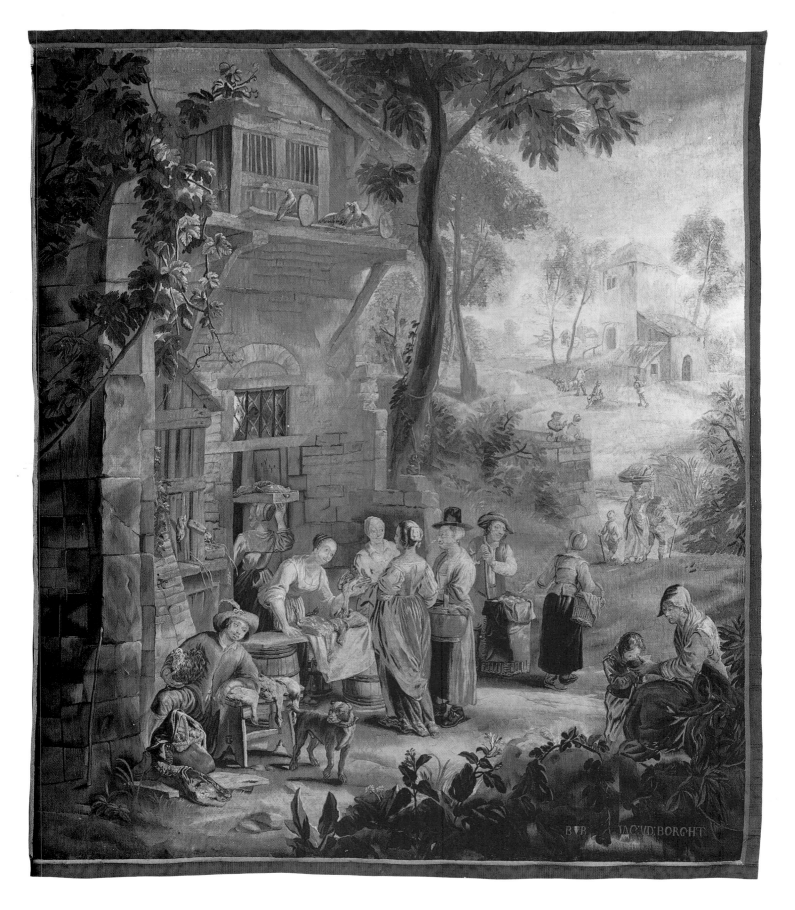

The Poultry Market

64. The Vegetable Market

Flemish (Brussels), 1765–1794
Design attributed to Jan van Orley (1665–1735) and Augustin
 Coppens (fl. ca. 1695)
Woven under the direction of Jacques van der Borcht, Jr.
 (fl. 1765–1794)
H: 2.72 m W: 2.32 m (8 ft. 11 in. × 7 ft. 7½ in.)
WARP: undyed wool, 7 per cm
WEFT: dyed wool and silk
MARKS: *Origin* lower right
 Weaver lower right
Gift of M. H. de Young Endowment Fund, 44.26.2

Peter van den Hecke wove the entire, very wide design of which The Fine Arts Museums' panel represents the left half. The complete scheme shows an open square with an obelisk in the center surmounting a fountain from which horses drink. The vegetable sellers of the present panel are balanced in the larger version by another group of vendors at the right who are unloading a wagon and setting out their wares.[1] A complete weaving may be found at the Musée des Arts Décoratifs, Paris. The presence of the rival vegetable sellers sharpens the point of the foreground exchange between the seated vegetable seller with her child and the dissatisfied shopper who is leaving with an empty basket and moving with a determined stride toward the establishment across the square.

The vegetables set out in baskets and wooden tubs can be identified as cabbages, asparagus, or perhaps black salsify—a typical Flemish vegetable—carrots, and turnips. A tall vase of flowers stands before the stall where a woman weighs cherries. A peddler and his dog stand on the periphery, hoping to attract business. Various secondary points of interest are included. A speaker has attracted a little crowd and harangues, not from a soap box, but probably from a wine cask. Other stalls are indicated in the background. Particularly intriguing is the figure of the man with a spade over his shoulder who advances in the foreground from the left. He wears boots and a broad-brimmed hat, and carries a satchel. Although to be iconographically correct he should be accompanied by his dog, it seems certain, nevertheless, that he is the Molecatcher, a figure frequently encountered in the Teniers tapestries.[2]

NOTES

1. H. C. Marillier, *Handbook to the Teniers Tapestries* (London: Oxford University Press, 1932), 43, pl. 30.
2. Marillier, *Handbook*, pl. 37b.

PROVENANCE
Duveen Brothers
Mrs. Henry E. Huntington
French & Co.

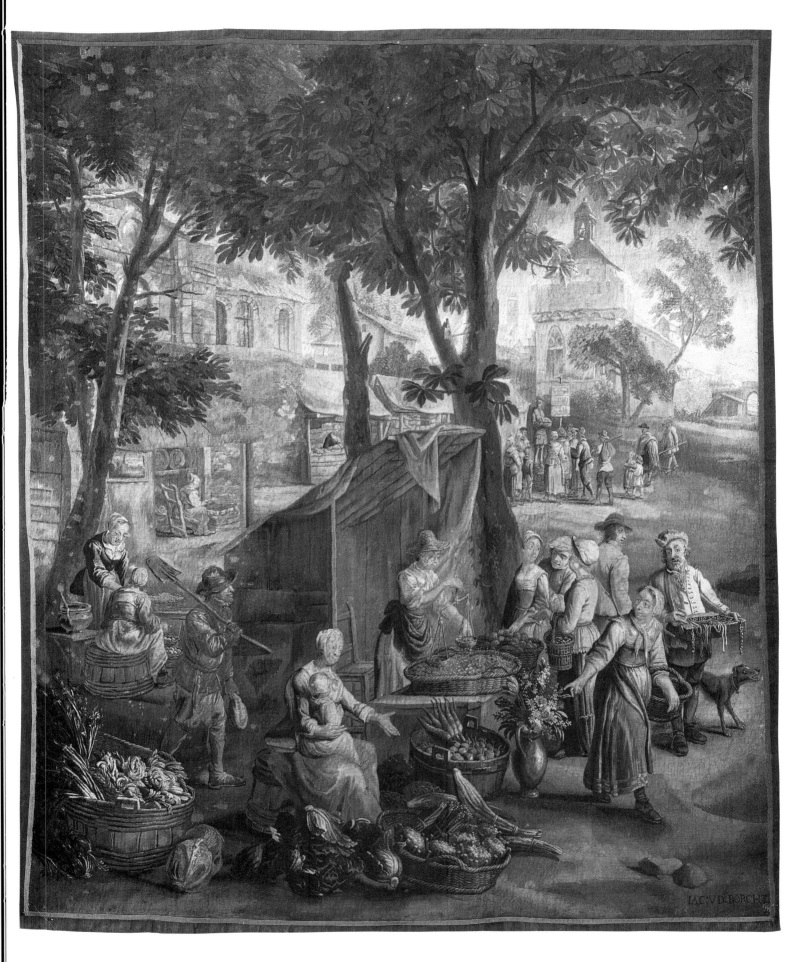

The Vegetable Market

65. The Vintage

Flemish (Brussels), 1765–1794
Design attributed to Jan van Orley (1665–1735) and Augustin
 Coppens (fl. ca. 1695)
Woven under the direction of Jacques van der Borcht, Jr.
 (fl. 1765–1794)
H: 2.72 m W: 2.4 m (8 ft. 11 in. × 7 ft. 10½ in.)
WARP: undyed wool, 7.5 per cm
WEFT: dyed wool and silk
MARKS: *Origin* lower right
 Weaver lower right
Gift of the M. H. de Young Endowment Fund, 44.26.4

Jacques van der Borcht's version of country wine making
shows nearly the complete scene woven by Peter van den
Hecke. Men and women carrying heavy packs bring
grapes from the vineyard. They pass near the center from
right to left. Three additional heavy-laden figures are visi-
ble in the distance, just left of the tree. The woman seated
at left has laid her pack aside and holds her bowl for some
refreshment.

Another woman in a broad-brimmed hat sits on a cask
from which wine is flowing into a container, as a cooper
in boots and apron stands by. This stalwart figure, as Ma-
rillier noted,[1] was borrowed from a *Packing and Carting Fish*
subject woven by V. and D. Leyniers and by Jacques van
der Borcht. He also appears in *The Fish Quay*. With him in
that panel, woven by van den Hecke, is the woman on the
cask of *The Vintage*. She sits dangling her feet over the edge
of a dock in *The Fish Quay*.[2]

Another cooper hammers at a cask at the left. Casks
lie on the ground at right and in the distance. The right
background is filled with winery buildings; the left is
spanned by the arches of an ancient bridge.

The larger panel by van den Hecke included the visit
from the master of the vineyard. While his groom holds
his horse, this portly proprietor, in the center of the panel,
samples the product of his vines. A *Vintage* in the Clayton
East set[3] shows the entire design.

NOTES
1. H. C. Marillier, *Handbook to the Teniers Tapestries* (London:
 Oxford University Press, 1932), 59 n. 1, pl. 40.
2. Dario Boccara, *Les belles heures de la tapisserie* (Zoug: Les Clefs
 du temps, 1971), 197.
3. Marillier, *Handbook*, pl. 28a.

PROVENANCE
Duveen Brothers
Mrs. Henry E. Huntington
French & Co.

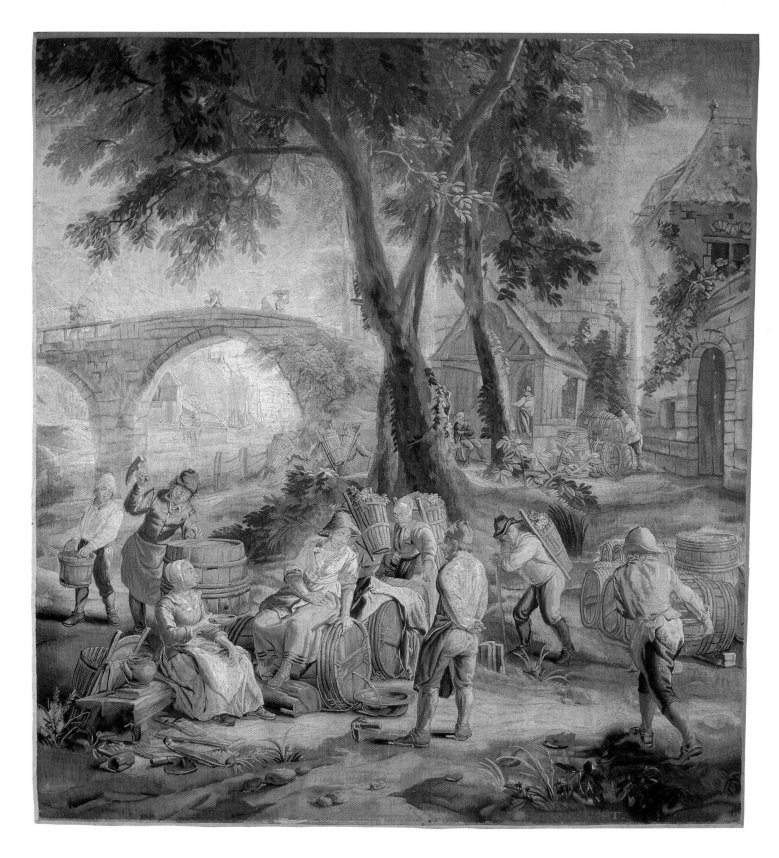

The Vintage

66. Milking

Flemish (Brussels), 1765–1794
Design attributed to Jan van Orley (1665–1735)
Woven under the direction of Jacques van der Borcht, Jr.
 (fl. 1765–1794)
H: 2.72 m W: 2.42 m (8 ft. 11 in. × 7 ft. 11 in.)
WARP: undyed wool, 7 per cm
WEFT: dyed wool and silk
MARKS: *Origin* lower right
 Weaver lower right
Gift of the M. H. de Young Endowment Fund, 44.26.3

Three women, a herd of cows, a flock of sheep, and a family of ducks are placed in the foreground of a rural landscape with thatch-roofed cottages. One woman sits beside a cow and holds a bowl. Another leans over to pour milk from her spouted bowl into a narrow-necked container. The other standing woman holds a similar large vessel over her arm. The eye moves back to the middle ground where a farm woman draws water from an old sweep well. In the dooryard of the house a man feeds his chickens. Still further back, rendered with great delicacy, trees and cottages fade into the distance.

The milking subject was apparently a family favorite with the van der Borchts for, as Marillier showed, three generations treated the same subject, but with considerable variation. The first Jacques van der Borcht, grandfather of the weaver of The Fine Arts Museums' panel, set the scene in a towering landscape; Peter van der Borcht, uncle of Jacques, Jr., placed the figures in a wooded grove.[1] Only a portion of the complete design is represented by the last weaver, Jacques, Jr. Figures are fewer, the details simplified, and the vaporous background is as insubstantial as a dream.

NOTE

1. H. C. Marillier, *Handbook to the Teniers Tapestries* (London: Oxford University Press, 1932), 5, 7–8, 51–52, pls. 18a/b, 19b.

PROVENANCE

Duveen Brothers
Mrs. Henry E. Huntington
French & Co.

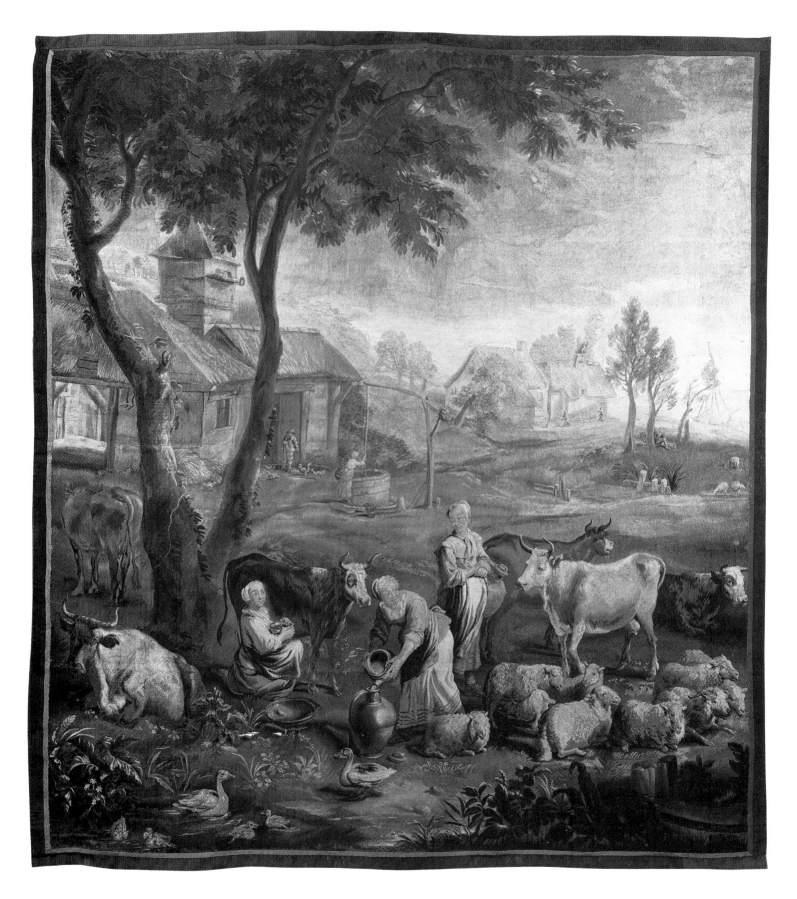

Milking

67. Verdure

Flemish, early seventeenth century
H: 3.07 m W: 4.83 m (10 ft. 1 in. × 15 ft. 10 in.)
WARP: undyed wool, 4 per cm
WEFT: dyed wool and silk
Bequest of Whitney Warren, Jr., in memory of Mrs. Adolph
Spreckels, 1988.10.24

Verdures, or "greenery" tapestries, mass-produced on the simplest level, trailed behind figured tapestries in prestige and in the price they commanded. They seldom bore the signature of the weaver. Nevertheless, their splendid decorative quality and continuing popularity over several centuries made them the bread-and-butter of certain weaving centers. Vegetation was the essential subject, but this often included more than plant forms or a landscape. Architectural elements, such as a distant castle or a bridge, crept into the design with small, recognizable, woodland animals in the foreground and an occasional hunter or shepherd in the distance. Bertrand Jestaz designated as "improved verdures" those enhanced with animals and small figures.[1] Some of the finer of these were, in fact, signed by the weaver.

This landscape scene in bluish greens and golds has only a church, a bridge, and a house to suggest human presence. Three groups of trees rooted in the foreground establish a rhythmic division. More distant tree trunks and hedges, aligned for perspective effect, lead the eye to the low horizon. A large rabbit in the left grove, and a deer in the center, constitute the minimal fauna, together with the long-tailed birds near the lower edge and those among the carnations and tulips of the wide border. Blue and white vases hold the flowers in ascending tiers on the sides. Flowers hang in garlands on the top and bottom, with bows and an occasional blossom overlapping the "frame." The dark brown shadow line edging the upper and the left border produces a trompe l'oeil effect.

Flemish verdures were widely copied in France, complicating the assignment of the place of origin. This fine verdure seems to be from Flanders; Brussels produced verdures, but the comparative coarseness of the weave points to some other Flemish center, possibly Oudenaarde or Antwerp.

NOTE
1. Bertrand Jestaz, "The Beauvais Manufactory in 1690," in *Acts of the Tapestry Symposium November 1976* (San Francisco: The Fine Arts Museums of San Francisco, 1979), 188–189.

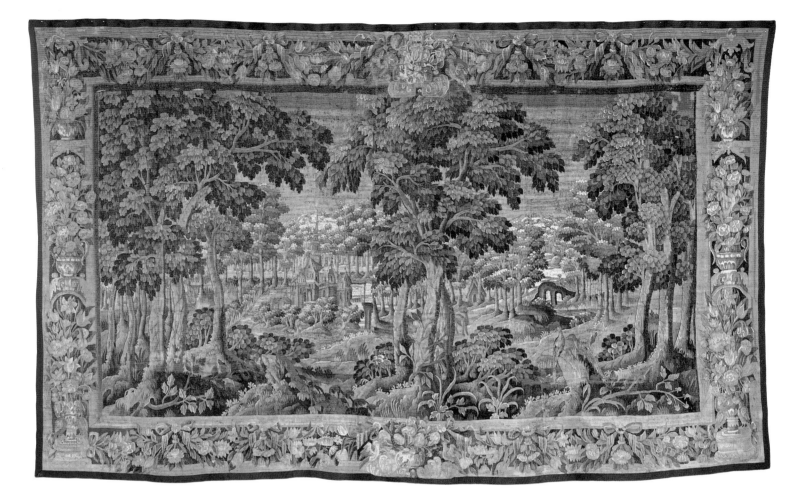

Verdure

PART FOUR

SEVENTEENTH- TO TWENTIETH-CENTURY TAPESTRIES IN FRANCE AND AMERICA

Paris 1601–1662

The seventeenth century, often called the Age of Kings, found many tapestry operations springing up under royal sponsorship. The early ateliers were launched by royal initiative, and they laid the foundations for the later successes. But the establishment of the Gobelins and the Beauvais manufactories under Louis XIV marked events of such consequence that they tend to obscure earlier enterprises of the century.

Henri IV's objective was to develop tapestry manufacture as a national industry. The atelier inaugurated by the king in the grand gallery of the Louvre in 1607 employed native weavers. Flemish weavers were brought to France in 1601 to operate an atelier situated at faubourg Saint-Marcel. Marc de Comans came from Antwerp, and Frans van den Plancken—who later became known as François de La Planche—from Oudenaarde. The contract between the king and these Flemings granted important favors: the waiving of taxes and protection from competition, both domestic and foreign. The ateliers were expected, however, to become self-sufficient, to serve town as well as crown. Their reason for being was profit, not prestige as at the later Gobelins. To distinguish the products of different Parisian ateliers is difficult. Most of the popular designs seem to have been woven at all the ateliers. Inventories are full of the designs after Simon Vouet, "the uncontested leader of the French school under Louis XIII."[1] A battery of French and Flemish aides helped him to supply the demand for cartoons by exercising their special talents as painters of landscapes, animals, or ornaments. The same division of labor among specialists was to characterize design making at the Gobelins and at Beauvais.

In 1627 at faubourg Saint-Marcel, the harmony between the de Comans and de La Planche families ended with the death of the cofounder, François de La Planche. His son, Raphael, left shortly thereafter to set up a rival weaving establishment at Saint-Germain-des-Prés. The neighbors complained that his Flemish weavers destroyed the tranquility of that ancient quarter, but the reputation of their skill surpassed that of other Parisian ateliers.[2] Between 200 and 250 weavers were working at faubourg Saint-Germain in 1661, with forty-two looms in use. After Colbert's reorganization of the Gobelins at faubourg Saint-Marcel in 1662, the activity at faubourg Saint-Germain decreased sharply, but tapestries were produced there for another decade or more.

NOTES

1. Jules Guiffrey, *Les manufactures parisiennes de tapisseries au XVIIe siècle* (Paris, 1892), 42.
2. Roger-Armand Weigert, *La tapisserie et le tapis en France* (Paris: Presses universitaires de France, 1964), 96.

The Story of Theagenes and Chariclea *Series*

The sale catalogue for the Victor Desfossés sale held in Paris on 6–7 May 1929 described Item 246 as "a series of six large Flemish tapestries of the seventeenth century with biblical subjects." Surprisingly, after labeling the tapestries "Flemish," the catalogue stated unequivocally "after the cartoons of Simon Vouet." The idealized, Italianate figures made such an attribution predictable, but the series remained undocumented. It was known that tapestry cartoons represented a large part of Vouet's studio output, but *Theagenes and Chariclea* was not listed in Crelly's catalogue raisonné of 1962 among the sets known to have been designed by Vouet,[1] nor was it known earlier to tapestry historians Maurice Fenaille writing in 1923 or Heinrich Göbel in 1928. It would be another sixty years until Barbara Brejon de Lavergnée, studying the Vouet drawings in the Louvre's Cabinet des Dessins and elsewhere, furnished proof at last of Vouet's authorship of the series and provided a clue to the probable commission and date as well.[2]

Claude de Bullion, Louis XIII's minister of state and superintendent of finance, one of the wealthiest and most powerful men of his time, had two splendid residences: the luxurious Hôtel de Bullion in the rue Platrière and the Château de Wideville, his country estate near Davron. Vouet had a hand in the decoration of both. He worked at the Hôtel de Bullion during the years 1634–1635,[3] painting the walls and vault of the gallery with scenes from the *Odyssey* and from Tasso's *Jerusalem Delivered*. The Musée des Arts Décoratifs owns a tapestry version of *Armide pleurant le départ de Renaud*, after a Vouet painting from the Tasso group. The tapestry's heavy "sculptural" borders, identical with those of The Fine Arts Museums' set, reproduce the decorative effect of Vouet's paintings set in Sarazin's ornamental stucco frames. In the words of Crelly, the effect of the ensemble was "a rich and sumptuous elegance."[4]

The decoration of the Château de Wideville used the same combination of talents. Vestiges remain of the grotto in Bullion's gardens at Wideville where Vouet's work was surrounded by stucco sculptures "où tout accuse la main de Sarazin."[5] J. Thuillier made the specific connection between Vouet, Bullion, Wideville, and *Theagenes and Chariclea* in his course given at the Collège de France (1984–1985). He pointed out that an inventory made in 1641 after Bullion's death listed twelve large canvases from the main salon of the Château de Wideville. They illustrated the "Ethiopian story of Theagenes and Chariclea." While Vouet was not mentioned, his authorship might be assumed because of his work at the Hôtel de Bullion in Paris and the grotto at Wideville. The study by Lavergnée of a drawing at the Ecole des Beaux-Arts confirmed the matter. A preparatory sketch for the *Ulysses* series was on the

front, one for the *Theagenes and Chariclea* series on the reverse. They must be contemporary, establishing the date of 1634–1635 for both.[6]

When the series came to the California Palace of the Legion of Honor in 1929, the literary subject was recognized as a pastoral romance and given the title of *Daphnis and Chloë*. The confusion was understandable, for the plots of novels of this kind are nearly interchangeable: lovers separated by sensational accidents are reunited after harrowing adventures. Heliodorus first told the story of Theagenes and Chariclea in late Greek times. The sixteenth-century translation of the love story by Jacques Amyot, bishop of Auxerre, enjoyed great popular success and inspired, in addition to Vouet's work, paintings by Ambroise Dubois at Fontainebleau and Mignard at Avignon,[7] and two tapestry series designed by artists other than Vouet.[8]

The Vouet cartoons were woven with four different borders. Some examples of the sculptural type of border applied to other subjects bear the mark of Raphael de La Planche, whose atelier was in the faubourg Saint-Germain. The *Theagenes and Chariclea* set at the Château de Châteaudun has amorini, garlands, and medallions in the corners with "cameo" busts. Madeleine Jarry pointed out a younger panel at São Paulo, Brazil, with a border of flowers and spiraling acanthus that Fenaille states was first used in 1668.[9] Finally, still another type with heavy garlands frames a panel at the Mobilier National, Paris.[10] The different sets show interesting variations. Lavergnée suggests there may have been more than one set of cartoons.

NOTES

1. William R. Crelly, *The Painting of Simon Vouet* (New Haven and London: Yale University Press, 1962), 11, n. 44 with bibliography.
2. Barbara Brejon de Lavergnée, *Inventaire général des dessins. Ecole française: Dessins de Simon Vouet 1590–1649* (Paris: Cabinet des Dessins, Musée du Louvre, Editions de la Réunion des Musées Nationaux, 1987), 88, 92–93. See also Jacques Thuillier, Barbara Brejon de Lavergnée, and Denis Lavalle, *Vouet* (Paris: Réunion des Musées Nationaux, 1990), 403–406.
3. Crelly, *Painting*, 102. Crelly cites Félibien for dates of Vouet's activity at Hôtel de Bullion and gives sources for Hôtel de Bullion, n. 74. See Félibien, *Entretiens sur les vies et sur des ouvrages des plus excellens peintres anciens et modernes, 1685–1688*, ed. Trevoux (Paris, 1725), 395.
4. M. V. Droguet has pointed out an *entrefenêtre* with identical borders belonging to the Préfecture of Indre-et-Loire in Tours (letter of 10 August 1989). Nello Forti Grazzini notes two tapestries with similar borders: one from a *Rinaldo and Armida* set at the Hermitage in Leningrad (N. Birioukova, *Les tapisseries françaises de la fin du XVe au XXe siècle dans les*

collections de l'Ermitage [Leningrad, 1974], no. 18) and a *Story of Diana* sold by Christie's, New York, 23–24 July 1985, no. 227.

5. L. Dimier, *Histoire de la peinture française du retour de Vouet à la mort de Lebrun, 1627 à 1690,* 2 vols. (Paris and Brussels: G. van Oest, 1926–1927), 1:8.
6. Lavergnée, *Inventaire*, 92; Thuillier et al., *Vouet*, 403, no. 93.
7. Lavergnée, *Inventaire*, 92.
8. Nello Forti Grazzini cites two *Theagenes and Chariclea* tapestries from an earlier series sold by Sotheby's, Château de Cleydael, 14 October 1987, nos. 244–245, said to have been woven by F. van den Plancken and M. Comans, ca. 1620 (personal communication, June 1990).
9. Maurice Fenaille, *Etat général des tapisseries de la manufacture des Gobelins depuis son origine jusqu'à nos jours 1600–1900, 1601–1662* (Paris: Librairie Hachette, 1923), 373.
10. Lavergnée, *Inventaire*, 94, illus. extreme left.

68. Persina Prepares the Cradle

from The Story of Theagenes and Chariclea *Series*

French (Paris), 1634–1635
Designed by Simon Vouet (1590–1649)
Woven under the direction of Raphael de La Planche (fl. 1629–1661)
H: 4.08 m w: 3.24 m (13 ft. 4½ in. × 10 ft. 7½ in.)
WARP: undyed wool, 7–8 per cm
WEFT: dyed wool and silk
Gift of H. K. S. Williams (CPLH), 1929.9.5

Inside the heavy border the central scene opens into deep space. Stately columns and a statue of Hercules denote a palace where a makeshift cradle is secretly prepared. An elderly woman brings drapery and jewels, a kneeling man holds a pen and paper. A third figure, his back to the viewer, watches intently.

The Fine Arts Museums' panel corresponds to the right-hand portion of a wide tapestry at the Château de Châteaudun. While the San Francisco example includes a little more at the right edge, including a handsome dog on a leash, it lacks an entire group of court ladies who spin and sew on the left (fig. 74). Persina's face offers another point of difference. In the San Francisco panel she is old and drawn. She appears much younger in the wider version. The old face closely resembles a drawing from the Cholmondeley Albums (Inv. 28.135) (fig. 75). The full-length figure in both versions owes much to a Vouet drawing in the Nationalmuseum, Stockholm (fig. 76), even to the bands at the bottom of the skirt. It was published by Lavergnée as a preparation for Vouet's painting, *The Visitation*, at Meilleraye Abbey in Brittany. As Lavergnée noted, Vouet was not afraid of repeating himself. The two-figure composition was repeated again in an *entrefenêtre* at Châteaudun showing Persina and her daughter.[1]

Although the primary role of the grisaille border is splendid decoration, its figures may have been intended to engage the intellect as well as the eye. It is tempting to see in the playful games of the putti a reflection of an elaborate system of pictorial imagery widely accepted in the seventeenth century. Ideas in allegorical form had been codified by Cesare Ripa into a handbook for poets and painters, his *Iconologia*. Emile Mâle states that Simon Vouet used it freely.[2]

Winged female figures holding fanfare trumpets in the upper corners of all six panels symbolize Fame. The putti with palm fronds and branches of oak and laurel are an allusion to Honor.[3] In the right lower border, a putto puts his hand into a lion's mouth; Ripa's personification of Courage performs the same action.[4] Putti at left play with small birds in a nest over which a large bird hovers anxiously. This may refer to Ripa's water hen, who adopts strange birds in need,[5] a not inappropriate adjunct to a scene of child abandonment.

NOTES

1. Barbara Brejon de Lavergnée, *Inventaire général des dessins. Ecole française: Dessins de Simon Vouet 1590–1649* (Paris, Cabinet des Dessins, Musée du Louvre. Editions de la Réunion des Musées Nationaux, 1987), 94, illus. LIII; Jacques Thuillier, Barbara Brejon de Lavergnée, and Denis Lavalle, *Vouet* (Paris: Réunion des Musées Nationaux, 1990), 406, no. 95.
2. Emile Mâle, *L'art religieux après le Concile de Trente* (Paris: A. Colin, 1932), 39.
3. Cesare Ripa, *Baroque and Rococo Pictorial Imagery*, Hertel Edition of 1758–1760, ed. Edward A. Maser (New York: Dover, 1971), 155.
4. Ripa, *Baroque*, 66.
5. Ripa, *Baroque*, 38.

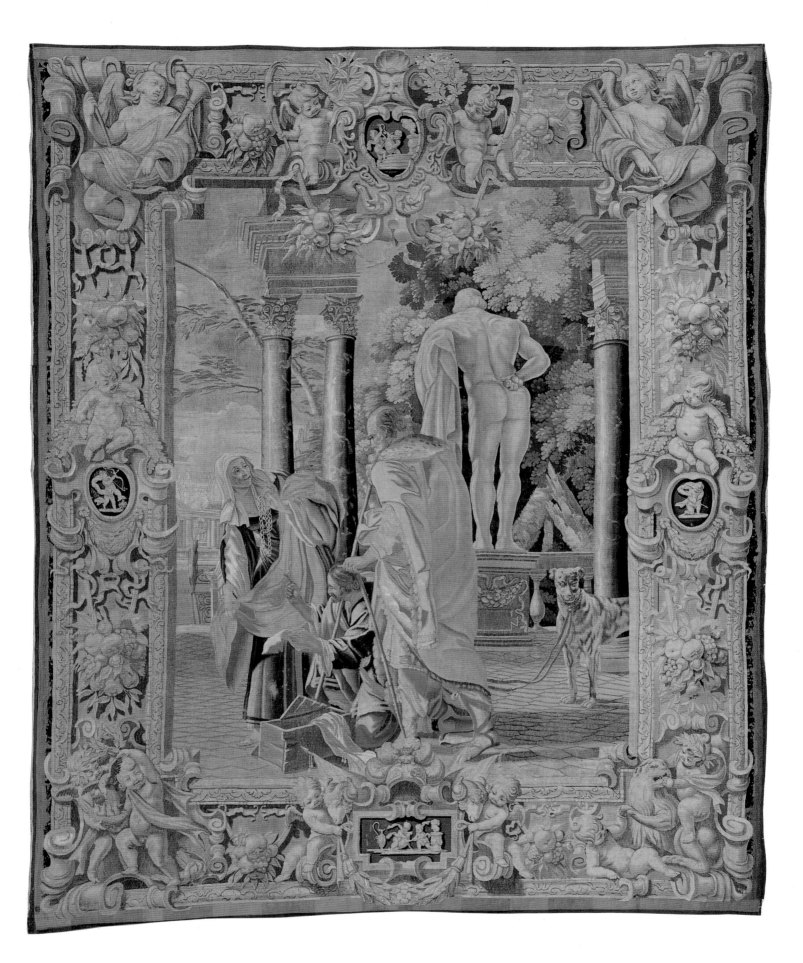

Persina Prepares the Cradle

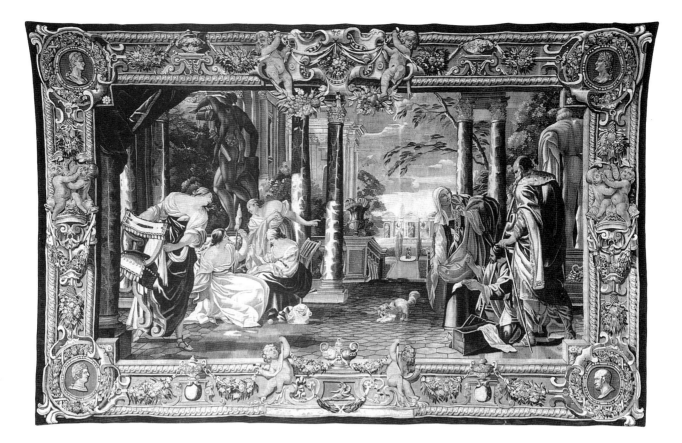

FIGURE 74
Persina Prepares the Cradle to Abandon Her Daughter, tapestry.
Château de Châteaudun

FIGURE 75
Attributed to Simon Vouet, drawing from the Cholmondeley
Albums. Musée du Louvre, Paris. Cabinet des Dessins, 28.135.

FIGURE 76
Simon Vouet,
"Saint Elisabeth,"
black chalk.
Nationalmuseum,
Stockholm,
NM 2423/1863

69. The Shepherd Finds the Infant Chariclea

from The Story of Theagenes and Chariclea *Series*

French (Paris), 1634–1635
Designed by Simon Vouet (1590–1649)
Woven under the direction of Raphael de La Planche (fl. 1629–1661)
H: 4.14 m W: 3.40 m (13 ft. 7 in. × 11 ft. 2 in.)
WARP: undyed wool, 7–8 per cm
WEFT: dyed wool and silk
Gift of H. K. S. Williams (CPLH), 1929.9.1

Highborn infants, abandoned at birth and raised in rustic simplicity, are a common feature of the pastoral romance. The small scene in the left background shows Chariclea's cradle discovered by the shepherd at the water's edge. In the central scene, the shepherd's wife lifts her hand in elegant surprise at the sight of the infant. These country people have a modish air about them and the forest is delicately contrived.

The corresponding panel at Châteaudun is a little wider and lacks the two children who play beside their mother. They have been replaced by a large flowering plant. Two goats nibble foliage behind the tree (fig. 77).

The sculptural border of The Fine Arts Museums' panel shows a variation in the left corner. A putto with a pinwheel probably symbolizes Youth or Spring. He is not a Ripa invention, but is described by Cartari as one of the four Ages of Man.[1]

Lavergnée has published a Vouet drawing from the Musée des Beaux-Arts et d'Archéologie, Besançon, that is certainly a preparatory study for the figure of the shepherd (fig. 78).[2]

NOTES

1. Cesare Ripa, *Baroque and Rococo Pictorial Imagery*, Hertel Edition of 1758–1760, ed. Edward A. Maser (New York: Dover, 1971), 20 (Youth).
2. Barbara Brejon de Lavergnée, *Inventaire général des dessins. Ecole française: Dessins de Simon Vouet 1590–1649* (Paris, Cabinet des Dessins, Musée du Louvre. Editions de la Réunion des Musées Nationaux, 1987), 92–93, illus. L. Jacques Thuillier, Barbara Brejon de Lavergnée, and Denis Lavalle, *Vouet* (Paris: Réunion des Musées Nationaux), 403–404, no. 93.

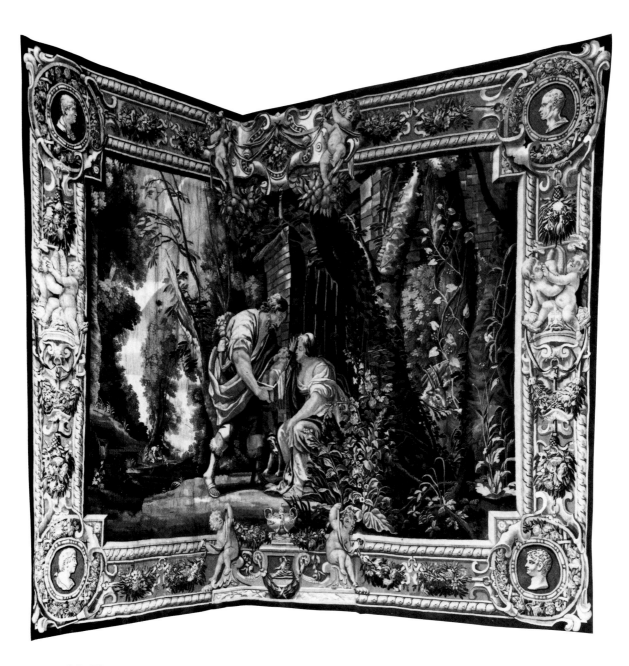

FIGURE 77
Chariclea Is Brought by a Shepherd to His Wife, tapestry.
Château de Châteaudun

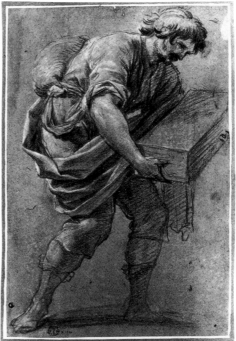

FIGURE 78
Simon Vouet, Study of a man carrying a box, black chalk.
Musée des Beaux-Arts et d'Archéologie, Besançon, D 1340

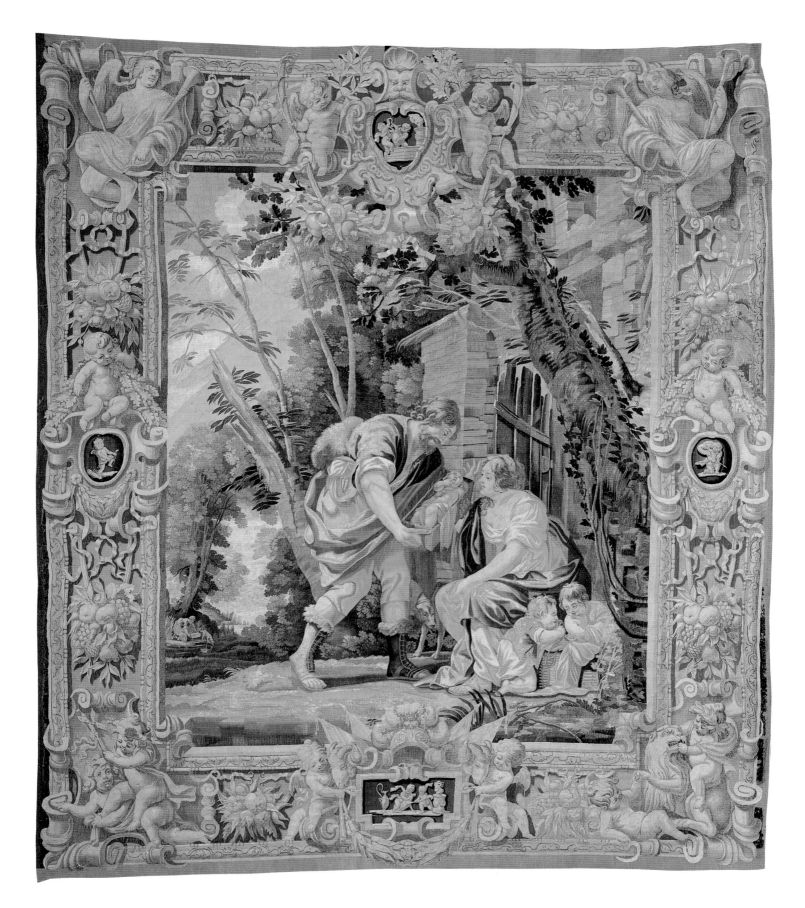

The Shepherd Finds the Infant Chariclea

70. Chariclea Led Away by the Pirates

from The Story of Theagenes and Chariclea *Series*

French (Paris), 1634–1635
Designed by Simon Vouet (1590–1649)
Woven under the direction of Raphael de La Planche (fl. 1629–1661)
H: 4.11 m W: 4.47 m (13 ft. 6 in. × 14 ft. 7 in.)
WARP: undyed wool, 6–7 per cm
WEFT: dyed wool and silk
Gift of H. K. S. Williams (CPLH), 1929.9.4

The old Greek story that furnished the theme for this se-
ries began like modern novels in the middle of the action,
the earlier history supplied by a flashback. This panel,
widest of the series, depicts the opening scene of the
book.[1] The silent ship, fully freighted, lies at anchor. The
foreground is littered with the dead and dying. Chariclea
is led away, weeping, by her abductors.

A "woman putting a handkerchief to her face and
holding her dress with her right hand" is on the reverse
side of a Vouet drawing for one of the *Ulysses* subjects (fig.
79).[2] The figure corresponds in all details to the figure of
Chariclea in the tapestry. Lavergnée points out that the
presence of the drawing on the reverse of the *Ulysses* study
(which can be dated) establishes a chronology for the
Theagenes and Chariclea series.

The Fine Arts Museums' tapestry and another example
at the Mobilier National (atelier François de La Planche),
correspond closely, except for the borders (fig. 80).[3] The
latter panel shows a little more of the design at the left
edge. In both these versions, and in a third at São Paulo,
Brazil, three men busy themselves with the sails at the left
edge. A fourth example of the design at the Hôtel de Sully
(Mobilier National) exhibits a startling variation. The
boat and the sailors are replaced by the large foreground
figure of a man on horseback, seen from the back. Laverg-
née found the preparatory drawing for this horseman
(Inv. RF 14719).[4] Such a significant variant adds weight to
her suggestion of multiple cartoons.

NOTES

1. Heliodorus, *An Aethiopian Romance*, trans. T. Underdowne,
 1587, rev. F. A. Wright (London and New York: E. P. Dutton,
 n.d.), 7.
2. Barbara Brejon de Lavergnée, *Inventaire général des dessins.
 Ecole française: Dessins de Simon Vouet 1590–1649* (Paris, Cabinet
 des Dessins, Musée du Louvre. Editions de la Réunion des
 Musées Nationaux, 1987), 88.
3. For the possible meaning of the variant group of putti and
 goat in the border, see cat. no. 72.
4. Lavergnée, *Inventaire*, 94.

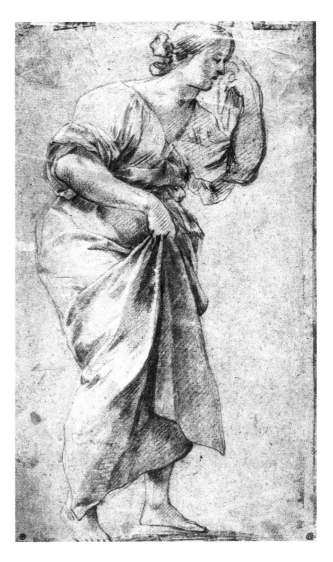

FIGURE 79
Simon Vouet, Study of a woman putting a handkerchief to her face,
black chalk. Ecole Supérieure des Beaux-Arts, Paris, M 1282 (verso)

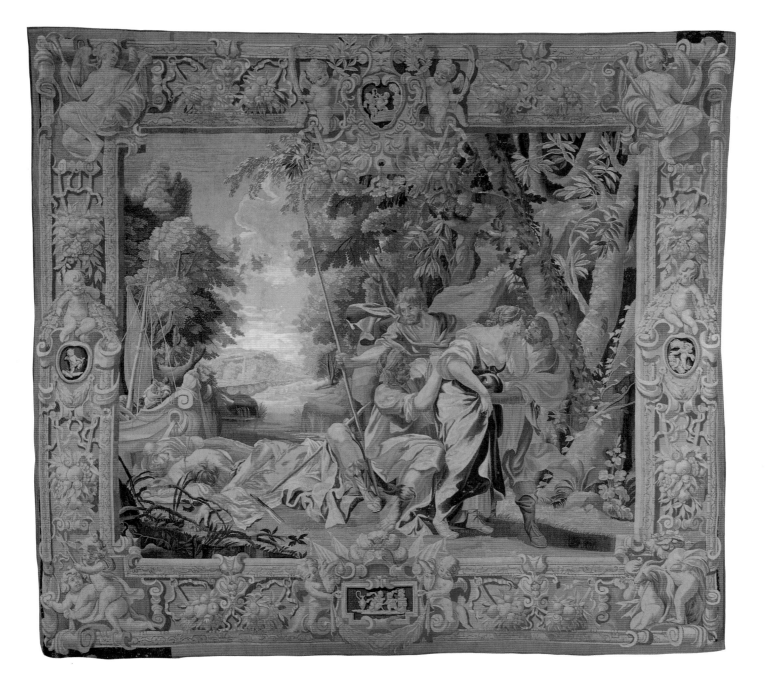

Chariclea Led Away by the Pirates

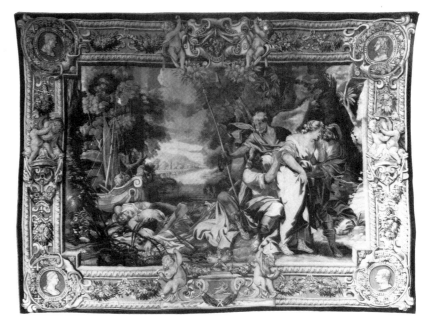

FIGURE 80
Chariclea in the Hands of the Brigands, tapestry.
Mobilier National, Paris

71. Chariclea

from The Story of Theagenes and Chariclea *Series*

French (Paris), 1634–1635
Designed by Simon Vouet (1590–1649)
Woven under the direction of Raphael de La Planche (fl. 1629–1661)
H: 4.14 m W: 2.54 m (13 ft. 7 in. × 8 ft. 4 in.)
WARP: undyed wool, 7–8 per cm
WEFT: dyed wool and silk
Gift of H. K. S. Williams (CPLH), 1929.9.2

This tall narrow panel, like its companion piece (cat. no. 72), was designed to cover a short wall, a door, or, more often, a space between windows. It shows Chariclea moving resolutely through the forest in search of parents and homeland. She holds a staff in one hand and gathers up her gown with the other. The course she follows will bring her directly out of the picture plane, satisfying the baroque preoccupation with dynamic movement.

The set of the heroine's head recalls Vouet, but her heavy arms may be the work of his Flemish cartoon makers who added pounds to Vouet's original Italian models.[1] Vouet was not averse to repeating single figures from other compositions. The figure of Chariclea recalls Pharaoh's daughter in *The Finding of Moses* at the Louvre, except the design is reversed. Marillier recorded a similar panel in an Austrian collection, called *Diana Huntress*.[2]

NOTES

1. Maurice Fenaille, *Etat général des tapisseries de la manufacture des Gobelins depuis son origine jusqu'à nos jours 1600–1900*, 1601–1661 (Paris: Librairie Hachette, 1923), 306.
2. H. C. Marillier, *Photo Book* iii, nos. 92–93 (London: Victoria and Albert Museum, n.d.).

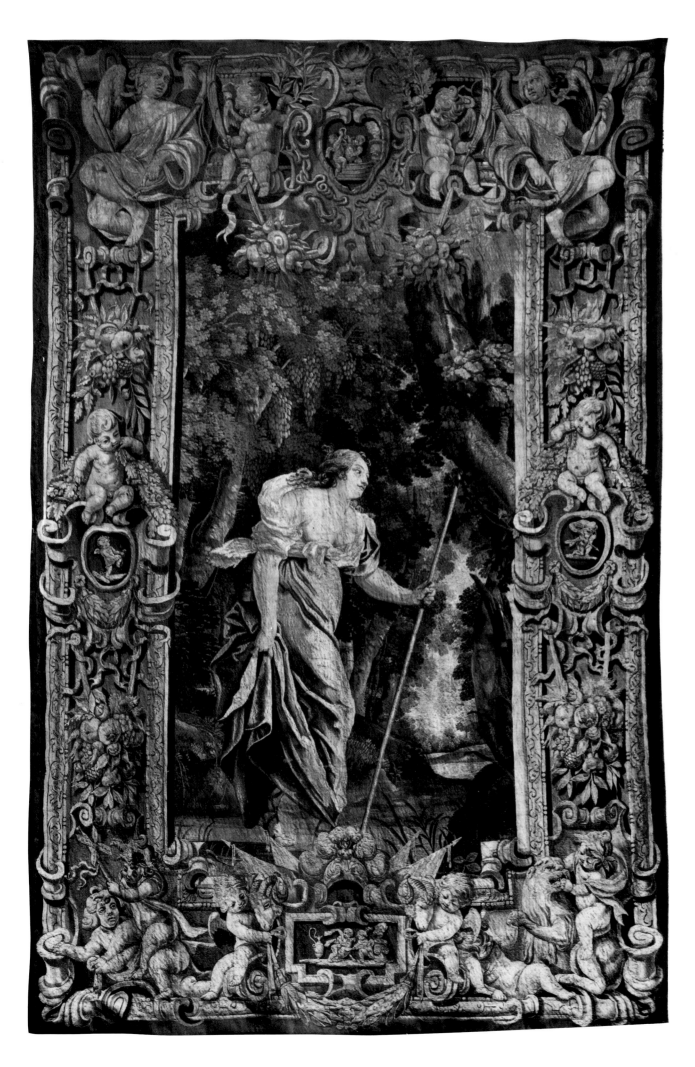

Chariclea

72. Theagenes and Chariclea

from The Story of Theagenes and Chariclea *Series*

French (Paris), 1634–1635
Designed by Simon Vouet (1590–1649)
Woven under the direction of Raphael de La Planche (fl. 1629–1661)
H: 4.14 m W: 2.92 m (13 ft. 7 in. × 9 ft. 7 in.)
WARP: undyed wool, 7–8 per cm
WEFT: dyed wool and silk
Gift of H. K. S. William (CPLH), 1929.9.3

This panel, like the preceding companion piece, was woven for a narrow wall space. The episode seems to represent a surprise reunion between the two lovers. A similar panel with two figures in an Austrian collection was given the title *Venus Restraining Adonis*.[1] An even narrower version showing only Theagenes is at the Château de Châteaudun.[2]

In a variant group in the lower right corner of the border a putto wreathed with leaves sits astride a goat. The goat in Ripa's *Iconologia* is the symbol of sexual passion, since he is an animal that is easily aroused.[3] This symbol is used in the border of the two panels showing the lovers alone, *Theagenes and Chariclea* and *The Departure*, and in the scene of abduction, *Chariclea Led Away by the Pirates*.

The two-figure composition of *The Temptation of Saint Anthony*, painted for the Temple de l'Oratoire, rue Saint-Honoré, Paris, is close to that of the present panel. Figures from sacred subjects were reused without hesitation in "profane" compositions. Lavergnée found the preparatory drawing for the figure of Christ in the *Saint Anthony* panel in the Musée des Beaux Arts, Grenoble.[4]

NOTES

1. H. C. Marillier, "Subject Catalogue of Tapestries" Victoria and Albert Museum, London, ms., n.d., Mythologies—General Mixed T 37EE 1946.
2. Jean Feray, letter and photograph (to A. G. B.), 23 January 1975.
3. Cesare Ripa, *Baroque and Rococo Pictorial Imagery*, Hertel Edition of 1758–1760, ed. Edward A. Maser (New York: Dover, 1971), no. 70.
4. Barbara Brejon de Lavergnée, *Inventaire général des dessins. Ecole française: Dessins de Simon Vouet 1590–1649* (Paris: Cabinet des Dessins, Musée du Louvre. Editions de la Réunion des Musées Nationaux, 1987), 133, illus. XCIII.

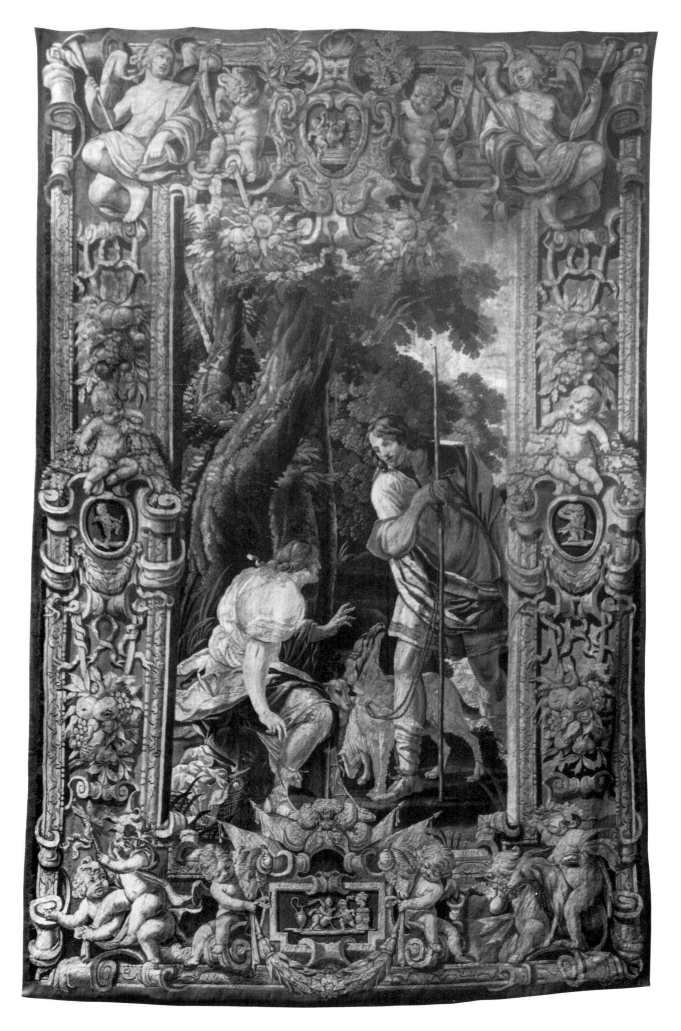

*Theagenes and
Chariclea*

73. The Departure

from The Story of Theagenes and Chariclea *Series*

French (Paris), 1634–1635
Designed by Simon Vouet (1590–1649)
Woven under the direction of Raphael de La Planche (fl. 1629–1661)
H: 4.14 m W: 4.17 m (13 ft. 7 in. × 13 ft. 8 in.)
WARP: undyed wool, 7–8 per cm
WEFT: dyed wool and silk
Gift of H. K. S. Williams (CPLH), 1929.9.6

The elaborate chimney and furnishings of the room depicted recall interiors engraved by Abraham Bosse, although no exact parallel has been found. Caravaggesque shadows from the flickering candlelight and the fire on the hearth create an air of secrecy and intimacy. A night scene is unusual in tapestry, and unprecedented in Vouet's Parisian period.[1] The panel is presumed to represent the moment when Theagenes swears "by Apollo of Delphi, and Diana, and Venus herself, and all the gods of love" that he would act in accordance with Chariclea's wishes,[2] as they prepare to depart for Egypt, Chariclea's homeland.

The open door leads the eye to the adjoining stable where a horse is groomed by candlelight. Lavergnée notes that the "anecdotal and intimate ambience" suggests a Flemish influence and recalls Félibien's statement that the Flemish painters d'Egmont and Vandrisse supplied details for Vouet's designs.[3] This northern note is countered by the impression given by the couple: Chariclea's profile and the pose of the lovers recall a painting from Vouet's early period, *Two Lovers*, at the Palazzo Rospigliosi, Galleria Pallavicini, Rome (fig. 81).[4]

Lavergnée points to two drawings in Amsterdam at the Rijksprentenkabinett. A preparatory drawing for the standing figure of Theagenes is on the recto (fig. 82).

A study on the verso corresponds to the drapery of Chariclea's dress (fig. 83).[5] Nello Forti Grazzini points out another tapestry with a night scene in an interior, *The Banquet of Scipio by Syphax*, from *The Story of Scipio* series designed by Giulio Romano for Francis I of France. In Giulio's scene, also, the background is closed by a fireplace and a door. Forti Grazzini suggests that a weaving of this design was probably known to the cartoon painter Vouet or his assistants.[6] See *Theagenes and Chariclea* (cat. no. 72) for border iconography.

NOTES

1. Barbara Brejon de Lavergnée, *Inventaire général des dessins. Ecole française: Dessins de Simon Vouet 1590–1649* (Paris: Cabinet des Dessins, Musée du Louvre. Editions de la Réunion des Musées Nationaux, 1987), 93, illus. LI, LIV.
2. Heliodorus, *An Aethiopian Romance*, trans. T. Underdowne, 1587, rev. F. A. Wright (London and New York: E. P. Dutton, n.d.), 130–131.
3. Lavergnée, *Inventaire*, 93.
4. William R. Crelly, *The Painting of Simon Vouet* (New Haven and London: Yale University Press, 1962), fig. 5.
5. Lavergnée, *Inventaire*, 93.
6. Personal communication, June 1990.

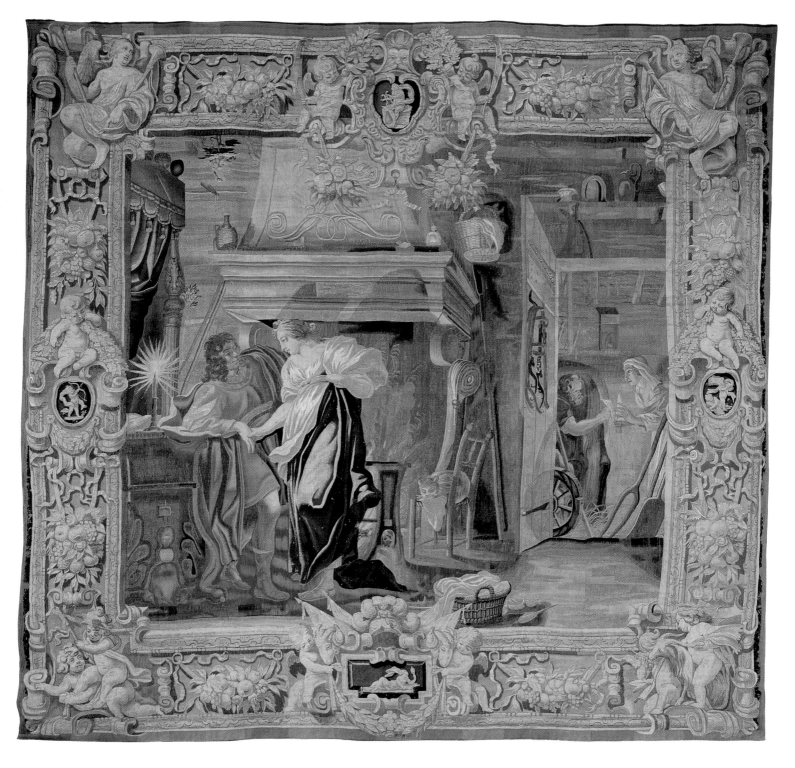

The Departure

FIGURE 81
Simon Vouet, *Two Lovers*,
oil on canvas. Palazzo
Pallavicini, Rome

FIGURE 82
Simon Vouet, Study of a young man standing, black chalk.
Rijksprentenkabinett, Amsterdam, 1956:123 (recto)

FIGURE 83
Verso: Study of the drapery of a dress

The Gobelins 1662–1794

1662–1694

The name Gobelin was borne by an obscure dyer who settled on the banks of the Bièvre in the parish of Saint-Marcel in Paris about 1447. By association, almost by accident, his name became the generic word for tapestry in many parts of the world.

The Gobelins conducted their trade between the ateliers of two other families of dyers, the Canayes and the Le Peultres. Of these, the Le Peultres disappeared when the family establishment was acquired by the Canayes. The fortunes of the Calvinist Canaye family foundered during the wars of religion. Their property, destined to become the royal manufactory, became known by the name of its neighbors to the north, the Gobelins. Jean Gobelin II did, in fact, own the property for a scant two years between 1571 and 1573. The Gobelin family was prominent, having risen to wealth and high position at court. Grown too great for trade, the Gobelins retired from the dyeing industry to which they owed their ascent. It was the tapestry industry that gave their name its luster.

Henri IV's agent, de Fourcy, looking for a location for the tapestry manufactory that the king wished to develop, rented the old Le Peultre-Canaye property in 1601.[1] De Comans and de La Planche moved in with their Flemish weavers. The operation, known as the atelier Saint-Marcel, continued without interruption despite such blows as the death of François de La Planche, the rift between his son, Raphael, and the de Comans, and the rivalry with faubourg Saint-Germain for weavers and, no doubt, for commissions.

The transformation of the atelier Saint-Marcel into the royal manufactory of the Gobelins began about 1662. The precipitating factor was, perhaps, the fall in 1661 of Nicolas Fouquet, minister of finance to Louis XIV. The looms he had set up at Maincy under Charles Le Brun were transferred to faubourg Saint-Marcel. Other ateliers were absorbed in turn and united on the premises Colbert bought for the king. The royal edict establishing the manufactory of the Gobelins is dated 1667, but the activity of the looms dates from 1662.

The manufactory enjoyed a brilliant early success under the leadership of Le Brun. After finishing the tapestries begun at Maincy, Le Brun directed his energy almost exclusively toward glorifying the king. Louis XIV's military achievements (in *The Story of the King*) and his diversions (*The Months* or *Royal Residences*) furnished themes for sumptuous artistic propaganda. In some cases, the composition alone was Le Brun's, the painting being done by artist-assistants and executed under his persistent vigilance. Le Brun's artistic vision was bold, but it did not overreach the limits of the medium for which he designed. He understood and respected tapestry's traditional technique. The 120 colors selected by Colbert for the wools still imposed restrictions on the execution of the cartoons. The 250 weavers of the Gobelins were required to submit to the direction of a painter, Le Brun, but they were not expected to produce woven paintings.

The death of the minister Colbert in 1683 stripped his protégé, Le Brun, of actual if not of nominal power. A treasury depleted by ruinous foreign wars curtailed expenditures. The new minister, Louvois, discontinued the use of Le Brun's cartoons and ordered series to be woven after Brussels tapestries in the royal collection. Four years after Le Brun's death in 1690, the Gobelins closed for five years (1694–1699). The last years witnessed a change in aesthetic—a movement away from the monumental toward the attractions of pure decoration—which heralded the eighteenth century.

1699–1794

The reopening of the Gobelins ushered in organizational changes. Authority thereafter was divided between an administrative and an artistic director. Many of the administrators were architects. Both Oudry and Boucher served as artistic directors. These painters have been held by many early art historians to be responsible for the subordination of weaving to painting that occurred during their time, but which did not in the slightest diminish the beauty of the tapestries. Architectural changes were, perhaps, a more critical factor, and these, in turn, came about in response to new needs for privacy, pleasure, and the escape mechanism of fantasy.

Except for the great series still being woven for the king, tapestries reflect the fact that the formal grandeur of Versailles had been left behind for life on a smaller scale in the elegant salons of Paris. The tapestries ceased to be windows looking out on heroic events, but became decorative screens around a society interested in itself. Occasionally the screen treatment consisted of shallow architectural elements and ornaments. Those panels with figured scenes eventually acquired simulated carved and gilded frames so that they resembled oil paintings hanging on the wall, and, like paintings, they were meant to be seen at close range. The color blending could not, as formerly, occur at a distance, in the eye of the viewer. The necessary number of color gradations multiplied, leading to the use of dyes less resistant to light. Tapestries were

more finely woven, more like the canvas of easel paintings. To achieve flatness and smoothness, tapestries were deprived of their mobility and fixed into the woodwork. An ever-increasing amount of silk was used in the weaving, a factor in their early deterioration.

The technical problems raised by the new artistic goals fell on the administrative directors. Correspondence between Jacques Germain Soufflot, director of the royal manufactories of the Gobelins and the Savonnerie from 1756 to 1776, and his superior, the marquis de Marigny, reveals Soufflot's resourcefulness and sense of responsibility in dealing with increasingly grave problems. Many letters are concerned with technical developments such as the use of tracing paper to obviate the cutting of cartoons; the invention of the Vaucanson loom that tipped up, allowing the low-warp weaver to check his work in progress; the multiplications of nuances of color; and colorfastness and mothproofing. Other letters deal with personnel problems, such as the defection of skilled workers, proper education and housing of weavers' families, and that most pressing of problems, the lack of financial support from a government approaching financial ruin.[2]

In the impending revolutionary mood, tapestry's aristocratic connections were a threat more basic than the crumbling economy of the *ancien régime*. On 30 November 1793, selected tapestries were burned before the Liberty Tree in the courtyard of the Gobelins manufactory. Those that were destroyed bore royal insignia or other hated marks of despotism. There was cause to wonder whether the industry would perish with the luxury-loving class that supported it.

NOTES

1. Jules Guiffrey, "Notes et documents sur les origines de la manufacture des Gobelins et sur les autres ateliers parisiens pendant la première moitié du dix-septième siècle," in Maurice Fenaille, *Etat général des tapisseries de la manufacture des Gobelins depuis son origine jusqu'à nos nours 1600–1900, 1601–1662* (Paris: Librairie Hachette, 1923), 80.
2. Jean Mondain-Monval, *Correspondance de Soufflot avec les Directeurs des Bâtiments concernant la Manufacture des Gobelins (1756–1780)* (Paris: Libraire Alphonse Lemerre, 1918).

The Seasons and the Elements (Les portières des dieux)

The first series to be put on the looms when the Gobelins manufactory reopened in 1699 was the *Portières des dieux*, after cartoons of Claude Audran III (1658–1734), one of the masters of Watteau. Elements of Audran's designs can be traced to the *Triomphes des dieux* (1686–1687) by Noël Coypel and the *Berain Grotesques* (before 1689) by Jean-Baptiste Monnoyer. The *Portières* proved one of the most successful series ever woven. It was executed in high warp and low, with gold ground, in solid color silks, and (after 1771) with a background imitating rose-crimson damask. Three different borders were designed for the series, of which the last, designed by Pierre-Josse Perrot, was the heaviest but simplest. Experts do not entirely agree on the total number of panels woven. The estimate varies between 212 (Jarry) and 235 (Weigert).[1] Many mixed sets were commissioned, like that of The Fine Arts Museums, which includes two Seasons and two Elements. Jacques Neilson executed the designs for the last time in 1789.

The *Portières* gratified the contemporary taste for mythology and graceful ornament. Beneath fragile architectural canopies, eight divinities are presented singly, sitting on clouds. They symbolize the Four Seasons and the Four Elements. The Seasons are represented by Venus (Spring), Ceres (Summer), Bacchus (Autumn), and Saturn (Winter). The Elements are Juno (Air), Diana (Earth), Neptune (Water), and Jupiter (Fire).

Garlands of flowers enrich the presentation, as do elegant arrangements of attributes, birds and animals, and children engaging in activities appropriate to each Season or Element. These contributing elements of design were the work of artist specialists, who seem to have collaborated at the Gobelins. Fenaille states specifically that the compositions were by Audran; the figures of gods, goddesses, and children were by Louis de Boulogne (the Younger) and Michel Corneille; and the animals were the work of François Desportes, Audran's close friend.[2] Records of payments to these specialists have survived.

The rose-crimson background of The Fine Arts Museums' *Portières* shows them to be a late weaving. Neilson, head of the low-warp tapestry workshop at the Gobelins since 1750, had first used the damask pattern as a surrounding element or *alentour* for the picture panels of Coypel's *Don Quichotte* series in 1760. The painter Jacques made the model for this damask background.[3] Neilson applied the damask background successfully to tapestries after Boucher, and finally in 1771 to the *Portières*, which Fenaille states were often used for diplomatic presents.[4] The effect was very rich. Twenty-eight pieces with this background were woven by Neilson between 1771 and 1789. The Fine Arts Museums' set probably dates from 1784 and can be identified with a gift of state made to Prince Henry of Prussia by Louis XVI. The National Archives record that four *Portières* with the damask background, representing Venus, Juno, Diana, and Ceres, were given to the prince along with other valuable tapestries and Sèvres porcelain when he visited incognito under the name of the comte d'Oels.[5] This particular combination of subjects, with the damask background, makes it seem probable that The Fine Arts Museums' panels are to be identified with this set.[6]

NOTES

1. Madeleine Jarry, *World Tapestry from Its Origins to the Present* (*La tapisserie*, Paris: Librairie Hachette, 1968; English ed., New York: G. P. Putnam's Sons, 1969), 236; Roger-Armand Weigert, *French Tapestry*, trans. Donald and Monique King (London: Faber and Faber, 1956), 115. Edith Standen points out that every door at Versailles, and presumably all the other palaces, had its portiere, or curtain, so enormous numbers were needed. Personal communication, May 1990.
2. Maurice Fenaille, *Etat général des tapisseries de la manufacture des Gobelins depuis son origine jusqu'à nos jours 1600–1900, 1699–1736* (Paris: Librairie Hachette, 1904), 2.
3. Fenaille, *Etat*, 1699–1736, 231–232.
4. Fenaille, *Etat*, 1699–1736, 52.
5. Fenaille, *Etat*, 1699–1736, 55.
6. Gertrude Townsend, letter to Dr. R. Neuhaus, Boston, 21 June 1940.

74. Venus Typifying Spring

from The Seasons and the Elements *Series*

French (Paris, Gobelins), 1784
Designed by Claude Audran III (1658–1734)
Woven under the direction of Jacques Neilson (1714–1788)
H: 3.58 m W: 2.82 m (11 ft. 9 in. × 9 ft. 3 in.)
WARP: undyed wool, 10 per cm
WEFT: dyed wool and silk
Gift of Archer M. Huntington (CPLH), 1926.78

A light portico resting on six slender columns forms the architectural frame for Venus, goddess of Love and Springtime. Lightly draped in rose, she floats on a cloud with swans beside her and Cupid nearby. In some versions, the head of the left swan is held high. Venus's hair is dressed with pearls. She holds an arrow in her right hand. Garlands of flowers hang from the portico above her. There are many birds.

Beneath the goddess a large vase of roses surmounts a fountain gushing from three dolphins. Cupids move toward the fountain on either side; one brings flowers and the other fills his watering can. The motive of watering cans reappears on the consoles with squirrels and birds.

The sign of Taurus can be seen at the top of the panel.

Tablets with the signs of Aries and Gemini dangle from the portico at either side, along with ribbons, rings, and arrows.

Behind these fragile elements, the background simulates a damask pattern of flowers on a deeper shade of rose-crimson. Madeleine Jarry has pointed out that this imitation of damask fabric performs the function of the late medieval verdures by providing continuous decoration,[1] obviating the blank spaces that are fatal in tapestry.

NOTE
1. Madeleine Jarry, *World Tapestry from Its Origins to the Present* (*La tapisserie*, Paris: Librairie Hachette, 1968; English ed. New York: G. P. Putnam's Sons, 1969), 239.

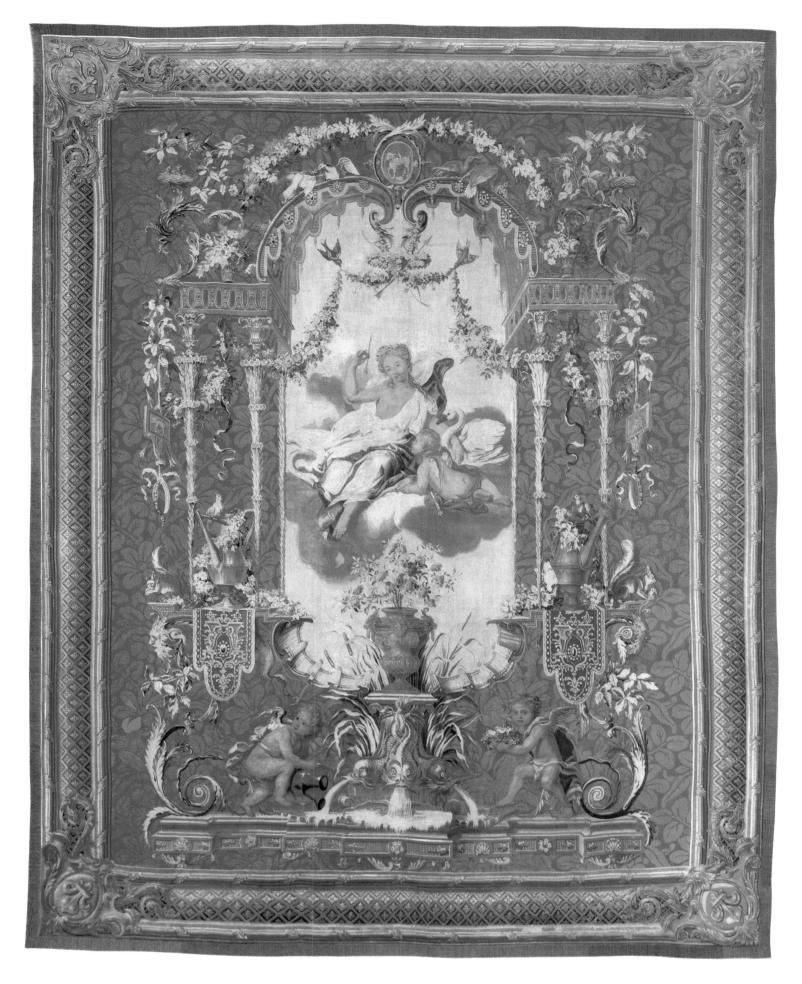

Venus Typifying Spring

75. Ceres Typifying Summer

from The Seasons and the Elements *Series*

French (Paris, Gobelins), 1784
Designed by Claude Audran III (1658–1734)
Woven under the direction of Jacques Neilson (1714–1788)
H: 3.61 m W: 2.82 m (11 ft. 10 in. × 9 ft. 3 in.)
WARP: undyed wool, 10 per cm
WEFT: dyed wool and silk
Gift of Archer M. Huntington (CPLH), 1926.77

Ceres sits on clouds in the center of the panel with her right arm around a sheaf of wheat. Stalks of wheat decorate her hair. Her left hand holds a lighted torch. A naked child beside her holds a sickle.

Below the goddess, agricultural tools are heaped up to make a trophy. Among these, one recognizes a rake, shovel, sun hat, a basket, a scythe and flail, and more cut wheat. Two small children on the ledge, leaning on *rinceaux*, engage in summer activities. The child on the right winnows wheat while his companion slakes his thirst from a bottle, watched by a panting dog. A measure for grain and a sickle lie near the center.

The recurrent motive of the water bottles suggests the heat of the summer. Stone vessels rest on each console at the base of the columns. A rabbit is on the left console and a cat and winnowing basket on the right. Other drinking bottles, enclosed in wicker, can be seen above the columns. These, and the crossed torches above the goddess's head, carry out the theme of summer's heat.

The central medallion above carries the sign of Leo. The signs of Cancer and Virgo hang at the sides with attributes of summer. The artist has imaginatively adjusted the "architecture" for each panel. In Ceres's portico, the columns are clearly made of the heads of wheat; in the portico of Venus they are leaves and flowers.

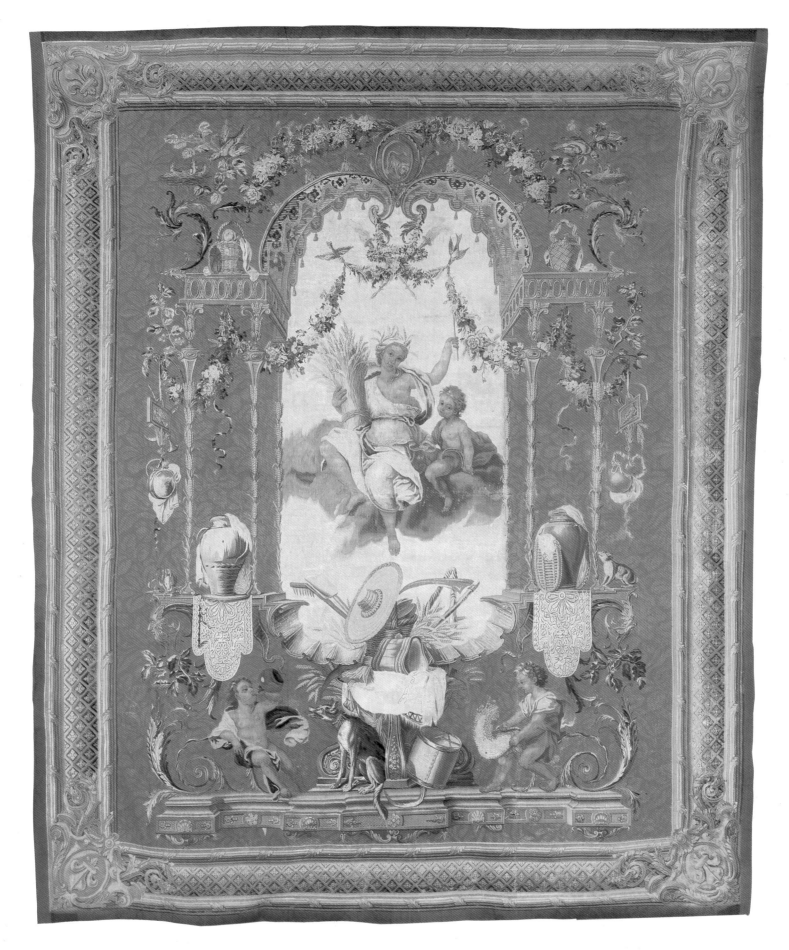

Ceres Typifying Summer

76. Juno Typifying Air

from The Seasons and the Elements *Series*

French (Paris, Gobelins), 1784
Designed by Claude Audran III (1658–1734)
Woven under the direction of Jacques Neilson (1714–1788)
H: 3.63 m W: 2.72 m (11 ft. 11 in. × 8 ft. 11 in.)
WARP: undyed wool, 9 per cm
WEFT: dyed wool and silk
Gift of Archer M. Huntington (CPLH), 1926.80

The portico of Juno, queen of heaven, is decorated with airy objects. Birds of many kinds flutter above her canopy and alight on its frame. Two birds of paradise support a garland in which flowers alternate with bunches of feathers. Above Juno's head, crossed scepters are crowned by a circlet of feathers. A winged child's head blows wind from beneath the cloud on which she sits. Vessels of goldsmith's work decorate the consoles, each surmounted by a magnificent peacock, Juno's bird. An organ and crossed trumpets at her feet form the central trophy.

Below, two putti play other wind instruments: the flute, at left, and the syrinx, or pan pipes, at right. Musettes (bagpipes) hang above the portico. Ribbons at the sides support a series of pendant objects: rackets, shuttlecocks, and two panels with a bird and a beast. Audran has given Juno's airy portico four supporting columns of shuttlecocks.

Juno was the guardian of finances. Her temple, on the Capitoline Hill, contained the Mint. This aspect of the goddess is suggested by the large central urn of coins with a cornucopia on either side, spilling out jewels and coins.

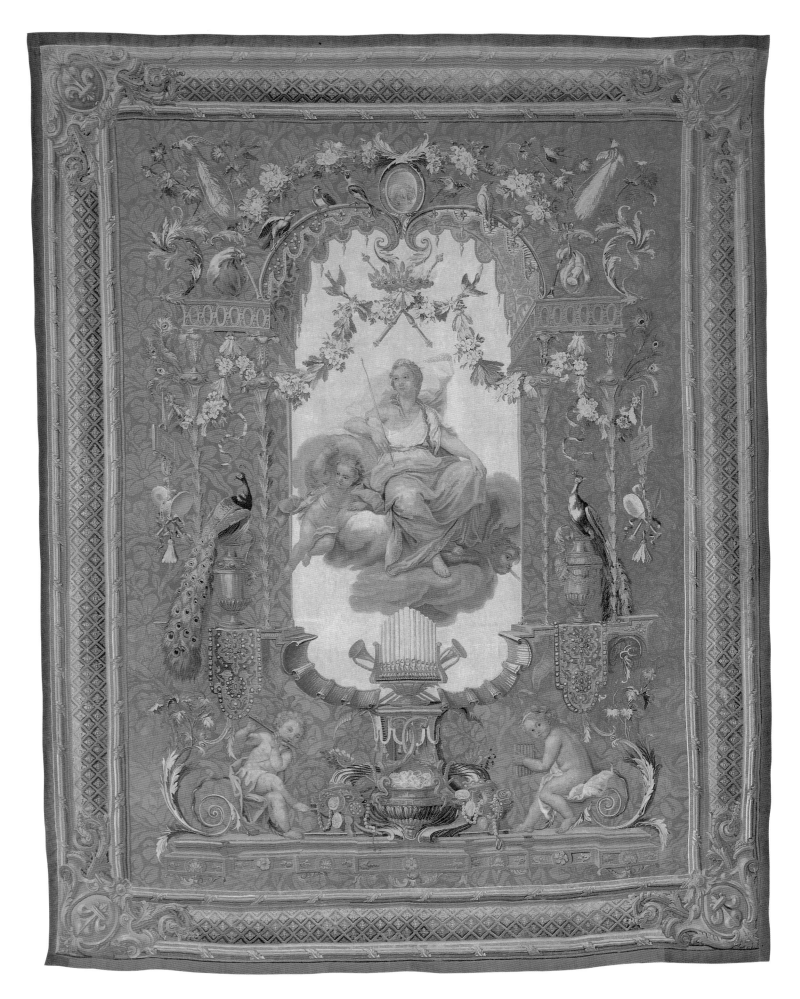

Juno Typifying Air

77. Diana Typifying Earth

from The Seasons and the Elements *Series*

French (Paris, Gobelins), 1784
Based on a design by Claude Audran III (1658–1734)
Woven under the direction of Jacques Neilson (1714–1788)
H: 3.58 m W: 2.67 m (11 ft. 9 in. × 8 ft. 9 in.)
WARP: undyed wool, 10 per cm
WEFT: dyed wool and silk
Gift of Archer M. Huntington (CPLH), 1926.79

Diana is presented in this panel as huntress, rather than as Earth goddess. She is surrounded by hunting attributes that enliven the *alentour*. Birds of prey perch above the portico, and javelins are crossed above the head of the deity. Diana holds a greyhound on a leash, and another sits on the left console. The body of a deer is tied by its foot to the right console. Pendant attributes hang from laurel branches: hunting horns, nets, stakes, and arrows.

A splendid stag's head, its antlers crowned with leaves, tops the pedestal below the goddess, part of a trophy with bow and arrow, nets, and spears. The stag's head is still the focus of attack. Two hunting dogs leap up toward it from the pedestal base; the naked child at right aims an arrow, the child at left a javelin. A hunting horn and quiver lie below the feet of the dogs. The cartouche at top, center, and the tablets hanging at the sides are blank, although they show symbols in the other panels. The important variation is in the figure of the goddess herself. In the three preceding panels, the deity was presented frontally, cloud-borne beneath her portico, with a symbolic object in her hand. The Diana of this panel differs both in format and in feeling from her predecessors. She is seen in profile, fully clothed and heavily draped. Her bow and quiver lie at her feet.

It is a matter of record that the original model for *Diana* was worn out after the sixth execution of the low-warp series in 1749 (fig. 84). It was retired and for the next ten years no series included the Diana panel. In 1758 Jacques Germain Soufflot, who served as administrative director of the Gobelins from 1756 to 1776, asked the marquis de Marigny, the minister in charge of the royal manufactories, for authorization to have the model remade for the portiere of *Diana*.[1] Marigny approved, and the painter Jacques copied the peripheral composition (the *alentour*) from the original panel. Soufflot himself, an architect by profession, designed the figure of the goddess.[2]

FIGURE 84
Diane, tapestry. Mobilier National, Paris

(1756–1780) (Paris: Libraire Alphonse Lemerre, 1918), 79, 81, 83 (necessity of repainting the *Diana* cartoon), and 84 (Marigny's order for the repainting).

2. Mondain-Monval, *Correspondance*, 87–88, fn. 2. The question is asked whether Soufflot was really the author of the new model. A memoir of Jacques, certified by Soufflot 22 November 1760, states that the new *Diana* was "by M. Soufflot." See Maurice Fenaille, *Etat général des tapisseries de la manufacture des Gobelins depuis son origine jusqu'à nos jours 1600–1900, 1699–1736* (Paris: Librairie Hachette, 1904), 8–11. In the opinion of Mondain-Monval, "the first model is more elegant, the second has more nobility."

NOTES

1. Jean Mondain-Monval, *Correspondance de Soufflot avec les Directeurs des Bâtiments concernant la Manufacture des Gobelins*

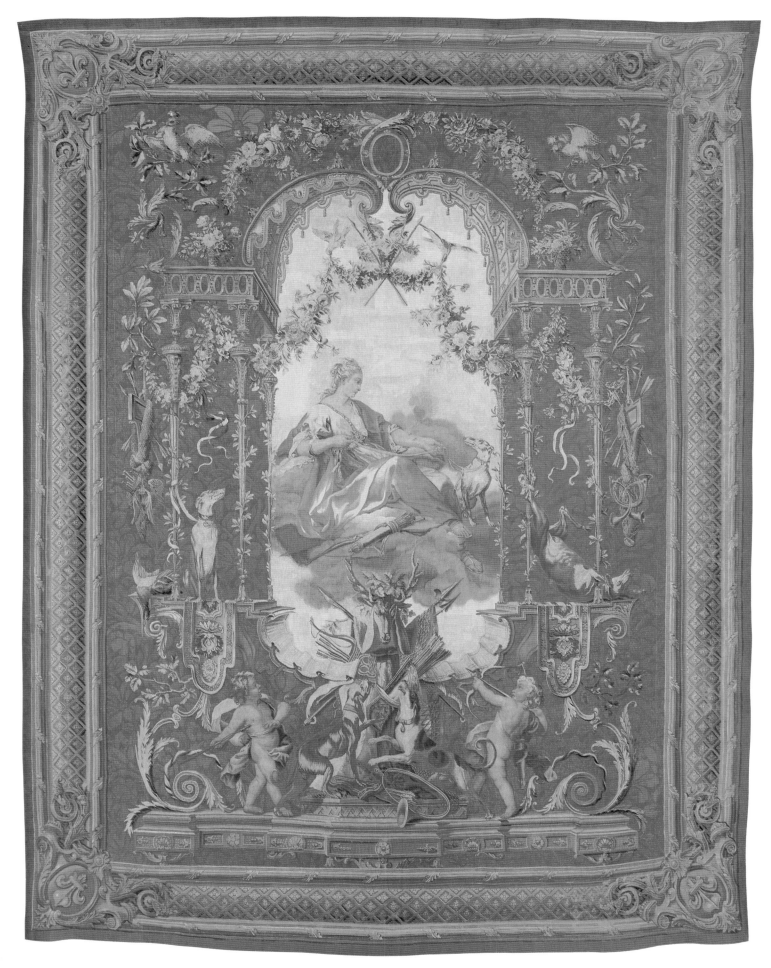

Diana Typifying Earth

78. The Infant Bacchus

Upholstery panels for a settee

French (Paris, Gobelins), early eighteenth century
After Noël Coypel (1628–1707)
H: 89 cm W: 223 cm (35 in. × 88 in.) back
H: 86 cm W: 228 cm (34 in. × 90 in.) seat
WARP: undyed wool, 8–9 per cm
WEFT: dyed wool and silk
FRAME: wood, late nineteenth–early twentieth century
Gift of Archer M. Huntington (CPLH), 1926.107

In 1673 Louis XIV bought from the collection of Casimir, king of Poland, seven panels of *The Triumphs of the Gods* (also known as the *Rabesques* or *Arabesques of Raphael*), woven in Brussels in the third quarter of the seventeenth century after designs of Giulio Romano (1499–1546).[1] As the newly-appointed king's minister in charge of the Gobelins, the marquis of Louvois had Noël Coypel copy and modify these tapestries for a new series that was woven between 1675 and 1713.

The Triumph of Bacchus, part of this series, was woven seven times, the last time without gold. The design is divided into three tiers. The central figure of the god of wine, wearing a garland of vine leaves, stands on a pedestal in a vine-covered arbor above a fountain of wine. He holds a bunch of grapes above his head and one by his side. A large dolphin and a faun share his pedestal, and three small dolphins in the shallow fountain basin support the elaborate superstructure. All details of the tapestry celebrate the enjoyment of wine. In the upper corners, herms with squared-off wings fill wine cups. In the lowest tier children are making wine and a faun stands beside a camel carrying a wine barrel.[2]

Official records do not state that tapestry-covered furniture was commissioned to match the *Bacchus* panel, but the striking similarities between it and the settee covering in The Fine Arts Museums make a strong case for that conclusion.

On the settee back, a blond, curly-headed infant Bacchus sits on a wine keg, holding a golden goblet in one hand, a large bunch of grapes in the other. A leafy garland encircles his hips. More vine leaves cascade down the side of the keg. At the left, a cherub with squared-off wings, coiffed in a tight-fitting cap, offers Bacchus a basket of grapes. Another in the center holds a torch; one on the right brings a half-filled decanter of red wine. An architectural frame, draped with a white cloth, passes behind the

figures. The wine keg on which the god sits is supported by three dolphins in a shallow gilt-edged fountain basin. Garlands hang from scrolling acanthus leaves, separating the scene from its surrounding brownish-purple ground.

On the seat, two parrots on a decorative frame peck at fruit heaped up on a tray. Conspicuous vines and grape leaves reiterate the theme of wine. While the fruit was clearly designed with the subject in mind, the same birds reappear on the back of a settee in the baron Gustave de Rothschild collection of 1904, illustrated by Fenaille.[3] The three dolphins of the Bacchus tapestry are also present in the same documented piece. Bacchus's attendants with their unusual wings are found in an armorial panel also in the de Rothschild collection.[4]

Tapestry-covered furniture was a specialty at Beauvais, but seldom produced at the Gobelins before the time of Madame de Pompadour. The present piece belongs to a group of rare early furniture coverings definitely attributable to the Gobelins. Fenaille suggests Claude Audran, F. Desportes, and Belin de Fontenay as collaborators in the design of the de Rothschild settee. The *Bacchus* tapestry at The Fine Arts Museums of San Francisco is ultimately derived from the work of Noël Coypel.

NOTES

1. Alphonse Wauters, writing in 1878, attributed the designs to Mantegna. A. Wauters, *Les tapisseries bruxelloises* (1878; reprint, Brussels: Editions Culture et Civilisation, 1973), 222.
2. Maurice Fenaille, *Etat général des tapisseries de la manufacture des Gobelins depuis son origine jusqu'à nos jours 1600–1900*, 1662–1699 (Paris: Librairie Hachette, 1903), 221–245.
3. Fenaille, *Etat*, 1737–1794, illus. opposite 380.
4. Fenaille, *Etat*, 1737–1794, illus. opposite 412.

PROVENANCE
Count Boni de Castellane

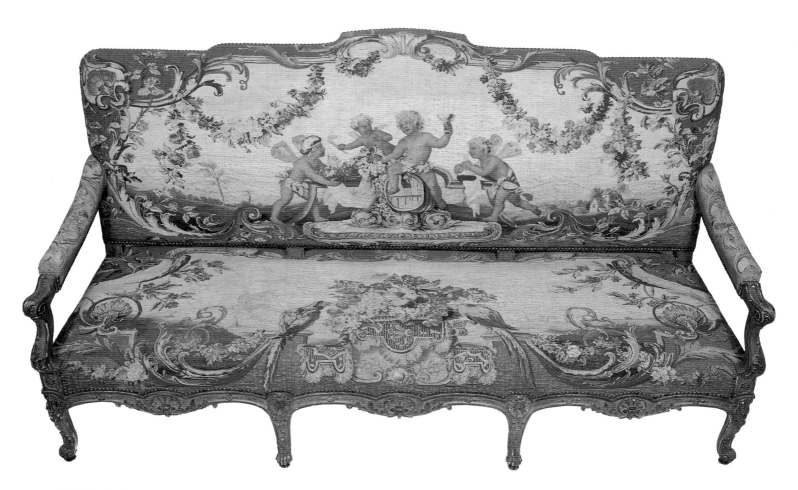

The Infant Bacchus

Beauvais 1664–1794

From its foundation in 1664 until it became a national institution in 1794, the manufactory of Beauvais was a private enterprise, dependent for survival upon individual commissions. Like the Gobelins, it was created by Colbert and enjoyed royal protection, but the operation remained commercial and unofficial. This essential difference in the nature of the enterprise resulted in desultory records, delicate financial health, and a production more closely geared to public taste.

The first four directors of Beauvais experienced grave financial difficulties, not excluding the second, Philippe Behagle, yet many famous sets were woven during his incumbency (1684–1705). Behagle was born in Oudenaarde and had worked in Tournai. He supplied foreign markets with fine examples of Beauvais work. The *Berain Grotesques* and the first Chinese series were woven for the first time during his directorship. Both of these series were repeated many times and have survived in great numbers. The twenty years of mismanagement following Behagle's death witnessed the decline of the Beauvais factory. Jean-Baptiste Oudry's activity as official designer (1726–1755) was a period of recovery. Beauvais, in the words of Voltaire, became "Oudry's kingdom" in truth. He breathed new life into the school of design, creating fresh cartoons for the weavers and bringing in successful contemporary painters from the outside. Professional training of the weavers was strengthened and an exact execution of the cartoons was required. Oudry began with portraits and history pieces, but gradually transferred his interest to landscapes and animals, producing the *Verdures* and the *Fables of La Fontaine* for which Beauvais is famous.

In figure tapestries, the great name is Boucher, who succeeded Oudry as director from 1756 to 1770. In 1736 he produced the *Fêtes italiennes*, designed for Beauvais. From the outset Boucher's great talent was evident in the elegance and ease of his compositions. The transitory preoccupations of his silken shepherdesses were entirely in the spirit of the first half of the eighteenth century. This spirit was to be superseded by the "grand goût" and a return to the classics.

Aubusson

Local ateliers had been active since medieval times in the section of central France known as La Marche. Family enterprises at Aubusson and nearby Felletin supplied local patrons. Henri IV's economic program of protection from Flemish competition encouraged their development. Letters patent of 1665 conferred a kind of royal status. The ateliers remained independent and could use the letters MRD or MRDB (Manufacture Royale d'Aubusson), followed by the weaver's initials (see cat. no. 85). A blue guard was used at Aubusson, a brown one at Felletin.

The Aubusson ateliers were promised a designer and a dyeing specialist, but neither materialized. In addition, the revocation of the Edict of Nantes in 1685 affected numerous Calvinist families. About two hundred artisans emigrated. Light colors were favored at Aubusson. An exact imitation of nature was not attempted, partly because tapestries were coarser and looser in weave. The subjects reflected contemporary taste. It is interesting to see these general characteristics in the Aubusson tapestries of modern times.

79. The Abduction of Orithyia by Boreas

from The Metamorphoses of Ovid *Series*

French (Beauvais), ca. 1690
Designed by René-Antoine Houasse (ca. 1644/45–1710)
Woven under direction of Philippe Behagle (1641–1705)
H: 3.10 m W: 5.28 m (10 ft. 2 in. × 17 ft. 4 in.)
WARP: undyed wool, 7 per cm
WEFT: dyed wool and silk
MARK: *Weaver* lower guard, right (turned under)
Gift of Mrs. Bruce Kelham and Mrs. Peter Lewis (CPLH), 1948.4

P BEHAGLE

Ovid provided artists with a nearly inexhaustible source of inspiration in the fifteen books of his *Metamorphoses*, recounting the transformations of gods and men. Many tapestry series were designed around this theme, with a widely differing choice of episode. Two distinct series of *Metamorphoses* came from the looms of Beauvais in the late seventeenth and early eighteenth centuries, distinguished by the size of the figures. The more costly, large-figured series, to which The Fine Arts Museums' panel belongs, was designed by the painter René-Antoine Houasse, a disciple of Le Brun,[1] and woven under Philippe Behagle, director of the Beauvais manufactory from 1684 to 1705.

The first panel of the Houasse series, *The Abduction of Orithyia by Boreas*, was woven at least seven times. Ovid's *Metamorphoses* (Bk. VI, vv. 682–710) tells the story of the princess who was beloved by the North Wind. After a long and unsuccessful suit, Boreas despaired of winning Orithyia by persuasion and reverted to the violent manner that was natural to him. He swept down and whirled the terrified girl away to the windy land of Thrace. The broken tree, flying draperies, and cowering figures in the tapestry testify to the wind's savage approach. At left, the princess's companions have dropped the garland they were making and run for safety. Only the girl in the center, braver than the rest, clings to Orithyia's garment to hold her back. The cartoons for the series could have been designed before 1688. Tapestries woven on the cartoons certainly existed in 1690.[2]

Other subjects represented in the series are: *Pan and Syrinx, Vertumnus and Pomona, Alpheius and Arethusa, Cephalus and Procris*, and *Diana* [Jupiter] *and Callisto*.[3]

Five different borders were used with them. The floral border with "cross-motifs" of The Fine Arts Museums' *Orithyia* is a rare and early form. Other border types include one with quivers, torches, and shells; acanthus bands around a stem; a plain frame with acanthus; and "flowers and convoluting ribbons." Jestaz gives a location for an example of each subject and describes the borders in his very thorough study. The San Francisco borders appear on a *Falcon Hunt* that Badin dates circa 1700.[4]

The series illustrates those characteristics described by Jestaz as essential in Beauvais tapestry: "fantasy, a taste for the marvelous, sensitivity to landscape, . . . a tender and trustful feeling for nature" that anticipated the eighteenth century and offered a "vital counterpart" to the academic style.[5]

NOTES
1. Bertrand Jestaz, "The Beauvais Manufactory in 1690," in *Acts of the Tapestry Symposium November 1976* (San Francisco: The Fine Arts Museums of San Francisco, 1979), 187–207, esp. 197–201.
2. Jestaz, "Beauvais," 188.
3. Jestaz, "Beauvais," 197–198.
4. Jules Badin, *La manufacture de tapisseries de Beauvais depuis ses origines jusqu'à nos jours* (Paris: Société de Propagation des Livres d'Art, 1909), illus. opp. 8.
5. Jestaz, "Beauvais," 204.

PROVENANCE
Viscountess Northcliffe (Lady Hudson)
Sale, London, 7–8 May 1923, no. 97
Grace Spreckels Hamilton, 1927

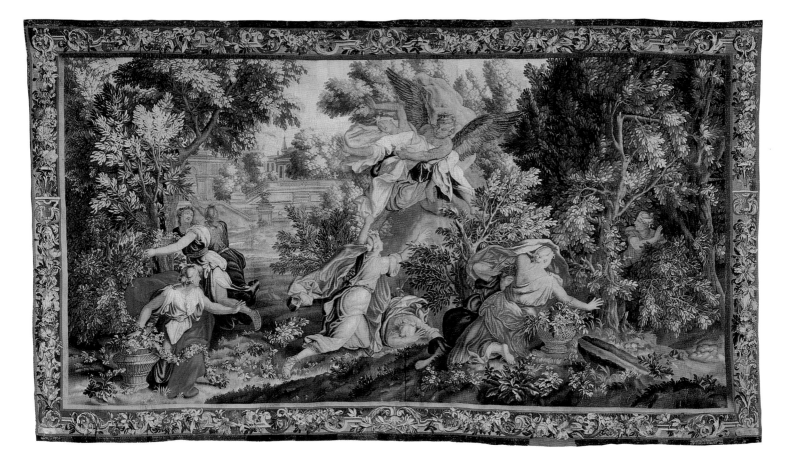

The Abduction of Orithyia by Boreas

The Berain Grotesques *Series*

Repetition and imitation, those reliable signs of success, attest to the incredible vogue of the *Grotesques* of Beauvais. The series was woven first under Behagle, and at least 150 panels are recorded. They were copied in Berlin and reproduced in embroidery. Great variety exists in the quality of execution, in the sizes and shapes of the panels, and in elements of the composition. Three different borders were used: the chinoiserie, the simulated frame, and a zigzag design, known as *bastons rompus*.

Jean Berain's name is firmly associated with the designs, although they were composed and drawn by Jean-Baptiste Monnoyer. The concept seems to have been Berain's, and he may have made preliminary sketches.[1] The cartoons were finished by 1689, for Monnoyer left for England in 1690 and did not return. Badin records several sets in a memo of Behagle's, which Edith Standen dates after 1692.[2]

The complete set of six panels may have been customarily divided between three vertical and three horizontal. The designs had great flexibility and could be lengthened or extended at the sides to fit architectural requirements. The usually vertical designs are *The Offering to Bacchus*, *The Offering to Pan*, and *The Musicians*; the horizontal are *The Camel*, *The Elephant*, and *The Animal Tamers*.[3]

Berain's achievement was a brilliant synthesis of old forms with the added touch of novelty that fashion demands. He continued the tradition of Nero's Golden House, the fanciful "grotesques" which, rediscovered by Raphael and used for Flemish tapestries, may have inspired Berain via Noël Coypel.[4]

Spidery ornament fills the upper third of the design, against a ground of gold or brown. A central architectural screen of narrow arches is decorated with garlands and jewels, or spindly columns of lapis lazuli. A central pediment or canopy interrupts the entablature with projecting bays, providing stage space for performers, animals, and musicians. The design's lower section is missing in all but the tallest versions. The complete cartoon included marble stairs leading from the stage into a formal garden.

Behagle's name does not appear on The Fine Arts Museums' *Grotesques*, which, therefore, probably postdate his death (in 1705) and the directorship of his son and widow (until 1711). The panels represent different weavings, for *The Animal Tamers* is coarser in weave and the wide panels show a different amount of cartoon below the stage. Curiously, those panels usually vertical—*The Musicians* and *The Offering to Pan*—are greatly extended in The Fine Arts Museums' versions. On the other hand, *The Animal Tamers* shows the center only of a normally wide design. "Chinese" herms, satyrs, and heads in the borders herald the Chinamania that raged for half a century. A different kind of drollery enlivens the top corners. Herms hold extended metal tongs with flower baskets.

NOTES

1. Roger-Armand Weigert, "Les commencements de la manufacture royale de Beauvais, 1664–1705," *Gazette des Beaux-Arts* 64 (1964): 344.
2. Jules Badin, *La manufacture de tapisseries de Beauvais depuis ses origines jusqu'à nos jours* (Paris: Société de Propagation des Livres d'Art, 1909), 12–13.
3. Edith Standen, *European Post-Medieval Tapestries and Related Hangings in The Metropolitan Museum of Art*, 2 vols. (New York: The Metropolitan Museum of Art, 1985), 2:441–458, no. 64a–f.
4. Fiske Kimball, *The Creation of the Rococo* (New York: W. W. Norton, 1943), 54.

80. The Offering to Pan

from The Berain Grotesques *Series*

French (Beauvais), first quarter eighteenth century
Designed by Jean-Baptiste Monnoyer (1636–1699)
H: 3.05 m W: 3.71 m (10 ft. × 12 ft. 2 in.)
WARP: undyed wool, 8.5 per cm
WEFT: dyed wool and silk
Roscoe and Margaret Oakes Collection (de Young), 59.49.4

In the center of the stage, the flower-crowned herm of Pan is outlined against a gold-colored background. A young woman in pink decorates the statue of the rustic god with flowers. Her left hand rests on Pan's shoulder; with the other hand she reaches into a basket of flowers held by a small boy. The girl's right knee rests on the back of a goat. Behind her, half-hidden by a balustrade, a smaller girl lifts both arms above her head as she plays the tambourine. These figures were borrowed by the flower painter Monnoyer, from Poussin's *Triumph of Pan* (fig. 85), now in the National Gallery, London. The full-length tambourine player is found in two prints after Berain.[1] Monnoyer's specialty is evident in the profusion of flowers, hanging in delicate swags along the arcade, growing from pots, and interspersed among the exotic elements of the border. An appeal is made to the other senses, in the incense burners, the basket of fruit, and the trophies of musical instruments.

About the same amount of green hedge is showing in the foreground of *Pan* as in *The Animal Tamers* (cat. no. 81), but here a red parrot sits on the edge of the stage, and the hedge blooms with red flowers. A narrower *Offering to Pan* at The Metropolitan Museum of Art has a large eagle over the central pediment. The border is a simulated gold frame, and three steps lead down from the stage.[2] A *Pan* sold at the Hôtel Drouot, 22 March 1983 (no. 115), is now at the Museum of Fine Arts, Boston.

A suite of five *Berain Grotesques* now decorates the Oval Room of the State Apartments in Stockholm's City Hall. Figure 86, a detail of *The Offering to Pan* from this suite, shows that portion of the cartoon seldom seen: the entire flight of stairs leading down from the stage with a splendid peacock at the foot.

NOTES
1. Jérôme de La Gorce, *Berain, dessinateur du Roi Soleil* (Paris: Herscher, 1986), 31–33. I owe this reference to Edith Standen.
2. Edith A. Standen, *European Post-Medieval Tapestries and Related Hangings in The Metropolitan Museum of Art*, 2 vols. (New York: The Metropolitan Museum of Art, 1985) 2:455–458, no. 64f.

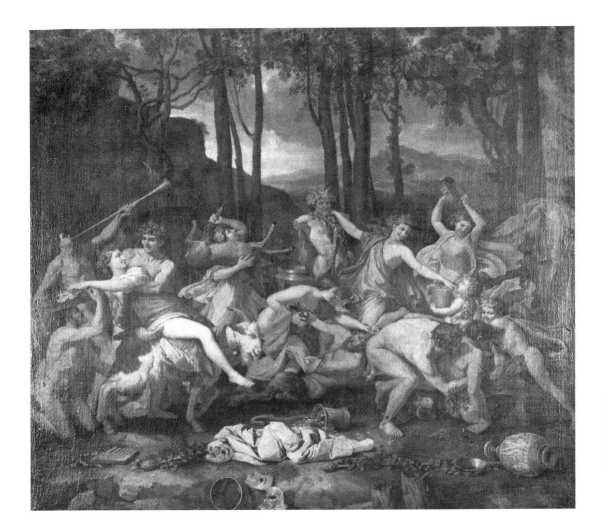

FIGURE 85
Nicolas Poussin,
The Triumph of Pan,
oil on canvas.
National Gallery,
London

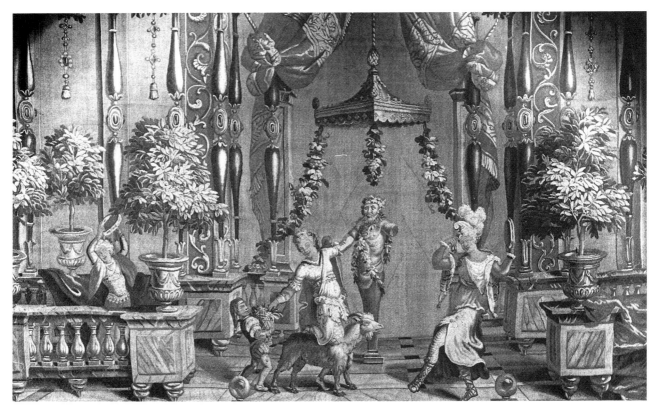

FIGURE 86
The Offering to Pan (detail), tapestry.
Stadshusexpeditionen, Stockholm

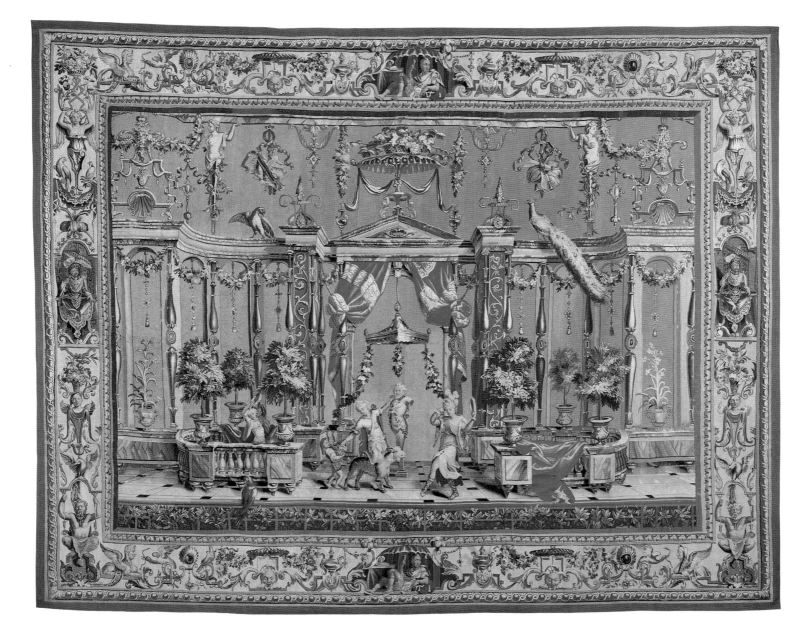

The Offering to Pan

81. The Animal Tamers

from The Berain Grotesques *Series*

French (Beauvais), first quarter eighteenth century
Designed by Jean-Baptiste Monnoyer (1636–1699)
H: 3.02 m W: 2.61 m (9 ft. 11 in. × 8 ft. 7 in.)
WARP: undyed wool, 8.5 per cm
WEFT: dyed wool and silk
Roscoe and Margaret Oakes Collection (de Young), 59.49.2

Two showmen put three undersized lions through their paces before a heavy purple curtain with gold stripes and fringe. The men wear short tunics and bizarre headgear. The turbaned trainer holds a baton and has a lion on a leash. The black and white marble stage on which they perform is set in a garden, for a leafy hedge trained on lattice is visible in the foreground. The canopy hangs from an architecturally unsound structure of polychrome marble, upheld by lapis lazuli colonnettes. Ribbons tie arrow trophies and crowns of roses to the unsupported spar overhead. Monnoyer exercised his specialty in the garlands draped over the central pendant and bouquets in spindly vases placed above the colonnettes. All the heterogenous elements are strictly paired, achieving an illogical symmetry.

The Berain Grotesques were woven for forty years in varying sizes and borders. *The Animal Tamers* is the rarest of the subjects; only about twelve examples are known.[1] The panels are normally very wide like *The Camel* and *The Elephant*, which use a tripartite form found in some of Berain's prints.[2] For The Fine Arts Museums' version, only the central section of the cartoon was woven.

In the chinoiserie border, fanciful and grotesque elements cover an off-white ground between a double trompe l'oeil frame of molding. Small "Chinese" figures mark the mid-points of the borders, under a red parasol at top and bottom and seated in niches on the sides. As Edith Standen has pointed out, the lateral figures recall Vernansal's emperor in *The Audience of the Emperor* (see cat. no. 83).[3]

NOTES
1. Edith A. Standen, "Some Beauvais Tapestries Related to Berain," in *Acts of the Tapestry Symposium November 1976* (San Francisco: The Fine Arts Museums of San Francisco, 1979), 210.
2. Standen, "Some Beauvais Tapestries," 209.
3. Standen, "Some Beauvais Tapestries," 210.

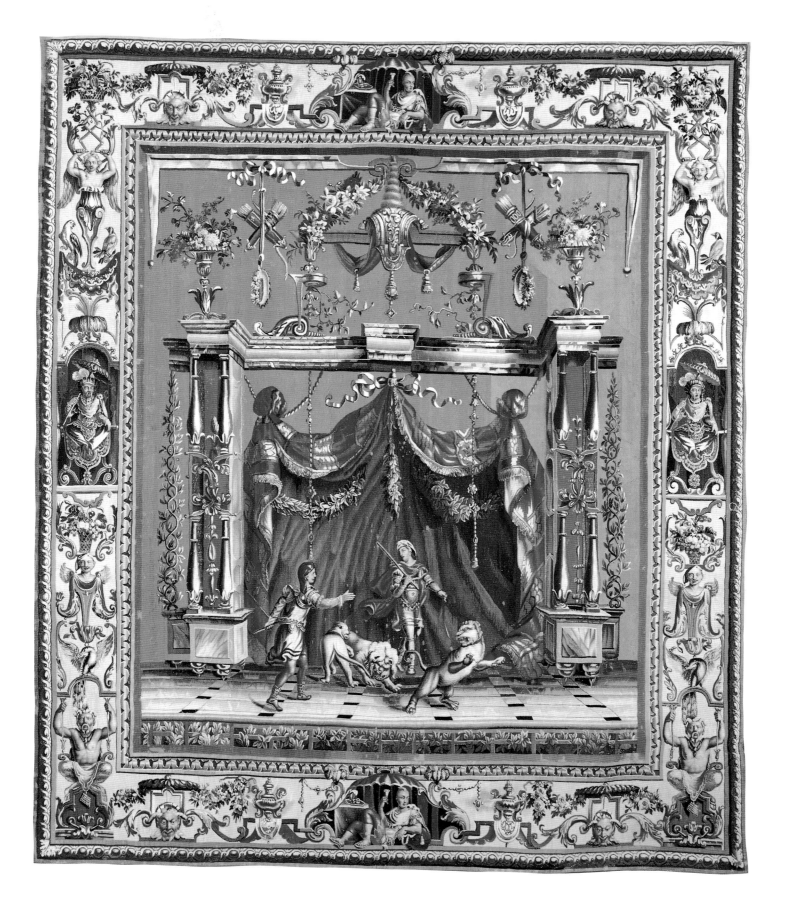

The Animal Tamers

82. The Musicians

from The Berain Grotesques *Series*

French (Beauvais), first quarter eighteenth century
Designed by Jean-Baptiste Monnoyer (1636–1699)
H: 3.07 m W: 3.71 m (10 ft. 1 in. × 12 ft. 2 in.)
WARP: undyed wool, 8.5 per cm
WEFT: dyed wool and silk
Roscoe and Margaret Oakes Collection (de Young), 59.49.3

A small round table covered with a red cloth is set in the center of the stage beneath an elaborate curved canopy. A lute and some music books are piled on the table. Two fantastically dressed musicians perform nearby between the projecting wings of the architectural screen. The girl with blond braids dances as she plays the triangle; her seated companion plays the viola da gamba.

Ornaments of every kind enrich the setting. Some of the objects carry the theme of music, like the heavy musical trophies hanging at either side, above, and the three birds that occupy prominent positions. Purely ornamental, apparently, are the plants in jardinieres, the garlands and baskets of flowers, the hanging incense burners emitting clouds of fragrance, and the three sphinxes.

The subject is comparatively rare, about sixteen examples being known.[1] This piece does not seem to have belonged to the same set as *Pan* and *The Animal Tamers* because it shows no greenery in the foreground; the simulated frame begins at the edge of the stage.[2]

NOTES

1. Edith A. Standen, "Some Beauvais Tapestries Related to Berain," in *Acts of the Tapestry Symposium November 1976* (San Francisco: The Fine Arts Museums of San Francisco, 1979), 210.
2. Another *Musicians* was in a 22 June 1939 sale at Christie's, no. 159. Although identical in the illustration, its width was given as 11 ft. 2 in.

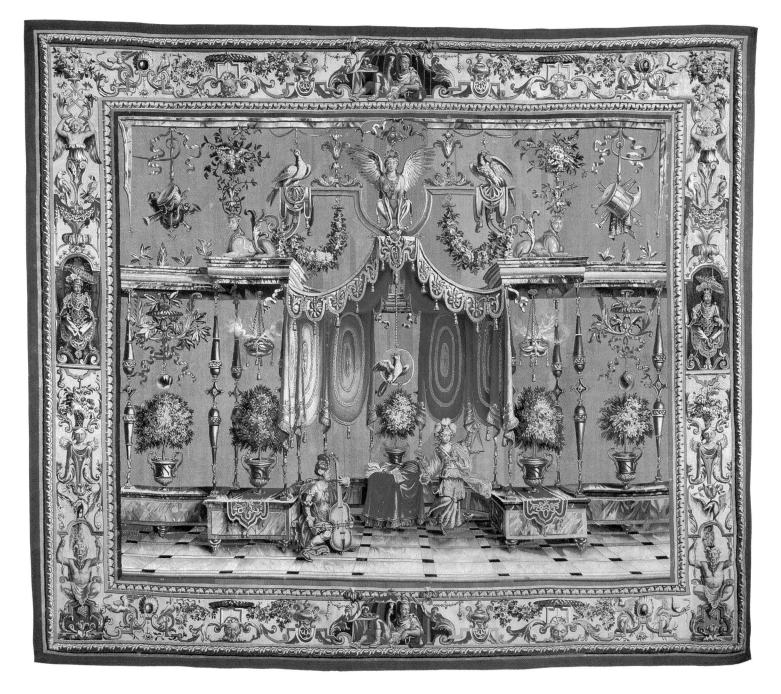

The Musicians

83. The Audience of the Emperor

from The Story of the Emperor of China *Series*

French (Beauvais), before 1732
Designed by Guy Louis de Vernansal I (1648–1729), Jean-Baptiste
 Belin de Fontenay (1653–1715), and, probably, Jean-Baptiste
 Monnoyer (1636–1699)
Woven under the direction of de Mérou (?)
H: 3.18 m W: 5.03 m (10 ft. 5 in. × 16 ft. 6 in.)
WARP: undyed wool, 8.5 per cm
WEFT: dyed wool and silk
Roscoe and Margaret Oakes Collection (de Young), 59.49.1

Enterprising Dutch traders of the seventeenth century
cultivated the myth of Cathay. Their illustrated accounts
of the country and its costumes and architecture encour-
aged the feverish collecting of Oriental objects and the
manufacture of thoroughly European items with Chinese
themes or motives, known as *chinoiserie*.[1] *The Story of the
Emperor of China* series is an example par excellence of
this genre.

The theme was probably inspired by the departure in
1685 of a Jesuit mission to the court of the Manchu em-
peror, K'ang-Hsi (Kangxi).[2] It is documented that four
painters made the cartoons for the series. The names of
three of them are known. Guy Louis de Vernansal I seems
to have had a major hand in the designing, for he signed
one of the panels. His collaborators were Jean-Baptiste
Belin de Fontenay and "Baptiste," presumed to be Jean-
Baptiste Monnoyer. Monnoyer left France in 1690. If
"Baptiste" can be identified correctly with him, the de-
signs should be placed between the years 1685 and 1690.[3]

The series may illustrate as many as ten subjects,
though one of these, *Gathering Tea*, has not been identified.
Other subjects besides *The Audience of the Emperor* include
The Emperor on a Journey, *The Astronomers*, *The Collation*, *Har-
vesting Pineapples*, *The Return from the Hunt*, *The Emperor on a
Voyage* (fig. 87), *The Empress Sailing*, and *The Empress's Tea*.[4]

The Jesuit Father Bouvet returned to France in 1697
and published a report of the mission, *Portrait historique de
l'Empéreur de la Chine*. Public imagination was further in-
flamed by stories of the monarch described by Jarry as the
Sun King of the Far East. The series of the *Emperor* was
woven many times. By 1732 the cartoons were worn out.[5]

The emperor holds audience in the open air, sitting
on an Oriental rug draped over a raised dais. He wears a
drooping mustache, a turban with feathers, and a long
string of beads. Edith Standen has pointed out that the
image of the monarch was adapted from the title page of
Johan Nieuhof's *L'ambassade de la compagnie orientale des*

Provinces Unies vers l'Empéreur de la Chine.[6] He sits like an
idol before a mosaic-lined niche decorated with griffons,
sphinxes, and fanciful inscriptions surmounted by pea-
cock feathers. Two guards attend him. The head and fore-
leg of an elephant emerge from behind the red and gold
curtain that shields the throne. This backdrop is sus-
pended at several points from an open loggia with two
central arches, pendent vaults, and lateral wings. Its archi-
tectural features combine Moorish and Gothic, and antic-
ipate the fantasy of the Royal Pavilion at Brighton, and
even the elegant, airy vault of the Crystal Palace.

At a level several steps below the emperor, three visi-
tors kowtow to him, and a fourth makes a reverential sa-
lute. Behind them a large bowl or basket of fruit overflows
onto the terrace with exotic delicacies. A peacock pauses
beside them. Service tables at the right edge are laden with
porcelain bowls, ewers, and jars.

On the left a blond lady approaches by rickshaw, agitat-
ing her feather fan. Bands from the vehicle pass over the
arms of two black men dressed in leaves or feathers, who
prostrate themselves before the emperor, burying their
heads in the rug. At the left edge of the curtain, one can
see a knot of warriors or guards with spears. On the hori-
zon behind them, bathed in golden light, are the walls and
tiered pagodas of Cathay.

The steps in the foreground, like the steps in *The Berain
Grotesques*, are a device for adjusting the height of the
weaving. In the higher panels, the rickshaw is moved be-
low the third step. Additional animals are added and, in
wider versions, additional figures as well. The first edition
with gold thread (woven under Behagle) was bought by
the duc du Maine. The *Audience* subject was included in
every weaving of the series, and many examples have sur-
vived. Several borders are found with the series, including
the wide, picture-frame type of Compiègne, the narrow
acanthus-leaf type of the present panel, and the chinoise-
rie of the panel at the Louvre (fig. 87).

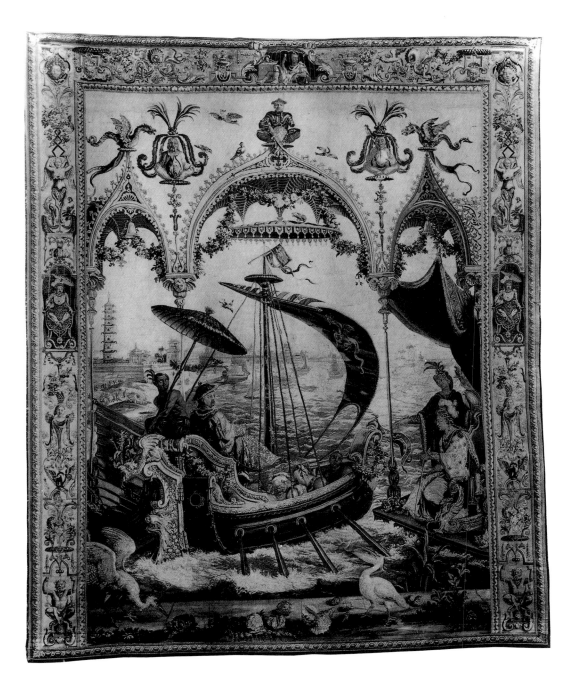

The mark BEAUVAIS is found on some panels woven under the directorship of de Mérou (1722–1734). Its absence from The Fine Arts Museums' panel makes the piece less likely to have been woven during that period. All that can be said with certainty is that it must be dated before 1732.

NOTES

1. Johan Nieuhof, *L'ambassade de la compagnie orientale des Provinces Unies vers l'Empéreur de la Chine* (Amsterdam, 1665).
2. Madeleine Jarry, "Chinoiseries à la mode de Beauvais," *Plaisir de France* 429 (May 1975): 54–59, esp. 56.
3. Edith A. Standen, *European Post-Medieval Tapestries and Related Hangings in The Metropolitan Museum of Art*, 2 vols. (New York: The Metropolitan Museum of Art, 1985), 2:461–468, esp. 463.
4. Adolph S. Cavallo, *Tapestries of Europe and of Colonial Peru in the Museum of Fine Arts, Boston*, 2 vols. (Boston: Museum of Fine Arts, 1967), 1:170–176, esp. 174–176.
5. Standen, *European Post-Medieval Tapestries*, 464.
6. Standen, *European Post-Medieval Tapestries*, 464.

EXHIBITION

Cathay Invoked—Chinoiserie: A Celestial Empire in the West, California Palace of the Legion of Honor, San Francisco, 11 June–31 July 1966, no. 164.

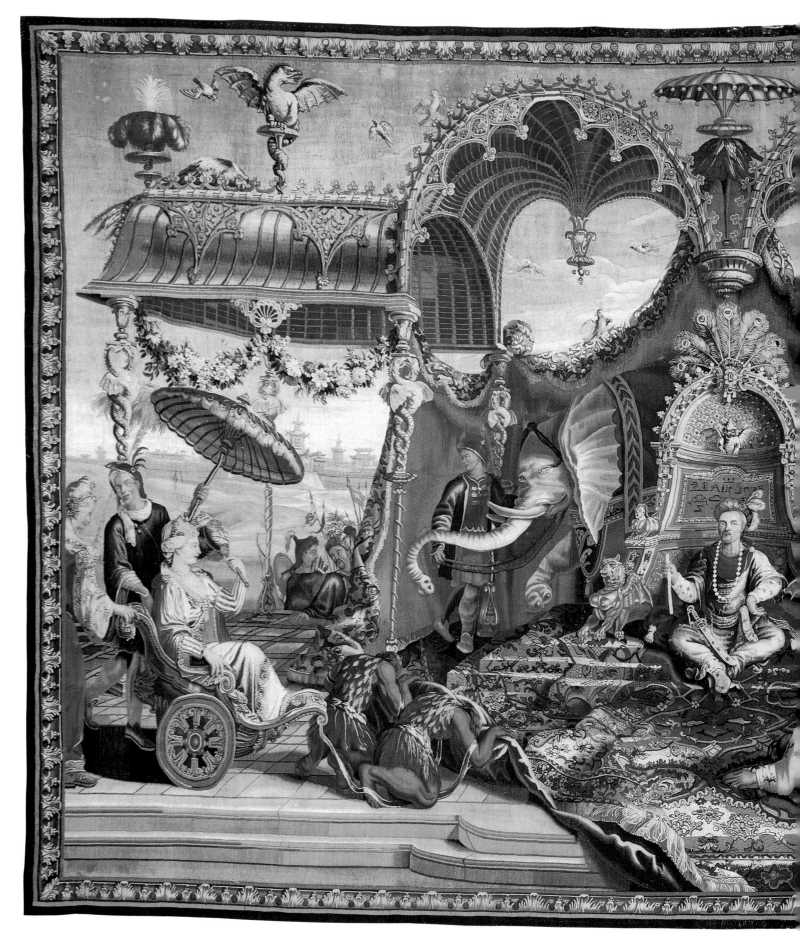

The Audience of the Emperor

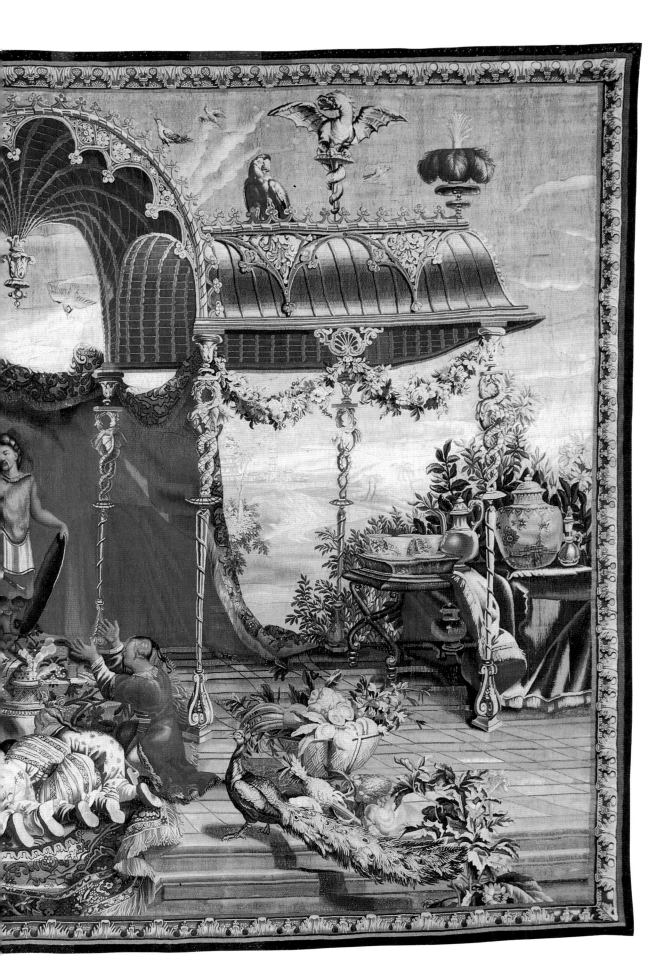

84. The Gypsy Fortune-Teller

from the Italian Village Scenes *Series*

French (Beauvais), 1736–1762
After a design by François Boucher (1703–1770)
H: 3.37 m W: 3.18 m (11 ft. ½ in. × 10 ft. 5 in.)
WARP: undyed wool, 8 per cm
WEFT: dyed wool and silk
Roscoe and Margaret Oakes Collection (de Young), 49.21

The *Italian Village Scenes* series was Boucher's proving ground in tapestry design and gave early indication of his decorative skill. Many writers followed Jules Badin in assigning fourteen subjects to the series.[1] Edith Standen has shown that it included only eight.[2] Certain of the designs were very wide; from them distinct figure groups were sometimes isolated and woven separately. This practice, plus the use of alternate titles for the subjects, inflated their apparent number.

The eight subjects were designed in two groups. The first, in 1736, probably included *The Charlatan and the Peep-Show*, *The Hunters and the Girls with Grapes*, *The Girls Fishing*, and *The Gypsy Fortune-Teller*. The other four, perhaps designed as late as 1742, were *The Dance*, *The Collation*, *Music*, and *The Gardener*.[3] Only *The Charlatan* has an obvious connection with village festivities. Each design was woven at least twelve times. A complete set of eight panels is at The Metropolitan Museum of Art, New York.

The caryatid supporting the ruins represents Pan, god of shepherds and flocks, for his attribute, the syrinx, hangs on a nearby tree. He presides over a scene of fortune-telling in which an exquisite shepherdess has her palm read by a gypsy. The shepherdess is dressed in pale pink silk with a yellow overshirt. She wears a bow around her neck, and another bow decorates her *houlette* (a staff with a metal plate for throwing earth clods at straying sheep). The gypsy's feet are bare and her blue underskirt is ragged. The hem of her lavender dress has been tucked up and her hair is covered by a scarf; the baby on her back is held by a blanket. Six sheep occupy the right corner.

Three other figures appear in the composition. The young woman beside the shepherdess is only partially visible. Seen in profile, she wears a lavender-pink dress with voluminous sleeves and has a red ribbon in her hair. She watches the gypsy intently. The two young people at left concentrate on a game of their own. The young man in a blue coat holds a wreath of small flowers and leaves over the head of his smiling, barefoot companion. A garland trails across her lap. She is barefoot. The strong vertical accent of the Pan caryatid stabilizes a diagonal buildup of rocks, ruins, and vegetation. A vaporous sky in shades of blue and gray fills in the background.

The *Gypsy Fortune-Teller* was woven at least thirteen times between 1736 and 1762. Some versions are wider, showing a second group of sheep on the left. The panel of The Fine Arts Museums of San Francisco is almost square, like that at the Victoria and Albert Museum in London.[4] The borders are sewn on, suggesting that the panel may have been woven without them and intended to fit into *boiseries*. On the other hand, Nello Forti Grazzini points to two tapestries that have the same border and may, therefore, have been part of the same "edition." *The Charlatan and the Peep-Show*, once at Elveden Hall (Thetford, Norfolk), collection of the earl of Iveagh, was sold at Christie's on 22 May 1984, no. 1766. *Fishing* was sold by Sotheby's, London, 2 December 1983, no. 2. Severe fading has resulted in significant loss of color and detail; the sheep in the right foreground are nearly invisible. Edith Standen has traced various elements in the design to Boucher paintings and sketches or to prints after him.[5] The couple at left, for example, appears in a print by C. L. Duflos after Boucher, called *Hommage champêtre*, and in another by P. Aveline, entitled *La bonne aventure* which is also related to the gypsy and her customer.

NOTES

1. Jules Badin, *La manufacture de tapisseries de Beauvais depuis ses origines jusqu'à nos jours* (Paris: Société de Propagation des Livres d'Art, 1909), 60.
2. Edith A. Standen, "Boucher as a Tapestry Designer," in *François Boucher 1703–1770* (New York: The Metropolitan Museum of Art, 1986), 325. Standen cites Roger-Armand Weigert, "La manufacture royale de tapisseries de Beauvais en 1754," *Bulletin de la Société de l'histoire de l'art français* (1933): 232.
3. Edith A. Standen, *European Post-Medieval Tapestries and Related Hangings in The Metropolitan Museum of Art*, 2 vols. (New York: The Metropolitan Museum of Art, 1985), 2:507.
4. Standen, *European Post-Medieval Tapestries*, 518.
5. Standen, *European Post-Medieval Tapestries*, 515–517.

PROVENANCE

The tapestry belonged to the William C. Whitney collection, New York. It was in the James Henry Smith Sale, American Art Association, New York, 18–22 January 1910, no. 244, illus.

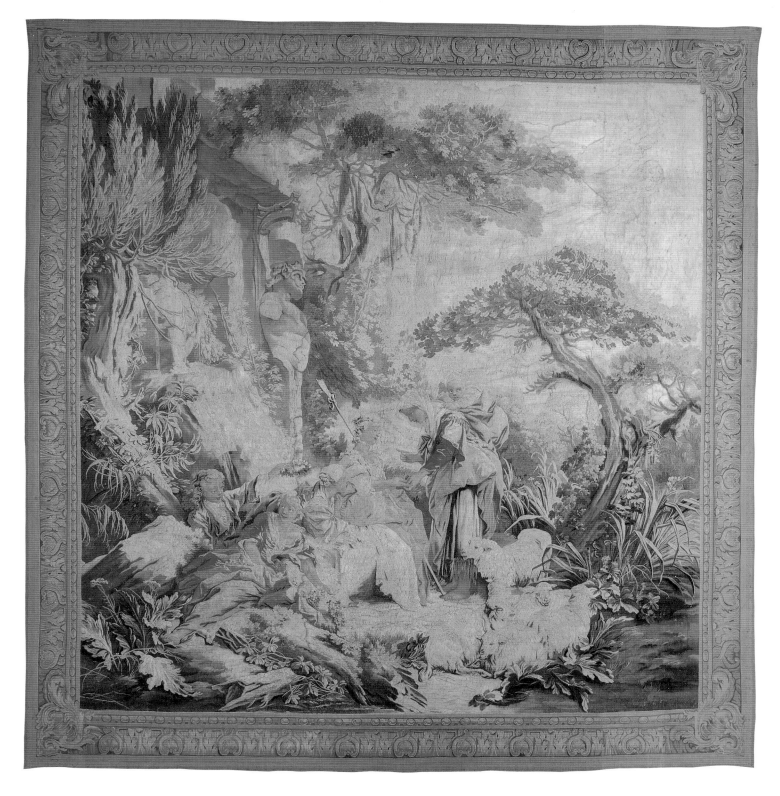

The Gypsy Fortune-Teller

85. Pastoral Scene

French (Aubusson), mid-eighteenth century
H: 2.89 m W: 4.10 m (9 ft. 6 in. × 13 ft. 6 in.)
WARP: undyed wool, 4 per cm
WEFT: dyed wool and silk
MARKS: *Origin* lower guard
 Weaver lower guard
Gift of William Walker II (CPLH), 1964.74

M·R·DAVBVSON·A·G

The subject of the tapestry is the contentment and seren-
ity of country life. An airy structure thatched with straw
is sheltered by tree tops at right. Far below, a young
woman rests in the shade. Her companion points toward
the pond; his *houlette* identifies him as a shepherd. Five of
his sheep have strayed near the water's edge. In the mid-
distance, the pond is spanned by a rustic bridge on which
a man and an animal are barely visible. The road sweeps
steeply upward from the dog at the landing to the round
tower and other buildings that crown the hill. The colors
are light; the contours pleasing. All elements of the en-
semble are consciously picturesque.

Shell and fan shapes fill the border. The mark in the
border guard stands for Manufacture Royale d'Aubusson,
followed by the initials of the weaver, A.G. These initials
may have belonged to a member of the Grellet family,
prominent weavers of Aubusson. He could have been An-
toine Grellet, recorded in 1705, 1726, and 1740.[1]

NOTE

1. Heinrich Göbel, *Wandteppiche. II Teil: Die romanischen Länder*, 2
 vols. (Leipzig: von Klinkhardt & Biermann, 1928), 1:537, 539
 (reference provided by Edith Standen); Dominique Chevalier,
 Pierre Chevalier, and Pascal-François Bertrand, *Les tapisseries
 d'Aubusson et de Felletin 1457–1791* (Paris: La Bibliothèque des
 Arts, 1988), 193 (shows Antoine Grellet recorded in 1760).

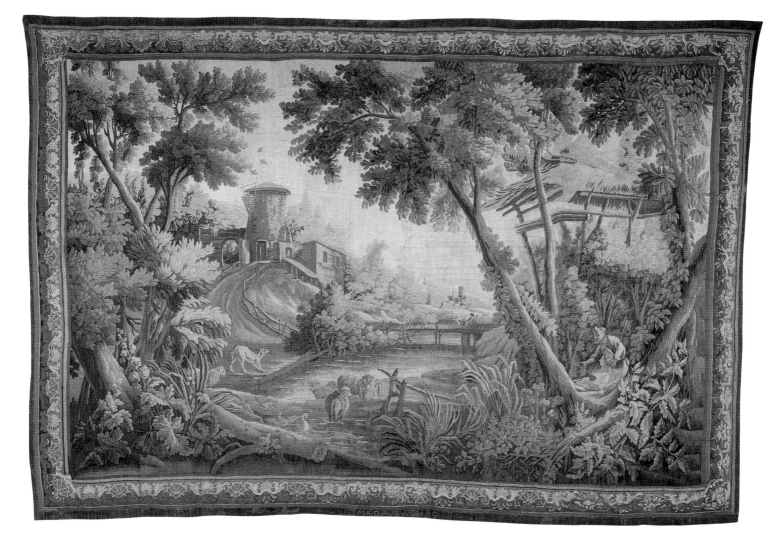

Pastoral Scene

86. Landscape with Pagoda

from The Chinese Landscape *Series*

French (Aubusson), second quarter eighteenth century
H: 2.64 m W: 3.81 m (8 ft. 8 in. × 12 ft. 6 in.)
WARP: undyed wool, 4 per cm
WEFT: dyed wool and silk
Gift of The William Randolph Hearst Foundation (CPLH), 1961.18

Steps cut into the rocks lead to a plateau from which rise the foundations of a three-tiered pagoda. A second, broken flight of steps continues to the narrow entrance, past substantial columns of a variant Ionic order. The pagoda roofs have external concave ribs terminating in sharply upswept eaves, fringed or feathered on the ends, each one supporting a single bell.

The pagoda is isolated by a heavy bank of mist from the valley below. A river flows beneath it through an arch or cavern, anticipating Coleridge's sacred river Alph in *Kubla Khan* (1797). Fantastic birds wheel in the air and animate the foreground. No human being is seen, although the bow and quiver at left imply human activity. These hang before a light shelter, semiconcealed by rich drapery. The textile is looped carelessly over the branch of a tree amid clusters of heavy fruit.

The Far Eastern theme contributed a strong, exotic flavor to the decorative arts for more than a century, outliving the rococo style that it had ornamented. In tapestry this spirit was first expressed in *The Story of the Emperor of China* series (cat. no. 83), designed by Guy Louis de Vernansal I, Jean-Baptiste Belin de Fontenay, and Jean-Baptiste Monnoyer before 1690. It was succeeded by a second Chinese set designed for Beauvais by François Boucher in 1743. Boucher's sketches were adapted for tapestry by Aumont or Dumont, who may be identical with Aubusson's Jean-Joseph Dumons.[1] Certainly it was Dumons, commissioned by Jean Picon, who adapted Boucher's chinoiserie fantasy for the looms of Aubusson from 1754, restating some of Boucher's designs and adding others of his own. Engravings of two hundred works of Jean Pillement (published by K. Leviez in 1767) furnished tapestry designers with a final French version of the Chinese dream, airier and more overtly fanciful than Boucher's convincing vision of an impossible Cathay.

The previous attribution of this panel to Pillement with a late date must be revised in view of the work of Madeleine Jarry and Pascal-François Bertrand.[2] Design elements confirm its links with an earlier period. The richly draped textile and the bow and quiver are in the tradition of Le Brun's design for *The Family of Darius*, for his Alexander series (1661). The pagoda derives from Fischer von Erlach's *Entwurff einer historischen Architektur* of 1721 (fig. 88). Von Erlach, in turn, had borrowed from Johan Nieuhoff's travel book (1665). The same pagoda, thinly disguised, reappears in a panel of the first Chinese series, *The Emperor on a Journey*.[3]

The Fine Arts Museums' panel is a partial weaving of a design known in at least two wider versions. An example in the Chevalier collection extends the weaving of the cartoon at the right edge, showing a second, eight-tiered pagoda and a peacock perched on a branch. A coat of arms in the upper border provides a date of 1725, and the piece has the name of the Rougeron workshop. A very wide version belongs to the Mobilier National, designated as workshop of Dorléac (fig. 89).[4]

NOTES

1. Alistair Laing in *François Boucher 1703–1770* (New York: The Metropolitan Museum of Art, 1986), 202–207; Pascal-François Bertrand, "La seconde 'Tenture chinoise' tissée à Beauvais et Aubusson," *Gazette des Beaux-Arts* 116 (November 1990), 176.

2. Dominique Chevalier, Pierre Chevalier, and Pascal-François Bertrand, *Les tapisseries d'Aubusson et de Felletin 1457–1791* (Paris: La Bibliothèque des Arts, 1988), 129–131; Madeleine Jarry, in *Exotisme et tapisserie*, exh. cat., 25 June–2 October 1983, Musée Departementale de la Tapisserie (Aubusson: Centre Culturel et Artistique Jean Lurçat, [1983]), 34.

3. Madeleine Jarry, "Chinoiseries à la mode de Beauvais," *Plaisir de France* 429 (May 1975), 55 illus.

4. Madeleine Jarry, *World Tapestry from Its Origins to the Present* (*La tapisserie*, Paris: Librarie Hachette, 1968; English ed. New York: G. P. Putnam's Sons, 1969), 246–247. Nello Forti Grazzini provides information on the following replicas recently passed in auction: Sotheby's, Florence, 22 May 1989, no. 380; Sotheby's, Monaco, 21 February 1988, no. 640; Sotheby's, Florence, 24 May 1979, no. 1397; Adler Picard Tajan, Paris, 27 March 1985, no. 170.

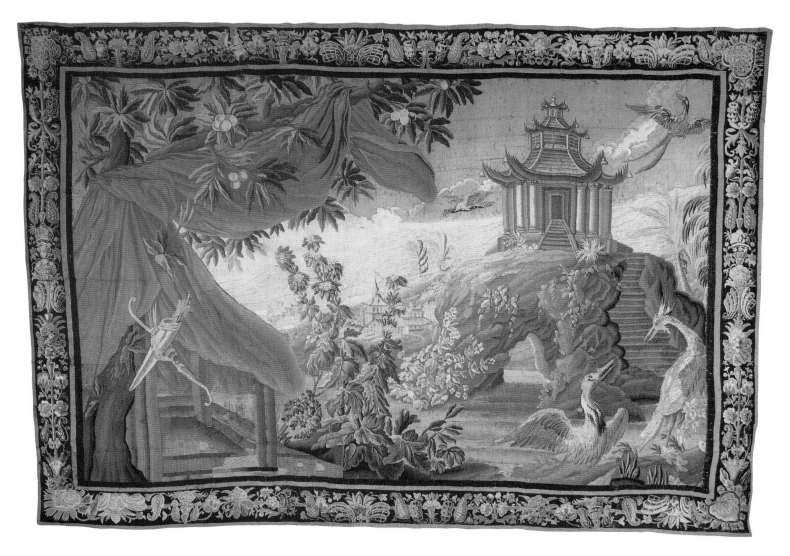

Landscape with Pagoda

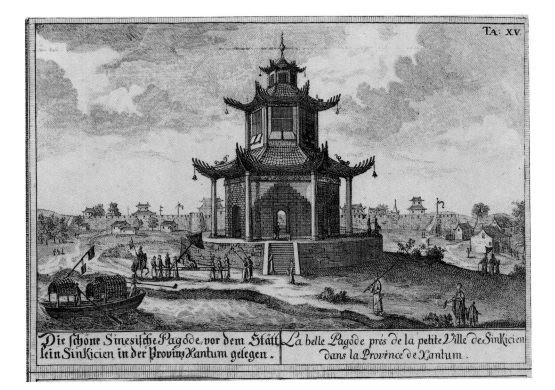

Die schöne Sinesische Pagode, vor dem Stätt
lein Sinkicien in der Provinz Xantum gelegen.

La belle Pagode près de la petite Ville de Sinkicien
dans la Province de Xantum.

FIGURE 88
Fischer von Erlach, *Chinese Pagoda*, engraving. The Metropolitan
Museum of Art, New York. Harris Brisbane Dick Fund, 1938, 38.13.1

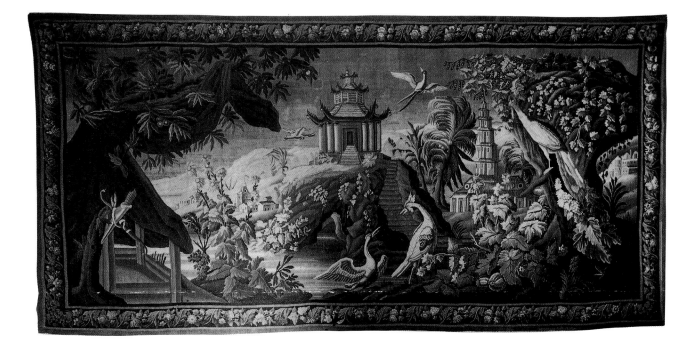

FIGURE 89
The Pagoda, tapestry. Mobilier National, Paris

87. Chinese Scenes

Upholstery panels for eight armchairs

French (Aubusson), mid-eighteenth century
H: 58 cm W: 61 cm (23 in. × 24 in.) back
H: 80 cm W: 86 cm (31½ in. × 34 in.) seat
WARP: undyed wool, 8–9 per cm
WEFT: dyed wool and silk
Mildred Anna Williams Collection (CPLH), 1940.72–79

François Boucher had a hand in promoting the eighteenth-century version of the Chinese style when he, Jeaurat, and Aubert engraved the Chinese figures that Watteau designed for the Château de la Muette.[1] In 1743, with the taste for chinoiserie at its apogee, Boucher made ten sketches for a second Chinese tapestry series for Beauvais, the first Vernansal-Belin de Fontenay-Monnoyer series having become outmoded and outworn. This new set was woven from 1743 to 1775.[2]

The fact that Boucher supplied only small sketches for the tapestries instead of full-scale paintings was a departure from the norm, requiring that another artist enlarge them and paint the cartoons. This artist's name is given variously as Aumont or Dumont. His traditional identification with Jean-Joseph Dumons of Tulle (1687–1779) has been questioned.[3] It was certainly Dumons of Tulle who became designer at Aubusson in 1731 and who adapted Boucher's Chinese series for the Aubusson looms. Some of these hangings are directly related to Boucher's designs for Beauvais; others are similar in theme but new in composition.[4]

The small tapestry pieces woven as coverings for settees and armchairs are still further removed from Boucher's originals, and yet the inspiration remains, for they furnish further glimpses of Boucher's fantasy world: its men with shaven heads, its pretty girls and Confucian sages, its strange stoves and musical instruments. For all its unreality, Boucher's Chinese world is consistent, detailed, and convincing.

1940.72 Back: A blond "Chinese" girl dozes in a garden, resting her head and folded arms on a blue pillow. She wears a red outergarment that is pulled up to reveal yellow trousers tapering to tiny feet. The small grilled structure on which she leans may be a cage. Another unidentified object lies on the ground beside her.

Seat: A European woman in a straw hat and long apron strolls with a small child.

1940.73 Back: A young woman in a flowing pink dress and blue petticoat carries an oval tray of flowers. She bends toward the left, hand outstretched, as if reaching for a flower. The garden has a lattice fence and repeats the architecture seen in 1940.72.

Seat: A European youth pushes a young woman in a swing.

1940.74 Back: An old sage sits beside a Chinese stove, taking tea. His bulging, shaven head, white beard and flowing costume are found in Boucher's sketch, *La pêche chinoise.*[5] The curious stove was borrowed from *Le thé* of Boucher and Dumons's *Tenture chinoise,* where it appears in larger format.[6]

Seat: A European couple carries a parasol.

1940.75 Back: Bells in various combinations form the instrument of the girl percussionist. They are prominent also in Boucher's sketch for a tapestry in the *Tenture chinoise* entitled *La danse chinoise* (Musée des Beaux-Arts, Besançon).

Seat: A dancing couple decorates the seat.

1940.76 Back: A pretty blond girl sits between bird cages. She holds one bird with another perched on the cage at the right. Bird cages are prominent in the foreground of Boucher's sketch *La foire chinoise,*[7] also at Besançon.

Seat: A rustic couple plays with a bird.

1940.77 Back: A "Chinese" fisherman at the water's edge seems to draw something toward himself, possibly a net.

Seat: Two European rustics are involved in some kind of altercation.

1940.78 Back: A Chinese musician sits before his drum with sticks raised.

Seat: European music is suggested by a musette. The musician is accompanied by a girl with a distaff.

1940.79 Back: The seated smoker is derived from the figure of the Emperor in *L'audience de l'Empéreur,* from the *Tenture chinoise* of Boucher and Dumons.[8] His canopy and headdress have been simplified.

Seat: A goatherd couple decorates the seat.

1940.72

1940.74

1940.73

1940.75

NOTES

1. Pierrette Jean-Richard, *L'oeuvre gravé de Boucher dans la collection Edmond de Rothschild*, Musée du Louvre, Cabinet des Dessins (Paris, 1978), 164–175. I owe this reference to Edith Standen.

2. Edith A. Standen in *François Boucher 1703–1770* (New York: The Metropolitan Museum of Art, 1986), 340.

3. Alistair Laing in *François Boucher*, 206; Pascal-François Bertrand, "La seconde 'Tenture chinoise' tissée à Beauvais et Aubusson," *Gazette des Beaux-Arts* 116 (November 1990), 176.

4. Laing in *François Boucher*, 206.

5. Laing in *François Boucher*, 204, fig. 44.

6. Dominique Chevalier, Pierre Chevalier, and Pascal-François Bertrand, *Les tapisseries d'Aubusson et de Felletin 1457–1791* (Paris: La Bibliothèque des Arts, 1988), 114–115.

7. Laing in *François Boucher*, 203, fig. 42, "La foire chinoise." Another example of this design was no. 333 (right), illustrated with no. 363, as one of four chinoiserie armchairs, in the Parke-Bernet catalogue of 1 April 1938, Ogden L. Mills Sale. Seats had La Fontaine fables after Oudry. The chinoiserie was described as "after Jean Baptiste Huet."

8. Laing in *François Boucher*, 203, fig. 41.

1940.76

1940.77

1940.78

1940.79

Chinese Scenes

Aesop–La Fontaine Fables

Animals that talk and act like human beings are common to the folk literature of almost all nations. In ancient Greece, Aesop's name became attached to the beast tales he used for political satire. Hundreds are known today, but only about twenty date from Aesop's time. Early in the Christian era, a large number collected by Demetrius Phalereus was put into Latin verse by Phaedrus. The Phaedrus core was expanded and enriched with moralizing fables from India. Babrius made a Greek verse translation of this Greco-Indian mix. While medieval clerics knew their Latin Phaedrus, simpler versions in prose delighted the lay public. A few even appear on the Bayeux Tapestry. Each translator or adaptor imparted a distinctive flavor. The greatest of these recyclers, Jean de La Fontaine (1621–1695), retold the old stories with such imagination and brilliance that he made them unmistakably his own.

The life spans of Jean de La Fontaine, man of letters, and the painter Jean-Baptiste Oudry (1686–1755) barely overlapped, but their interests coincided closely in a shared passion for animals. La Fontaine brought the beasts into the drawing room, so to speak, by making fables fashionable reading. Madame de Sévigné found his second collection of *Fables* "divine." Oudry illustrated the famous edition of 1755–1759. More exactly, the illustrations were engravings made by a team of artists after C. N. Cochin *fils* had given Oudry's rather free drawings the "finished" form required by the engravers.

Oudry's animal painting grew naturally from the Flemish tradition studied during his formative years.

Unlike the animals of the Flemish masters or those of his rival Desportes, Oudry's animals, as Opperman has remarked, show quasi-human emotions. This made them particularly suitable to portray animals exhibiting such human frailties as pride, deceit, and greed.

It would be a mistake to suggest that Oudry's drawings for the *Fables* were made expressly for tapestry. He did make four tapestry cartoons of "Fables," but the drawings seem to have been intended from the beginning to be engraved illustrations. Once the book was published, there was nothing to limit the reproduction and adaptation of his designs. Most of the animal scenes on furniture can claim collateral descent, at least, from Oudry. For the next forty years, the looms of Beauvais and Aubusson were producing small tapestry pieces with animal subjects. The *Fables* of La Fontaine contributed significantly to the financial security and the luster of the Beauvais works under Oudry's directorship.

BIBLIOGRAPHY

Jacobs, Joseph. *The Fables of Aesop.* 1894. Reprint. New York: Schocken Books, 1966.

Opperman, Hal N. "Some Animal Drawings by Jean-Baptiste Oudry." *Master Drawings* 4 (1966): 384–409; 317 Bibliography.

Opperman, Hal N. "Observations on the Tapestry Designs of J.-B. Oudry for Beauvais (1726–1736)." *Allen Memorial Art Museum Bulletin* 26, no. 2 (Winter 1969): 49–71.

Opperman, Hal N. *Jean-Baptiste Oudry.* 2 vols. New York and London: Garland Publishing, 1977, 1:83–101 esp. 99–100, 384 P63–P66; 2:682–710 esp. D221–D496, 712 D502, D504.

88. Fables on Blue Ground

Upholstery panels for four armchairs

French (probably Beauvais), first quarter eighteenth century
Overall design attributed to Christophe Huet (d. 1750)
Medallions after Jean-Baptiste Oudry (1686–1755) and others
H: 86 cm W: 67 cm (34 in. × 26½ in.) back
H: 71 cm W: 84 cm (28 in. × 33 in.) seat
WARP: undyed wool, 8–9 per cm
WEFT: dyed wool and silk
FRAMES: wood, late nineteenth–early twentieth century
Gift of Archer M. Huntington (CPLH), 1926.89–90, 1926.101–102

Centrally located wreaths of blue leaves and pink flowers enclose medallions with fables from La Fontaine or Aesop on both seats and backs. Each medallion is set against a light panel, separated from the surrounding blue ground by climbing vines and flowers. An airy, open dome crowns the design, with a central sunflower topped by a shell. Large birds at the lower edge perch on decorative framework.

1926.90 Back: "The Cock and the Pearl" (La Fontaine, Bk. I, 20).[1] A practical-minded rooster, turning up a pearl in a heap of straw, said he would prefer a single grain of wheat. The tapestry design is derived from Oudry's sketch for the 1755 edition of La Fontaine's *Fables*.[2] Rooster and coop are in the same position, but the hen has been transposed.

Seat: "The Bear and the Bees." An inquisitive bear, exploring a beehive, was stung by a single bee. Losing her temper, she pawed angrily, bringing out the whole swarm and losing all hope of honey. Not found in La Fontaine, the story is described and illustrated in collections of Aesop's fables. A Brussels edition of 1700[3] shows a mirror image of the chair design, with the variation that the bear covers her head.

1926.89 Back: "The Peacock Complaining to Juno" (La Fontaine, Bk. II, 20). Envying the nightingale's melodious song, the peacock complained to Juno about the voice he had been given. The goddess warned him to stop complaining or he would lose his splendid plumage. The peacock in the tapestry is similar to that of the La Fontaine illustration,[4] but his position is reversed. Clouds replace the goddess in the tapestry and a nightingale on a branch has been added.

Seat: "The Eagle and the Tortoise." Aesop tells of an eagle, who was treating a tortoise to a ride when she met a crow who suggested she drop her cargo on the rocks, thereby providing them both with a good meal. The story is not found in La Fontaine but is illustrated in the

Brussels 1700 Aesop.[5] In the tapestry version the eagle is shown more frontally, looking up, rather than down.

1926.101 Back: "The Tortoise and the Two Ducks" (La Fontaine, Bk. X, 2). A tortoise, desiring to see the world, grasped a stick held by two ducks in flight. All went well until she opened her mouth to acknowledge a compliment. The tapestry follows, but simplifies, Oudry's design.[6] The wings are narrowed to fit the frame and the admiring crowd has been eliminated.

Seat: "The Bear and the Bees." See 1926.90 (seat), above.

1926.102 Back: "The Monkey and the Cat" (La Fontaine, Bk. IX, 17). A monkey and a cat watched some chestnuts roasting at the hearth. Not wishing to burn himself, the monkey persuaded the cat to pull the nuts from the fire, then ate them all himself. The source of the tapestry design is unknown. It bears no similarity either to the illustration by Oudry, engraved by L. LeMire,[7] or to Harrewyn's illustration for the Brussels Aesop of 1700.

Seat: "The Frog Who Would Be as Large as the Ox" (La Fontaine, Bk. I, 3). The frog inflated herself to the bursting point in a vain effort to equal the bulk of the ox she admired. There is general correspondence between the tapestry image and the illustration designed by Oudry, etched by C. Cochin and engraved by P. Gaillart.[8] Oudry seems to have borrowed from earlier versions, since the Harrewyn illustration is a mirror image, with minor variations.

NOTES

1. Jean de La Fontaine, *Fables choisies, mises en vers*, 4 vols. (Paris: Imprimerie Charles Antoine Jombert, 1755–1759) 40, Bk. I, 20. "Oudry inv., Chenu sculp."
2. Hal N. Opperman, *Jean-Baptiste Oudry*, 2 vols. (New York and London: Garland Publishing, 1977), 2:687 D244.
3. *Esope en belle humeur* (Brussels, 1700). Illustrated by Harrewyn.

4. Opperman, *Oudry*, 2:689 D263.
5. *Esope en belle humeur*, 74.
6. Opperman, *Oudry*, 2:704 D431. "Oudry inv. Chedel sculp."
7. Opperman, *Oudry*, 2:703 D415.
8. Opperman, *Oudry*, 2:685 D224.

PROVENANCE

The extensive collections of Madame Camille Lelong were sold at the Galerie Georges Petit, Paris, 27 April–15 May 1903. The auction catalogue describes panels painted by Christophe Huet for the decoration of a salon. Huet, a contemporary of Gillot, Audran, and Berain, is best known for the *singeries* he painted for the Hôtel de Rohan. The Lelong panels represent the four seasons with vignettes in the manner of Watteau, surmounted by an airy gilded dome hung with garlands.* This distinctive dome, *ajouré et doré*, reappears in the four Fine Arts Museums armchairs that were probably designed for the salon with the same motif.

*See Galerie Georges Petit, Paris, sale 27 April 1903, Collection Mme C. Lelong, *Catalogue des objets d'art et d'ameublement des XVIIe & XVIIIe siècles*, 23, no. 22.

1926.90

1926.89

1926.101

Fables on Blue Ground

1926.102

89. The Monkey King

Upholstery panels for a settee

French (Beauvais), third quarter eighteenth century
H: 63.5 cm W: 250 cm (25 in. × 98½ in.) back
H: 84 cm W: 188 cm (33 in. × 74 in.) seat
WARP: undyed wool, 8 per cm
WEFT: dyed wool and silk
FRAME: wood, carved and gilded over gesso, eighteenth century (?)
Mildred Anna Williams Collection (CPLH), 1940.71

Back: Book VI, 6, of La Fontaine's *Fables* tells the story of the fox, the monkey, and the other animals who gathered to choose a successor after the old lion died. Each one tried on the crown, the monkey with such amusing antics that he was chosen to be the new king. The fox, pretending to bring him to a buried royal treasure, led him into a trap where he was humiliated and deposed.[1]

The tapestry shows the monkey king in his brief moment of glory, crowned, with a red mantle over his shoulders and a scepter in his hand. Thickly massed flowers, with a few shells and a little strapwork, frame the scene, separating it from the surrounding purplish gray background.

Seat: No fable has been found to correspond to this hunting scene, which was used very frequently for the seats of settees. The hounds, fox, and leopard or tiger[2] appear in the Gobelins tapestry that is believed to have been commissioned by Madame de Pompadour (see cat. no. 90,

53.29.2), as well as in the Aubusson tapestry covering another settee seat in The Fine Arts Museums' collection (see cat. no. 92, 1958.105).

NOTES

1. There is no similarity between this tapestry scene and Oudry's drawing (engraved by A. Radigues) for La Fontaine's *Fables* (1755). Oudry chose to illustrate the moment after the monkey had fallen into the trap. Edith Standen has pointed out another settee with a scene identical to that in San Francisco but woven for a higher back. It was illustrated by George Leland Hunter who attributed the design to Oudry. The tapestry covering of the seat duplicates the hunting scene of The Fine Arts Museums' settee. The piece was at Duveen Brothers in 1925. George Leland Hunter, *The Practical Book of Tapestries* (Philadelphia and London: J. B. Lippincott Company, 1925), pl. XX, f.
2. See cat. no. 90, 53.29.2, for contemporary confusion between tigers and leopards.

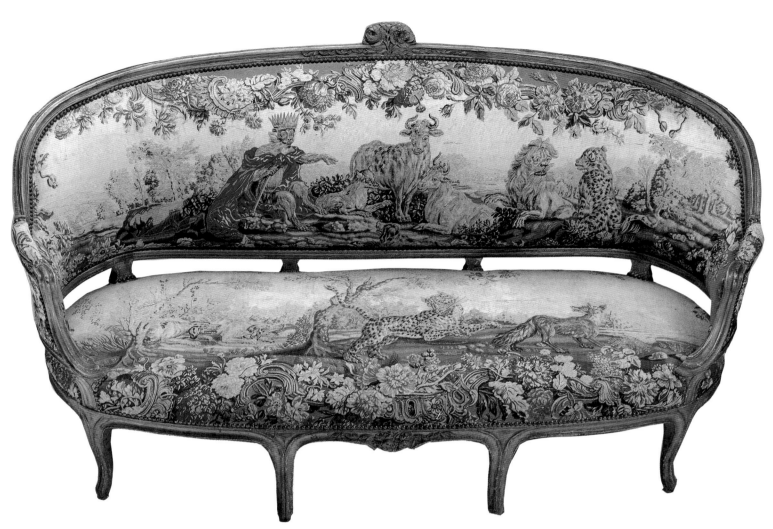

The Monkey King

90. The Arts and Sciences

Upholstery panels for a settee and four armchairs

French (Paris, Gobelins), ca. 1752
BACKS: Arts and Sciences after François Boucher (1703–1770)
SEATS: Fables of La Fontaine after Jean-Baptiste Oudry (1686–1775)
SETTEE: H: 71 cm W: 198 cm (28 in. × 78 in.) back
 H: 87 cm W: 229 cm (34 in. × 90 in.) seat
CHAIR: H: 61 cm W: 56 cm (24 in. × 22 in.) back
 H: 70 cm W: 80 cm (27½ in. × 31½ in.) seat
WARP: undyed wool, 8–9 per cm
WEFT: dyed wool and silk
FRAMES: wood, carved and gilded. Signed I AVISSE (Jean Avisse,
 1723–1796)
Roscoe and Margaret Oakes Collection (de Young), 53.29.2–6

A sense of the appropriate is evident in the distinctly different choice of subjects for the chair backs and seats. It seems to have been generally more acceptable to sit on animals or a fable than on a person or an art or science. The tapestries covering the chair backs derive from paintings by Boucher; those on the seats are adapted from engravings by various artists after Oudry's drawn illustrations for La Fontaine's *Fables*.

Children who behave like adults are a rococo convention.[1] These precocious infants and youngsters engage in all kinds of activities, including flirtation. The settee back shows a juvenile version of Boucher's painting *Pensent-ils au raisin?* (Are they thinking about the grapes?).[2] The children who personify arts and sciences on the chair backs, indicating by gesture or attribute the activity they represent, correspond to figures in a series of panels (oil on canvas) belonging to The Frick Collection, New York.[3] According to nineteenth-century tradition, the panels were commissioned by Madame de Pompadour for the octagonal boudoir of her Château de Crécy. While this is undocumented, the talents and interests depicted are unquestionably those of Louis XV's accomplished mistress.

Each of the tall, narrow panels portrays two subjects, surrounded by garlands and joined by small blue landscape scenes (*en camaïeu*). The upper scenes are oval in format, the lower ones rectangular. "Matching" is a word frequently encountered in texts on eighteenth-century furniture.[4] While Madame de Pompadour might have commissioned furniture to complement Boucher's painted panels, she is known to have sometimes acted to prevent the duplication of her art works.[5] Other instances of tapestry upholstery with the Arts and Sciences represented by children are found on chairs with oval backs, typical of the Louis XVI period. The Fine Arts Museums' furniture set, being pure Louis XV in style, might have been made

before Madame de Pompadour's death in 1764 and might even be the furniture covers with "children" known to have been owned by her.

53.29.2 Settee Back: A young girl, seated in a pastoral landscape, offers grapes to a half-reclining boy. Boucher's original painting has been simplified in this adaptation and given the added width required by the dimensions of a settee.

Seat: Elegant eighteenth-century hunting dogs pursue a leopard holding an arrow in its mouth, with a fox in the lead. This unexpected combination of the familiar and the exotic apparently appealed to a society passionately interested in hunting, for many examples of the design have survived. In one case the "leopard" has stripes.[6] Edith Standen has noted the contemporary confusion between tigers and leopards.[7] The design is traditionally attributed to Oudry, but its animals also recall the work of Desportes.

53.29.3 Armchair Back: A very young blond child, portraying Comedy, sits under a tree. The child holds a mask and points to an oval mirror turned toward the viewer. A jester's puppet and books lie beside the child. The books are inscribed TERE[NCE], PLAUTUS, and MOLIE[RE]. The related panel in The Frick Collection pairs "Comedy," above, with "Tragedy" in the lower tier. The tapestry version of "Comedy" has been reduced in height, a change dictated by the round shape of the chair back. There is loss of detail from fading. No other weavings of the design are known.

Seat: Two nanny goats meet on a narrow plank bridge. Neither being willing to cede, they are both about to fall into the water. The story appears in Book XII, 4, of La Fontaine's *Fables*. The tapestry bears only the vaguest resemblance to Oudry's illustration engraved by Gallimard.

53.29.4 Back: The little girl in a rose-colored dress is a

286

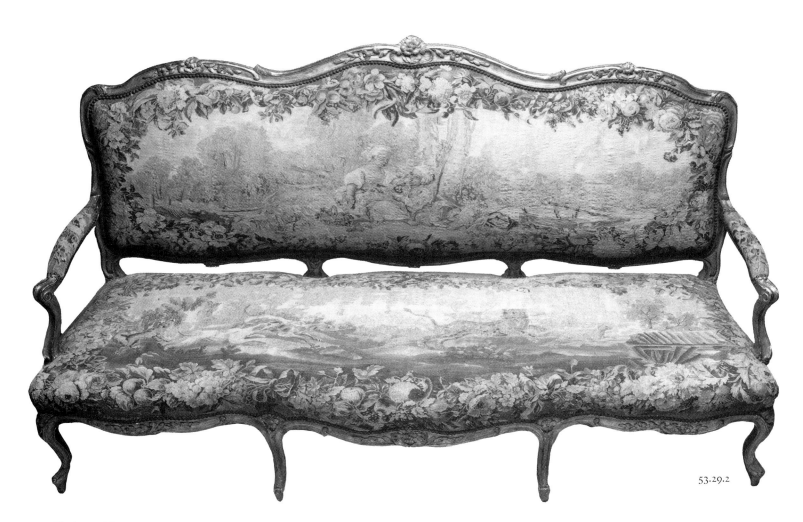

53.29.2

The Arts and Sciences

standard "enfant de Boucher." A *modèle* of the design at the Mobilier National is called "La petite danseuse,"[8] so perhaps she here symbolizes the art of the dance. The child, tightly corseted, wears a tucked-up, simplified version of adult costume with a large skirt over a gold petticoat. She has roses in her hair and at her breast, and she dances with a tambourine in her hand. On the corresponding Frick panel, she occupies the lower half with "Singing" above. A panel in the Rijksmuseum, Amsterdam, offers another woven example of the design, in a set of the "enfants."

Seat: A dog with a piece of meat looks down as he crosses a bridge and seems to see a dog with a larger piece looking up at him. He barks and drops his prize, losing both the reality and the shadow. The La Fontaine version of the fable is Book VI, 17. A general similarity exists between the tapestry and Oudry's design, engraved by J. Ouvrier.

53.29.5 Back: A very young, barefooted architect sits beneath scaffolding in an unfinished peristyle. He points with his compass to a ground plan of a temple. A mason's dresser and square are in evidence, together with building materials and books on architecture, including one inscribed VETRUVE (Vitruvius). The design appears in the upper half of the Frick panel showing "Chemistry" below. The height has been reduced in the tapestry version by eliminating part of the scaffolding. There is significant loss from fading.

Seat: Hares, being easily frightened, are forever on the run. In La Fontaine's fable (Bk. II, 14), illustrated here, they startle a troop of frogs and are delighted to find animals more timid than they. With some changes in position, the tapestry follows Oudry's drawing engraved by C. Baquoy.

53.29.6 Back: Boucher's little poet, caught in a moment of inspiration, appears on the upper half of a Frick panel with "Music" below. The Frick Collection also owns a drawing of the subject. The poet composes in a woodsy setting, and, as Edith Standen has noted, his subject is Love, indicated by the doves, a flute, and a chaplet of roses. In the painting one can also see amorous swans in the distance and a medallion with the head of Louis XV in the foreground.[9] Besides the variance in height, the painted and woven versions differ in the poet's expression. In the Frick panel (16.1.4) and in the tapestry back of a chair in the Huntington collection, the poet stares intently at his scroll. In The Fine Arts Museums' tapestry, he looks up thoughtfully as if searching for *le mot juste.* In this detail the tapestry seems to be closer to Duflos's print, cited by Ananoff, than to the Frick panel.

Seat: In La Fontaine's *Fables* (Bk. II, 15), the fox tells the rooster about a universal amnesty, hoping to lure him from the safety of the tree. However, at the approach of the hounds, the fox flees, disproving his story. J. Ouvrier engraved Oudry's drawing.

NOTES

1. Compare *Architecture* by Carle van Loo in Pierre Rosenberg and Marion C. Stewart, *French Paintings 1500–1825* (San Francisco: The Fine Arts Museums of San Francisco, 1987), illus. 297.
2. Alistair Laing in *François Boucher 1703–1770* (New York, The Metropolitan Museum of Art, 1988), 234, illus. fig. 53.
3. *Handbook of Paintings: The Frick Collections* (New York, 1985), 12–15, accession nos. 16.1.4–16.1.11.
4. Jean Meuvret, *French Cabinetmakers of the Eighteenth Century* (Paris: Librairie Hachette, 1963), 13.
5. Maurice Fenaille, *Etat général des tapisseries de la manufacture des Gobelins depuis son origine jusqu'à nos jours 1600–1900, 1737–1794* (Paris: Librairie Hachette, 1904), 384–388.
6. See cat. no. 92, 1958.105.
7. Edith A. Standen, *European Post-Medieval Tapestries and Related Hangings in The Metropolitan Museum of Art*, 2 vols. (New York: The Metropolitan Museum of Art, 1985), 2:478.
8. Alexandre Ananoff, *François Boucher*, 2 vols. (Lausanne and Paris: La Bibliothèque des Arts, 1976), 2:70, no. 367/17; 126, no. 441, fig. 1252.
9. Edith A. Standen, letter to A. G. B., 16 August 1989.

BIBLIOGRAPHY

Avisse:
Meuvret, Jean. *French Cabinetmakers of the Eighteenth Century.* Collection Connaissance des Arts: "Grands Artisans d'Autrefois." Paris: Librairie Hachette, 1963. New York: French and European Publications, 1965, 108–113.
Mme de Pompadour:
Compardon, Emile. *Madame de Pompadour et la cour de Louis XV au milieu du dix-huitième siècle.* Paris: Henri Plon, 1867.
Cordey, Jean. *Inventaire des biens de Mme de Pompadour redigé après son décès.* Paris, 1939, 26, 71.
Bastien, Jean. *Madame de Pompadour et la floraison des arts.* Exh. cat. Montreal: David M. Stewart Museum, 1988.
La Fontaine and Oudry:
La Fontaine, Jean de. *Fables choisies, mises en vers.* 4 vols. Paris: Imprimerie Charles Antoine Jombert, 1755–1756.
Opperman, Hal N. *Jean-Baptiste Oudry.* 2 vols. New York and London: Garland Publishing, 1977.
The Frick Panels:
The Frick Collection. Pittsburgh, 1949–1955. 12 vols. 1: 150–154; 3: pl. LXIX, LXX, LXXI, LXXIV.
Wark, Robert R. *French Decorative Art in the Huntington Collection.* San Marino, 1961.
Handbook of Paintings: The Frick Collection. New York, 1985, 12–15.

PROVENANCE

Said to have belonged to the duc de la Tremoille, mid-eighteenth century, and the comte de Sesmaisons.
Jansen, Paris
Mrs. Charles A. Wimpfheimer, New York
American Art Association, Anderson Galleries, 1 November 1935
Duveen Bros.
Roscoe and Margaret Oakes, 27 July 1953

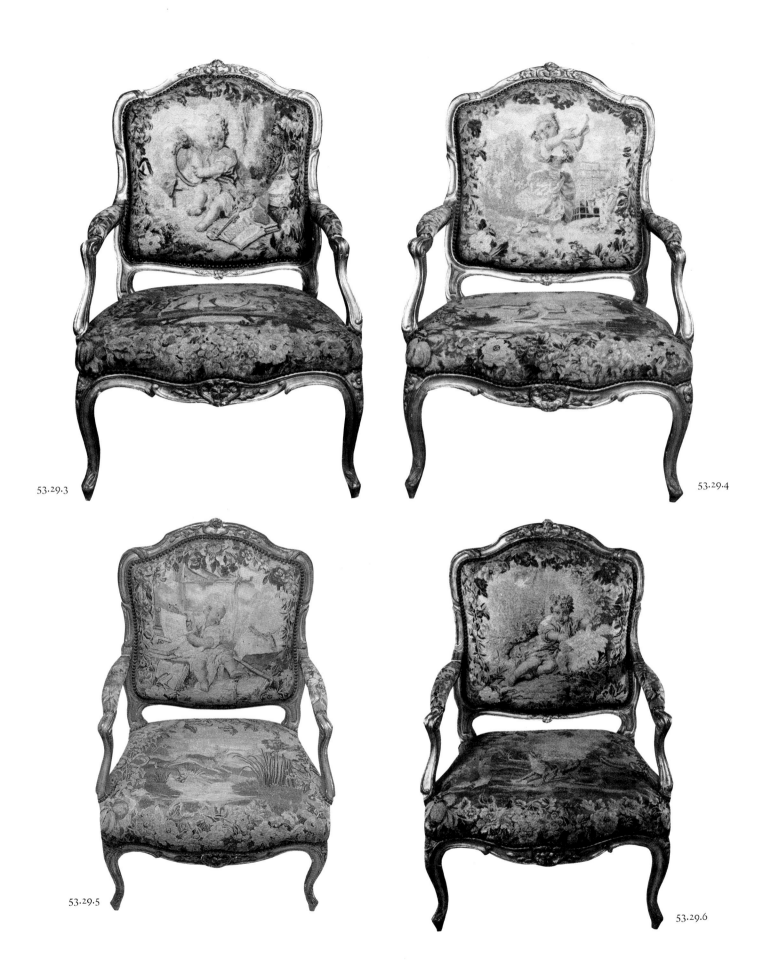

53.29.3

53.29.4

53.29.5

53.29.6

91. The Seesaw

Upholstery panels for a settee and an armchair (from a set of four)

French (Aubusson), third quarter eighteenth century
Design after Jean-Baptiste Huet (1745–1811) (settee back);
 Jean-Baptiste Oudry (1686–1775) (settee seat)
SETTEE: H: 67 cm W: 174 cm (26½ in. × 68½ in.) back
 H: 81 cm W: 199 cm (32 in. × 78½ in.) seat
CHAIR: H: 62 cm W: 57 cm (24½ in. × 22½ in.) back
 H: 72 cm W: 79 cm (28½ in. × 31 in.) seat
WARP: undyed wool, 9 per cm (settee), 8 per cm (chair)
WEFT: dyed wool and silk
FRAMES: wood, carved, guilloche/acanthus pattern, painted white
Signed C. SENE (Claude II Sené, master, 1769)
Roscoe and Margaret Oakes Collection (de Young), 55.41.13–14

55.41.13 Settee Back: The seesaw theme, with its overtones of playful innocence and rusticity, seems to have pleased late eighteenth-century taste. The five children and a seesaw appear on the backs of at least five settees from the Louis XVI period, including that of The Fine Arts Museums. Considerable variety exists in the form of the frames and the length of the settees. Shorter examples eliminate the sheep at the left or the dog on the right.[1]

Seat: The tapestry covering the seat illustrates La Fontaine's fable of *The Lion's Share* ("The Heifer, the Goat, and the Ewe in Partnership with the Lion," Bk. I, 6). The lion directed that the stag taken in the goat's net be divided into quarters, then, by spurious reasoning, laid claim to all four shares for himself. The woven scene closely follows Oudry's illustration,[2] except that the heifer was transposed to the left side, as necessitated by the horizontal format.

55.41.14 Armchair Back: A rosy-cheeked half-grown boy in a straw hat and country costume stands beside a wine barrel. He appears to wear on his back the kind of basket-type carrier used by grape harvesters, his arms passing through the straps. The scene is enclosed in a wide floral garland wrapped with ribbons. The boy can be compared to the *enfants de Boucher* engaging in an innocent, agricultural pastime.[3]

Seat: A dog "freezes" at the sight of a rabbit. He is in the tradition of the royal dog portraits painted by Oudry for Louis XV. Portraits of English greyhounds Turlu and Misse hung in the king's bedroom in 1733. Greyhounds Mignonne and Sylvie were in the *cabinet du conseil* with Lise, a favorite spaniel. More spaniels, Perle, Ponne, and Polydore, decorated the corridor. Opperman called the hunt the *cérémonie baroque par excellence*, a show of strength and power.[4]

NOTES
1. Edith A. Standen pointed out (personal communication) a narrower settee example at the Historisch Museum der stad Venlo in which the dog is missing, and a wall tapestry (1.6 m × 1.4 m) entitled *La Bascule*, sold at Palais Galliera, Paris, 25 March 1969, no. 160; Elisabeth Kalf, *Waar legwerk hangt: Corpus van wandtapijten in Nederlands openbaar en particulier bezit* (Limburg 1988), 222–223, illus.; Sotheby's, Monaco, 23 June 1985, no. 885, another narrow version with a double frame, sold with two chairs; Sotheby's, London, 26 June 1987, no. 118, draped border above, sold with two chairs; American Art Association, 19 March 1937, nos. 407–409, a wide example, sold with two chairs.
2. Hal N. Opperman, *Jean-Baptiste Oudry*, 2 vols. (New York and London: Garland Publishing, 1977), 2:686 D228. "Oudry inv P. E. Moitte sculp."
3. See "la petite danseuse" (cat. no. 90, 53.29.4, "Dancing"). Edith A. Standen (letter to A. G. B., 12 December 1989) notes that this was a type briefly in vogue, developed by Boucher in his designs for Madame de Pompadour, adopted by Le Prince in the Beauvais *Jeux russiens* of 1769, but not used by Casanova in his 1772 Beauvais series, *Amusements de la campagne*. It seems to have been a Louis XV, rather than a Louis XVI, fashion.
4. Hal N. Opperman and Pierre Rosenberg, *J.-B. Oudry 1686–1755*, exh. cat. Grand Palais, Paris, October 1982–January 1983 (Paris: Editions de la Réunion des Musées Nationaux, 1982), 105.

PROVENANCE
Schwarz collection, ca. 1890
James Deering collection, Chicago
French & Company.

There were eight armchairs originally. Three others (55.14.15–17) are in The Fine Arts Museums. The other four were given to The Art Institute of Chicago by Chauncey McCormick (1944.5, 1944.6, 1943.1223, and 1943.1235).

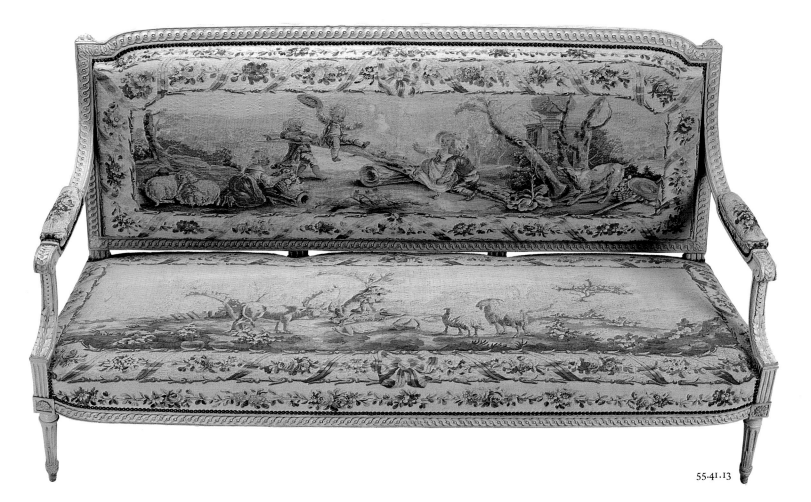

55.41.13

The Seesaw

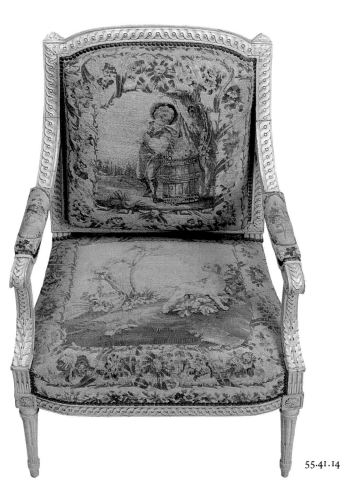

55.41.14

92. Birds and Beasts

Upholstery panels for a settee and an armchair (from a set of four)

French (Aubusson), ca. 1785
SETTEE: H: 67 cm W: 174 cm (26½ in. × 68½ in.) back
 H: 81 cm W: 202 cm (32 in. × 79½ in.) seat
CHAIR: H: 62 cm W: 56 cm (24½ in. × 22 in.) back
 H: 72 cm W: 79 cm (28½ in. × 31 in.) seat
WARP: undyed wool, 8–9 per cm
WEFT: dyed wool and silk
FRAME: channeled wood frame, painted gray, in Louis XVI style
Gift of Mr. and Mrs. Peter Lewis to the Grace Spreckels Hamilton
 Collection (CPLH), 1958.105–106

The well-preserved tapestry covering both settee and chairs shows birds on the backs with beasts below on the seats. Unlike illustrations for fables, these animal scenes seem devoid of narrative or didactic message.

1958.105 Settee Back: An inner panel in tones of ivory is separated from the forest green ground by a double trompe l'oeil frame. A heavy garland of flowers stretches across the top with dependent pieces at the sides. The subject is bird life, taken from nature, in the taste of Desportes. A hawk swooping down on a nesting ground causes great commotion among the pheasants (left) and two ducks (right).

Seat: The scene depicted was a popular choice for settee seats. It appears on three of the five settees chosen for publication from The Fine Arts Museums' collection,[1] as well as on other pieces in auction sales and in public collections. The original design may have been a leopard hunt originating with Oudry, but this is speculation. Here, as in a few other examples, the quarry is a tiger.[2] He appears to be trying to draw a bloody arrow from his side.

1958.106 Armchair Back: A hawk stands over his kill. He looks back behind him, his strong talons resting on the body of the dead bird.

Seat: The impression is of a barnyard scene with a donkey in the center of the composition and a dog curled up peacefully beside it.

The three other armchairs in the collection are nos. 1958.107–109.

NOTES
1. See also cat. no. 89, 1940.71. and cat. no. 90, 53.29.2.
2. See cat. no. 90, 53.29.2, n. 7.

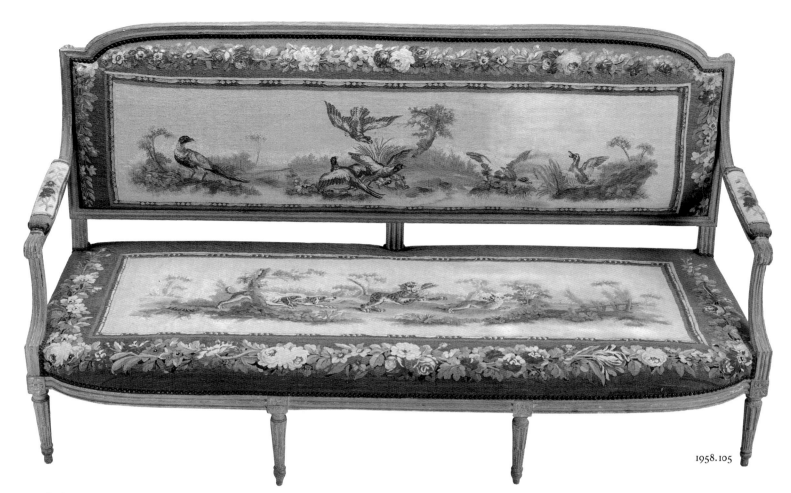

1958.105

Birds and Beasts

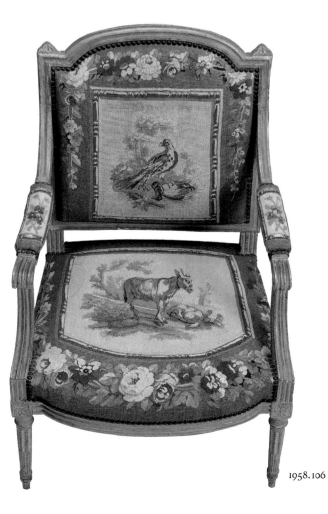

1958.106

93. Cabrera Armorial

Peruvian, ca. 1600–1625
H: 2.03 m W: 2.13 m (6 ft. 8 in. × 7 ft.)
WARP: undyed cotton, 8–10 per cm
WEFT: dyed wool from sheep or cameloid animal of South America
Gift of Mr. and Mrs. Robert Gill, through the Patrons of Art and
 Music, 1975.4.1

Woven in Peru two centuries after the Spanish conquest, this offspring of two cultures bears a general resemblance to the European tapestries among which it is included, while retaining certain technical features typical of its New World inheritance.

The tapestry displays the heraldic shield of Don Luis Jerónimo Fernández Cabrera y Bobadilla, count of Chinchón, beneath a uniting seven-pointed crown.[1] Each quarter of the shield corresponds to either the Cabrera or the Bobadilla family. The lion and the castle in the border are the insignia of León and Castile. Don Luis, whose biography has been published, was viceroy of Peru from 1627 to 1629. Two other tapestries bearing his arms are in the Hearst collection at San Simeon. The Fine Arts Museums' example differs from these in the surrounding area between shield and border.

Heavy black outlines define the major areas: the outer frame, the rounded shield shape, the narrow device-bearing strip forming its outer edge, and its internal divisions. This use of black intensifies the predominating red of the ground, as well as the golds, tans, and whites. Dark outlines were characteristic of the final phase of pre-Columbian tapestries. Their presence in this panel may represent a continuation of this tradition.

The brilliant coloration of the shield is heightened further by a pale pattern of branching stems and leaves filling the space between shield and frame, much as textile patterns were used later in the eighteenth-century European *alentour*. The pale pattern itself is ambiguous in origin. Insofar as it recalls Islamic designs, it follows the European Renaissance tradition; to the extent that it suggests a Chinese influence, it might relate to those Chinese textiles pirated en route from China to Spain after the fall of the Mandarin government.[2] The color changes within the pale background are subtle. The shading of the crown,

however, is done with alternating dark and light wefts, recalling the European *hachure*.

Tapestries woven in Peru before the conquest were generally exceedingly fine in texture, colorful, and technically brilliant. Certain specifically Peruvian features persist in this late colonial example.

Direction of the weave. The design is woven in the same direction as the warp so that the warps hang in a vertical position. Tapestries with this orientation have greater strength than those in which the weight is supported by interrupted wefts. Not all Peruvian tapestries exhibit this feature, but it is encountered more often than among European tapestries.

Selvages. Typical Peruvian pieces show four selvages. The Peruvian custom of continuous warping around the front and back beam of the loom differs from the European method of individually cut warp threads. Tapestries from Peru typically have terminal loops in the direction of the warp. The undamaged top edge of the present example shows this feature.

Surface texture. Slits, which are normal at points of color change, occur irregularly in one-color areas in Peruvian tapestries, adding to the surface interest. These slits are short and never stitched together. Both slits and interlockings are found where two colors meet. Only single wefts are used in these interlockings.[3]

NOTES

1. Identification of identical arms in Hearst Castle tapestries by Guillermo Lohman Villena, Director, Biblioteca Nacional del Perú, 1968.
2. Mary N. Kahlenberg, *Fabric and Fashion*, exh. cat. (Los Angeles: Los Angeles County Museum of Art, 1974), no. 13.
3. I am indebted to Ellen C. Werner for technical information.

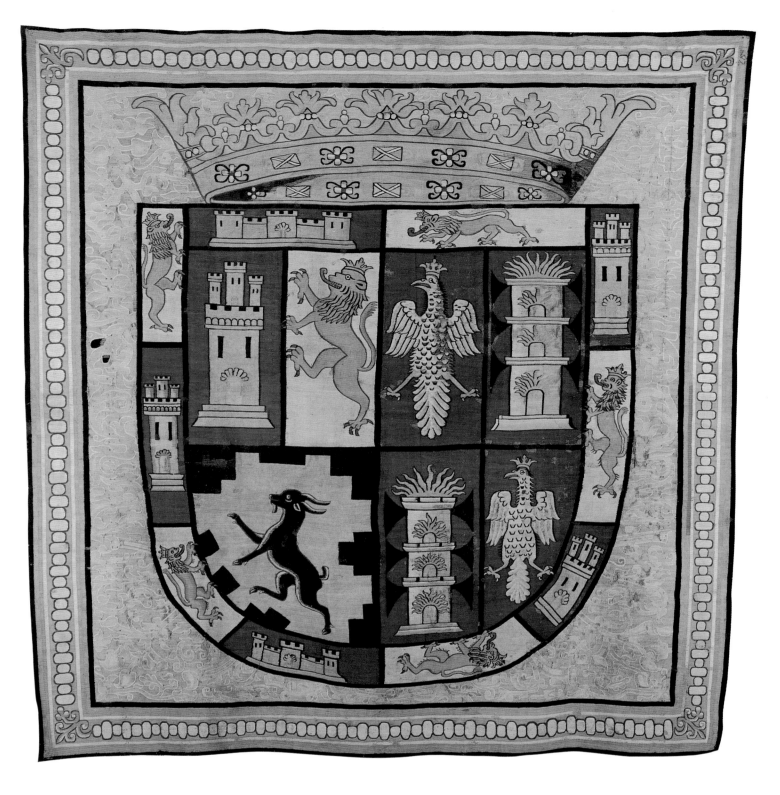

Cabrera Armorial

PART FIVE

DECLINE AND RENEWAL

Decline and Renewal

The fire lighted at the foot of the Liberty Tree in 1793 destroyed a selected group of tapestries; it did not consume the industry itself. The taste of the *ancien régime* was evidently under attack, rather than the art of tapestry or the manufactories. Both the Gobelins and Beauvais were made national institutions in 1794. A jury was appointed to regenerate the Gobelins manufactory by selecting those models considered consistent with revolutionary ideology. It utterly rejected Boucher, as an exponent of decadence, and ruled that no Boucher model was ever to be repeated.[1] One hundred eighty of the richest panels were burned for their content of gold and silver.[2] The subjects approved by the jury were scenes from Greek and Roman history and heroic acts of the Revolution.

Nineteenth-century antiquarianism encouraged reprises of many historical sets. The careers and the tastes of political leaders dictated other subjects as diverse as Napoleon's triumphs and the copies of Boucher that Empress Eugénie admired. But variety of subject matter did not compensate for the unrelieved monotony of technique. Calmettes, writing in 1912, doubted that a single piece of the four thousand square meters woven at the Gobelins during the nineteenth century was indisputably worthy to be included among France's textile treasure. In fact, the last eighteenth-century tapestries produced at the Gobelins—woven imitations of individual paintings—seemed to have set the art on a fatal course. To enable the weavers to make exact copies, M. Chevreul, in charge of the dyeing laboratory for the Gobelins, developed 14,400 woolen tones (72 ranges of 200).

The woven paintings they produced were not only ambiguous as works of art, but prohibitively expensive as well. The weaver's productivity dwindled as tapestries grew finer. The one square meter that the medieval weaver could produce per month shrank in the eighteenth century to fifteen to twenty square centimeters.[3] Specially dyed and subtly graded colors added to the expense. The cost records of the *Joan of Arc* series at The Fine Arts Museums of San Francisco, woven between 1899 and 1908, reflect this escalation. Tapestry, at an artistic and industrial impasse, was ready for the bulldozing reforms of Jean Lurçat.

Lurçat studied Gothic tapestries with the eye of a craftsman to determine what made them great. For him the great lesson of medieval tapestry lay in its monumen-

tality achieved by economy of means. He limited his colors by choice where the medieval weaver had done so by necessity. Coarseness of weave had long distinguished the products of Aubusson. Lurçat worked within a local tradition by opting for heavier wools and further reducing the number of threads per centimeter. He adopted high horizons to avoid perspective effects and dispensed with borders. Subjects were contemporary and personal. Lest the weaver who executed his designs be tempted to paint with wool, Lurçat furnished him with cartoons in black and white, the colors indicated by number. Further instructions showed where hatchings should be used, shades varied, dots and lines employed. Lurçat demanded that his designs be carried out with complete fidelity. In this respect he was no more—and no less—autocratic than Oudry, against whom so much criticism had been leveled.

This fresh approach to design, materials, and technique revitalized the art and to some extent restored its mural character, although without the effect of "walk-in art" achieved by the great medieval and later sets that covered all the walls of a room.

How permanent and significant were Lurçat's reforms? The question arises as one sees the most prestigious weaving centers duplicating contemporary paintings in wool. His legacy may have been best understood by individual artists practicing the art today. For them, Lurçat lessened the distance between the artist's vision and its realization by eliminating such intermediate steps as the artist's preliminary sketch and the cartoonist's translation. Composing directly on the full-scale cartoon,[4] he recaptured the spirit of mural art and validated the tapestry medium as a vehicle for contemporary expression.

NOTES

1. Maurice Fenaille, *Etat général des tapisseries de la manufacture des Gobelins depuis son origine jusqu'à nos jours 1600–1900*, 1794–1900, ed. Fernand Calmettes (Paris: Librairie Hachette, 1912), 54.
2. Madeleine Jarry, *World Tapestry from Its Origins to the Present* (*La tapisserie*, Paris: Librairie Hachette, 1968; English ed. New York: G. P. Putnam's Sons, 1969), 300.
3. Jean Lurçat, *Designing Tapestry*, trans. Barbara Crocker (*Tapisserie française*, Paris: Bordas, 1947; English ed. London: Rockliff, 1950), 46.
4. Mark Adams, personal communication, 15 February 1991, describing Lurçat's working methods.

The Story of Joan of Arc *Series*

The series of *The Story of Joan of Arc*, woven at the turn of the century, owes its existence to a project that was never carried out. About 1890 a plan was afoot to transform the home of Joan at Domremy into a museum. The Beaux-Arts administration decided to commission historical tapestries for the decoration of the future museum. The Gobelins manufactory, traditional supplier to public monuments, was to execute the designs. Somewhat prematurely, the search for a designer was initiated and several prominent artists were approached, including Gustave Moreau and Elie Delaunay. Puvis de Chavannes finally accepted, but he later grew alarmed at the technical problems of designing for tapestry and postponed executing the commission.

The stalemate was broken when six sketches by Jean-Paul Laurens were seen by a council member at the Salon of 1895. These had been made for the decoration of a church but had not been accepted. Laurens was commissioned to paint the first three of the sketches for the tapestries, to be followed later by the second group of three. The first two paintings, exhibited at the Exposition Universelle de Paris in 1900, were not well received. Nevertheless, the commission voted in 1903 that the series should be completed. A more favorable reception attended the fourth subject. The fifth, however, was a failure, and the work on the series was suspended.

The first weavings of *The Mission* and *The Departure* were given to Pope Leo XIII. In 1924 the French government presented the four panels of *The Story of Joan of Arc* to the newly opened California Palace of the Legion of Honor. *The Mission* and *The Departure* are second weavings of the cartoons. *The Arrival of Joan of Arc before Patay* and *The Execution of Joan of Arc* are unique weavings. The models and sketches for the series are preserved at the Gobelins manufactory.

BIBLIOGRAPHY

Fenaille, Maurice. *Etat général des tapisseries de la manufacture des Gobelins depuis son origine jusqu'à nos jours 1600–1900*. 1794–1900. Ed. Fernand Calmettes. Paris: Librairie Hachette, 1912, 199–202.

94. The Mission of Joan of Arc

from The Story of Joan of Arc *Series*

French (Paris, Gobelins), 1905–1907
Designed by Jean-Paul Laurens (1838–1921)
Woven under the direction of Emile de Brancas
H: 2.37 m W: 4.44 m (7 ft. 9½ in. × 14 ft. 6 in.)
WARP: undyed wool, 7 per cm
WEFT: dyed wool and silk (?)
MARKS: *Artist* lower right corner of field
 Origin right guard
 Weavers right guard
 Date right guard
Gift of the French Government (CPLH), 1924.32.2

E de B	J M	R F	
℔.	P R	⬡	1905·07

Joan kneels in an attitude of ecstasy in her cottage garden. Her distaff lies discarded and her eyes are fixed on a vision above her. She listens to the voice of Saint Michael, a monumental figure in Gothic armor with large pink wings and three concentric haloes. The Archangel holds a sword before Joan with his right hand and points with his left to scenes of violence in the background.

Tall hollyhocks fill the left corner. A scroll at their base is inscribed: L'AME DE JEANNE S'ÉPANOUIT AU MILIEU DE SCÈNES DE DÉSOLATION DE LA GUERRE CIVILE (The soul of Joan expands amid desolate scenes of the civil war). The inscription in Gothic script in the upper border reads: FILLE AU GRAND COEUR VA. IL LE FAUT (Great-hearted girl, go. It is necessary). The scenes to which Saint Michael points show the violation and massacre of women and children by English soldiers before a row of gibbets. A running border of mistletoe encloses the picture panel. Lilies growing in the garden are allowed to extend into the border here and there; a clump at the right has been slashed and broken, symbolizing the acts of wanton cruelty.

The right guard shows the RF for République Française and a large G with the vertical bobbin and thread of the Gobelins. Underneath is the date *1905–07* and the initials of the weavers: E de B (Emile de Brancas), JM, PR. A shield with three fleurs-de-lis occupies the upper left corner. The monogram of the artist, JPL, is diagonally across from it, at lower right.

Gobelins records state that the cost of this second weaving of the design was nearly double that of the first.

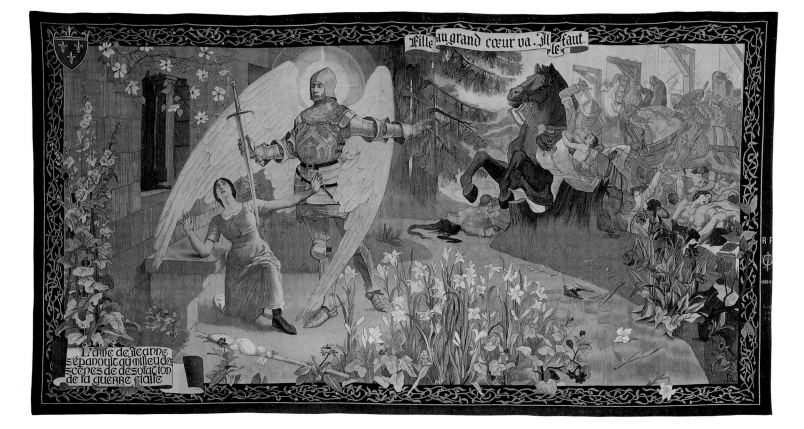

The inscriptions within the tapestry read:

Fille au grand cœur va. Il le faut.

L'âme de Jeanne s'épanouit au milieu des scènes de désolation de la guerre civile

The Mission of Joan of Arc

95. The Departure of Joan of Arc

from The Story of Joan of Arc *Series*

French (Paris, Gobelins), 1905–1907
Designed by Jean-Paul Laurens (1838–1921)
Woven under the direction of Gaston Durand
H: 2.38 m W: 4.55 m (7 ft. 9½ in. × 14 ft. 10 in.)
WARP: undyed wool, 7 per cm
WEFT: dyed wool and silk (?)
MARKS: *Artist* right guard
 Origin right guard
 Weavers right guard
 Date right guard
Gift of the French Government (CPLH), 1924.32.1

Mounted on a black horse, Joan advances from the left, leading her men. Her head is covered by a hood; long spurs are attached to her boots. Emerging from the trees, she reins in her mount before the vision of Saint Catherine. The saint's right hand holds a sword, the point of which penetrates the neck of a fantastic dragon. With her left hand she points to a distant city on the horizon. The banderole with Gothic script must represent the saint's words: TON CHEMIN EST PRÉPARÉ (Your way is prepared). Another inscription in a rounder script is at lower left: S'IL Y A DES ENNEMIS SUR MON CHEMIN, MOI J'AI DIEU, MON SEIGNEUR, QUI SAURA M'OUVRIR UNE VOIE POUR ALLER JUSQU'AU DAUPHIN, CAR JE SUIS NÉE POUR LE SAUVER (If there are enemies on my way, I have God, my Lord, who will be able to open a way for me to the Dauphin, for I was born to save him).

The border is of holly branches, in keeping with the winter scene. The artist's monogram appears in the lower right corner, the shield with three fleurs-de-lis in the upper right. In the right guard the RF and the large G with the vertical bobbin and threads stand for République Française and the Gobelins manufactory. Underneath is the date *1905–07*. The GD in the group of weavers' marks stands for Gaston Durand.

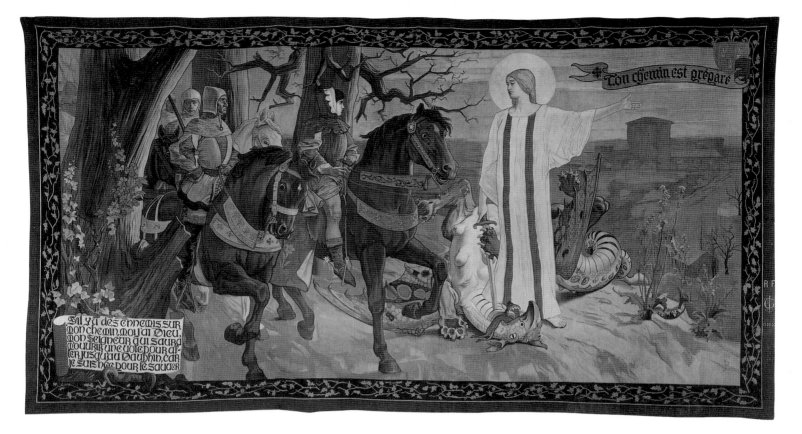

The Departure of Joan of Arc

96. The Arrival of Joan of Arc before Patay

from The Story of Joan of Arc *Series*

French (Paris, Gobelins), 1899–1901
Designed by Jean-Paul Laurens (1838–1921)
Woven under the direction of Antoine Urruty
H: 2.37 m W: 4.58 m (7 ft. 9½ in. × 15 ft.)
WARP: undyed wool, 7 per cm
WEFT: dyed wool and silk (?)
MARKS: *Artist* lower right corner of field
 Origin lower guard
 Date lower guard
Gift of the French Government (CPLH) 1924.32.4

Seated on a white horse in a a triangle formed by three great tree trunks, Joan urges her men on to battle. A fortified town appears in the distance with vague masses before it, presumably the ranks of the enemy. Joan raises both arms in a gesture of encouragement and, incidentally, of sacrifice. She points to Patay with her right hand and holds a banner inscribed JHESVS in her left. The arms of the Savior on the banner are raised in similar fashion. A ghostly Saint Michael, at the right, extends toward Joan the sword he has drawn from its scabbard. His words in Gothic script appear behind him: ILS SONT TOUS VÔTRES (They are all yours). Joan's words, in rounded Italian script, occupy the lower left corner: EN MON DIEU! IL FAUT COMBATTRE, S'ILS ETAIE[NT] PENDUS AUX NUES NOU[S] LES AURIONS. .JE SUIS SÛRE DE LA VICTOIRE (In God's name! We must fight. If they were hung from the clouds, we would have them. I am sure of victory).

The border is composed of running vines, possibly honeysuckle. The painter's monogram is in the lower right corner of the picture panel and the shield with fleurs-de-lis in the upper corner. The mark of the République Française and the Gobelins and the date, *1899–1901*, appear in the lower guard; no weavers' marks are evident.

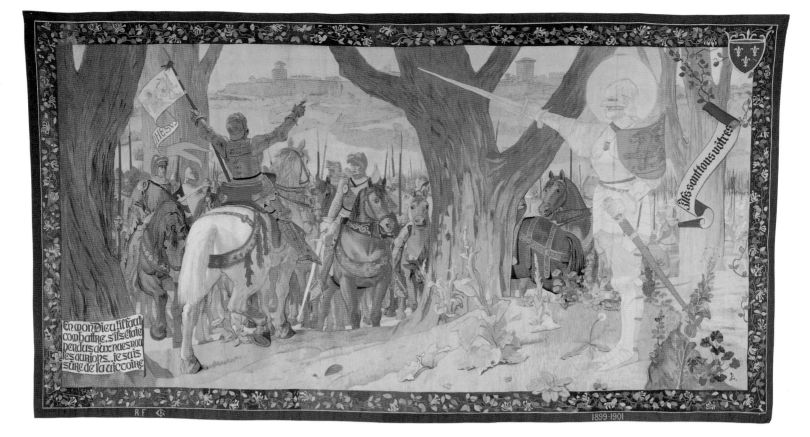

The Arrival of Joan of Arc before Patay

97. The Execution of Joan of Arc

from The Story of Joan of Arc *Series*

French (Paris, Gobelins), 1905–1907
Designed by Jean-Paul Laurens (1838–1921)
Woven under the direction of Georges Maloisel
H: 2.39 m W: 4.45 m (7 ft. 10 in. × 14 ft. 6½ in.)
WARP: undyed wool, 7 per cm
WEFT: dyed wool and silk
MARKS: *Artist* lower right
 Origin left guard
 Weaver lower left guard
 Date lower left guard
Gift of the French Government (CPLH), 1924.32.3

The painting of *Le supplice de Jeanne d'Arc*, made by Laurens for translation into tapestry, drew favorable notice in the Salon of 1904. Its picturesque quality was admired, as was the stage setting it seemed to provide for the final act of the drama.

On a scaffold erected in an open square, Joan, robed in white, is guided by a hooded priest toward the steps leading to her place of execution. She hides her face in her hands. Her words are inscribed on the scroll above her head: C'EST PAR TOI, EVESQUE, QUE JE MEURS. ROUEN! ROUEN! MALHEUR À TOI (Bishop, I die because of you. Rouen! Rouen! Evil betide you!). Another scroll at the foot of the scaffold reads: OUI! TOUTES CES VOIX ÉTAIEN[T] [VRAIE]S. TOUT CE QUE J'AI FAIT JE L'AI FAIT PAR L'AIDE DE DIEU (Yes! All these voices were [true]. All I have done I have done with the aid of God).

Mounted men-at-arms surround the scaffold. A brilliant light from the right falls across the scaffold and reflects on their armor, as if the fire already burned. In the review stand at the left, a mitered bishop is prominent on the upper level, accompanied by other members of the clergy. Various textiles hang before them, as if for a festival. Secular witnesses fill the lower benches, and a small boy climbs up the pillar for a better look.

The executioner waits on the raised brick platform at right, holding a length of rope. A large heap of brush has been laid around a stake with a transverse support. A second man stands ready with a smoking torch.

The border shows thorny stems with a very few leaves and flowers at the right side. The martyr's branch of palm is placed directly above the stake.

The artist's monogram appears at the lower right edge of the scaffold. Those of the weavers are in the left border guard, including that of Georges Maloisel, the RF (République Française), the Gobelins sign (a large G transfixed by the high-warp weaver's pointed bobbin), and the dates *1905–07*.

The Gobelins records show that this fourth and final panel of the series cost nearly three times as much as the first.

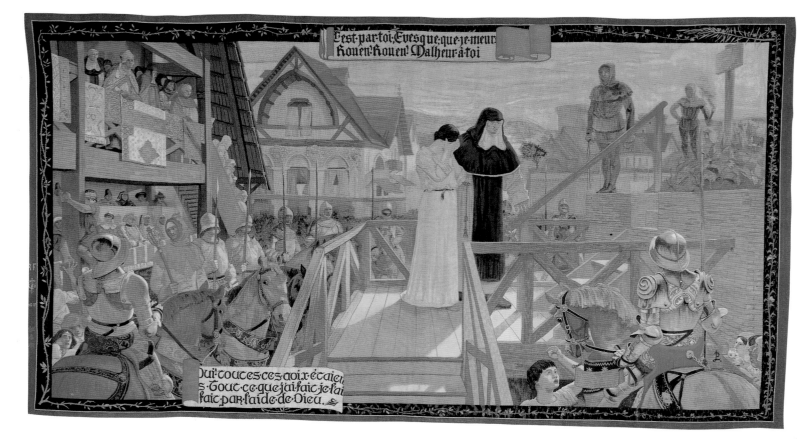

The Execution of Joan of Arc

98. The Ship

American (New York), 1913
Designed by Albert Herter (1871–1950)
H: 2.97 m W: 1.48 m (9 ft. 9 in. × 4 ft. 10½ in.)
WARP AND WEFT: dyed wool, vertical open warp design
MARKS: *Origin* right guard
 Date right guard
Museum purchase, The Trustees' Fund (de Young), 77.5

A storybook ship in a choppy sea dominates this long narrow panel intended to hang in a doorway. The ship's archaic shape recalls a Spanish galleon, rendered in a decorative, rather than a historic spirit. The tapestry's colors, deep blue, gray, tan, and orange, on the other hand, look to the East for inspiration, as do the fish that play in the waves. They resemble *koi-nobori*, the carp banners of the Japanese. Clouds, birds, and pennants fill the sky. The presence of human figures suggests a story. A bearded man draws alongside the ship in a dinghy; another watches from the deck, a third from the crow's nest. The artist's preoccupation with pattern, evident throughout the design, extends to the weaving technique itself. Areas of dyed warp have been left exposed, creating surface interest and a semi-transparent effect (fig. 90). This feature showed to best advantage when the portiere, finished on both sides, hung in a doorway.

The designer, Albert Herter, was educated in France and studied in the Paris studio of Jean-Paul Laurens (cat. nos. 94–97). His murals decorated many public buildings across the United States. His seven huge designs commissioned for the "Mural Room" of the St. Francis Hotel, San Francisco, were originally intended to be woven as tapestries, but the canvas panels were installed to meet the opening date of the Panama Pacific Exposition of 1915. Two weavings of *The Ship* decorated the Herter Looms display in the Varied Industries Building of that Exposition where the Herter booth took a Gold Medal.

Although *The Ship* is believed to have been woven for the Panama Pacific Exposition,[1] it was shown at The Art Institute of Chicago in 1913, where it was hailed as "something absolutely new in the weaver's art," referring to the open-warp technique.[2] As Alice Zrebiec notes, Herter was preceded by Frida Hansen of Norway, who patented the process in 1897, and the Swedish painter Carl Larssen, who also used the technique. Tiffany made "transparent" tapestry portieres about the same time, and J. R. Herter & Co., based in New York and Paris, continued to provide

American clients with "tapisseries ajourées" as late as the 1930s.[3]

Boucher-type tapestries were being produced by Baumgarten in New York in the 1890s, but Albert Herter established tapestry manufacture on a serious scale at Herter Looms (first called "Aubusson Looms") in 1908. He imported Aubusson weavers to execute his designs, first copying Gothic and Renaissance models, then designing independently. His role was critical in bringing French tapestry manufacture to the United States and in promoting the taste for its products.

NOTES
1. Harold Wallace, director of the San Francisco showroom of Herter Looms. Personal communication, 1976.
2. Alice Zrebiec, "The American Tapestry Manufactures: Origin and Development, 1893–1933," (Ph.D. diss., New York University, Institute of Fine Arts, 1980).
 Dr. Zrebiec's help is gratefully acknowledged in providing information for this entry.
3. Zrebiec, "American Tapestry Manufactures."

BIBLIOGRAPHY
Pilgrim, Dianne H. "Decorative Art: The Domestic Environment." *The American Renaissance 1876–1917.* Exh. cat. New York: The Brooklyn Museum and Pantheon Books, 1979, 221, no. 190.

PROVENANCE
Harold V. Wallace collection

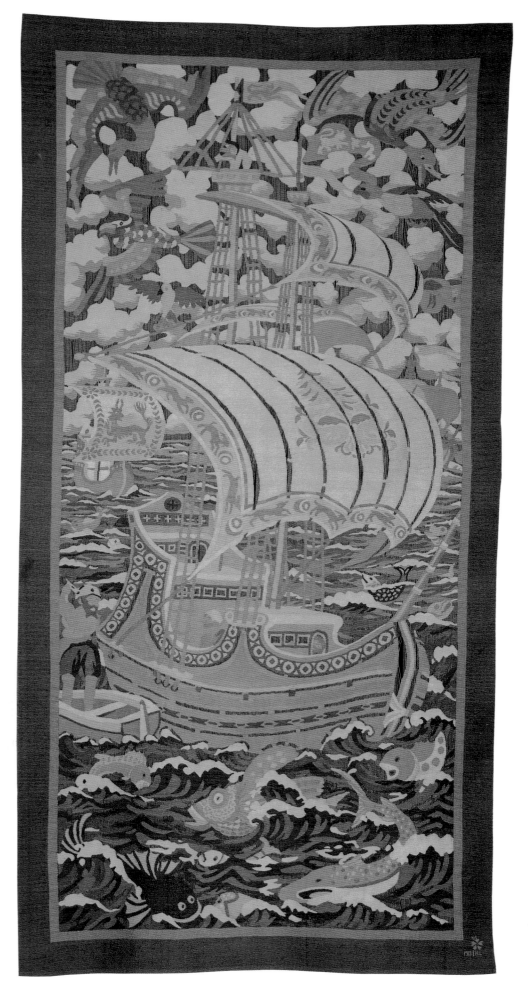

The Ship

99. Spirit of France

French (Aubusson), 1943
Designed by Jean Lurçat (1892–1966)
Woven in the atelier of Mme Goubély
H: 1.57 m W: 2.24 m (5 ft. 2 in. × 7 ft. 4 in.)
WARP: undyed wool, 5 per cm
WEFT: dyed wool
MARKS: *Origin* lower left corner
 Weaver lower left
Gift of Mrs. Marie Stauffer Sigall in memory of her father, Mr. John
 Stauffer (CPLH), 1950.3

The original name given to this tapestry was *Coq-France*;
the present title evokes a similar meaning. The heroic
rooster symbolizes the spirit of the French nation. The im-
age recurs throughout Lurçat's work in bewildering vari-
ety. It is the apotheosis of an ordinary animal seen with
the eye of an artist and a poet. Lurçat himself describes
the initial impact of the rooster on his artistic conscious-
ness: "The bird was overwhelmingly proud. The sun en-
veloped him, polished up his breast, made it shine, in fact
made him a sort of Red God. . . . his claws come to
ground like a wave of a marshal's baton. What glory!
What splendour—an image presents itself—a King!"[1]

This splendid creature wears a radiant sun as halo. Be-
neath his feet is another sphere, double-cored and ringed
with light. From it emerge red waving, tapering forms.
A third sphere explodes with vegetation at upper right.
Three lines, inscribed against the yellow ground, *Feux de
ciel/Coq France/Mariage d'espérance* (Fires from the sky/
Rooster of France/Marriage of Hope). The signature of
Lurçat and the mark of Madame Goubély appear in the
lower left corner.

The symbolism, according to Madame Jean Lurçat,
would be easily understood by anyone who had lived
through the German Occupation. The rising sun symbol-
izes the Liberation and the cock symbolizes France—
France that does not die but watches and sings and will
live again in liberty.[2]

A detail from the tapestry (fig. 91) illustrates Lurçat's
particular contribution to tapestry design and explains his
role in its twentieth-century renaissance. His return to
medieval principles of two-dimensionality, limited colors,
and coarse weave gained power and excitement. The way

FIGURE 91
Detail

he used black added drama, and he broke up color areas
with bold and intricate patterning.

NOTES
1. Jean Lurçat, *Designing Tapestry*, trans. Barbara Crocker (*Tapis-
 serie française*, Paris: Bordas, 1947; English ed. London: Rock-
 liff, 1950), 52.
2. Mme Jean Lurçat, letter to Madeleine Jarry, Paris, 28 January
 1975.

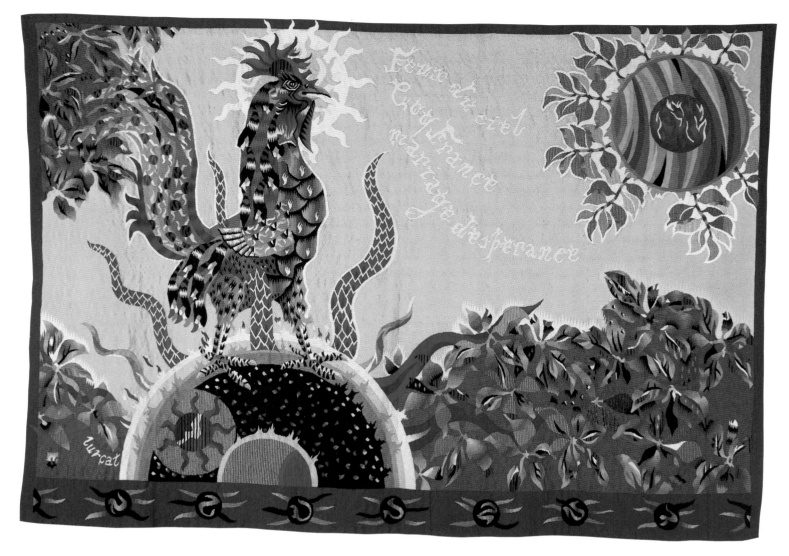

Spirit of France

100. Lotus, Sumatra

American (San Francisco), 1989
Designed by Mark Adams (b. 1925)
Woven by Phoebe McAfee and Rudi Richardson
H: 2.03 m W: 2.33 m (6 ft. 8 in. × 7 ft. 8 in.)
WARP: undyed cotton, 3.3 per cm
WEFT: dyed wool
MARK: *Origin and weavers* lower left
Promised future gift of Mark Adams and Beth van Hoesen

A large, fully opened lotus blossom in shades of intense pink is brilliantly illuminated against a red background. The lotus, a universal symbol of Buddhism, rises up from the mud to flower in the light. It is associated with purity and beauty, as well as with nourishment, for every part is used as food. Even to Western eyes, the lotus is a miracle, at once fragile and strong, coolly luminous in the humid heat of its surroundings.

The lotus that inspired the tapestry grew on the shores of Lake Toba, Sumatra, in a village of the Batak people. Batak houses are built on a foundation of logs put together log-cabin fashion. Batak builders divide the cut ends of the logs into quarters and paint them alternately black and white. The two circles in the lower corners of the tapestry embody this design idea, but black and white lines, applied vertically and horizontally, have been substituted to maintain a separation from the background. The small ocher-bronze spots beneath the blossom suggest the leaves of a small water plant often found with the lotus.

Like the repeating pattern of an Indonesian fabric, dark spots enliven the red ground, interspersed with fine upward-moving lines that evoke the steaming atmosphere. Two vertical bars near the top function as an architectural element, their orange color a clear reference to the Orient.

Adams's approach to tapestry design, as illustrated by the *Lotus*, offers an instructive comparison with the work of Lurçat. Lurçat's *Spirit of France*, 1943 (cat. no. 99), represents the essentially fanciful, somewhat surreal, French decorative work of that period. The artist laid bold, highly stylized patterns in a rather arbitrary way on the natural form of the rooster. Like Lurçat, with whom he studied, Adams is much concerned with pattern, but his patterns evolve from observation of nature. His goal is to communicate the visual experience and its emotional impact. That experience is not intellectualized; the image appeals directly to the eye and to the spirit.

Lotus, Sumatra

APPENDIX A

Fragments *from* The Apocalypse

French (Paris), fourteenth century and later
H: 1.88 m W: 1.89 m (6 ft. 2 in. × 6 ft. 2 ½ in.)
Bequest of Hélène Irwin Fagan (CPLH), 1975.5.26

The panel published in 1976 as a scene from *The Apocalypse* has been re-evaluated in the light of studies conducted by colleagues in technical and scientific fields. Their findings explained certain contradictory features that had been noted in the panel by visiting European experts as well as by the curatorial staff.

The tapestry was found to consist of five fragments of fourteenth-century date that had been incorporated into a new weaving patterned after scenes at Angers. The work was probably carried out in the nineteenth century when many attempts were made to "recreate" Gothic art. The foreground revealed patches from the sixteenth century, but most of the weaving showed the presence of aniline dyes typical of the nineteenth century.

BIBLIOGRAPHY

Bennett, Anna G. "Recycling the Apocalypse: A Reconstruction Using Fourteenth-Century Fragments." A lecture at Krefeld, West Germany, 23 September 1985, subsequently published in *Bulletin de liaison du Centre international d'étude des textiles anciens*, no. 59–60 (1984):17–26.

Bennett, Anna G. "Four Tapestries with Identity Problems." *Apollo* 111, no. 216 (February 1980):106–109.

Areas outlined are original fourteenth-century fragments

Other Tapestries in the Collection

The Victory of Queen Tomyris
from **The Story of Cyrus the Great** *series*
Flemish (Brussels), late sixteenth century
H: 3.84 m W: 2.44 m (12 ft. 7 in. × 8 ft.)
Wool and silk
Gift of Mr. and Mrs. Joseph W. Cochran III, 1983.97

Hannibal Receiving Tribute from the Ligurians
Flemish (probably Oudenaarde), ca. 1600
H: 3.40 m W: 2.62 m (11 ft. 2 in. × 8 ft. 7 in.)
Wool and silk
MARKS: *Weaver* right guard, bottom
Museum purchase (de Young), 49747

Tapestry Border with Grotesque Designs (fragment)
Flemish (Brussels), ca. 1600
H: 0.56 m W: 3.05 m (1 ft. 10 in. × 10 ft.)
Wool and silk
Gift of Archer M. Huntington (CPLH), 1934.3.6

Forest Landscape with Dolphin Border
Flemish, 1650–1700
H: 3.12 m W: 4.04 m (10 ft. 3 in. × 13 ft. 3 in.)
Wool and silk
Gift of Richard B. Gump (de Young), 44.28.5

The Battle of Marcus Aurelius
from **The History of Marcus Aurelius** *series*
Flemish (Antwerp), 1650–1675
Designed by Abraham van Diepenbeek (1596–1675)
Woven under the direction of Michiel Wauters
H: 3.20 m W: 5.23 m (10 ft. 6 in. × 17 ft. 2 in.)
Wool and silk
Gift of Mr. and Mrs. Sidney M. Ehrman (CPLH), 1959.80

Samson with Lion and Angels (upholstery panel for
 chair seat)
Flemish, early seventeenth century
H: 56 cm W: 56 cm (1 ft. 10 in. × 1 ft. 10 in.)
Linen, wool, and silk
Gift of Archer M. Huntington (CPLH), 1934.3.2

Christ Healing the Sick (upholstery panel for chair back)
Flemish, seventeenth century
H: 56 cm W: 51 cm (1 ft. 10 in. × 1 ft. 8 in.)
Wool and silk
Gift of Archer M. Huntington (CPLH), 1934.3.4

Forest Landscape with Crane
Flemish, seventeenth century
H: 3.16 m W: 2.17 m (10 ft. 1½ in. × 7 ft. 1½ in.)
Wool and silk
Gift of Richard B. Gump (de Young), 44.28.2

Tapestry Border with Monkeys
Flemish (possibly Brussels), seventeenth century
H: 2.79 m W: 0.20 m (9 ft. 2 in. × 8 in.)
Wool
Gift of Archer M. Huntington (CPLH), 1934.3.7

Floral Panel
Brussels, late seventeenth century
H: 2.06 m W: 1.03 m (6 ft. 9 in. × 3 ft. 1½ in.)
Wool and silk
Gift of Archer M. Huntington (CPLH), 1926.86

Pair of Side Chairs with Tapestry Upholstery:
 Floral Design
French, late seventeenth century
Gift of Archer M. Huntington (CPLH), 1926.105–106

Pair of Side Chairs with Tapestry Upholstery
BACKS: Parrots beside table with bowl and fruit
SEATS: Wreath surrounding quiver crossed by an arrow
French, late seventeenth century
Gift of Archer M. Huntington (CPLH), 1926.109–110

Tapestry Border with Fruit and Flowers
French, early eighteenth century
H: 0.20 m W: 5.44 m (8 in. × 17 ft. 10 in.)
Linen and wool
Gift of Archer M. Huntington (CPLH), 1934.3.8

Armchair with Tapestry Upholstery: Game of Ninepins
French, mid-eighteenth century
Gift of Archer M. Huntington (CPLH), 1927.50

Chasuble with Scenes from the Life of Saint Stanislaus
Polish (Kraków), 1747–1758
Woven by F. Glaize
H: 1.03 m W: 0.81 m (3 ft. 1½ in. × 2 ft. 8 in.)
Linen, wool, silk, gold, and silver
Gift of Archer M. Huntington (CPLH), 1934.3.256

Pair of Armchairs with Tapestry Upholstery
BACK: Kneeling girl
SEAT: Two monkeys
BACK: Seated girl
SEAT: Two goats
French (possibly Aubusson), ca. 1750
Roscoe and Margaret Oakes Collection (de Young),
 49.23.1–2

Pair of Armchairs with Tapestry Upholstery
BACK: Seated young man pouring drink into a cup
SEAT: Lion
BACK: Girl arranging flowers
SEAT: Lamb and dog
French (possibly Aubusson), ca. 1770
Roscoe and Margaret Oakes Collection (de Young),
 49.22.1–2

Pair of Chairs with Tapestry Upholstery
BACK: Woman and child
SEAT: Two rabbits
BACK: Young man and woman
SEAT: Dog and fox
French, ca. 1774–1793
Mr. and Mrs. E. John Magnin Gift (de Young),
 75.18.39–40

Upholstery Panel for Chair Seat: Armorial
Probably French, eighteenth century
H: 56 cm W: 53 cm (1 ft. 10 in. × 1 ft. 9 in.)
Wool and silk
Gift of Archer M. Huntington (CPLH), 1934.3.1

**Upholstery Panel for Chair Back: Floral Wreath
 Surrounding Hanging Basket of Flowers**
French, late eighteenth century
H: 48 cm W: 36 cm (1 ft. 7 in. × 1 ft. 2 in.)
Wool and silk
Gift of Archer M. Huntington (CPLH), 1934.3.9

Canyon Country
American, 1966
Designed by Ednah Root (1907–1987)
H: 2.18 m W: 1.72 m (7 ft. 2 in. × 5 ft. 8 in.)
Wool
Estate of Ednah Root, 1989.35

California Poppies
American (San Francisco), 1976
Designed by Mark Adams (b. 1925)
A demonstration weaving for the *Five Centuries of Tapestry*
 exhibition
H: 1.37 m W: 0.86 m (4 ft. 6 in. × 2 ft. 10 in.)
Cotton and wool
Gift of Mark Adams, 1977.3

Gemini
Detail of *La Poésie* from *Le Chant du Monde* series
Designed by Jean Lurçat (French, 1892–1966)
Woven under the direction of Jean-Pierre Larochette,
 1988–1989
H: 1.68 m W: 0.79 m (5 ft. 6 in. × 2 ft. 7 in.)
Wool and cotton
Gift of Simone Lurçat, The San Francisco Tapestry Work-
 shop, and the Textile Arts Council of San Francisco,
 1989.70

APPENDIX C

Recent Acquisition: May and July *from* The Twelve Months *Series*

English, ca. 1700
Weaving attributed to Stephen de May
H: 2.79 m w: 3.90 m (9 ft. 2 in. × 12 ft. 9½ in.)
WARP: undyed wool, 6.5 per cm
WEFT: dyed wool and silk
MARK: *Origin* lower guard, right
Gift of Mr. and Mrs. J. Frederick Kohlenberg, 1991.123

Two scenes separated by a slender column illustrate the familar theme of the labors (and sports) of the months. On the left, three on horseback leave for a falcon hunt. The young lord holds the hawk, his companion a leafy branch traditionally carried on the first of May. The noble sport of hawking is balanced on the right by the labor of haymaking. Field-workers with scythes and rakes toil in the July heat, while some pause under a tree for the mid-day meal.

Flemish designs by Jerome de Potter were adapted for the Mortlake factory and first woven for the prince of Wales in 1623.[1] Other sets followed, some with inscriptions and floral borders. The narrow border with a ribbon wound around a rod suggests a late date.[2] A verdure signed by the weaver Stephen de May shows a similar border and figures borrowed from *July*.[3] Like *May and July*, the verdure carries the Mortlake mark: a white shield with the red cross of Saint George.

NOTES
1. H. C. Marillier, *English Tapestries of the Eighteenth Century* (London: Medici Society, 1930), 61, 63.
2. Marillier, *English Tapestries*, 64.
3. George Wingfield Digby, "Late Mortlake Tapestries," *Connoisseur* 134, no. 542 (January 1955), 245.

Acknowledgment is made of assistance provided by Wendy Hefford in a letter to A.G.B., 19 February 1975.

PROVENANCE
Earls of Bristol, Rushbrooke Hall, according to Marillier, *English Tapestries*, 64 (sale 19 December 1928, Christie's, no. 146)
Lurline B. Roth, "Filoli" (sale 25 March 1975, Butterfield & Butterfield, no. 444)
Mr. and Mrs. J. Frederick Kohlenberg

Bibliography

JOURNALS

Bacri, Jacques. "A New Fragment of Guillaume de Hellande Tapestries." *The Burlington Magazine* 101, no. 680 (November 1959): 402–404.

Barraud, Abbé. "Description de deux nouvelles tapisseries exécutées pour la Cathédrale de Beauvais." *Mémoires de la Société académique de l'Oise (1852–1857)*, 2:321–328.

Bennett, Anna G. "Four Tapestries with Identity Problems." *Apollo* 111, no. 216 (February 1980): 106–112.

Calberg, M. "Le triomphe des vertus chrétiennes. Suite de huit tapisseries de Bruxelles du XVIe siècle." *Revue belge d'archéologie et d'histoire de l'art* 29 (1960).

Cavallo, Adolph S. "The Redemption of Man: A Christian Allegory in Tapestry." *Bulletin of the Museum of Fine Arts, Boston* 56, no. 306 (Winter 1958): 147–168.

Crick-Kuntziger, Marthe. "A Fragment of Guillaume de Hellande's Tapestries." *The Burlington Magazine* 45, no. 260 (November 1924): 225–231.

———. "La tenture d'Achille d'après Rubens et les tapissiers Jean et François Raes." *Bulletin des Musées Royaux d'Art et d'Histoire*, 3d ser., 6 (1934): 2–12, 70–71.

Delmarcel, Guy. "Jules Romain: L'histoire de Scipion. Tapisseries et dessins." *Bulletin Monumental* 136 (1978).

———. "Text and Image: Some Notes on the Tituli of Flemish 'Triumphs of Petrarch' Tapestries." *Textile History* 20, no. 2 (1989): 321–329.

Destrée, Joseph. "La Sibylle Agrippa: Fragment de tapisserie française, XVe–XVIe siècle." *Annales de la Société royale d'archéologie de Bruxelles* 35 (1930), 131–136.

Duverger, Erik. "Tapijten naar Rubens en Jordaens in het bezit van het Antwerps handelsvennootschap Fourment-Van Hecke." *Artes Textiles* 7 (1971): 119–121, 148–162.

Ferrero, Mercedes Viale. "Tapisseries rubéniennes et jordaenesques à Turin." *Artes Textiles* 3 (1956): 67–74.

Hunter, George Leland. "Guillaume de Hellande's Tapestries." *The Burlington Magazine* 46, no. 265 (April 1925): 193–194.

Huyghe, René. "French Tapestries in Paris." *Magazine of Art* 40, no. 1 (January 1947): 10–12.

Jarry, Madeleine. "Chinoiseries à la mode de Beauvais." *Plaisir de France* 429 (May 1975): 54–59.

Junquera de Vega, Paulina. "Les series de tapisseries de 'Grotesques' et 'L'histoire de Noé' de la couronne d'Espagne." *Bulletin des Musées Royaux d'Art et d'Histoire*, 6th ser., 45 (1973): 163–165.

Mahl, Elisabeth. "Die Romulus und Remus-folgen der Tapisseriensammlung des kunsthistorischen Museums." *Jahrbuch der kunsthistorischen Sammlungen in Wien* 61 (n.s. 25) (1965): 8–40.

———. "Die 'Mosesfolge' der Tapisseriensammlungen des kunsthistorischen Museums in Wien." *Jahrbuch der kunsthistorischen Sammlungen in Wien* 63 (1967): 7–38.

Nickel, Helmut. "The Man beside the Gate." *The Metropolitan Museum of Art Bulletin*, n.s. 24 (April 1966): 237–244.

Oppe, A. P. "The Right and Left in Raphael's Cartoons." *Journal of the Warburg and Courtauld Institutes* 7 (1944): 82–94.

Opperman, Hal N. "Some Animal Drawings by Jean-Baptiste Oudry." *Master Drawings* 4 (1966): 384–409, 317 Bibliography.

———. "Observations on the Tapestry Designs of J.-B. Oudry for Beauvais (1726–1736)." *Allen Memorial Art Museum Bulletin* 26, no. 2 (Winter 1969):49–71.

Prudhomme, A. "Le trésor de Saint Pierre de Vienne." *Bulletin de l'Académie delphinale* (23 January 1884), 1885.

Roethlisberger, Marcel. "La tenture de la licorne dans la collection Borromée. *Oud Holland* 92, pt. 3 (1967): 85–115.

———. "Deux tentures bruxelloises du milieu du XVIe siècle." *Oud Holland* 86, pt. 2–3 (1971):88–115.

Scheicher, Elisabeth. "Die *Trionfi*, eine Tapisserienfolge des kunsthistorischen Museums in Wien," *Jahrbuch der kunsthistorischen Sammlungen in Wien* 31 (1971): 7–46.

Standen, Edith A. "Some Sixteenth-Century Flemish Tapestries Related to Raphael's Workshop." *Metropolitan Museum Journal* 4 (1971): 109–121.

———. "Romans and Sabines: A Sixteenth-Century Set of Flemish Tapestries." *Metropolitan Museum Journal* 9 (1974): 211–228.

———. "Some Tapestries at Princeton." *Record of The Art Museum, Princeton University* 47, no. 2 (1988): 3–18.

Stechow, Wolfgang. "A Modello by Jacob Jordaens." *Allen Memorial Art Museum Bulletin* 23 (Fall 1965): 5–16.

Urseau, C. "La tapisserie de la Passion d'Angers et la tenture brodée de Saint-Barnard de Romans." *Bulletin archéologique du Comité des travaux historiques et scientifiques* (1917): 54–61.

Verdier, Philippe. "The Tapestry of the Prodigal Son." *The Journal of the Walters Art Gallery* 18 (1955): 9–58.

Versyp, Jacqueline. "Zestiende-Eeuwse Jachttapijten met het Wapen van de Vidoni en Aanverwante Stukken." *Artes Textiles* 7 (1971): 23–46.

Weigert, Roger-Armand. "La manufacture royale de tapisseries de Beauvais en 1754." *Bulletin de la Société de l'histoire de l'art français* (1933).

———. "Les commencements de la manufacture royale de Beauvais, 1664–1705." *Gazette des Beaux-Arts* 64 (1964): 331–346.

Wells, William. "Heraldic Art and the Burrell Collection." *The Connoisseur* 151, no. 608 (1962): 101–105.

White, John, and John Shearman. "Raphael's Tapestries and Their Cartoons." *Art Bulletin* 40 (1958): 193–221.

Wood, D. T. B. "Tapestries of the Seven Deadly Sins—I." *The Burlington Magazine* 20, no. 106 (January 1912): 210–222.

———. "Tapestries of the Seven Deadly Sins— II." *The Burlington Magazine* 20, no. 107 (February 1912): 277–289.

BOOKS AND CATALOGS

Ackerman, Phyllis. *Catalogue of the Retrospective Loan Exhibition of European Tapestries.* San Francisco: San Francisco Museum of Art, 1922.

———. *Catalogue of a Loan Exhibition of Gothic Tapestries*. Exh. cat. Chicago: The Arts Club of Chicago, 1926.

Asselberghs, Jean-Paul. *La tapisserie tournaisienne au XVe siècle*. Tournai, 1967.

———. "Charles VIII's Trojan War Tapestry." *Victoria and Albert Museum Year Book*. London: Victoria and Albert Museum, 1969.

———. *Chefs-d'oeuvre de la tapisserie flamande: Onzième exposition du château de Culan*. Exh. cat. 12 June-12 September 1971.

———. *Les tapisseries flamandes aux Etats-Unis d'Amérique*. Brussels: Artes Belgicae, 1974.

Badin, Jules. *La manufacture de tapisseries de Beauvais depuis ses origines jusqu'à nos jours*. Paris: Société de Propagation des Livres d'Art, 1909.

Begemann, Egbert Haverkamp. *The Achilles Series. Corpus Rubenianum, Ludwig Burchard*. Brussels: Arcade Press, 1975, pt. 10.

Birioukova, N. *Les tapisseries françaises de la fin du XVe au XXe siècle dans les collections de l'Ermitage*. Leningrad, 1974.

Blažkova, Jarmila. "Les marques et signatures trouvées sur les tapisseries flamandes du XVIe siècle en Tchécoslovaquie." In *L'âge d'or de la tapisserie flamande*. International Colloquium (Gent), 23–25 May 1961. Brussels: Paleis der Academien, 1969.

Boccara, Dario. *Les belles heures de la tapisserie*. Zoug: Les Clefs du Temps, 1971.

Brejon de Lavergnée, Barbara. *Inventaire général des dessins. Ecole française: Dessins de Simon Vouet 1590-1649*. Paris: Cabinet des Dessins, Musée du Louvre. Editions de la Réunion des Musées Nationaux, 1987.

Cavallo, Adolph S. *Tapestries of Europe and of Colonial Peru in the Museum of Fine Arts, Boston*. 2 vols. Boston: Museum of Fine Arts, 1967.

———. *Textiles: Isabella Stewart Gardner Museum*. Boston: Trustees of the Isabella Stewart Gardner Museum, 1986.

Cetto, Maria. *Der Berner Traian und Herkinbald Teppich*. Bern, 1966.

Chevalier, Dominique, Pierre Chevalier, and Pascal-François Bertrand. *Les tapisseries d'Aubusson et de Felletin: 1457-1791*. Paris: S. Thierry and Bibliotheque des Arts, 1988.

Coffinet, Jules. *Arachné ou l'art de la tapisserie*. Paris: Bibliothèque des Arts, 1971.

Comstock, Helen. "Tapestries from the Hearst Collection in American Museums." In *The Connoisseur Year Book, 1956*. London, 1956.

Crelly, William R. *The Painting of Simon Vouet*. New Haven and London: Yale University Press, 1962.

Crick-Kuntziger, Marthe. *La tenture de l'histoire de Jacob d'après Bernard van Orley*. Antwerp: Imprimeries Générales Lloyd Anversois, 1954.

———. *Catalogue des tapisseries (XIVe au XVIIIe siècle)*. Brussels: Musées Royaux d'Art et d'Histoire, 1956.

Dacos, N. "Tommaso Vincidor. Un élève de Raphael aux Pays-Bas." In *Relations artistiques entre les Pays-Bas et l'Italie à la Renaissance: Etudes dediées à Suzanne Sulzberger*. Vol. 4. of *Études d'histoire de l'art*. Brussels-Rome: Institut Historique Belge de Rome, 1980.

Delmarcel, Guy. *Tapisseries bruxelloises de la pré-Renaissance*. Exh. cat. Brussels: Musées Royaux d'Art et d'Histoire, 1976.

———. *Tapisseries anciennes d'Enghien*. Mons: Fédération du Tourisme, 1980.

Demotte, G.-J. *La tapisserie gothique*. Paris and New York: Demotte, 1924.

Desjardins, G. *Histoire de la cathédrale de Beauvais*. Beauvais, 1865.

Destrée, Joseph. *Tapisseries et sculptures bruxelloises à l'exposition d'art ancien bruxellois*. Exh. cat. Brussels: Librairie Nationale d'Art et d'Histoire, 1906.

Digby, G. Wingfield, and Wendy Hefford. *The Devonshire Hunting Tapestries*. London: Victoria and Albert Museum, 1971.

Duverger, Erik. "Geschiedenis van Romulus en Remus (Wenen, Kunsthistorisches Museum)." In *De Bloeitijd van de Vlaamse Tapijtkunst (L'âge d'or de la tapisserie flamande)*. International Colloquium (Gent), 23–25 May 1961. Brussels: Paleis der Academien, 1969.

———. "Tapisseries de Jan van Tieghem representant l'histoire des premiers parents, du Bayerisches National Museum de Munich." In *L'art brabançon au milieu du XVIe siècle et les tapisseries du château de Wawel à Cracovie: Actes du colloque international, 14-15 décembre 1972. Bulletin des Musées Royaux d'Art et d'Histoire* 45 (1973; offprint, Brussels, 1974).

Duverger, Erik, and Guy Delmarcel. *Bruges et la tapisserie*. Bruges: Mouscron, 1987.

Erkelens, A. M. Louise. *Wandtapijten I: Late gotiek en vroege renaissance*. Amsterdam: Rijksmuseum, 1962.

Farcy, Louis de. *Histoire et description des tapisseries de la Cathédrale d'Angers*. Lille and Angers, n.d.

Les fastes de la tapisserie du XVe au XVIIIe siècle. Exh. cat. Paris: Musée Jacquemart-André, 1984.

Fenaille, Maurice. *Etat général des tapisseries de la manufacture des Gobelins depuis son origine jusqu'à nos jours 1600-1900*. 5 vols. Paris: Librairie Hachette, 1903–1923.

Ferrero, Mercedes Viale. "Quelques nouvelles données sur les tapisseries de l'Isola Bella." In *L'art brabançon au milieu du XVIe siècle et les tapisseries du château de Wawel à Cracovie: Actes du colloque international, 14-15 décembre 1972. Bulletin des Musées Royaux d'Art et d'Histoire* 45 (1973; offprint, Brussels, 1974).

———. *Museo Poldi Pezzoli. Arazzi-tappeti-tessuti copti-pizzi-ricami-ventagli*. Milan, 1984.

Ffoulke, Charles M. *The Ffoulke Collection of Tapestries*. New York, 1913.

Forti Grazzini, Nello. *Museo d'Arti Applicata. Arazzi*. Milan: Electa, 1984.

———. *Arazzi del cinquecento a Como*. Exh. cat. Como: Società Archeologica Comense, 1986.

———. *Arazzi a Milano. Le serie fiamminghe del Museo della Basilica de Sant'Ambrogio*. Milan, 1988.

———. *Gli arazzi. Monza. Il Duomo e i suoi tesori*. Milan, 1988.

Friedlaender, Walter. *Nicolas Poussin: A New Approach*. New York: Harry N. Abrams, [1964].

Gilbert, Creighton. "Are the Ten Tapestries a Complete Series or a Fragment?" In *Studi su Raffaello: Atti del Congresso internazionale*

di studi, Urbino-Firenze, 6–14 aprile 1984. Urbino: Quattro Venti, 1987.

Göbel, Heinrich. Wandteppiche. I Teil: Die Niederlande. 2 vols. Leipzig: von Klinkhardt & Biermann, 1923.

———. Wandteppiche. II Teil: Die romanischen Länder. 2 vols. Leipzig: von Klinkhardt & Biermann, 1928.

de La Gorce, Jérôme. Berain, dessinateur du Roi Soleil. Paris: Herscher, 1986.

Guiffrey, Jules. Les manufactures parisiennes de tapisseries au XVIIe siècle. Paris, 1892.

———. "Notes et documents sur les origines de la manufacture des Gobelins et sur les autres ateliers parisiens pendant la première moitié du dix-septième siècle." In Maurice Fenaille. Etat général des tapisseries de la manufacture des Gobelins depuis son origine jusqu'à nos jours 1600–1900. 1601–1662. Paris: Librairie Hachette, 1923.

Heinz, Dora. Europäische Wandteppiche I. Braunschweig: von Klinkhardt & Biermann, 1963.

Held, Julius S. The Oil Sketches of Peter Paul Rubens. 2 vols. Princeton: Princeton University Press, 1980.

Hennel-Bernasikowa, Maria. "Verdures aux animaux." In Jerzy Szablowski, ed. Les tapisseries flamandes au château de Wawel à Cracovie: Trésors du roi Sigismond II Auguste Jagellon. Antwerp: Fonds Mercator, S.A., 1972.

Houdoy, Jule. Les tapisseries de haute lisse. Lille and Paris, 1871.

Hullebroeck, Adolphe. Histoire de la tapisserie à Audenarde du XVe au XVIIIe siècle. Renaix: Presses du maître-imprimeur J. Leherte-Delcour, 1938.

d'Hulst, Roger-A. Arazzi fiamminghi. Bologna, 1961.

———. Flemish Tapestries from the Fifteenth to the Eighteenth Century. New York: Universe Books, 1967.

———. Jacob Jordaens. Trans. P. S. Falla. London: Sotheby Publications, 1982.

Hunter, George Leland. Tapestries, Their Origin, History, and Renaissance. London: John Lane Company, 1912.

———. The Practical Book of Tapestries. Philadelphia and London: J. B. Lippincott Company, 1925.

Jaffe, Michael. Jacob Jordaens, 1593–1678. Exh. cat. Ottawa: National Gallery of Canada, 1968–1969.

Jarry, Madeleine. World Tapestry from Its Origins to the Present. English ed., New York: G. P. Putnam's Sons, 1969. Originally published as La tapisserie. Paris: Librairie Hachette, 1968.

———. "Les tapisseries faites sur les mêmes cartons." In Krotoff, Marie Henriette. Les tapisseries de la vie du Christ et de la Vierge d'Aix-en-Provence. Exh. cat. Aix-en-Provence: Musée des Tapisseries, 1977.

———. In Exotisme et tapisserie. XVIIIe siècle. Exh. cat. (Aubusson: Musée Departementale de la Tapisserie, 1983).

Jestaz, Bertrand. "The Beauvais Manufactory in 1690." In Acts of the Tapestry Symposium November 1976. San Francisco: The Fine Arts Museums of San Francisco, 1979.

Jeux et divertissements. Tapisseries du XVIe au XVIIIe siècle. Exh. cat. Arras: Musée des Beaux-Arts, 1988.

Joubert, Fabienne. La tapisserie médiévale au musée de Cluny. Paris: Editions de la Réunion des Musées Nationaux, 1987.

Junquera de Vega, Paulina, and Concha Herrero Carretero. Catálogo de tapices del patrimonio nacional. Vol. 1, sixteenth century. Madrid: Editorial Patrimonio Nacional, 1986.

Junquera de Vega, Paulina, and Carmen Díaz Gallegos. Catálogo de tapices del patrimonio nacional. Vol. 2, seventeenth century. Madrid: Editorial Patrimonio Nacional, 1986.

Kalf, Elisabeth. Waar legwerk hangt: Corpus van wandtapijten in Nederlands openbaar en particulier bezit. Limburg, 1988.

Krotoff, Marie-Henriette. Les tapisseries de la vie du Christ et de la Vierge d'Aix-en-Provence. Exh. cat. Aix-en-Provence: Musée des Tapisseries, 1977.

Kumsch, E. Die Apostel-Geschichte: Eine Folge von Wandteppichen nach Entwurfen von Raffael Santi. Dresden, 1914.

Laing, Alistair. "Catalogue of Paintings." In François Boucher 1703–1770. New York: The Metropolitan Museum of Art, 1986.

Lurçat, Jean. Designing Tapestry. Trans. Barbara Crocker. English ed., London: Rockliff, 1950. Originally published as Tapisserie française, Paris: Bordas, 1947.

Mâle, Emile. L'art religieux de la fin du Moyen Age en France. 3d ed. Paris: A. Colin, 1925.

———. L'art religieux après le Concile de Trente. Paris: A. Colin, 1932.

———. The Gothic Image: Religious Art in France of the Thirteenth Century. Trans. Dora Nussey from 3d French ed. 1913. Reprint. New York: Harper & Row, 1966.

Marillier, H. C. Handbook to the Teniers Tapestries. London: Oxford University Press, 1932.

———. The Tapestries at Hampton Court Palace. 4th ed., rev. London: Her Majesty's Stationery Office, 1962.

Mayer [Thurman], Christa. Masterpieces of Western Textiles. Chicago: The Art Institute of Chicago, 1969.

Migeon, Gaston, and Jules Guiffrey. La collection Paul Blanchet. Paris: Georges Petit, 1913.

Misiag-Bochenska, Anna. "Tapisseries historiées: Scènes de la Genese." In Jerzy Szablowski, ed. Les tapisseries flamandes au château de Wawel à Cracovie: Trésors du roi Sigismond II Auguste Jagellon. Antwerp: Fonds Mercator, S.A., 1972.

Mondain-Monval, Jean. Correspondance de Soufflot avec les Directeurs des Bâtiments concernant la Manufacture des Gobelins (1756–1780). Paris: Libraire Alphonse Lemerre, 1918.

Piwocka, Magdalena. "Les tapisseries à grotesques." In Jerzy Szablowski, ed. Les tapisseries flamandes au château de Wawel à Cracovie: Trésors du roi Sigismond II Auguste Jagellon. Antwerp: Fonds Mercator, S.A., 1972.

Planchenault, René. Les tapisseries d'Angers. Paris: Caisse Nationale des Monuments Historiques, 1955.

van Puyvelde, Leo. Les esquisses de Rubens. Basel: Holbein, 1948.

Reynolds, Graham. The Raphael Cartoons. London: Victoria and Albert Museum, 1966.

de Ricci, Seymour. Twenty Renaissance Tapestries from the J. Pierpont Morgan Collection. Paris: P. Renouard, 1913.

Ripa, Cesare. Baroque and Rococo Pictorial Imagery. Hertel Edition of 1758–1760. Ed. Edward A. Maser. New York: Dover, 1971.

Salmon, Larry. "The Passion of Christ in Medieval Tapestries." In Acts of the Tapestry Symposium November 1976. San Francisco: The Fine Arts Museums of San Francisco, 1979.

Sánchez Cantón, Francisco J. Libros, tapices y cuadros que coleccionó Isabel la Católica. Madrid: Consejo Superior de Investigaciones Científicas, 1950.

Scherer, Margaret R. The Legends of Troy in Art and Literature. New York and London: Phaidon Press, 1963.

Schneebalg-Perelman, Sophie. "Un grand tapissier bruxellois: Pierre d'Enghien, dit Pierre van Aelst." In L'âge d'or de la tapisserie flamande. International Colloquium (Gent), 23–25 May 1961. Brussels: Paleis der Academien, 1969.

———. "La tapisserie flamande et le grand témoignage du Wawel." In Jerzy Szablowski, ed. Les tapisseries flamandes au château de Wawel á Cracovie: Tresors du roi Sigismond II Auguste Jagellon. Antwerp: Fonds Mercator S.A., 1972.

Shearman, John. Raphael's Cartoons in the Collection of Her Majesty

the Queen and the Tapestries for the Sistine Chapel. London: Phaidon, 1972.

Souchal, Geneviève. *Masterpieces of Tapestry from the Fourteenth to the Sixteenth Century.* Exh. cat. Paris: Editions des Musées Nationaux, 1973. New York: The Metropolitan Museum of Art, 1974.

————. "*The Triumph of the Seven Virtues:* Reconstruction of a Brussels Series (ca. 1520–1535)." In *Acts of the Tapestry Symposium November 1970.* San Francisco: The Fine Arts Museums of San Francisco, 1979.

Standen, Edith A. "Some Sixteenth-Century Grotesque Tapestries." In *L'art brabançon au milieu du XVIe siècle et les tapisseries du château de Wawel à Cracovie: Actes du colloque international, 14–15 décembre 1972. Bulletin des Musées Royaux d'Art et d'Histoire* 45 (1973; offprint, Brussels, 1974).

————. "Some Beauvais Tapestries Related to Berain." In *Acts of the Tapestry Symposium November 1976.* San Francisco: The Fine Arts Museums of San Francisco, 1979.

————. *European Post-Medieval Tapestries and Related Hangings in The Metropolitan Museum of Art.* 2 vols. New York: The Metropolitan Museum of Art, 1985.

————. "Boucher as a Tapestry Designer." *In François Boucher 1703–1770.* New York: The Metropolitan Museum of Art, 1986.

Steppe, Jan-Karel. "Vlaamse Kunstwerken in het bezit van doña Enríquez, echtgenote van Jan II van Aragon en moder van Ferdinand de Katholieke." *Scrinium lovaniense: Mélanges historiques E. van Cauwenbergh.* Lovain, 1961.

————. "Inscriptions décoratives contenant des signatures et des mentions de lieu d'origine sur les tapisseries bruxelloises de la fin du XVe et du début du XVIe." In *Tapisseries bruxelloises de la pré-Renaissance.* Exh. cat. Brussels: Musées Royaux d'Art et d'Histoire, 1976.

Sternberg, Charles. *Verdure Tapestry.* Exh. cat. New York: Vigo-Sternberg Galleries, 26 May–14 June 1983.

Stucky-Schürer, M. *Die Passionsteppiche von San Marco in Venedig.* Bern, 1972.

de Tervarent, G. *Les animaux symboliques dans les bordures des tapisseries bruxelloises.* Brussels: Paleis der Academien, 1968.

Thomson, F. P. *Tapestry: Mirror of History.* New York: Crown Publishers, 1980.

Thomson, William George. *A History of Tapestry from the Earliest Times until the Present Day.* Rev. ed. London: Hodden and Stoughton, 1930. 3d rev. ed. Wakefield, England: EP Publishing Limited, 1973.

Thuillier, Jacques, Barbara Brejon de Lavergnée, and Denis Lavalle. *Vouet.* Paris: Réunion des Musées Nationaux, 1990.

Torra de Arana, Eduardo, Antero Hombría Tortajada, and Tomás Domingo Pérez. *Los tapices de la seo de Zaragoza.* Zaragoza: Caja de Ahorros de la Imaculada, 1985.

Treasures from the Burrell Collection. Exh. cat. London: Hayward Gallery, 1975.

Les trésors des églises de France. Exh. cat. Paris: Musée des Arts Décoratifs, 1965.

Vandevivere, I., and Jean-Paul Asselberghs. *Tapisseries et laitons de choeur XVe et XVIe siècles.* Liège: Imprimerie Soledi, 1971.

van de Velde, Carl. "The Grotesque Initials in the First Ligger and in the Busboek of the Antwerp Guild of Saint Luke." In *L'art brabançon au milieu du XVIe siècle et les tapisseries du château de Wawel à Cracovie: Actes du colloque international, 14–15 décembre 1972. Bulletin des Musées Royaux d'Art et d'Histoire* 45 (1973; offprint, Brussels, 1974).

Verlet, Pierre, Michel Florisoone, Adolf Hoffmeister, and François Tabard. *Great Tapestries: The Web of History from the Twelfth to the Twentieth Century.* Ed. Joseph Jobé. Lausanne: Edita, 1965.

Versyp, Jacqueline. "Vlaamse wantapijten uit de XVIIe eeuw te Fabriano en te Urbino." In *La tapisserie flamande au XVIIe et XVIIIe siècles.* International Colloquium, 8–10 October 1959. Brussels: Paleis der Academien, 1959.

Viale, Mercedes, and Vittorio Viale. *Arazzi e tappeti antichi.* Turin: ILTE, 1952.

Wauters, Alphonse. *Les tapisseries bruxelloises.* 1878. Reprint. Brussels: Editions Culture et Civilization, 1973.

Weigert, Roger-Armand. *French Tapestry.* Trans. Donald and Monique King. London: Faber and Faber, 1956.

————. *La tapisserie et le tapis en France.* Paris: Presses universitaires de France, 1964.

Wells, William. "The Earliest Flemish Tapestries in the Burrell Collection, Glasgow (1380–1475)." In *L'âge d'or de la tapisserie flamande.* International Colloquium (Gent), 23–25 May 1961. Brussels: Paleis der Academien, 1969.

OTHER

Ackerman, Phyllis. "Tapestries: Gift from William Randolph Hearst." Typescript, files, The Fine Arts Museums of San Francisco, January 1954.

Delmarcel, Guy. "De Brusselse wandtapijtreeks 'Los Honores' (1520–1525). Een Vorstenspiegel voor de jonge keizer Karel V." 2 vols. Doctoral dissertation, Katholieke Universiteit Leuven, 1981.

Marillier, H. C. "Subject Catalogue of Tapestries." MS. Victoria and Albert Museum, London, n.d.

Zrebiec, Alice. "The American Tapestry Manufactures: Origin and Development, 1893–1933." Ph.D. diss., New York University, Institute of Fine Arts, 1980.

Index

Titles of tapestries in the collection of The Fine Arts Museums of San Francisco are in boldface; all other titles are in italics. Boldface numbers indicate pages with illustrations.